Painter 11 for Photographers

Dedicated to my wife Doreen

Painter 11 for Photographers

Creating painterly images step by step

Martin Addison

AMSTERDAM • BOSTON • HEIDELBERG • LONDON • NEW YORK • OXFORD
PARIS • SAN DIEGO • SAN FRANCISCO • SINGAPORE • SYDNEY • TOKYO
Focal Press is an imprint of Elsevier

Focal Press is an imprint of Elsevier
Linacre House, Jordan Hill, Oxford OX2 8DP, UK
30 Corporate Drive, Suite 400, Burlington, MA 01803, USA

First edition 2009

British Library Cataloguing in Publication Data
A catalogue record for this book is available from the British Library

Library of Congress Control Number: 2009928672

ISBN: 978-0-240-52123-7

For information on all Focal Press publications
visit our website at focalpress.com

Printed and bound in Canada

09 10 11 12 11 10 9 8 7 6 5 4 3 2 1

Contents

Foreword . **xi**

Introduction . **xiii**

Where can I get help? . **xix**

Acknowledgements . **xxi**

Chapter 1: Getting started in Painter 11 . **1**
 The Painter 11 workspace . 2
 Default view. 2
 Toolbox . 3
 Opening a picture in Painter . 3
 Brush Selector . 3
 Picking a color from the Colors palette . 4
 Properties bar . 5
 Correcting mistakes . 5
 Moving around the picture . 6
 Rotating the canvas. 7
 Normal view. 7
 Full Screen view . 8
 Keyboard shortcuts for the screen. 8
 Using and organizing palettes . 8
 Creating custom palettes . 9
 Palette menu . 10
 Brush Creator. 11
 Using a graphic tablet . 11
 Saving images. 13
 Brush default settings. 13
 Setting up preferences. 14
 Preferences – General. 14
 Preferences – Operating System. 15
 Preferences – Undo . 15
 Preferences – Customize Keys . 15
 Customize workspace. 16
 Photoshop – Painter 11 . 17
 Terminology and usage. 17
 File compatibility . 18
 Tools . 19
 Some useful keyboards shortcuts in Painter 11 19

Chapter 2: First steps in cloning . **21**
 Basic cloning techniques. 22
 Tracing paper. 22

Contents

Auto-Painting. 23
 Underpainting palette . 24
 Auto-Painting palette. 26
 Restoration palette . 27
Auto-Painting – Tough Guy?. 28
Soft cloning . 32
Camel Impasto clone . 36
Impressionist clone . 38
 An introduction to Paper Grain. 40
 Creating texture . 41
'Real' Watercolor . 44
Pastel flower. 47

Chapter 3: Choosing brushes . **49**
Selecting brushes in Painter 11 . 50
First select the category. 50
Understanding the shape . 50
Now for the texture . 51
Blenders for smoothing and mixing . 51
Acrylics. 52
Airbrushes. 54
Art Pen . 56
Artists . 58
Artists Oils. 60
Blenders. 62
Calligraphy . 64
Chalk. 66
Charcoal. 68
Cloners. 70
Colored Pencils . 72
Conte . 74
Crayons . 76
Digital Watercolor. 78
Distortion . 80
Erasers . 82
F-X . 84
Felt Pens. 86
Gouache . 88
Image Hoze. 90
Impasto . 92
Liquid Ink. 94
Markers . 96
Oil Pastels . 98
Oils. 100

Palette Knives .102
Pastels. .104
Pattern Pens .106
Pencils .108
Pens. .110
Photo .112
RealBristle .114
Smart Stroke. .116
Sponges. .118
Sumi-e .120
Tinting .122
Watercolor. .124

Chapter 4: Customizing brushes. .127
The Brush Creator. .128
 General palette – dab types .129
 General palette – dab types 1 .130
 General palette – dab types 2 .132
 General palette – Method. .134
 General palette – subcategory .135
 General palette – grain. .135
 Spacing palette. .136
 Angle palette. .136
 Well palette .137
 Random palette .137
 Watercolor or Digital Watercolor? .138
 Watercolor explained .138
 Watercolor layers .139
 Water: Wetness .139
 Water: Dry rate .140
 Water: Diffuse amount .140
 Water: Wind force. .141
 Water: other controls .141
 The Randomizer .142
 The Transposer .143
Creating a captured dab .144
Saving brush variants .146
Making a new brush category .146

Chapter 5: Paper textures. .149
What are paper textures?. .150
Paper scale .151
Paper contrast .151
Paper brightness. .152

Contents

Using extra paper libraries . 152
Creating your own paper texture . 153
Using paper textures for creating pictures . 155
Using paper textures for stamping . 158
Applying surface textures . 160
 Using: Paper . 161
 Applying paper textures to a layer . 165

Chapter 6: Layers and montage . 167
The Layers palette . 168
 Active layer . 168
 Layer visibility . 168
 Canvas . 168
 Making new layers . 168
 Renaming a layer . 169
 Deleting layers . 169
 Merging and flattening layers . 169
 Layer compatibility . 170
 Grouping layers . 170
 Layer masks . 170
 Duplicating layers . 171
 Locking a layer . 172
 Preserve Transparency . 172
 Layer opacity . 172
 Layer Composite Depth . 172
 Layer Composite Method . 173
Family history montage . 177
Cloning onto layers . 185
Cloning from three images . 189
Designing a poster . 192

Chapter 7: Using color . 197
Choosing colors . 198
 The Colors palette . 198
 Color sets . 199
 Mixer . 201
Adjusting tone and color . 202
 Brightness and Contrast . 202
 Equalize . 203
 Correct Colors . 203
 Adjust Color . 206
 Adjust Selected Colors . 207
 Match Palette . 208
 Negative . 209
 Posterize . 210

Posterize using Color Set. .210
Toning techniques. .211
Underpainting palette .213
Hand coloring photographs. .214
Hand coloring a graphic image. .220

Chapter 8: Landscape .**223**
Impressionist landscape .224
Landscape with oils. .227
Dry Bristle Watercolor .231
Oil Pastels .235
Pencil landscape .240

Chapter 9: Children .**245**
Using Blender brushes .246
Portrait using Blenders. .248
Portrait in Pastel .252
Making an inset mount .255
Portrait in Oils .260
Blenders and Pastels .266

Chapter 10: Portraits .**271**
Portrait using Artists Oils .272
Portrait using Pastels. .276
Acrylics Real Wet. .280
Design ideas for portraits .284
Moody portrait .286
Weddings .287
Bride in white. .290

Chapter 11: Special effects .**295**
Woodcut .296
Apply Screen .297
Distress. .298
Quick Warp .299
Sketch. .300
Glass Distortion. .302
Liquid Lens .303
Bevel World. .304
Burn. .305
Kaleidoscope .306

Chapter 12: Printing and presentation .**309**
A simple workflow .310
Photographic capture .310
File sizes. .311

Contents

Sharpening . 311
Preparing to print . 312
Increasing the file size . 313
Color management . 314
What is color manangement? . 314
Why do I need color management? . 315
The Color Management Dialog Box . 315
Applying and changing profiles . 317
Soft-proofing . 318
Problems with printing textures . 318
Viewing on screen . 318
How file sizes affect paper textures . 320
How print sizes affect paper textures . 321
Resampling files with paper textures . 321
Edge effects . 322
Last word . 324
Congratulations! . 324
Painter for Photographers DVD . 325
Video tutorials . 325
Step by step original photographs . 325
Pdf tutorials . 325

Index . **327**

Foreword

Photographers are always looking for new ways to process their images into fine art and paintings. Most are fearful that their final artwork is not painterly enough and still has photographic elements. This is where this book takes a huge leap forward to specifically speak to photographers learning to paint with Corel Painter software.

Truly defining how to use Painter 11 for photographers is a special niche that Martin Addison knows well. In his new book he teaches photographers to easily understand Corel Painter 11 and the power behind it with an emphasis on a variety of clone painting methods. This is the best method for photographers to be painting as they can see their image while they paint. Martin makes choosing brushes a breeze and goes into detail on customizing your personal brushes. Each brush is explained in detail plus the steps to create your own specialized brushes. The examples used are colorful, easy to see and to visualize following the lessons.

In this new book the details are what set it apart from all previous books. It goes into depth on the topics that teach a photographer how to make the jump from image capture to painted artistry. All photographers and Painter 11 enthusiasts will enjoy this book and refer to it often.

Once again Martin has written a book that will be on my book shelf as a primary reference for Painter 11 and for learning the tips and tricks that help to make digital painting a wonderful and creative experience. Enjoy the artistic journey from the first chapter to the ending when you print your work and frame it.

Marilyn Sholin

Corel Painter Master

Author, Artist & Educator

Asheville,NC

http://www.marilynsholin.com

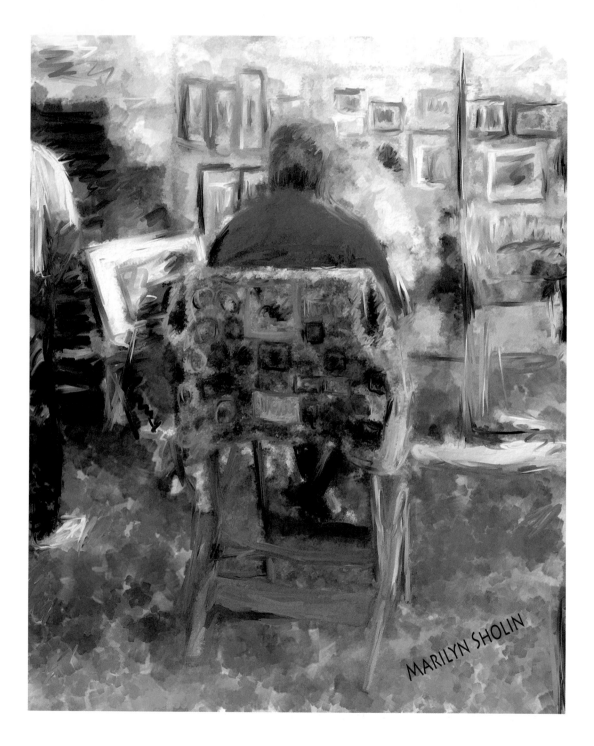

MARILYN SHOLIN

Introduction

Who is this book for?

Whether you are new to digital imaging or are already familiar with Painter and other graphics programs, I am confident that this book will help you to expand your creative abilities and make many brilliant new pictures from your photographs.

As the title suggests, this book is aimed solely at photographers – of all types.

For the professional photographer there are techniques which can turn a standard portrait or wedding picture into a premium priced product which is unique and desirable.

If you are a serious amateur photographer you can learn how to make pictures which are subtle or powerful according to your intentions and which are very different to work produced by many others.

For the casual photographer who would like to turn family snapshots into painterly pictures suitable for hanging on the wall there are simple step by step demonstrations to guide you from the original photograph to the finished picture.

What's special about this book?

There are other books which teach you how to use Painter from an artist's point of view, but this is the only one to focus solely on the photographic aspect. This approach has the great advantage that everything in the book is relevant and useful to photographers.

Painter 11 for Photographers progresses step by step from very simple techniques to more advanced technical expertise. Throughout the book the many illustrations are intended to provide ideas and inspiration combined with clear instructions to make the very best of your own image.

The purpose of this book is to give you a sound knowledge of the tools which Painter provides and of the techniques needed to use them. There is a wide range of skills to be learned and this book guides you through them in a simple, logical and exciting way. Of course, this is only the starting point; good technique does not ensure that you make a good picture, but it is essential to master this first. Once that is done your own imagination and personal style will lead you to make the great pictures that you are visualizing.

All the image files for the step by step examples are provided on the accompanying DVD. Use these first and then try out the technique on your own photographs.

Why use Painter?

Photography is about documenting the reality around us – the photographer deciding how to interpret that reality through the choice of lenses, viewpoint and composition. Sometimes, however, this reality is not enough; it doesn't reflect the feelings that we originally experienced. This is not surprising of course as the conditions have changed, the sensory pleasure has been lost, the smells, sounds and atmosphere are all gone and all we now have is a one-dimensional piece of film, print or electronic image.

So we often want to take our picture further to better reflect what we felt at the time and to communicate this to the viewer who has no recall of the original experience.

This is where the fabulous Corel Painter program comes in. It is quite unique in the way it replicates traditional media and gives us the opportunity to take our pictures into another dimension altogether, revealing the hauntingly beautiful, mysterious and alluring world of the imagination.

What's in *Painter 11 for Photographers?*

Learning the basics

'Getting started in Painter 11' is a simple guide to the Painter program. This is for the total beginner and takes a brief look at the main tools and palettes, and includes general hints and tips on how to get the best out of the program. It also gives help to Photoshop users in understanding the differences between the two programs. If you have used Painter before you could skip this section and go straight on to the first cloning chapter. 'First steps in cloning' shows the process through which we transform photographs from their original state to a new and exciting existence. Even at this early stage of the book you will be able to make beautifully soft images and we are still only on the first chapter!

Understanding brushes

Brushes are at the heart of everything we do in Painter and understanding which brush to use and how it works is crucial to working creatively. 'Choosing brushes' illustrates every one of the main brush categories and explains how they differ. Examples of finished pictures are provided as a source for

ideas and inspiration. There are more detailed step by step tutorials on the DVD, together with the source photographs to enable you to make these pictures yourself. The 'Customizing brushes' chapter shows how the standard brushes can be customized using the Brush Control palettes and Brush Creator.

Paper textures

Paper textures are an essential part of using Painter; they provide depth and texture to the picture and the program has hundreds to choose from. 'Paper textures' explains what textures are and how to use them while painting, and also how to apply the same textures at the end of the painting process.

There are illustrations of every paper texture which is available in the Painter program on the DVD that accompanies this book. This is an invaluable resource which can be printed or viewed in more detail on your own computer.

Advanced techniques

The chapter on 'Layers and montage' explains how layers work, including the way in which individual layers can be combined creatively to produce stunning new effects.

The 'Using color' chapter shows how to select colors and how to use the many adjustment menus to enhance the tone and color in your pictures. Hand tinting and toning are also covered here.

Landscape and portraits

These chapters contain various ways to create landscapes and portraits from original photographs.

Other ways to use Painter

There are also lots of special effects available – everything from simulating burnt paper to making kaleidoscopic images. This section is great fun and packed full of colorful examples.

Printing and presentation

When you have completed your picture you still need to print and present it to the best possible advantage. This chapter gives some ideas on presentation and design, plus practical advice on printing including what file size you should use.

What should I know before I start?

This book has been written on a PC and all the screen shots reflect that platform. Painter operates virtually identically on both PC and Macintosh computers. Keyboard shortcuts are of course different – the Ctrl key on Windows becomes the Cmd key on the Mackintosh, and likewise the Alt becomes Opt.

If you have used Painter before and are following my step by step instructions it may be advisable to return the brushes to their default settings before you begin, or they may not react as predicted. To do this, click on the small triangle on the Brush Selector and select Restore All Default Variants.

Always remember to save your picture regularly to avoid losing work. It is also good practice to work on a copy of your picture and keep the original safe.

When you see this symbol, it means that the original files are on the DVD for you to use.

What's new in Painter 11?

The most exciting introduction in Painter are the new brushes – 40 in all and all really excellent. There is also a significant quantity of changes to make the program easier and faster than ever to use. Most of these features are covered within the main body of the book so this is an overview of the principal changes.

Color management

Not perhaps the most exciting of subjects, but one of vital importance to all users of Painter. When we want to share or send our picture to other people, or to print them, we want them to look the same as they did when we created them. Color management handles this and in Painter 11 we finally have the tools necessary to control colors effectively. The new settings are described in detail in Chapter 12 'Printing and presentation' The ability to soft-proof prior to printing is also very useful.

FIG 1 Color Management Settings dialog box

New tools

The Polygonal Selection tool has been added which makes it much easier to select straight lines without resorting to the Pen tool. When you are using the Polygonal tool you can switch to the Lasso tool by keeping the Ctrl/Cmd key depressed – the tool will revert back when the key is released.

The Transform tool is new and very welcome; all the Transform menu items have been combined in this tool and the options are available on the Properties bar. They include Move, Scale, Rotate, Distort and Perspective.

The Magic Wand has been improved and now selects more accurately.

Other improvements

Many of the brushes have been made to work faster and now utilize Tablet Tilt so the angle of the pen determines the width of the stroke. Velocity Control has been improved so that fast brush strokes deposit less paint than slow strokes.

Operational improvements mean that Painter can now use dual core processors and also has improved compatibility with Photoshop. As you would expect, it now uses the current operating systems from Microsoft and Apple.

Painter 11 now supports the png format: This is a lossless file compression format which allows transparency, unlike JPEG.

New brushes

There is one new brush category, Markers, which replicates the use of the real life markers in that they have broad strokes which build up with each application. From a photographic point of view they are of limited interest as they will not clone well due to the density increasing very quickly.

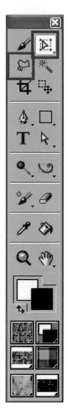

FIG 2 The Toolbox with the new tools highlighted in red

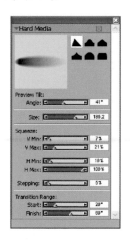

FIG 3 The new Hard Media palette

The other brushes are not in a separate category but are sensibly spread in the existing brush categories and are all called 'Real' brushes. Unlike the Markers, these are nearly all excellent for use in cloning from photographs. They are fast and easy to use, and are mainly in the Hard Media style, that is Chalks, Pastels, Pens, etc. They even have their own palette in which the characteristics can be altered with ease. There are several step by step tutorials in this book which use the new brushes. The new variants are in the following brush categories:

Pencils, Erasers, Colored Pencils, Chalk, Conte, Pastels, Blenders, Sumi-e, Calligraphy, Digital Watercolor and Acrylic. A selection of the new brush types are shown in Figure 4; all these are on the default settings with the Clone Color option turned on.

FIG 4 Some of the new 'Real' brushes

Acrylics–Real Long Bristle

Chalk–Real Fat Chalk

Pencils–Real Soft Coloring Pencil

Pastels–Real Hard Pastel

Pens–Real Drippy Pen

Sumi-e–Real Sumi-e Wet Brush

Where can I get help?

www.painterforphotographers.co.uk

Painterforphotographers is the website which accompanies this book. There are additional step by step techniques, galleries, information and links to other Painter sites, plus amendments to this book if necessary.

www.corel.com

The home site of Corel is where you can find information on the latest versions of Painter, updates and training. Look out in particular for the Painter Canvas – a regular newsletter which has tutorials and news about Painter.

www.painterfactory.com

This is a dedicated Painter community that is run by Corel and has forums for sharing artwork, getting help and communicating with the Painter community.

www.digitalpaintingforum.com

Marilyn Sholin runs this Digital Painting Forum which allows members to participate and share ideas and pictures with other Painter users.

www.permajet.com

A supplier of some excellent inkjet papers suitable for painterly pictures. A copy of their current catalog with lots of information on papers and profiles is included on the DVD.

martin@painterforphotographers.co.uk

I would be happy to receive comments regarding the contents of this book. If you would like to contact me, please send an e-mail to the above address.

Acknowledgements

I would like to thank the following people for their help in the making of this book:

Carol Addison for allowing me to use her pictures of Jack, Jessie, Harvey and Toby.

Annabel, Bob, Diane, Donna, Griff, Harvey, Jan, Ksenia and Rebecca for allowing me to use photographs of them in various chapters of the book.

Hilary for her family history pictures.

Neil and Flatworld for the poster pictures.

David and Lisa of Focal Press for their encouragement and assistance at all stages of the book.

Steve at Corel for doing the technical checking.

Permajet Ltd of Warwick UK (www.permajet.com) for providing me a range of their excellent inkjet papers and ink systems.

Marilyn Sholin for writing the Foreword.

Most of all to my wife Doreen for not only letting me use several of her photographs, but also for her unfailing support and encouragement, not to mention keeping me working on the book!

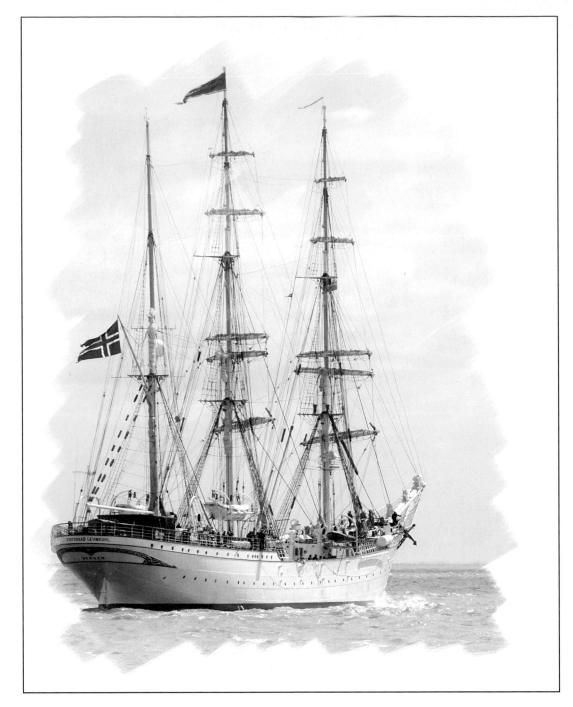

FIG 1.1 Sailing ship – painted with the Square Chalk brush

Getting started in Painter 11

The first part of this chapter is intended for complete beginners to Painter and contains simple exercises to guide the user in identifying the key areas of the workspace. If you have previously used Painter you may wish to skim this section or just pick up on the newer features.

The second part of the chapter contains information to enable you to customize the program to your own requirements and covers the use of graphic tablets and setting preferences to make the work process smoother and quicker.

Both sections can be used as a quick reference guide to the key elements as you work through the step by step examples in later chapters.

Information on printing and color management can be found in Chapter 12.

Many readers will have already used and be very familiar with Adobe Photoshop, and for them I have included a section highlighting the differences between the two programs: sometimes the naming of techniques differs and of course the location of particular commands. There are also tables of file compatibility, tools and keyboard shortcuts.

The Painter 11 workspace

Default view

Figure 1.2 shows the default view of Painter 11 with the File bar at the top of the screen and the Properties bar just beneath, leading to the Brush Selector on the right. The tools are on the left and a selection of palettes on the right beneath the Brush Selector.

FIG 1.2 The default view of Painter 11

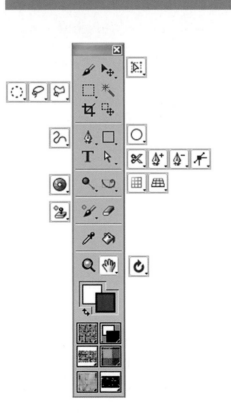

FIG 1.3 The Toolbox with hidden tools shown to the side. The Library palette icons at the bottom of the Toolbox are shortcuts to the following palettes: Papers, Gradients, Patterns, Weaves, Brush Looks and Image Nozzles

Toolbox

The Toolbox is where all the tools are stored (no surprise there then) and Figure 1.3 shows the Painter 11 Toolbox with all the hidden tools revealed and shown alongside.

To access the hidden tools, click and hold the visible tool and the other options will appear to the side – just click the one required. Some of the important tools which are being used in this book are detailed in this chapter, but most are very obvious by their icons.

Keyboard shortcuts are set up for many of the regularly used tools and others can be customized in the Preferences menu. A full explanation of all the tools can be found in the Painter program under Help>Help Topics.

New tools added in Painter 11 are the Transform tool, which is behind the Layer Adjuster tool, and the Polygonal Lasso, which is behind the Rectangular Selection tool

Opening a picture in Painter

Painter is able to use several different types of pictures. If you are bringing in pictures from a digital camera, the most common file types are JPEG or TIFF format. If you are importing a picture that has been saved in Adobe Photoshop the file type is likely to be PSD. Painter will happily use all these file types and several others. Painter does have its own file type called RIFF, however when importing photographs it is not necessary to use this in the majority of cases. It is generally desirable not to use very large image files as they will slow the program down and some of the complex brushes in particular can be very slow.

Painter is unable to read RAW files, so they will need to be opened first in a RAW reader such as Adobe Camera Raw or Aperture

If the image is to be printed then a resolution between 150 dpi and 300 dpi is preferable, which means a file size of between 10 and 20 mb is suitable to print up to A4 and A3. For web use a much smaller file size can be used: in most cases around 1mb. More information on file sizes and printing can be found in Chapter 12.

Open 'Boots' from Chapter 1 folder on the DVD, or use your own photograph to try these procedures.

Brush Selector

The Brush Selector is where the type of brush is chosen. Brushes are at the heart of everything in Painter and are dealt with in a lot more depth in Chapters 3 and 4.

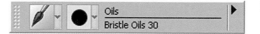

FIG 1.4 The Brush Selector

On the right of the Properties bar is the Brush Selector. Click the brush icon on the left and the drop down menu will reveal the extensive range of brush

categories that are available. Click and drag down the bottom right corner of the menu to see the full list of brush categories. Select the Oils category.

Click on the right-hand icon to reveal another drop down menu that shows the list of variants for the Oils brush category. Once again you will need to drag down the list to reveal all the variants. This is a very large category and will give some idea of the huge number of brushes available. Click on the Bristle Oils 30 brush as illustrated in Figure 1.4.

Picking a color from the Colors palette

To choose a color go to the Colors palette, which should be visible on the right of the screen. If this is not the case go to Window>Color Palettes>Colors and it will appear.

FIG 1.5 The Colors palette

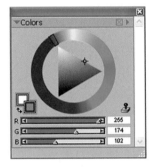

The Colors palette is much improved in Painter 11. The addition of the RGB and HSV sliders is a great help, as is the ability to enlarge the palette to make choosing colors easier.

It is also now possible to make small adjustments by pressing the arrow keys on the keyboard; this will move the Color palette cursor by precise amounts

Figure 1.5 shows the Colors palette. Click in the outer colored circle to choose the hue or color. The inner section defines the brightness of the color – the pure color is on the right, the darker colors bottom left and lighter at the top – click within the triangle to choose the tone. The orange square (lower square on the left in Figure 1.5) is the Main color and confirms which color has been chosen. The Colors palette is explained in more detail in Chapter 7. Draw some lines on the picture to get a feel for the brush. If you are using a graphic tablet you will see that the brush responds differently depending on the angle used – this is common to many of the brushes. I recommend that you use a graphic tablet as it is essential for getting the most out of the program. At the end of this chapter there are some tips on setting up your graphics tablet for Painter.

Now try a brush from the Chalk brush category; click on Square Chalk 35 which is very different to the Oil brush. Try some of the other brush categories yourself but for the moment avoid the Watercolor and Liquid Ink categories as they need a special layer to work on. Get rid of the brush marks by using Ctrl/Cmd+Z.

Properties bar

FIG 1.6 The Properties bar

Figure 1.6 shows the Properties Bar. This is a context sensitive bar and changes to whatever tool is currently active. In the example shown it is relevant to the brush and this is where the brush size is usually changed. Alongside this is the Opacity setting that adjusts the density of color being put onto the paper. The other settings will be dealt with in more detail in Chapter 4.

Correcting mistakes

Your image will now be covered with paint strokes (Figure 1.7) so this is a good point to show how to correct mistakes and, if necessary, return a picture back to its original state.

FIG 1.7 Correcting mistakes

The very valuable Undo command is found in the Edit menu and as we have been using a brush the line will read Undo Brush Stroke. Click on this and the last brush stroke will be undone; click on it again and the previous brush stroke will also be undone. As you can see, the command works backward and continues to remove the last action taken until you reach the maximum numbers of Undo, which is 32 steps. This number can be changed in the Preferences menu which is covered later in this chapter. Rather than go to the menu every time you want to use Undo, it is much quicker to use the keyboard shortcut Ctrl/Cmd+Z. If you are a Photoshop user you will need to be aware that the Undo command in Painter works differently and is not a toggle action.

To redo an action, go to Edit>ReDo or use the shortcut Ctrl/Cmd+Y.

If you want to get back to the original, go to File>Revert. Confirm you want to do this by clicking Revert in the pop up dialog box and the picture will return to its original state. This will work provided the original picture is still in the same place from which it was loaded, either on your computer or on the DVD.

Moving around the picture

FIG 1.8 Magnifier options on the Properties bar

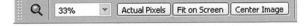

One of the great advantages with all graphic programs is the ability to enlarge the picture to work at a more detailed level. The quickest way of doing this is to use the keyboard shortcuts, but I will mention the Toolbox method as well.

Click on the Magnifier in the Toolbox and click in the picture; this will enlarge the picture by 25% each time you click. To reduce the magnification, hold down the Alt/Opt key and click in the picture again. When the Magnifier tool is active there are three buttons on the Properties bar that give preset views, as shown in Figure 1.8.

Actual Pixels shows the image at 100% enlargement, which is very useful for checking detail.

Fit on Screen will show the whole picture on the screen as large as possible without being hidden by anything else.

Center Image will return the image to the center when it has been magnified.

Another way to change the magnification is to use the slider at the base of the document window (Figure 1.9). The percentage number shown on the right of the bar is the current magnification of the picture. Type in an amount and press Enter to go to a specific magnification. Increase the magnification significantly then click on the binoculars icon shown in Figure 1.9 to the left of the slider; this will show you which part of the image is being magnified.

FIG 1.9 Using the slider to magnify the picture

The screen is shown in Figure 1.10 with the full picture in the small rectangle bottom left and a red rectangle showing the part of the picture that is being shown on screen. Click and drag inside the rectangle to move the area being magnified.

FIG 1.10 Using the Navigator

Click the Grabber (Hand icon) in the Toolbox and the cursor will change to a hand; click and drag in the window to move the image. Double-click on the Grabber icon in the Toolbox and the picture will change from a magnified view to the full picture being visible on screen.

Rotating the canvas

The Grabber is one of several tools that have alternative options in the Toolbox. Click and hold the Grabber and select the second icon with a circular arrow. This is the Rotate Page tool and allows the picture to be rotated to make it easier to paint with certain brushes. Click and drag in the document window to see the image rotate. To return to the original position click once in the image or double-click on the Rotate Page icon in the Toolbox. Don't confuse this with the Rotate Canvas command in the Canvas menu; Rotate Page simply turns the picture around in the same way a traditional artist might move a canvas around to get a better angle. Figure 1.11 shows the rotated image.

FIG 1.11 Rotating the Canvas

Normal view

The Normal view is shown in Figure 1.12 with the picture contained within its document window. The Full Screen option frees the image from the confines

FIG 1.12 The Normal view

of the document box and fills the entire screen including behind the palettes and Toolbox. This is a good way to work as it allows more freedom to move the image around on screen and removes much of the clutter.

Full Screen view

Figure 1.13 shows the Full Screen view. To use this mode either go to the Window menu or click on Screen Mode Toggle, or use the keyboard shortcut Ctrl/Cmd+M.

This is a toggle action so pressing the keys again will revert to the Normal view.

FIG 1.13 Full Screen view

Keyboard shortcuts for the screen

Ctrl/Cmd++ will magnify the image.

Ctrl/Cmd+− will reduce the magnification.

Ctrl/Cmd+Alt/Opt+0 will show the picture at 100% (actual pixels).

Ctrl/Cmd+0 will make the image fit on the screen.

Pressing the Spacebar while painting will activate the Grabber to enable the image to be moved. When the Spacebar is released the current tool will be active once again.

Using and organizing palettes

There are over 30 palettes in Painter 11 and even though they will collapse and stack very neatly they do take up room on the screen that could be used for the image. Many of them are not usually needed when working with photographs so fortunately they are easy to organize and unwanted ones can be removed.

To remove a palette from the screen, click on the cross in a square on the palette header. To show palettes not visible on the screen, go to the Window

menu and click on the name of the palette you want. Some of the palettes such as Brush Controls are arranged in groups for convenience.

FIG 1.14 Some useful palettes to keep on screen

To expand or collapse a palette click either on the triangle on the left, or on the name of the palette itself. To move and link palettes together click on the blank area to the right of the palette name and drag the palette over another palette and they will dock together.

Figure 1.14 shows the palettes that I keep on the screen and use regularly; they are usually kept collapsed as shown and opened when required.

Creating custom palettes

FIG 1.15 Custom palette

It is often very useful to create custom palettes – some to use on a regular basis and others just for a particular picture or project. Here is a quick guide to creating a custom palette with a variety of shortcuts.

Select a brush variant from the Brush Selector; click on the variant icon and drag it out into the main workspace. A Custom menu will be immediately created as in Figure 1.15; you can now add further items to the palette. Select a brush from another brush category, drag that onto your new custom palette, and position it to the right of the original icon.

FIG 1.16 Add Command dialog box for the custom palette

9

The icon can be positioned anywhere on the custom palette, alongside or below. If you want to rearrange the icons hold down the Shift key and drag the icon to where you want it to be. To delete an icon hold down the Shift key and drag the icon off the palette.

Now add a paper texture. Open the Papers palette or use the quick icons in the Toolbox and drag the paper icon from the palette onto the Custom palette.

FIG 1.17 A custom palette for cloning

Menu commands can also be added. Go to Window>Custom Palette>Add Command and the dialog box shown in Figure 1.16 appears; select the name of the palette you are working on. To add the Tracing Paper command, go to Canvas>Tracing Paper then return to the Add Command palette and click OK; the shortcut will appear on the new palette.

To delete or rename custom palettes go to Window>Custom Palettes>Organizer, highlight the palette you want to change, and click the relevant button. Painter will remember this palette each time you open the program, but to save a really useful palette permanently it can be saved as a file by pressing Export. The Import button will add palettes previously saved. Figure 1.17 shows an example of a completed custom palette.

FIG 1.18 The extended palette menu

Palette menu

One further note regarding palettes – on the right side of the palette name is a small triangle (circled in Figure 1.18) which indicates that the palette contains a Palette menu. This is a further selection of options relevant to that particular palette – click and hold on the triangle to see the drop down menu. The various palettes will be looked at in more detail as you work through the step by step examples in the book.

Brush Creator

The Brush Creator is covered in some detail in Chapter 4 but gets a quick mention here as it is used in a few step by step examples in earlier chapters. This palette, which is accessed by the Ctrl/Cmd+B shortcut or from Window>Show Brush Creator, houses the controls for customizing brushes. Clicking on a category from the list on the left opens the relevant sub palette and reveals the sliders and options available. On the right is the Scratch Pad where brushes can be tried out prior to use; we will return to this palette later.

FIG 1.19 The Brush Creator

In Painter 11 all the sub palettes are also available as separate palettes that can be brought on the screen individually, which is very useful as many of the palettes are rarely used. One palette I recommend you keep on screen is the General palette; this is available from Window>Brush Controls>General. In some earlier versions of Painter this is not available separately but it can be accessed from the Brush Creator.

Using a graphic tablet

A graphic tablet with a pressure sensitive stylus is a must to obtain the full potential from the brushes in Painter. Wacom are the leading brand of tablets

and have a large range from small to very large sizes. I personally find the A5 (6 × 8 inch) size ideal – it is large enough to have ample room for brush strokes yet not take up too much space on the desktop. Widescreen versions are now available which are excellent for modern widescreen monitors.

How you set up the button configuration for your pressure sensitive pen is a matter of personal preference. Once the software has been installed on your computer the controls can be accessed via the Control Panel for Windows or in System Preferences on Mac computers.

All the brush and opacity settings used throughout the book are for use with a graphic tablet. If you are using a mouse you will need to reduce the specified opacities quite considerably.

FIG 1.20 Brush Tracking in the Preferences menu

Brush Tracking is a control within Painter to adjust the sensitivity of the pen to suit your own hand. In the Edit menu go to Preferences and select Brush Tracking in the dialog box.

Make a few sample strokes pressing at various intensities in the Scratch Pad as in Figure 1.20 and Painter will automatically adjust the pen sensitivity to your own hand pressure. It is good practice to make strokes using variations in pressure and speed to ensure you get the full range of both. It is also a good idea to revisit the Brush Tracking control frequently as at different times you may feel differently – with more or less pressure, faster or slower – so if you go into this and make a few strokes to let Painter know how you are feeling it will react better to your hand at any given time. Brush Tracking can be accessed via the shortcut Ctrl+Al+K.

Saving images

There are three options for saving images available from the File menu.

'Save' will save the image, overwriting the original file.

'Save As', will save a copy under a different name if required.

'Iterative Save' is very useful when you need to keep interim versions of the image showing different stages of completion. Each time the image is saved Painter adds an incremental number to the file, for example 001 then 002 and so on. This is a very useful option for returning to an earlier stage, and if you do not need them you can delete these interim saves when the image is completed.

Painter will save images in several file formats, but generally it should be saved in the same file type in which it was originally opened. In the case of photographs this will usually be PSD if it has come via Photoshop, or JPEG if from a digital camera.

Images that started as JPEGs should be saved as a PSD, or RIFF (see below) while being worked on in Painter, as continually saving in JPEG format will degrade the image quality.

The native file format for Painter is RIFF. If you are only using Painter then this is the file format to use; if you are using Painter in conjunction with Photoshop then Photoshop PSD may be preferred as the files can then be opened directly in Photoshop.

It is however advantageous, indeed essential, to use RIFF when particular brush categories are being used, mainly Watercolor and Liquid Ink. In RIFF file format these can be saved and reopened at a later date and brush strokes can be edited. Mosaics are another case where it is useful for RIFF to be used for the same reason. If you are a Photoshop user it is easy to think of these as adjustment layers, which are permanently editable until the file is flattened. Dynamic Plug-in layers, which are available from the bottom of the Layers palette, are also very similar to Photoshop adjustment layers and are not editable once the file is saved in any format other than RIFF.

Brush default settings

As you continue to use Painter you will change the settings of many brushes. Painter remembers these from session to session, which is very useful, however it is often desirable to return to the default settings from time to time.

To return an individual brush variant to its default setting either click the brush icon on the far left of the Properties bar or click the palette menu

triangle in the Brush Selector and choose Restore Default Variant. The option to restore all of the brushes to their defaults is in the same place.

Should you wish to restore all of the Painter defaults to their original settings then hold down the Shift key when you open the Painter program and this will give you the option of returning all the defaults to factory settings. You will of course lose ALL of your changes throughout the whole program so think carefully before doing this!

It is a good idea to keep a back-up of any custom brushes that you make as these will also be lost when you restore to factory defaults.

Setting up Preferences

Preferences – General

Apart from the Brush Tracking already mentioned, there are a number of other important and useful settings to be found in the Edit>Preferences menu.

Figure 1.21 shows the controls under the General heading – the top left controls the appearance of the cursor.

FIG 1.21 Preferences, General section

The Cursor type is usually best set to Brush, but other shapes can be selected from the drop down menu on the right.

Enable Brush Ghosting means that the size of the brush can be seen on screen before painting – it changes to the cursor during actual painting.

Enhanced Brush Ghosting stays as a circle but also has a point/line to indicate the centre and in which direction the brush is painting. This is particularly useful when using large brushes as you can identify very precisely the point at which to paint.

Brush size increments control the amount of increase or decrease in brush size when the square brackets keyboard shortcut is used.

The Quick Clone options control the steps that are carried out when Quick Clone is used. I suggest that you set them as in Figure 1.21 to start with.

All other options can be left on the default settings.

Preferences – Operating System

Tick both boxes in this dialog box. The No Device Dependent option is for Windows users who use 16 bit monitors; if you use other monitors it will not have any effect.

Preferences – Undo

In this dialog box the number of steps of 'Undo' Painter will remember is specified. The decision on the number to set will be based largely on the amount of RAM that is installed on the computer. The higher the number, the more flexible the Undo is, but the downside is that this uses more memory as Painter keeps track of the Undo steps. The maximum number is 32 which is the default.

FIG 1.22 Undo dialog box

Preferences – Customize Keys

For those people, like myself, who use keyboard shortcuts a lot the Customize Keys option is superb. It allows shortcuts to be made for all the main functions in Painter and you can also change the default ones if you wish. It is particularly useful if you use another program like Photoshop for instance, as you can use the same shortcuts in both programs.

FIG 1.23 The Customize Keys dialog box

To bring up the dialog box, go to Edit>Preferences>Customize Keys. Figure 1.23 shows the dialog box at this stage. It is all very easy to follow, but here is an example of how to make a shortcut for the Revert option (which has the Function key F12 in Photoshop).

Open the dialog box and click on the plus sign to the left of the word 'File'; this will bring up the list of commands in the File menu. Highlight Revert and as you will see there is no shortcut allocated to it. Press the F12 key to set this as the shortcut, make any more shortcuts in the same way, then press OK to accept all the changes you have made. It is that simple.

Apart from commands in the Menu bar, keyboard shortcuts can be set for the Palette menus and tools; change the option in the Shortcuts dialog box to access the other areas.

The changes you have made will be saved for immediate and ongoing use, but if you have to reload the program they may be lost; you can therefore save your own set by pressing the save icon. You can also save and load different sets for specific types of usage.

Customize workspace

In Painter 11 you have the ability to create and save custom workspaces and to share created workspaces with other people. For more advanced users this can be particularly useful when you want to do a particular type of work, for instance you may want to create a workspace for cloning pictures in which you have particular papers or brush libraries on view while others are hidden.

FIG 1.24 New workspace

To create a new workspace go to Window>Workspace>New Workspace and give your new workspace a name (Figure 1.25).

Arrange the palettes and tools how you want them – you could make a custom palette with favorite brushes and papers as shown earlier in this chapter.

FIG 1.25 Naming a new workspace

Photoshop – Painter 11

This book has been written so that no knowledge of any other program is necessary, however I am well aware that many readers will already be very familiar with Adobe Photoshop as it is the premier professional image editing program. Therefore this section aims to explain the main differences between the two programs, how the name for the same procedure differs, how the files can be interchanged and the consequences of doing so, and supply some workarounds to make life easier.

Terminology and usage

Photoshop	Painter 11	Comments
Actions	Scripts	Work in a similar way
Background	Canvas	Similar but does not always work in the same way
Background Color	Not available	What looks like the Background Color is actually the Additional Color which is used for two color brushes
Color Picker	Color Picker	Single-click in Toolbox in Photoshop, double-click in Painter
Duplicate Canvas	No option – see right for workaround	Activate Canvas, Select>All, Edit>Copy, Edit>Paste in Place to make a copy at the top of the layer stack
Duplicate Layer	Duplicate Layer	Right-click layer in Painter
Fill	Fill	Under the Fill menu in Painter (previously in the Effects menu)
Flatten Image	Drop All	Available from the Layers palette menu
Foreground Color	Foreground Color	Work in the same way
Filters menu	Effects menu	Filters are in the Effects menu
Image adjustments menu	Effects menu	Image adjustments are in the Effects menu
Layer blending mode	Layer Composite Method	Work in the same way but not all layer modes are compatible – see below for more details
Merge Visible	Collapse	Select all the layers to be merged by holding down the Shift key and clicking on each layer Click the layer command icon which is bottom left in the Layers palette and select Collapse to merge the layers

File compatibility

Photoshop to Painter 11	
Adjustment layers	Effect ignored, opens as an empty layer
Alpha channels	Compatible
Layer	Compatible
Layer blend modes	The modes which open correctly are: Normal, Dissolve, Darken, Multiply, Lighten, Screen, Overlay, Soft Light, Hard Light, Difference, Hue, Saturation, Color and Luminosity. All other layer blend modes will change to Default
Layer effects	Ignored
Layer masks	Compatible
Layer groups	Compatible
Smart layers	Converts to normal layer
Text layers	Converts to normal layer

Painter 11 to Photoshop	
Alpha channels	Compatible
Dynamic Plug-in layers	Converts to normal layer
Layer	Compatible
Layer blend modes	The modes which open correctly are: Normal, Dissolve, Darken, Multiply, Lighten, Screen, Overlay, Soft Light, Hard Light, Difference, Hue, Saturation, Color and Luminosity. All other layer blend modes will change to Normal
Layer groups	Compatible
Layer masks	Compatible
Liquid Ink layers	Converts to normal layer
Mosaics	Converts to normal layer
Text layers	Converts to normal layer
Watercolor layers	Converts to normal layer

Tools

Photoshop	Painter 11	Comments
Eyedropper	Dropper	Same usage
Hand	Grabber	Same usage but has an additional tool to rotate the canvas
Move	Layer Adjuster	Same usage
None	Selection Adjuster	A useful tool; Photoshop has the command under the Select menu
Selection Tool	Marquee	Same usage

Some useful keyboard shortcuts in Painter 11

Change Brush Size	Ctrl/Cmd+Alt/Opt and drag in the document – the circle shows the brush size
Increase Brush Size (Incremental)	Square Brackets – Left (The incremental amount can be set in the General Preferences)
Decrease Brush Size (Incremental)	Square Brackets – Right
Change between active documents on screen	Ctrl/Cmd+Tab
Select All	Ctrl/Cmd+A
Deselect	Ctrl/Cmd+D
Copy	Ctrl/Cmd+C
Paste	Ctrl/Cmd+Shift+V
Paste in Place	Ctrl/Cmd+V
Save	Ctrl/Cmd+S
Save As	Ctrl/Cmd+Shift+S
Incremental Save	Ctrl/Cmd+Alt/Opt+S
Undo	Ctrl/Cmd+Z
ReDo	Ctrl/Cmd+Y
Tracing Paper	Ctrl/Cmd+T
Adjust Opacity	Numbers on keyboard, i.e. 2 for 20%
Remember that you can change any keyboard shortcut and create your own in the Preferences>Customize Keys	

FIG 2.1 Castleton in the Mist, painted with the Soft Cloner.

First steps in cloning

There are many ways to create artistic pictures with Painter: painting from scratch in a blank document, using plug-in filters to change photographs in various ways, and using a method called cloning.

The major part of this book deals with cloning techniques of all kinds, so it is worth explaining just what cloning means in this context. The term has a different meaning in other graphic programs such as Photoshop where cloning tools are chiefly used for retouching images. It can mean this in Painter too, as there are tools which do just that, however when I discuss cloning photographs I am referring to the process which takes the imagery from an original photograph and reinterprets it in an artistic manner through the use of Painter brushes and paper surfaces.

In this chapter you will learn, through step by step examples, the basic clone types in Painter. They are very easy to create and by the end of the chapter you will understand how to make artistic clones from photographs. The remainder of the book builds on these basic techniques and will gradually introduce more complex ideas and other ways to reinterpret your photographs.

Basic cloning techniques

The steps needed to create a clone copy are easy to follow.

Open and select your picture then File>Quick Clone; this will carry out several steps which in earlier versions had to be done separately. A copy of the original picture is created, all the contents are removed ready to clone, a brush from the Cloners category is selected, and the Tracing Paper option activated. Figure 2.2B shows the screen after the Quick Clone command has been used.

FIG 2.2 A Tracing Paper off
B Tracing Paper on

A

B

The steps which the Quick Clone carries out can be customized to your preference by going to the Preferences which are explained in Chapter 1. For instance I prefer that this command does not revert to the Cloner brushes each time so I untick that option, but I tick the option for Clone Color which will turn most brushes into cloners. There is a lot more information on individual brushes which are suitable for cloning in Chapter 3.

You can save your clone copy and continue on another day. Save the clone picture as normal. When you want to continue cloning, open the original image first, then the clone copy. With the clone copy active, go to File>Clone Source and click on the name of your original image.

File>Clone is a different process; this makes a second copy of your original, which can be blended or painted rather than cloning into an empty document.

FIG 2.3 Tracing paper icon

Tracing paper

Tracing Paper is a semi transparent overlay of the original picture that assists in the early steps of making a clone copy. The overlay can be clearly seen in Figure 2.2B; when the Tracing Paper option is turned off the clone copy will be shown as an empty document (which it is) (as in Figure 2.2A). The overlay is created

automatically when the default Quick Clone procedure is used and can be turned on and off at any time. To turn the Tracing Paper on and off click the top icon on the right of the document window, just above the grid icon as shown in Figure 2.3. The keyboard shortcut is Ctrl/Cmd+T, which is a toggle action. It is important to note that the overlay is purely there to help you start the painting; it is not part of the picture and will not be part of the final image if you print it.

Auto-Painting

The Auto-Painting feature allows you to make fast painterly clones using a vast number of brush variants and is a very easy way to get started with cloning photographs. There are three parts to this process – Underpainting, Auto-Painting and Restoration – and each of them has their own palette and controls (Figure 2.6).

If you are a complete beginner to Painter it is worth trying one of the Auto-Painting clones before looking at the palettes in more detail.

1. Open 'Mannequin' from Chapter 2 folder on the DVD.

The default opacity for Tracing Paper is 50%, but this can be changed.

Click and hold on the Tracing Paper icon and a drop down menu will reveal a set of opacities from which you can choose.

This is really useful if you just want a low level view to help with the early stages of cloning

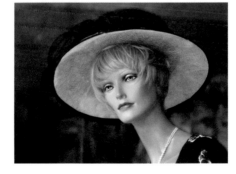

FIG 2.4 Original photograph

2. Open the Auto-Painting palettes (Window>Auto-Painting); this will open all three Auto-Painting palettes.
3. In the Underpainting palette, select 'Classical' from the drop down menu under Color Scheme. Click Apply and save a copy under a different name.
4. In the Auto-Painting palette make sure that the Smart Stroke box is not ticked. Select Scribble Large in the Stroke box.
5. Select the Smart Stroke Brushes>Sponge Soft.
6. Click the Quick Clone button in the Underpainting palette.
7. Turn off the Tracing Paper (Ctrl/Cmd+T) so that you can see the clone working.
8. Click the Play button to start the painting and watch the picture build up. Stop it after a couple of minutes by pressing the Stop button or clicking in the document window.
9. The final version is shown in Figure 2.5.

When you apply an effect from the Underpainting palette to an original photograph prior to cloning, as in the Auto-Painting example, it is always worth saving a copy of the picture under a different name. This will keep your original image unaltered but allow you to work with the changed image again in the future

FIG 2.5 Auto-Painting was used to paint this picture, using the Classical Scheme as the underpainting

Underpainting palette

The Underpainting palette has features for both preparing a photograph prior to cloning and also for making adjustments to pictures that have been finished.

The **Color Scheme** options are used to enhance or change the color of a photograph prior to cloning. When first applied the color schemes may not look very good, but the color change looks better after the clone is finished. They are most useful when you want to create an artistic rather than realistic picture. Figure 2.7 shows some color schemes.

FIG 2.6 The three palettes which make up the Auto-Painting system

A

B

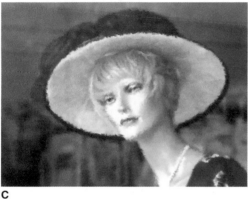

C

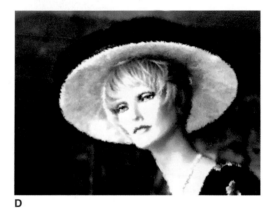

D

Photo Enhance offers shortcuts to alterations in color and tone. There is a drop down menu list of changes available, and this is an alternative to making the changes yourself with the sliders. You can apply more than one of these by selecting an effect and clicking Apply, and then adding more in the same way.

The six sliders are all self-explanatory and can be easily tried; small changes can be made by clicking on the arrows at each end of the sliders. There are illustrations of these sliders being used in Chapter 7 'Using Color'.

These effects are often used on the original photograph prior to cloning to brighten the picture, as the cloning process tends to lose some of the original brightness and contrast. Naturally they can also be used at the end to finish the image.

Edge Effects can also be applied from this dialog box and some examples of these effects can be seen in Figure 2.8 and in Chapter 12 'Printing and Presentation'. These effects could be applied either before or after cloning.

FIG 2.7 Four other color schemes from the Underpainting palette.
A Watercolor
B Sketchbook
C Chalk
D Modern

FIG 2.8 Two of the Edge effects available in the Underpainting palette

Auto-Painting palette

The Auto-Painting dialog box allows you to use an automated process when cloning from a photograph. Sometimes the result can be very good but more often extra work needs to be done by hand to finish the picture.

The first option is the tick-box for **Smart Stroke Painting** – this changes the brush strokes from random application to following the lines in the photograph. This works well in some cases but less well in others so try both before deciding which option is best for the picture you are making. The main problem with using Smart Stroke is the contour lines which the brush marks create; this does not happen with the random strokes. Although the process is quite fast for most brushes, you can try this quickly by making a selection in

FIG 2.9 Smart Stroke painting on the left and non-Smart Stroke painting on the right. Check the differences in texture

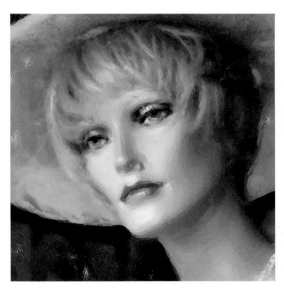

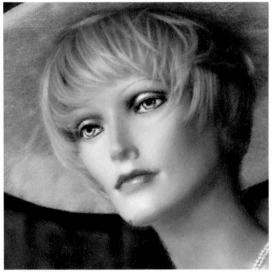

26

the clone copy and working only within this area. The Auto-Painting process is started by clicking on the Play button in the Auto-Painting palette and stops when the Stop button is pressed. Press the Play button to start it again.

When you have ticked the Smart Stroke option another tick-box will appear below. **Smart Settings** makes the process even more automated as the brush sizes start large and get progressively smaller as the process continues, so more detail is being revealed. The process stops automatically when the smaller brushes have finished cloning.

The Smart Stroke brush category has been specially developed to work with the Auto-Painting palette so they are a good place to start; however nearly all brushes can be used with Auto-Painting.

When the Smart Stroke Painting option is not selected, other options in the palette become available. The Stroke drop down reveals a large choice of brush strokes (Figure 2.10) which will modify the choice of brush previously selected in the Brush Selector. There is also the chance to customize the brush further by altering the five sliders in the palette.

Restoration palette

The last of the three Auto-Painting palettes makes it easy to restore some of the original photograph to the clone copy. This is useful when the clone needs more clarity, and the Soft Edge Cloner brush is the brush to use.

FIG 2.10 The list of options in the Stroke drop down menu

360 Degree Bearing Rotate
Size/Bearing Modulate
Size/Tilt Modulate
Fade In/Out
Short Stroke
Bearing Rotate
C Curve
Circle
Diagonal
Hatch
Medium Dab
Scribble
✓ Scribble Large
Short Dab
Single Sketch Line 1
Single Sketch Line 2
Sketchy Circle
Sketchy Square
Splat
Square
Squiggle
Sweeping S Curve
Swirly
Triangle
Zig Zag

FIG 2.11 Using the Restoration palette

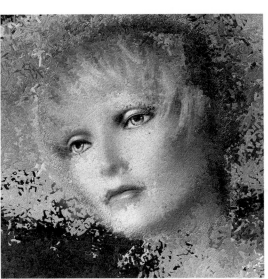

Auto-Painting – Tough Guy?

1. Open 'Tough guy?' from Chapter 2 folder on the DVD.
2. Open the Underpainting palette (Window>Underpainting).
3. In the Color Scheme drop down menu select the Sketchbook Scheme – this will make the colors more muted.
4. In the Photo Enhance menu select Increase Contrast to further enhance the clone. Click Apply to apply the changes and save a copy under a different name. This will enable you to return to this altered version should you wish to work with it later, and also leave your original intact.

FIG 2.12 Original photograph is on the left and on the right is the result of applying the edge effect in step 5.

5. Select an edge effect to soften the edges. Use Rectangular at 32%.
6. File>Quick Clone.

Stage 1

7. Select the Smart Stroke Painting>Pastel Chalk. Use size 52.2 and opacity 100%.
8. Click the Clone Color option in the Colors palette.

FIG 2.13 After the first Auto-Painting

9. In the Auto-Painting palette select Scribble Large in the Stroke drop down menu. Ensure that the Smart Stroke Painting is unticked.
10. Start the Auto-Painting and allow it to run until the whole picture is covered. Paint out any remaining white gaps with the same brush (Figure 2.13).
11. The next few steps will use smaller brush sizes, but will restrict them to certain areas so that the outer areas will remain rough and the central areas more detailed.

Stage 2

12. Use the Oval Selection Tool from the Toolbox and draw an oval selection to include the face, hair and part of the hat (Figure 2.14).
13. Select>Feather and enter 40 into the dialog box; this will soften the transition between the different brush sizes of the cloning.
14. Change the brush size to 25 and run the Auto-Painting until the central areas have smaller brush strokes.

FIG 2.14 Oval selection created in step 12

FIG 2.15 Result at step 15

15. With the selection still active, increase the saturation slider to 10% in the Underpainting palette; this will emphasize the centre (Figure 2.15).
16. Select>None.

Stage 3

17. Use the Oval Selection tool again and select the face, neck and hair. Feather the selection as before (Figure 2.16).

FIG 2.16 Oval selection created in step 17

18. Change the brush size to 12 and run the Auto-Painting again.
19. Increase the Saturation slider to 10% with the selection still active (Figure 2.17).
20. Select>None.

FIG 2.17 Result at step 19

Stage 4

21. Use the Lasso and select the eyes, mouth and chin. Feather the selection as before.
22. Change the brush size to 6.4 and run the Auto-Painting again. This will define the face very clearly.
23. Increase the Saturation slider to 10% with the selection still active.
24. Select>None.

FIG 2.18 Tough Guy?

As you will have discovered in the last few pages, the Auto-Painting process is very flexible and far from being just something for beginners to Painter – it has real applications for making pictures.

The ability to use selections makes it possible to restrict the varying brush sizes to the areas where they are required. Another way of achieving this effect with more flexibility is to make each different clone on a separate layer which can then be blended using layer opacity and layer masks. The use of layers is covered in Chapter 6.

Although it has not been done in this example, it is very often necessary to switch from Auto-Painting to painting by hand at the later stages of a clone, as this allows you to bring back clarity and detail with greater precision.

The Restoration palette is also often used at the end of the cloning. After you have saved this picture, click on the Soft Edge Cloner Brush button in the Restoration palette and gently paint in the eyes and around the mouth. You will see that the original detail from the photograph has been restored. In this particular case the detail is sufficient in the picture without carrying out this step. This is a useful option when you need more detail, but do not overdo the restoration as you want to avoid making this obvious.

Tutorial files on the DVD

Soft cloning

Having explored the benefits and ease of the Auto-Painting system, it is time to create some clone pictures by hand; Auto-Painting is useful, but the key techniques which you will be using for most of your work in Painter will be created with individual brush strokes.

This example is what is called a soft clone, which is a clone that does not use any paper texture and which has a very smooth finish. It is a simple clone that can result in a beautiful delicate picture and is a good one to start with. Try it with the picture that is on the DVD – it has been tested with this image so it will be easier to follow. Throughout the book the precise settings will be given for each brush and it is most important that you follow these carefully to achieve the desired result with the picture provided. Remember that if you are using a mouse you will need to use lower opacity settings. When you try this with your own pictures the settings will vary depending upon the content and size of the image; generally the larger the file size, the larger the settings you will need.

This particular cloning brush (Cloner>Soft Cloner) is used extensively throughout the book. Not only can it be used for creating a picture, as in this example but it is often used to bring back parts of the original image to a picture made with more painterly brushes. This is the same brush that was used from the shortcut in the Restoration palette in the step by step example on the preceding pages.

To avoid any potential problems with brushes working differently to those indicated I suggest that you return the brushes chosen to their default settings. To return a single brush to its default setting first select the brush you are using and then click on the brush icon on the far left of the Properties bar. To return all the brushes to their default settings click on the small triangle in the Brush Selector palette (top right of the screen) and select Restore All Default Variants.

FIG 2.19 Original photograph

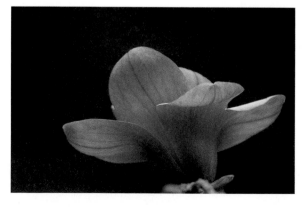

1. Open 'Magnolia' from Chapter 2 on the DVD.
2. File>Quick Clone. If you still have the Quick Clone settings on their default this should have created a new document, cleared the picture information, and overlaid the Tracing Paper.
3. Click on the bar at the top of the clone document and drag it to see the original beneath. The Tracing Paper overlay is hiding what is now an empty canvas; click the Tracing Paper icon in the top right corner of the clone document window to check that this is indeed empty, and click again to reapply the tracing paper. Remember that the original image must stay on the screen at all times, as the brush strokes you are about to make will be coming from that linked photograph.
4. Go to Window>Screen Mode Toggle to put the picture in Full Screen mode which allows the picture to spread across the whole screen. I prefer to paint in this mode as it hides the original picture and makes it very easy to move the picture around. The keyboard shortcut for this is Ctrl/Cmd+M which is a toggle action.
5. The Brush Selector is on the right of the Properties bar and is seen in Figure 2.20. The brush category should now be Cloners and if it is not, click the brush icon on the left and select Cloners in the drop down menu.

FIG 2.20 The Brush Selector

To select a brush variant click the icon to the right and a long list of variants in the Cloners category will drop down. All these brush variants have been set up to work as Cloners with no adjustments needed, which means they are ready for use immediately. Select the Soft Cloner; this variant will give a very smooth and gentle effect. Click the brush icon on the left of the Properties bar (Figure 2.21) to return the brush to its default settings.

FIG 2.21 The Properties bar

6. Check the Properties bar at the top and change the settings to those in Figure 2.21. Enter 223.0 in the Size box. This can be done either by clicking on the arrow to the right of the figures and using the slider, or by typing the amount in and pressing Enter. This is a very large brush size, which will work well with the low opacity set in the next step.
7. Change the Opacity to 3%; small adjustments of the slider can be made by clicking on the arrows at either end. Very low opacities are common when cloning from photographs but each type of brush will need a different setting so you will need to experiment with each picture before starting to paint. Make a few light strokes in the clone copy – start in the lower right corner and sweep out the strokes in the direction the magnolia petals take. You will probably not see any difference immediately because the Tracing

Paper hides the very light strokes you are making. Turn off the Tracing Paper to see what you have painted so far. The Tracing Paper is usually only needed for the first few strokes and then it is better to remove it as it hides the result. Switch it back on every now and then if you need to check progress. Just paint the petals at this stage and leave the background till later.

FIG 2.22 Screen at step 8

8. Continue to paint the image into the clone copy; the low opacity brush will allow you to do this very gradually. The effect to aim for is a very soft, delicate and dreamlike quality. Check Figure 2.22 to see where you should be at this point.

If you need to undo any step use the keyboard shortcut Ctrl/Cmd+Z or go to the File menu and click Undo. The Undo function will continue to undo the previous action until it reaches the limit set in the Preferences section. Setting the preference limit is covered in Chapter 1.

FIG 2.23 Screen at step 10

9. Reduce the brush opacity to 1% to paint the background. We need just the hint that there is a background present without really showing what it is. Sweep your brush out from the petals but leave the outer edges white.

10. If you need to enlarge any part of the picture to see more clearly, use the slider at the base of the document window. The keyboard shortcuts are Ctrl/Cmd++ to enlarge and Ctrl/Cmd+− to reduce. To move the enlarged section around the screen press and hold the Spacebar and click and drag in the picture. Figure 2.23 shows an interim stage.

11. A very light smooth finish is required to create the soft ethereal effect, but even by painting with great care there are often areas which are rather darker than is ideal. This is very easy to correct by some erasing of the area that you have cloned. Go to the Brush Selector and choose the Erasers brush category and select the Eraser as the variant. Change the brush size to around 223.0 and make the Opacity 1%; leave the other settings unchanged.

12. Lightly paint over the dark areas in your picture until the finish is very smooth and even. If you overdo this stage simply change back to the Soft Cloner brush and clone some imagery back from the original picture. The whole process is very flexible and can be repeated as often as necessary.

Now it is time to find some photographs of your own on which to try the technique. Choose a picture that will benefit from the very soft treatment. An important part of making successful images is matching the right picture with the right technique. You may wish to save your picture for future reference.

FIG 2.24 Magnolia

Camel Impasto clone

For this next clone we will use the same original photograph of the magnolia but use a very different brush to illustrate how the choice of brush variant can dramatically change the final result.

1. Open 'Magnolia' from Chapter 2 folder on the DVD.
2. File>Quick Clone.
3. Ctrl/Cmd+M to go into Full Screen mode.
4. Select the brush icon in the Toolbox.
5. From the Brush Selector bar choose the Cloners brush category and the Camel Impasto Cloner variant.

If you are not familiar with traditional painting, the impasto effect implied in the name of this brush refers to paint applied very thickly to the canvas giving the picture a three-dimensional finish. In Painter this effect is achieved through the use of shadows added automatically to the brush strokes as the picture is painted.

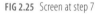

FIG 2.25 Screen at step 7

6. Change the brush size to 20 and the Opacity to 72%.
7. With the Tracing Paper turned on, start painting the flower; make your brush strokes follow the lines of the petals. After a few minutes take the tracing paper off to view what you have painted and increase the size of the picture on the screen to 100% (Ctrl/Cmd+0) which will enable you to see clearly the three-dimensional brush strokes. The direction of each brush stroke is critical to the success of the picture so paint over any areas which have the brush strokes going the wrong way.
8. Continue painting the petals until they are complete but avoid painting any background as far as possible. This is unavoidable at times and the dark green will appear around the edges; however this will be dealt with later.
9. If you feel that the brush strokes are too strong, they can be softened quite easily. Go to the Brush Selector bar and choose the Impasto brush

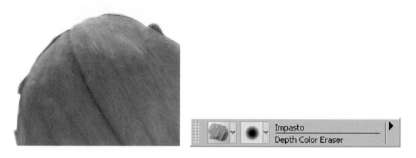

FIG 2.26 Cleaning the edges with the Depth Color eraser

category and the Depth Smear variant. Use brush size 37 and Opacity 15%; paint lightly over the brush strokes and the impasto effect is reduced.

10. Let's deal with the edges now. Select another variant from the Impasto brush category, this time the Depth Color Eraser. Change the size to 15 and the Opacity to 66%. Put the screen size to 100% again and carefully go around the edges of the petals and remove all the dark edges. Start with the brush well outside the edge and gradually bring the brush inwards; it is quite tricky to get a smooth edge which looks right and you may have to use larger or smaller brush sizes.

FIG 2.27 Magnolia Impasto clone

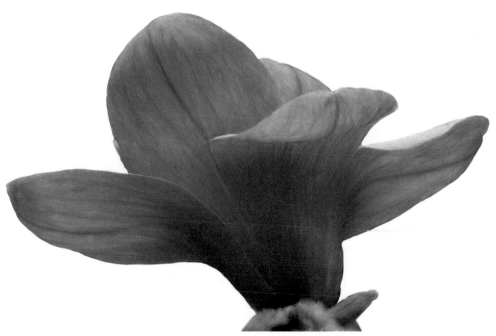

Impressionist clone

This clone uses a very different brush; the Impressionist brush is one of several that are specific to a particular artist and therefore very distinctive and recognizable. This brush is in the Cloners category and the other similar brushes are in the Artists brush category.

1. Open 'Scarecrow' from Chapter 2 on the DVD (Figure 2.28).

FIG 2.28 Original photograph

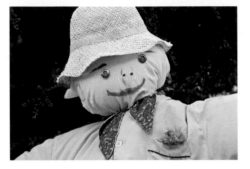

2. File>Quick Clone.
3. Select the brush icon in the Toolbox.
4. From the Brush Selector bar select the Cloners>Impressionist Cloner, size 48, Opacity 100%.
5. Use the Tracing Paper as a guide throughout this picture.

FIG 2.29 Painting the background

6. Paint the dark background of trees. If you are using a pressure sensitive tablet rather than a mouse, you will notice that the brush strokes are angled in the direction that the pen is pointed. Paint close to the scarecrow but not too much over the edges. There is no need to paint the area with solid color; leave streaks of white visible (Figure 2.29).

FIG 2.30 Painting the hat and shirt

7. Reduce the brush size to 25 and paint the shirt and the hat (Figure 2.30).
8. Reduce the brush size to 19 and paint the face.
9. Reduce the brush size to 6 and paint the eyes, mouth and nose to give them more definition.

This has (hopefully) been an easy picture to make; individual brushes vary considerably in the time needed to create a picture.

FIG 2.31 Scarecrow

An introduction to Paper Grain

Before a painter using a 'traditional', i.e. non-digital method starts to paint, two important decisions have to be made. Firstly, which medium to use (which might be oil, watercolor, pencil, pastel, and so on) and then the surface on which to paint, perhaps paper, board, pastel paper, etc.

What Painter does is to replicate as closely as possible the result of the chosen combination. A soft camel hair brush on a smooth board will give a clean edged smooth color, whereas when using a piece of hard chalk on a heavily textured paper the chalk will skim the surface leaving the paper indentations with no paint, in other words a very rough effect. These choices will have a major influence on the finished look of the artwork.

It is very similar when a photograph is cloned using the brushes and surfaces available in Painter; the huge range of brushes and papers cover virtually every type available to the traditional artist and many that are not.

There is something like 600 different papers in Painter, some of which have to be loaded separately from the program disc, so the combination of 900 brushes combined with 600 papers is pretty mind-boggling. Figure 2.32 shows a few of the hundreds of textured papers available. Chapter 5 deals with this subject in a lot more depth but this introduction will give you a quick understanding before you start on the next step by step.

FIG 2.32 Some of the paper textures in the Painter program

Creating texture

This step by step example will look at how to use paper textures when making clones. You will learn how to change the appearance of a photograph to give the impression of painting on a coarse textured paper. The range of paper textures and how to use them in various ways is explored in more detail in Chapter 5.

1. Open 'Witley Court' from Chapter 2 folder on the DVD (Figure 2.33).

FIG 2.33 Original photograph

2. In the Underpainting palette (Window>Underpainting) increase the Contrast by 10% and the Saturation by 15%.
3. We now need to add some white space around the photograph. This helps to create a softer edge; the Clone brush will smear the edges.
4. Canvas>Canvas Size. Add 100 pixels to each dimension (Figure 2.34A).
5. File>Quick Clone.
6. Select the Chalk>Real Hard Chalk brush, size 80, Opacity16% and Grain 20%. This is one of the new brushes introduced in Painter 11. Almost all of the 'Real' brushes work well when cloning from photographs.
7. Select the Rough Charcoal Paper from the Papers palette (Window>Library Palettes>Papers, or from the shortcuts at the bottom of the Toolbox) (Figure 2.34B).

FIG 2.34
A Increasing the Canvas size
B The Papers palette

A

B

FIG 2.35 The early stages of cloning

8. Click the Clone Color option in the Colors palette.
9. Paint the whole picture. At this stage it will be a light texture due to the opacity and grain settings (Figure 2.35).
10. Change the brush size to 40 and the Opacity to 40% and paint the picture again, concentrating mainly on the building and main features.
11. In the Papers palette change the Paper Scale to 70% (the Paper Scale slider is the top slider). This will allow more paint to sink into the canvas which therefore will darken more quickly.
12. Paint over the buildings again and lightly paint the grass to strengthen the color.

FIG 2.36 Building the tones

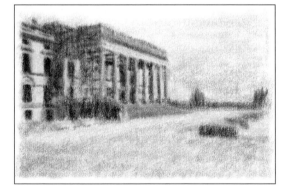
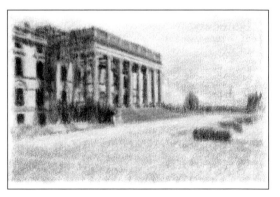

13. Change the brush size to 20 and the Opacity to 50%.
14. Change the paper to Basic Paper; this will allow more paint to sink into the paper.
15. Paint over the building. Keep the brush moving following the lines of the architecture; the density will build up more quickly now. Keep the painting away from the edges as they need to fade out gradually to the white edge.

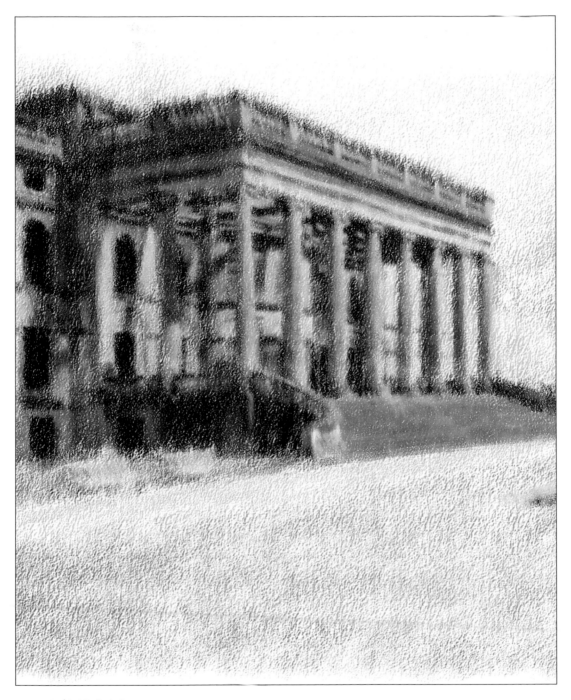

FIG 2.37 Detail of the finished picture

'Real' Watercolor

Painter 11 introduced some excellent new Digital Watercolor brushes and this step by step example uses one of them.

The early stages of the painting can be completed by hand, or in this case I have used the Auto-Painting palette to make it quicker.

1. Open 'Clematis' from Chapter 7 folder on the DVD (Figure 2.38).

FIG 2.38 Original photograph

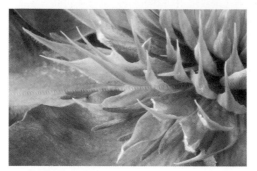

2. Make a Quick Clone.
3. Turn the Tracing Paper off.
4. Select the French Watercolor Paper.
5. Select the Watercolor>Real Filbert brush, size 30, Opacity 10%, Grain 85%, Diffusion 20, Wet 5%.

FIG 2.39 After the Auto-Painting

6. Click the Quick Clone option in the Colors palette

7. Open the Auto-Painting palette (Window>Show>Auto-Painting).

8. In the Auto-Painting palette, click the Smart Stroke Painting box (Figure 2.40).

9. Start the Auto-painting by clicking the Play button at the bottom of the palette.

10. Allow the Auto-Painting to continue until most of the white areas are covered.

11. You can stop the Auto-painting at any time by pressing the Stop button or by clicking in the picture. To start it again press the Play button.

12. When you have finished the Auto-Painting there will still be quite a few white gaps; how many depends upon how long you left the Auto-painting running (Figure 2.39).

13. Use the same brush to paint over the picture; turn the Tracing Paper on and off to check where you need to paint. The object is to turn the rather contoured strokes of the Auto-Painting into shapes that better reflect the shapes in the photograph. In the early stages the brush should be generally moving in the direction of the petals and painting over all the white areas. Don't overwork any area as the watercolor can build up unattractive textures, so a good way is the keep the pen on the tablet for some time and then let the diffusion finish (Figure 2.41).

FIG 2.40 Auto-Painting palette

14. Reduce the brush size to 15 and start to refine the shapes. Paint over the bright stalks to make them stand out; sometimes the edge is too hard so paint each side of the brush stroke and the diffusion will soften the edges.

FIG 2.41 Picture at step 13

FIG 2.42 Picture at step 14

I find that a good method is to paint an area with the Tracing Paper turned on and then soften the edges with it turned off. There is no need to soften all the edges however, just those that need it.

Continue until you are happy with the result.

FIG 2.43 Clematis

Pastel flower

This is a really simple and quick to make picture which uses a pastel chalk. The main difference between this brush and the ones used previously is that we are changing settings in the General palette; this will make an accurate clone copy which will show paper textures very clearly.

FIG 2.44 Original photograph

1. Open 'Flower' from Chapter 2 folder on the DVD (Figure 2.44).
2. In the Underpainting palette select the Jagged Edge Effect, amount 33% (Figure 2.45). Save this version under a different name.
3. Make a Quick Clone.
4. Select the Pastels>Artist Pastel Chalk, size 190 and Opacity 8%.
5. In the General palette change the category to Cloning, the subcategory to Grainy Hard Cover Cloning and the Grain to 16%.
6. Select the Sandy Pastel Paper from the Papers palette.
7. Paint the flower; the alteration made to the Grain slider will emphasize the paper texture.
8. Change the brush size to 82 and the Opacity to 23%, and paint the flower head to strengthen the colors.

FIG 2.45 Applying the Edge effect

FIG 2.46 Flower

FIG 3.1 St Luke. This picture was painted using the Graphic Bristle brush in the Liquid Ink brush category

Choosing brushes

When faced with the hundreds of brushes which come with Painter, how do you know which one to choose? This large chapter devotes two pages to every brush category in Painter 11 and can be used as an invaluable reference for when you are unsure as to which brush to use for a particular painting.

Each two page layout contains:

An overview of the brush category.
A finished picture made with brushes from the brush category.
An edited step by step example of how it was created.
Examples of eight different variants from the category.

In addition to the edited step by step instructions included in this chapter there are more detailed instructions with interim illustrations included on the DVD. I recommend that you use these in preference to the ones in the book. The files are in pdf format and can be viewed on screen or printed for reference. The original photographs for all these pictures are also on the DVD so that you can follow them using my originals. The step by step instructions on the DVD amount to over 130 additional pages of instructions and illustrations.

Selecting brushes in Painter 11

Before you start checking the brush categories, it is worth being aware of the terminology used in Painter to describe each brush. The category and variant name will usually give a good idea of what to expect so this is a brief overview of what the names mean.

First select the category

The category name gives the first clue. Most of them are easily recognizable – Airbrush, Oil, Watercolor, Chalk, Pencils – and they speak for themselves. Categories such as Chalk and Conte have very hard finishes and are good for picking up paper textures.

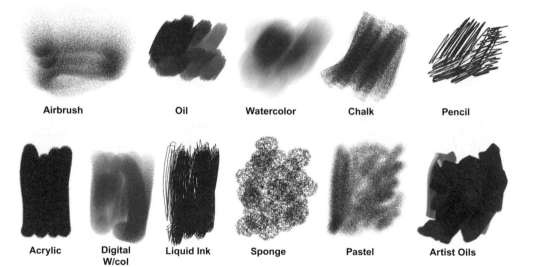

| Airbrush | Oil | Watercolor | Chalk | Pencil |

| Acrylic | Digital W/col | Liquid Ink | Sponge | Pastel | Artist Oils |

Understanding the shape

These are also fairly obvious – flat, round, square, tapered, pointed, thick, calligraphic, and so on. Another way of recognizing the shape is to check the tiny dab illustration alongside each variant, which will show you the basic shape of the brush.

| Flat | Round | Square | Tapered | Pointed | Thick | Calligraphic |

Now for the texture

The texture has a major impact on the appearance of the brush and the examples below show the main types. Look out for variants named Greasy and Smeary – these will smear the photograph, painting in a similar way to blenders. Camel hair brushes are very smooth while Glazing brushes are set up to paint very gently without hiding what is underneath. The Resist brushes are unique to the Liquid Ink category and are used to protect areas which are not to be painted over. Impasto brushes add a shadow to the brush strokes in order to give a three-dimensional appearance while Markers are very flat and solid.

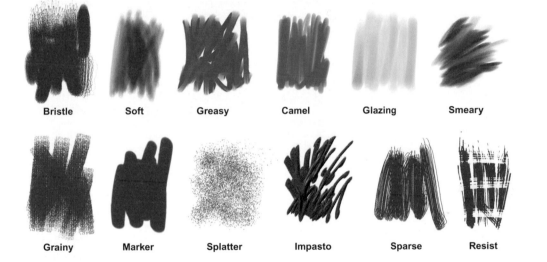

Bristle	Soft	Greasy	Camel	Glazing	Smeary

Grainy	Marker	Splatter	Impasto	Sparse	Resist

Blenders for smoothing and mixing

There are many diffusers and blenders in various categories and they each have different ways of blending existing paint or imagery in your picture.

When the description says Grainy, then the mix will take on some characteristics of the paper texture currently selected; the Oily and Directional blenders will pull the paint in a particular direction. A soft finish will result from using blenders such as Just Add Water and ones with Soft in their name. For more information on blenders refer to the detail later in this chapter and also in Chapter 9 where they are used to paint a child's portrait.

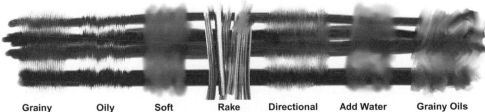

Grainy	Oily	Soft	Rake	Directional	Add Water	Grainy Oils

Acrylics

The Acrylics brush category contains some very useful brushes, many of which display strong brush strokes. The Captured Bristle is one of the most useful brushes in Painter; using it in Grainy Hard Cloning Method at a reduced Opacity (say 10%) will give a light but distinctive texture based on the paper chosen, while in Clone Color mode the same opacity will give an attractive smeary finish. Try cloning with Clone Color first and then bringing back detail by changing to Grainy Hard Cloning Method.

The Soft Wet Acrylic brush is another favorite; it gives beautifully soft strokes when used in Clone Color mode.

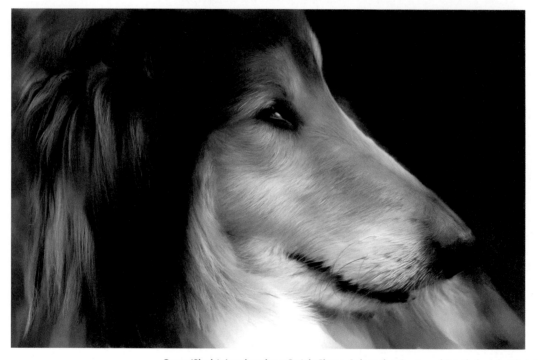

FIG 3.2 Sheltie

Open 'Sheltie' and make a Quick Clone. Select the Captured Bristle brush. Click the Clone Color option and using brush size 72 and Opacity 70% clone the picture. Paint with short brush strokes and follow the lines of the hair and shape of the head. Continue until the whole picture has been covered. Turn the Tracing Paper off and continue to paint until all the white areas are filled in. Change the Method to Cloning and the Subcategory to Grainy Hard Cover Cloning. Change the brush size to 72 and Opacity to 30%. Gently paint again; this time select areas which will benefit from detail being added. Continue over the head; follow the lines of the hair very carefully, particularly where it goes in several directions. Change the brush size to 32.2 and Opacity 100% and selectively paint over again. Concentrate mainly on the areas around the eyes and nose and also on some tufts of hair.

Tutorial files on the DVD

Full step by step instructions for this picture are on the DVD.

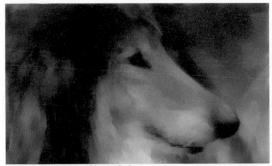

Captured Bristle–Clone Color

Captured Bristle–Grainy Hard Cover Cloning Method

Wet Soft Acrylic–Clone Color

Wet Soft Acrylic–Grainy Hard Cover Cloning Method

Dry Brush–Clone Color

Thick Acrylic Round–Clone Color

Opaque Acrylic–Clone Color

Thick Acrylic Flat–Clone Color

Airbrushes

Airbrushes used non-digitally often give an ultra smooth finish to an illustration and for the photographer this is perhaps too smooth and realistic. It is more interesting to use the textural finish of this brush category as in the picture below.

Airbrushes like Graffiti and Pepper Spray give a very rough finish while the Variable Splatter is the most striking and can be utilized to help enhance texture in the background of a picture.

Soft airbrushes, which include the Soft Airbrush, Fine Tip Soft Air and the Fine Detail Air are very smooth and difficult to use when cloning.

FIG 3.3 The old bible

This is a very simple and quick picture to make. Make a Quick Clone and select the Broad Wheel Airbrush, size 127 and Opacity 47%.

Click the Clone Color option in the Colors palette. Lightly paint over the central parts of the picture to establish the outlines. In common with most airbrushes, this brush will spray paint outwards in the direction that your pressure sensitive pen is held. Use this characteristic and hold the pen inside the area of the book and spray outwards. Change to the Graffiti brush, size 128 and Opacity 48%. Click the Clone Color option. Brush over the book to bring more detail to the text. Change to the Fine Spray brush, size 52 and Opacity 44%. Click the Clone Color option in the Colors palette. Paint over the book to get more clarity. When the picture is finished add a touch of sharpening to add to the texture.

Full step by step instructions for this picture are on the DVD.

Tutorial files on the DVD

Broad Wheel Airbrush–Clone Color

Coarse Spray–Clone Color

Digital Airbrush–Clone Color

Fine Tip Soft–Grainy Hard Cover Cloning Method

Fine Spray–Clone Color

Graffiti–Clone Color

Variable Splatter–Clone Color

Fine Detail Air–Grainy Hard Cover Cloning Method

Art Pen

The Art Pen brushes were originally introduced to be used with the Wacom 3D Art Pen, however they can equally be used with any other graphics tablet. Most of the brushes can be used very successfully when cloning from photographs. All the Grainy types will pick up the selected paper texture – in the examples opposite I have used the Artists Canvas Paper.

Several of the brushes can also be customized to use the Grainy Hard Cover Cloning Method; this will give a more accurate clone and, depending on the brush, will often pick up the paper texture.

FIG 3.4 Cistus

This picture of the attractive Cistus flower was created using the Worn Oil Pastel. Make a Quick Clone. Select the Worn Oil Pastel, brush size 148 and Opacity 12%. Click the Clone Color option in the Colors palette.

Change the paper to Artists Canvas. Clone the entire picture. This will give an attractive pastel finish; leave some small areas not fully painted to allow the canvas texture to show through. The rest of the work is to add detail to the flower. Use brush size 53, Opacity 53% and then size 18 to bring in the detail; emphasize the petal edges and variations of light and dark in the petals.

To finish the picture reduce the brush size to 11 and increase the Opacity to between 50% and 100%. If this is too sharp, smooth off with a larger brush size at a low opacity. I also painted out the pink flower on the right which was in the original image.

Full step by step instructions for this picture are on the DVD.

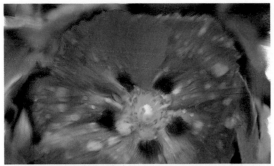

Tapered Camel–Clone Color

Grainy Calligraphy–Clone Color

Soft Flat Oils–Clone Color

Square Grainy Pastel–Clone Color

Worn Oil Pastel–Clone Color

Worn Oil Pastel–Grainy Hard Cover Cloning Method

Tapered Gouache–Clone Color

Grainy Edge Calligraphy–Clone Color

Artists

This brush category is unusual in the sense that it does not represent a range of brushes of one type, but rather includes a small selection of brushes designed to work in the style of some great painters. Probably the most appealing brush is the Impressionist brush and the picture below was created with this brush. It has a very distinctive texture which emphasizes brush strokes and can be used for many types of picture.

The Sargent brush is ideal for the early stages of a clone, when you want to completely break up the photographic texture and replace it with a mass of rough strokes.

FIG 3.5 Tomatoes

The Impressionist brush was used for this group of tomatoes and it has given the picture a very strong sense of depth and texture.

Create a Quick Clone.

Select the Impressionist brush, size 92 and Opacity 100%.

Click the Clone Color option in the Colors palette.

Paint loosely over the tomatoes, leaving the outer area blank.

Change the brush size to 38 and paint over the tomatoes individually, following the shape of the tomatoes and the spaces between them.

Use a size 18 brush to emphasize the stalks and the edges of the tomatoes.

The Impressionist brush is an easy brush to use but at smaller sizes, as used in this picture, it does take quite a while to complete.

Full step by step instructions for this picture are on the DVD.

Impressionist–Clone Color

Impressionist–Grainy Hard Cover Cloning Method

Sargent Brush–Clone Color

Tubism–Clone Color

Seurat–Clone Color

Seurat–Grainy Hard Cover Cloning Method

Auto Van Gogh–Clone Color

Van Gogh–Clone Color

Artists Oils

The Artists Oils brush category is a beautiful set of brushes for painting; they will pick up multiple colors from the Mixer and display many of the properties of real oil brushes. They run out of paint just like a real brush and leave very attractive bristle marks depending on the brush being used.

Unfortunately they are very difficult to use when making clone copies from photographs. (Look at the examples at the bottom of the opposite page to see the difference between cloning and painting). The one distinguishing feature all the brushes have is that they drag out the clone colors in one continuous line; this makes it very difficult to make a cloned picture.

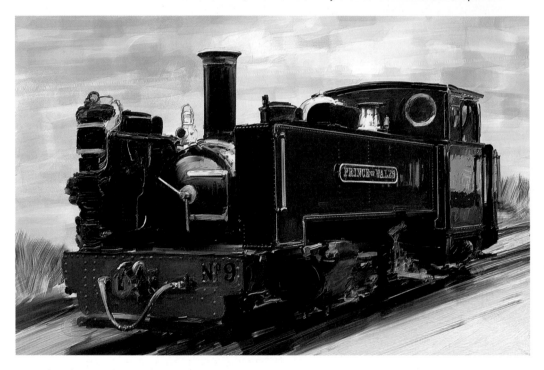

FIG 3.6 Steam locomotive

Make a Quick Clone and create a new layer to clone onto. Select the Wet brush, size 20, Opacity 100% and click the Clone Color option.

Paint the locomotive using short strokes but leave the background for now. Reduce the brush size to 11 and later to 4 to bring out detail. It is very difficult to retain detail using Artist Oils brushes as cloners so you will continually need to refine each side of a line to keep the colors in the right place. Create a new layer and move it beneath the layer on which you have been painting. Using the Dry Bristle brush, size 74 and Opacity 27% clone the rails and the grass. Create another new layer, also beneath the locomotive layer, and paint the sky. Use the same brush as before, untick the Clone Color box, and paint the sky by choosing blue and white in the Color palette.

Tutorial files on the DVD

Full step by step instructions for this picture are on the DVD.

Bristle Brush–Clone Color

Dry Brush–Clone Color

Wet Oily Brush–Clone Color

Grainy Dry Brush–Clone Color

Dry Bristle–Clone Color

Thick Wet Impasto–Clone Color

Dry Bristle–Used for painting (not cloning)

Thick Wet Impasto–Used for painting (not cloning)

Blenders

The Blenders category contains some really useful brushes and they can all be used successfully on photographs. They are not cloning brushes and should be used to paint over photographs leaving a textured finish.

The range is quite wide and contains brushes that will blend softly and others that create textures which look like oils, pastel and watercolor. Although this category has been created to bring together a range of blenders, there are actually many more scattered throughout the other categories. It is also worth remembering that many regular brushes can be changed into blenders by reducing the ReSat value to zero and increasing the Bleed value.

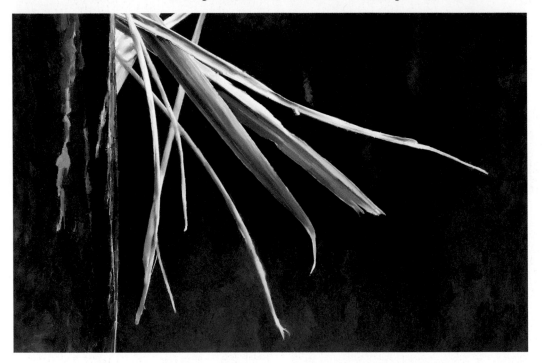

FIG 3.7 Blue Pot and Agave

Start by making a clone (File> Clone) to make a second identical copy. Select the Water Rake size 4.5; the Opacity will be 100% throughout.

Paint the blue background by making short strokes at angles to each other which will create a brushy texture. Paint the plant leaves using various brush sizes between 1.6 and 2.5 depending on the width of the stalk.

When painting the stalks it helps to turn the canvas on one side; do this by clicking and holding the Hand symbol in the Toolbox, which will change to a turning icon, then click and drag in the picture to turn the canvas around. Double-click in the centre to return to normal orientation.

When painting the panel on the left use brush size 2.5 and follow the colors with the brush, making lots of small movement again to create texture.

Full step by step instructions for this picture are on the DVD.

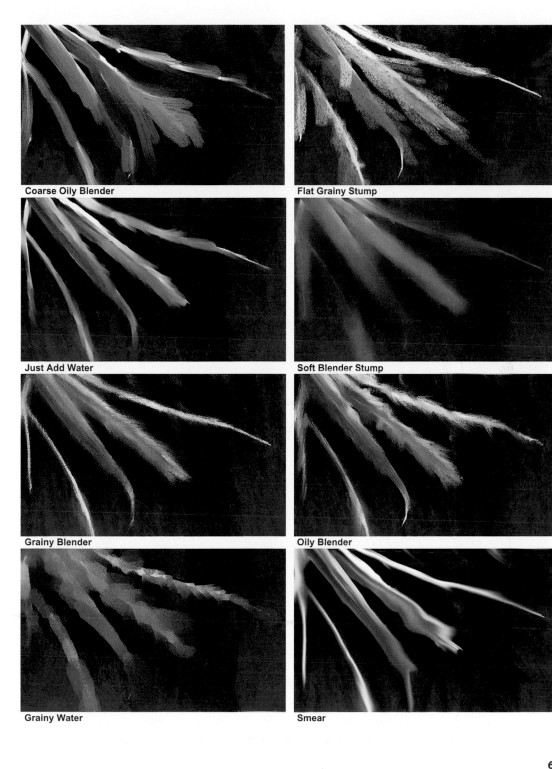

Coarse Oily Blender

Flat Grainy Stump

Just Add Water

Soft Blender Stump

Grainy Blender

Oily Blender

Grainy Water

Smear

Calligraphy

At first sight this rather small and specialized brush category does not offer much for the photographer. It is perhaps ideal for handwritten text or painting in the Chinese style, however the brushes will produce some very attractive textures when used in the right way. The selections of examples opposite illustrate some of the ways in which they can be used. When the Clone Color option is active most brushes will give a very distinctive calligraphic brush stroke, however by making the brushes smaller than the default sizes quite a lot of detail can be brought in. All the brushes will pick up the paper texture when changed to the Grainy Hard Cloning Method.

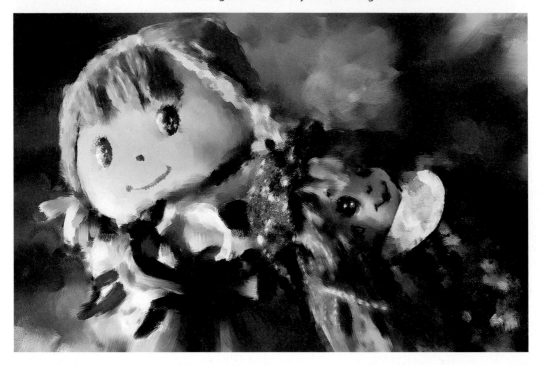

FIG 3.8 Rag dolls

Make a Quick Clone, select the Dry Ink brush and click the Clone Color icon in the Colors palette. Paint over the dolls with brush size 32 and Opacity 100%. Use short brush strokes for the main areas, long strokes for the golden hair, and dabs for the patterned dress. Reduce the size to 11.3 and refine the face and eyes. Change to brush size 85 and Opacity 100%, and roughly paint the background, then reduce the Opacity to 13% and brush over the background to soften and texture. Fill in all the white gaps with brush size 32 and Opacity 15% and generally improve any areas which need improving. Reduce the brush to size 11 with a 50% Opacity to paint in the areas that will improve the depth and detail, for example down the left side of the doll's face where the darker line needs to be emphasized.

Finally, you may need to adjust the contrast to give the picture a boost.

Full step by step instructions for this picture are on the DVD.

Calligraphy–Clone Color

Wide Stroke–Clone Color

Dry Ink–Clone Color

Dry Ink–Grainy Hard Cover Cloning

Broad Grainy Pen–Clone Color

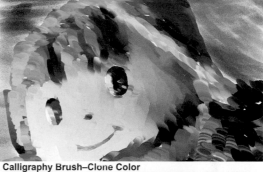

Calligraphy Brush–Clone Color

Thin Smooth Pen–Clone Color–Jitter at 4.00

Calligraphy Brush–Clone Color–Jitter at 4.00

Chalk

The Chalk brushes are particularly useful for showing the paper texture, and the Square Chalk brush is my favorite in this category. All the brushes will work in Clone Color mode and also in Grainy Hard Cover Cloning Method. It is generally necessary to reduce the opacity and reduce the Grain slider to bring out the grain. In the examples opposite the paper chosen was the French Watercolor paper, which gives an attractive dappled surface texture.

Chalk brushes are excellent for creating a rough background for a clone painting and although it is difficult to bring in fine detail while in Clone Color mode, this can be achieved by changing to Grainy Hard Cover Cloning Method.

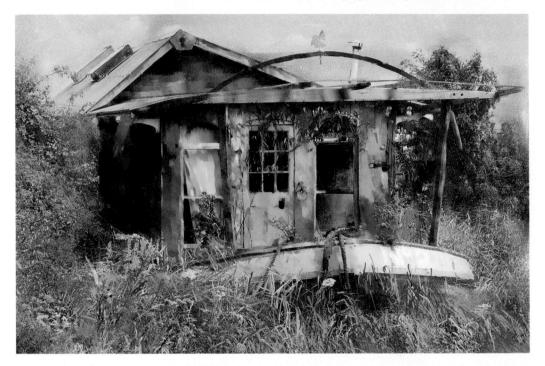

FIG 3.9 Houseboat

Make a Quick Clone and select the Square Chalk brush, size 149 and Opacity 13%. Click the Clone Color icon in the Colors palette and paint over the entire picture to give an overall background color. Create a new layer, change the brush size to 99 and start to bring in some more shapes. Reduce the brush to size 23 and increase the Opacity to 54% to add more detail. Reduce the size further to 12 and paint along the lines of the picture to enhance the lights and darks. Create another new layer, un-tick the Clone Color, and in the General palette change the Method to Cloning and the Subcategory to Grainy Hard Cover Cloning. Use brush size 32 and 28% Opacity and Grain at 6% to gently bring some extra detail into the picture. Finally, return to the Clone Color mode and use brush sizes between 10 and 35 with 54% Opacity to bring back some painterly strokes over the more realistic elements.

Full step by step instructions for this picture are on the DVD.

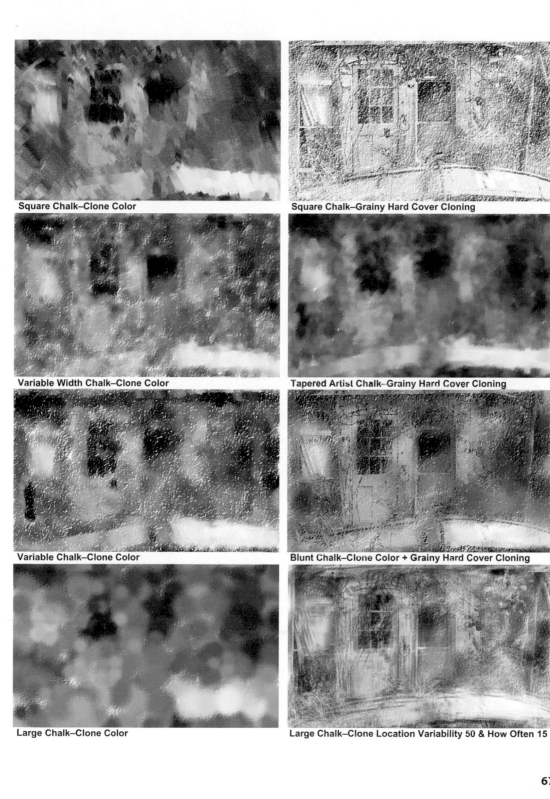

Square Chalk–Clone Color

Square Chalk–Grainy Hard Cover Cloning

Variable Width Chalk–Clone Color

Tapered Artist Chalk–Grainy Hard Cover Cloning

Variable Chalk–Clone Color

Blunt Chalk–Clone Color + Grainy Hard Cover Cloning

Large Chalk–Clone Color

Large Chalk–Clone Location Variability 50 & How Often 15

Charcoal

In traditional painting Charcoal is usually just black with shades of gray and the examples shown here are just that; however, this being Painter you can of course use these brushes to clone in full color from photographs. In many ways they are similar to the Chalk category in that they are excellent at picking up a paper texture. When used in Clone Color mode it is hard to resolve fine detail but they do produce some really good rough textures. All the brushes will work in Grainy Hard Cover Cloning Method but the brushes do not vary very much in texture. You will need to reduce the Grain slider and usually the Opacity to show the paper texture at its best.

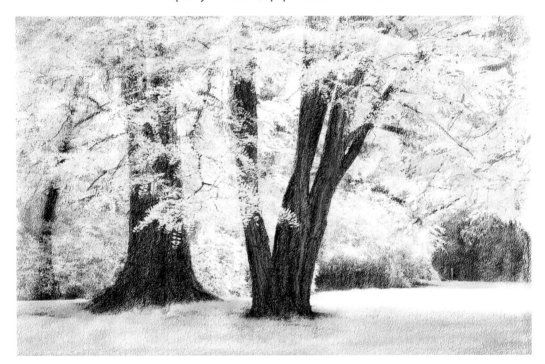

FIG 3.10 Trees in charcoal

Make a Quick Clone and select the Charcoal brush, size 72, Opacity 100% and Grain 10%. In the General palette change the method to Cloning and the subcategory to Grainy Hard Cover Cloning. Choose the Rough Charcoal Paper and paint over the tree trunks to get a good density. Switch to the Soft Charcoal brush, size 78 and change to the Grainy Hard Cover Cloning as above. Make the Opacity 17% and Grain 15%. Clone the rest of the picture; this will be softer and lighter than the trunks. Using the Sharp Charcoal Pencil (also in Grainy Hard Cover Cloning Method) size 24, Opacity 100% and Grain 10%, paint over the tree trunks and smaller branches to darken them further. Return to the Soft Charcoal brush used previously and paint over any areas that require more detail. Make a copy of the canvas (Select>All, Edit>Copy, Edit>Paste In Place), then change the Layer Composite Method to Multiply.

Full step by step instructions for this picture are on the DVD.

Soft Charcoal–Grainy Hard Cover Cloning–Grain 10%

Soft Charcoal–Clone Color–Grain 100%

Soft Vine Charcoal–Clone Color–Grain 17%

Gritty Charcoal–Clone Color–Grain 20%

Hard Charcoal Pencil–Clone Color–Grain 10%

Hard Charcoal Pencil–Grainy HC Cloning–Grain 10%

Soft Charcoal Pencil–Clone Color + Grainy HC Cloning

Charcoal Pencil–Clone Color–Grain 21%

69

Cloners

If you are new to Painter, this is the ideal place to start cloning from photographs. All the brushes in this category have been created specially for cloning and will work well without any modification. There is a wide variety of finishes; brushes like the Bristle Brush Cloner, Wet Oils Cloner and the Thick Bristle Cloner will drag out the color into attractive textures. They will also react differently depending on the speed the brush is moved. Try moving the brush fast and it will smear the image, move it very slowly and the clone will appear very clearly. The Soft Cloner is used regularly in conjunction with other brushes to return some detail to a picture.

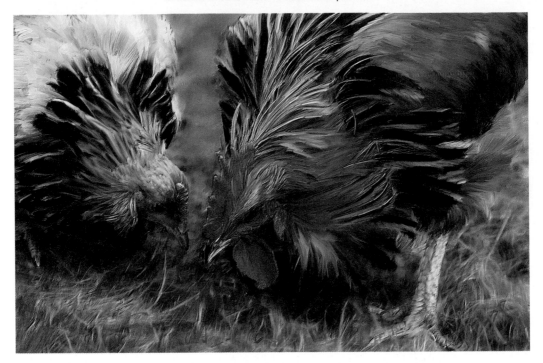

FIG 3.11 Chickens

Make a Quick Clone and select the Wet Oils Cloner, brush size 29 and Opacity 39%. Create a new layer to paint on and paint the chickens with the brush strokes, tracing the lines of the feathers. Create a new layer and place it under the layer just painted. Change to the Chalk Cloner, size 68, Opacity 20% and paint the grass; because this is below the top layer you can paint quite freely without affecting the birds. Change the layer opacity to 80%. Create another new layer, on top of the previous one, and using the Wet Oils Cloner, size 27, Opacity 6% paint a rough texture over the grass. Create a further layer, just under the chickens layer and reduce the Wet Oils Cloner to size 10, Opacity 100% and paint in some tufts of grass. Change this layer's Opacity to 80%. Finally, paint over the chickens again; use brush size 22 with Opacity 20% and soften down any rough edges.

Full step by step instructions for this picture are on the DVD.

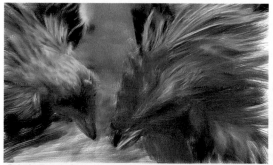

Bristle Brush Cloner

Chalk Cloner

Furry Cloner

Smeary Camel Cloner

Impressionist Cloner

Thick Bristle Cloner

Thick Flat Cloner

Watercolor Run Cloner

Colored Pencils

Pencils tend to be small and sharp, and when used to draw a detailed picture it takes a long time to complete. Painter pencils are no different. If you want a picture with delicate tones and crosshatching it can be done by using a very small size brush, but you will need a lot of patience. The examples shown here use larger brushes and the result is not like the traditional pencil, but it is certainly worth exploring some of the different effects. One feature is that most of the brushes use the Build-up Method and this means that the color will very rapidly go dark; this can be a problem but may be avoided by changing the Method to Cover.

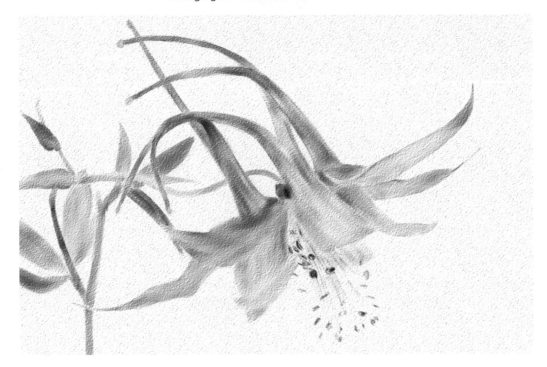

FIG 3.12 Aquilegia

Make a Quick Clone, select the Hard Colored Pencil, size 20, Opacity 8%, Grain 26%, and choose the French Watercolor paper and click the Clone Color option. Clone over the picture; use brush strokes to indicate the edges of the petals only, do not fill the centres of the petals. You will need to use many different brush sizes depending on the size of each petal.

Change the brush to Blenders>Just Add Water, size 21, Opacity 23% and blend over the petals to get a smooth finish. Drag out the painted color and spread it across the surface. As before, you will need to use different sizes of brush to blend the various areas. Return to the colored pencil to emphasize darker lines then blend again. The result should be something like a traditional watercolor pencil which has had water applied to the pencil marks to blend and soften. I applied a texture based on the watercolor paper used.

Full step by step instructions for this picture are on the DVD.

Tutorial files on the DVD

72

Cover Colored Pencil–Clone Color

Oily Colored Pencil–Clone Color

Variable Colored Pencil–Clone Color

Colored Pencil–Clone Color

Grainy Colored Pencil–Clone Color

Cover Colored Pencil–Grainy Hard Cover Cloning

Hard Colored Pencil–Clone Color + Just Add Water

Grainy Colored Pencil–Clone Color–Size 25, Opacity 6%

Conte

Conte is the smallest brush category in Painter, with just three variants. They work rather like Chalks or Pastels and traditionally are used in brown, black or red.

When used in Clone Color mode they smear the image and only produce detail when the brush is very small. The brush strokes are attractive, however, and do show the active paper texture quite clearly.

They can also be used in Grainy Hard Cover Cloning Method when they will produce a clear cloned image. Reduce the Opacity and the Grain to make the best use of these brushes. When the Jitter control is increased, the brush dabs are placed randomly and this can make an attractive texture.

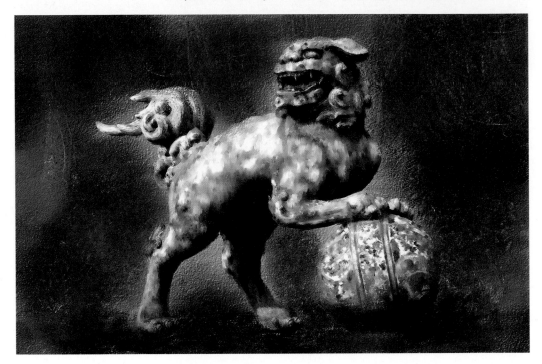

FIG 3.13 Fearsome beast

Make a Quick Clone and select the Square Conte brush, size 190, Opacity, 5% Grain 1%. Use Clone Color. Choose the French Watercolor Paper. Fill the picture with color, Edit> Fill> Current color, and choose a mid brown in the Colors palette. Paint over the background with rough strokes and make it fairly dark. Paint the stone beast with brush size 22, Opacity 16%; keep the Grain at 1% throughout. Reduce the brush size to 10, Opacity 60% and bring out areas of light and dark to make the shapes clearer; then reduce to size 5 and 100% Opacity to paint over the head and other important details. The smaller brush leaves very hard lines which do not look good against the looser background, so change to a blender brush, Blenders> Soft Blender Stump, size 10, Opacity 37%, and blend the hard edges, but don't soften everything; leave plenty of brush strokes to keep the texture varied.

Tutorial files on the DVD

Full step by step instructions for this picture are on the DVD.

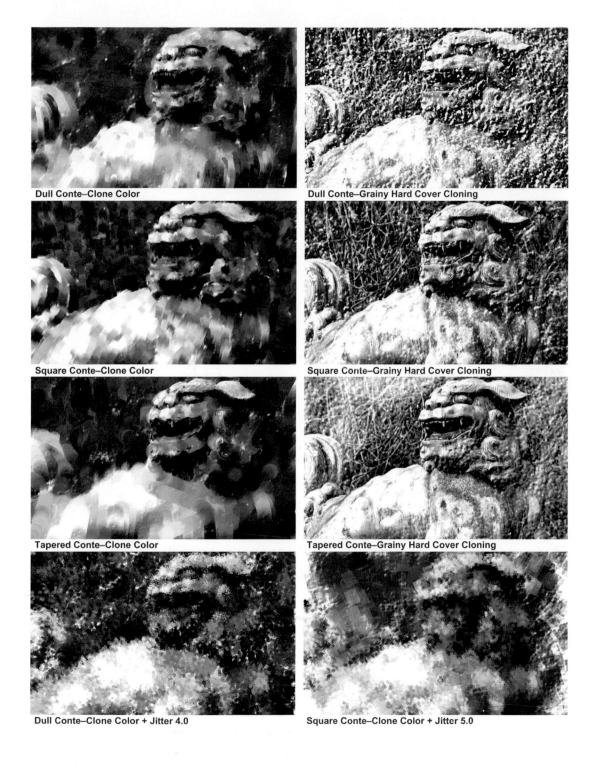

Dull Conte–Clone Color

Dull Conte–Grainy Hard Cover Cloning

Square Conte–Clone Color

Square Conte–Grainy Hard Cover Cloning

Tapered Conte–Clone Color

Tapered Conte–Grainy Hard Cover Cloning

Dull Conte–Clone Color + Jitter 4.0

Square Conte–Clone Color + Jitter 5.0

Crayons

In their default state these brushes are very difficult to use as cloners. The reason is that they all use the Build-up Method, which makes the brush strokes darker as they overlap; check the example for the Dull Crayon opposite. You will find that they go to black extremely quickly. The way around this is to change the method to Cover, which makes them much more manageable. You do this in the General palette; change the method to Cover and the subcategory to Grainy Edge Flat Cover. It is worth experimenting with the different settings; by changing from Clone Color to Grainy Hard Cover Cloning Method most brushes by default will give a very soft smeary effect.

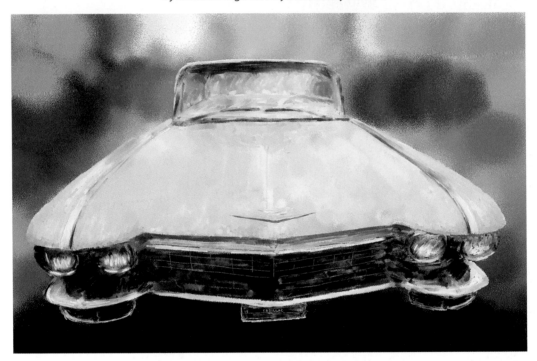

FIG 3.14 Pink Cadillac

Make a Quick Clone and select the Grainy Hard Crayon. Open the General palette and change the Method to Cover and the Subcategory to Grainy Edge Flat Cover. Click the Clone Color option. Create a new empty layer and, using brush size 334 and Opacity 100%, roughly paint the background. Create a new layer above the previous one and with brush size 161, paint over the car to bring out some general shapes.

Continue to build more detail with smaller brush sizes – use size 48 and then 23 each on their own layers. To bring out some stronger detail go down to brush size 4 and paint around the headlamps and other details.

You may need to darken the foreground. If so, create a new layer just above the very first layer on which you painted and change the Layer Composite Method to Gell; the brush marks will then appear dark.

Full step by step instructions for this picture are on the DVD.

Basic Crayons–Clone Color

Basic Crayons–Grainy Hard Cover Cloning

Dull Crayon–Clone Color

Med Dull Crayon–Grainy Edge Flat Cover Method

Grainy Hard Crayon–Clone Color

Grainy Hard Crayon–Grainy Hard Cover Cloning

Pointed Crayon–Clone Color

Waxy Crayons–Grainy Edge Flat Cover Method

Digital Watercolor

When used for painting rather than for cloning, these brushes give a beautifully gentle watercolor finish with wonderful translucent colors. Sadly, when used as cloners the effect is lost and at the default settings many of the brushes are harsh and hard to use. The key to using them as cloners is to reduce the Opacity right down and to bring in detail by using smaller brushes. The Dry brushes are the easiest to use with photographs as they give a very attractive texture. Several of the blenders will also work as cloners and can give a strong feeling of watercolor although it is often difficult to resolve much fine detail. There is more information on Watercolor in Chapter 7.

FIG 3.15 Arabian horse

Tutorial files on the DVD

Make a Quick Clone and select the Dry brush, size 242, Opacity 11%. Make a new layer on which to paint the background colors. Choose a very light blue in the Colors palette and paint the sky with horizontal brush strokes. Add some white to indicate clouds then paint a light green for the grass. Switch off the visibility of this layer for the moment. Make a new layer, use the Dry brush again, size 19, Opacity 65%, and this time click the Clone Color option in the Colors palette. Paint the horse and then reduce the brush to size 6, Opacity 100%, and paint the harness; keep the detail fine by painting the harness first then painting each side to reduce the width of the stroke. Switch to the Flat Water Blender, size 8.2, Opacity 9% in Clone Color mode and blend in any rough areas and soften down parts of the mane. Return to the Dry brush, size 7, Opacity 100% to refine details, particularly around the head and eye.

Full step by step instructions for this picture are on the DVD.

Dry Brush–Clone Color

Coarse Dry Brush–Clone Color

Fine Tip Water–Clone Color

Coarse Mop Brush–Clone Color

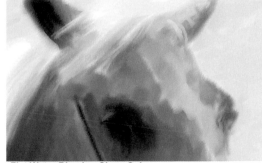

Flat Water Blender–Clone Color

Pure Water Blender–Clone Color

Finer Mop Brush–Clone Color

New Simple Diffuser–Clone Color

Distortion

As the name suggests, the brushes in this category all distort images to some extent. Variants like Hurricane and Turbulence create wild patterns, while the Distortion and Marbling Rake will pull the detail in the direction of the stylus.

Brushes such as Pinch and Bulge also distort the picture.

All the brushes are used directly on the image and not via cloning.

This could be seen as just a set of effects brushes but they can be used in the course of a painting; the Diffuser will soften areas which are too rough and Confusion will create a Watercolor Edge effect. Another use for these brushes may be to create a diffuse background at the start of a painting.

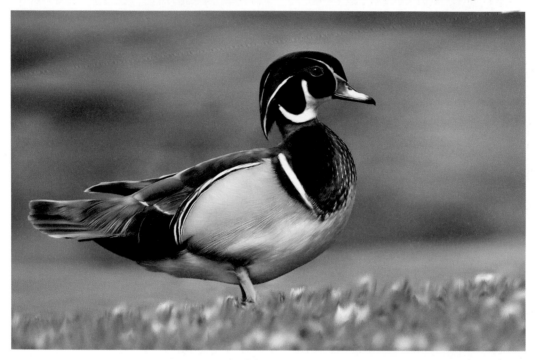

FIG 3.16 Mandarin duck

Make a Clone copy (not a Quick Clone) and select the Grainy Mover brush, size 150, strength 50%. Choose the Artists Rough Paper in the Papers palette. Paint over all the background except the grass; this will increase the diffuse look of the area and give a light texture. Paint the grasses using brush size 66 and Opacity 26%; pull the brush strokes upwards to follow the grass stalks. Switch to the Diffuser brush, size 10, Opacity 50%, and carefully brush over the head of the bird following the lines and shapes of the feathers.

Return to the Grainy Mover brush, size 20, strength 25%, and paint the remainder of the bird; follow the lines of the feathers at all times and keep the brush strokes fairly short. Reduce the brush to size 3 and, after enlarging the picture on screen, paint over the eye and other fine details in the feathers to finish off the picture.

Tutorial files on the DVD

Full step by step instructions for this picture are on the DVD.

Hurricane

Diffuser

Marbling Rake

Coarse Brush Mover

Coarse Distorto

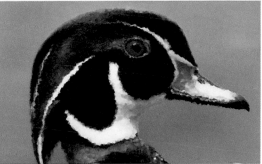

Confusion

Water Bubbles

Turbulence

Erasers

The erasers are primarily for correcting brush marks made in error and for removing unwanted areas. For the purposes of these examples, however, I have looked at the creative possibilities for using erasers for tonal changes and textural overlays. As you can see, they can be used to lighten areas in order to give the picture a very light appearance.

When using the Tapered erasers, directional lines can easily be introduced, while the 1 pixel eraser can create a distressed finish. Should you be using a Paper Color other than the default white, you need to remember that erasers will erase to paper color while bleaches always go to white.

FIG 3.17 Tulips

In the picture above the eraser has been used to delicately remove all darker areas and lighten the whole picture to create a soft, high key image.

Make a Clone copy (not Quick Clone) and select the Gentle Bleach eraser, size 310 and Opacity 10%. Using a graphic tablet paint very gently over the picture, concentrating on the outer areas of the picture; if you are using a mouse reduce the Opacity to around 3%. The whole picture should become much lighter and delicate but you will find that the yellow at the base of the picture is not affected much by the eraser, so switch to the Erase All Soft eraser, size 234, Opacity 6%, and gently lighten that area. You need to be careful about burning out any areas to white, as this is easily done. Should this occur, change to the Soft Cloner, size around 245, Opacity 3%, and clone back in from the original picture.

Full step by step instructions for this picture are on the DVD.

1 pixel Eraser

Tapered Eraser

Erase All Hard

Erase All Soft

Eraser

Bleach

Eraser with Paper Color set to light pink

Tapered Darkener

F-X

As the name indicates, this brush category has lots of special effect brushes – some more useful than others. Two of the most attractive and fun ones are the Furry Brush and Hair Spray, which spray out colors from the picture using an airbrush effect. You will find that some of the brushes act as cloners, while others have to be used directly on the picture.

Fairy Dust is a useful brush for adding highlights to a picture – use at low opacity for a subtle result. Glow is also useful to add a warm glow to an object. This category is certainly worth exploring and several of the brushes are useful for backgrounds.

FIG 3.18 Jazz girls

Make a Quick Clone and select the Gradient Flat brush, size 92 and Opacity 29%. Click the Clone Color option in the Colors palette. Paint over all the picture using short brush strokes; this will leave a vibrant, very colorful mosaic. You will very quickly notice that this brush deposits blobs of color at the start and end of each stroke. This color comes from the Additional color swatch which is behind the Main color in the Colors palette. Reduce the brush size to 27 for the main figures and continue to use a range of smaller sizes right down to 4 for the eyes to bring in detail. Make a new layer and change to the Fairy Dust brush, size 162, Opacity 9%; choose white in the Colors palette and paint stars over the picture. Make several new layers and paint stars of different sizes and colors on each; adjust the layer opacities until you are happy with the effect. Use the Soft Clone brush to clone back some detail on the faces and arms.

Full step by step instructions for this picture are on the DVD.

Tutorial files on the DVD

Furry Brush

Hair Spray

Gradient Flat Brush

Fairy Dust

Confusion

Shattered

Piano Keys

Squeegee

Felt Pens

In their default settings these brushes are not very rewarding when used as cloners. The main reason is that they all use the Build-up Method which causes the brush strokes to build in intensity and go dark very quickly.

In the examples shown on these pages the Method has been changed from Build-up to several other alternatives. In this way some interesting textures and finishes can be created.

Most of the examples tend to be very graphic, as befits the category; in several of the examples the paper texture has been increased in size to roughen the finish.

FIG 3.19 Umberella

Make a Quick Clone and select the Fine Point Marker, size 155, Opacity 45% and Grain 10%. In the General palette change the Method to Cloning and the Subcategory to Grainy Hard Cover Cloning. In the Papers palette select the Worn Pavement Paper. Change the Paper Scale slider to 261%.

Change the Paper Contrast slider to 137%. Clone in the whole of the picture; the finish will be rough due to the paper chosen and the increased size and contrast. Reduce the brush size to 29.7 and change the Opacity to 60%.

Paint over the edges of the umbrella to make them more defined. Reduce the brush further in size to bring in the handle and spike. Make a new layer and change to the Design Marker, size 10, Opacity 7%, Build-up Method and Grainy Hard Build-Up Subcategory. On the new layer, clone over the graffiti on the umbrella.

Full step by step instructions for this picture are on the DVD.

Art Marker–Cover Method, Grainy Edge Flat Cover

Blunt Tip–Cover Method, Grainy Edge Flat Cover

Felt Marker–Cloning Method, Grainy Hard Cover Cloning

Thick n Thin Marker–Buildup Method, Grainy Edge Flat Cover

Fine Tip–Cloning Method, Grainy Hard Cover Cloning

Design Marker–Cover Method, Grainy Edge Flat Cover

Medium Tip Felt Pen–Drip Method, Hard Drip

Dirty Marker–Cover Method, Soft Cover

Gouache

The Gouache brushes tend to give rich accurate detail when used as cloners.

By reducing the Opacity and choosing a suitable paper they will show the paper texture quite clearly. My favorite is the Wet Gouache Round brush which smears the picture while giving rich colors, as you can see in the picture below. The Feature slider controls how the bristles are separated, and increasing the amount will result in the brush marks showing through clearly. The Jitter slider has been substantially increased in the example showing the Detail Opaque brush on the next page and the result is a very heavily textured finish. The Jitter slider is in the Random palette.

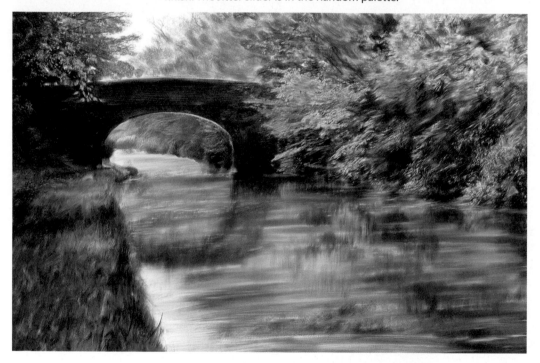

FIG 3.20 Hanbury canal

Make a Quick Clone and select the Wet Gouache Round brush, size 30 and Opacity 100%. Use the Clone Color option. Clone the picture with the bridge and the surrounding trees, reduce the brush opacity to 13% and clone the lighter trees at the top of the bridge. Continue cloning the remainder of the trees and grass. Keep the brush moving all the time and use short strokes in different directions to keep the textures interesting. Increase the brush Opacity to 60% and go over the painted areas and bring in more density and detail. Cover most of the area, but leave some small areas of white canvas. Paint the water with the same brush, 60% Opacity using horizontal brush strokes. Reduce the brush size to 30 and the Opacity to 22% and paint the reflections by making small strokes in a downwards direction. Emphasize the reflection of the bridge and the colourful trees.

Tutorial files on the DVD

Full step by step instructions for this picture are on the DVD.

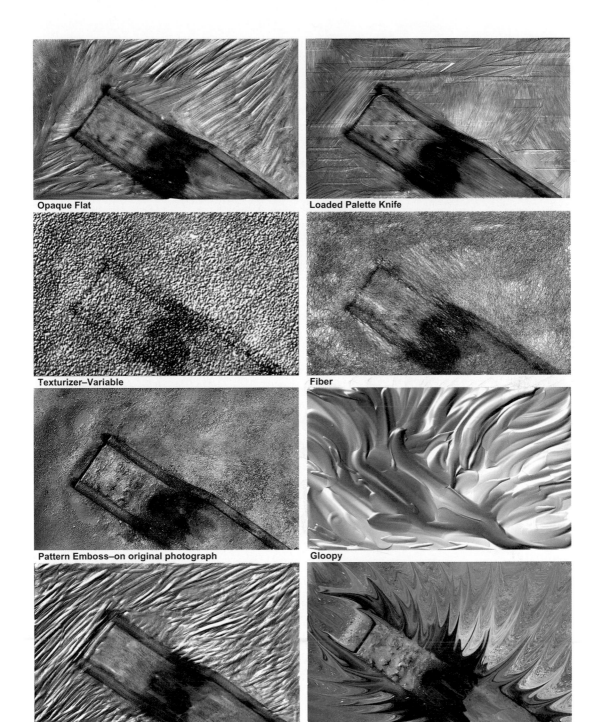

Opaque Flat

Loaded Palette Knife

Texturizer–Variable

Fiber

Pattern Emboss–on original photograph

Gloopy

Thick Wet Flat

Distorto Impasto

Liquid Ink

Liquid Ink is a large group of brushes which replicate the use of ink based artists materials. The ink flows very fast and covers the paper quickly, and has a graphic appearance. All Liquid Ink brushes use a special layer and a new Liquid Ink layer is created automatically when you use one of the brushes.

Resist brushes are used to reserve areas on which paint is not required in the same way as masking tape might be used.

The Liquid Ink section in the Brush Creator has many controls for adjusting the brushes, in particular the amount of ink. If this slider is very high the inks spills over the paper in pools. Try moving some of the sliders and see the result.

FIG 3.23 Handles

Open the file from the DVD and make a Quick Clone. Select the Sparse Bristle brush, size 34.9, Opacity 50%. Use the Clone Color option. In common with many of the brushes in this section the brush will have a streaky appearance if you paint lightly. Paint over again and they will disappear, but I prefer the texture, so in this example you will need to paint lightly and leave some white paper showing.

Paint the left and right panels first, angling the brush strokes to follow the direction of the wood. Continue with the remainder of the wood.

When painting the handles allow the brush to spray out over the picture to increase the textural finish.

This is a simple and fast picture to make so, when it is complete, try another brush and see the difference. It is also worth experimenting with the sliders in the Liquid Ink palette – they can have a huge effect on the finished picture.

Full step by step instructions for this picture are on the DVD.

Graphic Bristle

Depth Bristle

Clumpy Ink

Smooth Camel

Sparse Flat cloned on layer with 28% Opacity

Sparse Bristle with Sparse Bristle Resist

Smooth Thick Flat–with Jitter at 3.76

Velocity Sketcher

Markers

The Markers brush category is a new introduction in Painter 11 and all feature the properties which you would expect of the real world markers, that is they have flat strokes which build up density when overlapped.

This causes difficulties when used as cloners as each additional brush stroke becomes darker so it is difficult to get a satisfactory clone picture. However with a bit of perseverance and by altering some settings, it is possible to use some of them. In the examples on the right-hand page, some of the brushes are on default settings while others use different methods, which can be changed in the General palette.

FIG 3.24 Boots

Open 'Boots' from Chapter 3 on the DVD. Make a Quick Clone. Select the Chisel Tip Marker, size 45 and Opacity 30%. Select the Clone option in the Colors palette. In the General palette or in the Brush Selector change the Method to Drip and the Subcategory also to Drip. The Drip category makes the brush drag and distort the image. In the Random palette move the slider full to the right, this will break up the image and provide the base for the picture. Paint the whole picture using dabs and short brush strokes.

Make a copy of the canvas (Select>All, Edit>Copy, Edit>Paste in Place).

Tutorial files on the DVD

Return the Random slider full to the left and then in the copy layer paint the boots (brush size 30) following the lines of the picture. With this brush the detail is limited, but the result is interesting and should be easily recognizable.

Full step by step instructions for this picture are on the DVD.

Chisel Tip Marker

Chisel Tip Marker–Drip Method

Leaky Marker

Flat Rendering Marker–Grainy Edge Flat Cover

Variable Chisel Tip Marker

Variable Chisel Tip–Grainy Hard Cover Cloning

Fine Tip Marker

Sharp Marker

Oil Pastels

There are very few variants in this brush category but they are all very attractive brushes. Used in their default settings they display the distinctive pastel finish. The Variable Oil Pastel is one of the most useful and blends well with existing paint on the canvas. This is due to the Resaturation and Bleed settings (Resaturation is just 2%, while Bleed is 92%).

One of the best papers to use with these brushes is Sandy Pastel, which has a very gritty finish. To make the paper texture more noticeable, decrease the Grain slider. It is worth mentioning that the brushes paint beautifully when not used as cloners, especially if the Opacity is kept low.

FIG 3.25 Pink Flower

Make a Quick Clone; select the Soft Oil Pastel, size 140, Opacity 80%.

In the General palette change the Method to Cloning and the Subcategory to Soft Cover Cloning. Paint the background first by pulling the brush strokes from the top left-hand corner; don't include the flower as far as possible.

Paint the flower at 45% Opacity. Pull the brush strokes from the bottom right corner and in the direction that the petals run. When everything has a light covering of color, make the brush size 40 and increase the Opacity to 80%.

Paint over the petals, turning the tracing paper on and off to check where to paint. Build up the density in the petals; concentrate on one petal at a time and paint using small strokes, keeping the brush on the canvas and working sideways across the petal. Emphasize the edges of the petals to bring out the detail and then work the areas close to the edges to make the transitions smooth.

Full step by step instructions for this picture are on the DVD.

Tutorial files on the DVD

Chunky Oil Pastel

Oil Pastel

Round Oil Pastel

Soft Oil Pastel

Variable Oil Pastel

Chunky Oil Pastel–Cloning Method, Soft Cover Cloning

Soft Oil Pastel–Cloning Method, Hard Cover Cloning

Oil Pastel–Cloning Method, Grainy Hard Cover Cloning

Oils

The Oils brush category has some very attractive brushes which can be used for cloning photographs. I particularly like the Smeary variants as the new brush strokes will merge with paint already placed on the canvas.

The best way to use these brushes for cloning is to paint over the picture first with a Smeary brush, which will provide the necessary underpainting, then use smaller brushes to bring in more detail. Several brushes such as Thick Oil Flat use an Impasto effect to indicate that a thick paint is being used. All the brushes have that thick luscious painterly finish which is the great attraction of traditional oils.

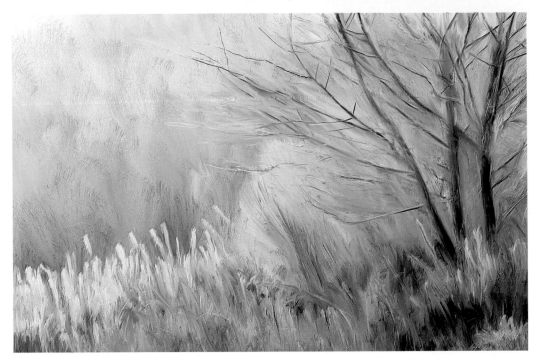

FIG 3.26 Frost on the Malvern Hills

Make a Quick Clone and use the Smeary Bristle Spray, size 78, in Clone Color mode to paint over the whole picture. Paint downwards on the left then follow the lines of the tree on the right. Change to the Smeary Flat, size 32, in Clone Color mode and paint in the seed heads on the left and the grasses at the bottom. Continue with the brush and paint over the branches, following each main branch from the trunk until the end. Use the Bristle Oils brush in Clone Color mode to bring back more detail in the twigs and inside the tree; blend with the Smeary Flat brush at 50% Opacity to remove any photographic textures that may be apparent. Return to the Smeary Flat brush, size 16 at 100% Opacity, and paint over the entire picture to bring back more detail; this will also increase the contrast of the picture. Finally, make a copy of the canvas and apply an embossing effect to the brush strokes.

Tutorial files on the DVD

A more detailed step by step example is on the DVD.

Smeary Bristle Spray

Thick Oil Flat

Smeary Round

Fine Feathering Oils

Smeary Flat

Bristle Oils

Thick Wet Camel

Thick Wet Oils

Palette Knives

This is a small brush category and in the main the brushes are not ideal for cloning from photographs. The exception is the Loaded Palette Knife which does give a very satisfactory result with some good textures.

All the brushes can be used directly on the top of photographs in which case they act very much like blenders and can make some great backgrounds prior to cloning in more detail.

Extra depth can be added by changing to Color and Depth in the Impasto palette or the Brush Creator.

FIG 3.27 Rare Breed Hen

Make a Quick Clone; select the Loaded Palette Knife, brush size 61.4, Opacity 30%. In the Colors palette click the Clone Color option. Paint the green background using a variety of brush strokes in different directions. Continue to paint over the top until the background is fairly smooth but still has some marks left by the Palette Knife. Reduce the brush size to 22 and increase the Opacity to 100%. Paint the hen, starting with the head and moving down the feathers. Reduce the brush size to 3.5 and paint the eye. Make the brush size 12.5 and with the Opacity still at 100% paint over all the head to bring out detail and definition. Keep the brush moving in the direction of the feathers. Watch out for the feathers which flick out, they need careful painting to keep the shapes correct. When you are happy with the result, add some texture to enhance the brush strokes.

A more detailed step by step example is on the DVD.

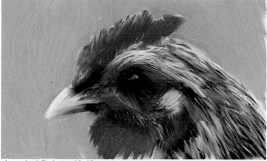

Loaded Palette Knife

Neon Knife

Palette Knife

Sharp Triple Knife

Smeary Palette Knife

Subtle Palette Knife

Loaded Palette Knife–cloned on top of original photograph

Tiny Smeary Knife–cloned on top of original photograph

103

Pastels

The pastel brushes in this category work very successfully with photographs. The textures are quite beautiful and ideally suited to light delicate pictures such as the one below.

The Artist Pastel Chalk is one of my all-time favorite brushes in Painter, but most of the others work extremely well. The hard pastels pick up the paper grain more strongly than the soft pencils which show the grain primarily on the edges of the brush strokes. I tend to use the Sandy Pastel Paper for these brushes as the gritty texture suits the brush strokes. As the name suggests, the Pencil Pastels are for very detailed work.

FIG 3.28 Magnolia

This picture is a little more complex than most in the chapter as it involves cloning from two separate originals. Open the two original photographs and then create a Quick Clone. Select the Square X-Soft Pastel, size 137 and Opacity 7%. Click the Clone Color option in the Colors palette. Paint the whole picture very lightly then reduce the Resat slider to zero and use this as a blender to soften everything. Clone from Magnolia A with the same brush, size 30, Opacity 46%. Resat 60%; paint the petals but not the background. Change the clone source to Magnolia B and do the same with that.

Reduce the brush size to 8.8, Opacity to 60% and paint over the edges of the petals to clarify the shapes. Do this from both originals. Change the brush size to 72, Opacity to 11% and Resat to 7%. Blend in the brush strokes across the picture, particularly those in the background.

A more detailed step by step example is on the DVD.

Artist Pastel Chalk

Blunt Soft Pastel

Square X-Soft Pastel

Square Hard Pastel

Sharp Pastel Pencil

Round X-Soft Pastel

Soft Pastel

Tapered Pastel

Pattern Pens

The Pattern Pens use a pattern to paint with, therefore they are of limited use when using direct from photographs.

By default they use the patterns already in the Painter program, which can be selected from the Patterns palette. Try a few of them as they are quite fun and can certainly be used as part of a design project.

In addition to the default patterns, it is easy to make your own from photographs; they can be used for montages or backgrounds. The Pattern Pen Soft Edge is very useful for making backgrounds; capture a subtle pattern and by overpainting at low opacities the result can be very pleasing.

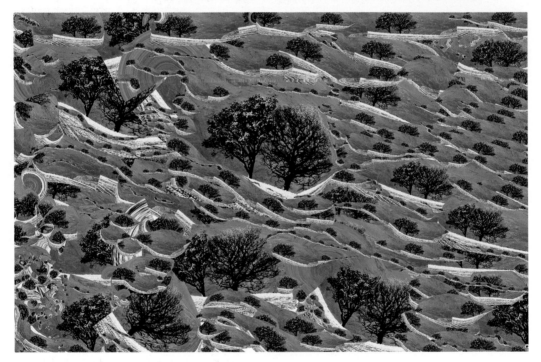

FIG 3.29 Tree fantasy

Start by creating the pattern to use. Open the file on the DVD and Select> All. Open the Patterns palette (Window> Library Palettes> Patterns) and click on the tiny triangle top right to reveal the drop down menu. Select Capture Pattern. A dialog box opens and asks for a name; leave all the sliders on default settings. In the Patterns palette click on the icon which shows the patterns to reveal another drop down menu; select the pattern you have just captured from the list.

Now create a new document (File> New) and make the dimensions: width 20 cm and height 13 cm, and Resolution 200 pixels per inch.

Select the Pattern Pen and paint into the new document. Use various sizes. You will immediately notice that if you paint from right to left the trees are vertical, while a right to left movement turns the trees upside down.

Full step by step instructions for this picture are on the DVD.

Pattern Chalk

Pattern Marker

Pattern Pen

Pattern Pen Masked

Pattern Pen Soft Edge

Pattern Pen Transparent

Pattern Marker Grad Color

Pattern Pen Micro

107

Pencils

Whether drawing traditionally or using these pencils in Painter, it is likely to take quite a long time to finish a quality painting so you need to bear this in mind. Try using the pencils at a larger size to save time and you will find that the result will no longer look like a pencil drawing.

Although the examples on these pages are in monochrome, you can of course clone from a color original just as easily. The main differences between the pencils are described in their names; greasy pencils will pull the image round while the grainy pencils show the grain well. The old favorite 2B is the equivalent of the traditional pencil.

A step by step tutorial using the new Red pencils is included in the Landscape chapter.

FIG 3.30 Owl

The first step is to turn this picture to monochrome. Reduce the Saturation slider in the Underpainting palette to zero. Select the Sketching Pencil, size 3.0, and Opacity 40%. Use Basic Paper and the Clone Color option. Make a Quick Clone, turn the tracing paper on and clone in the picture. Start below the eye, painting in medium strokes. Turn the tracing paper off to get an indication of the textures that are showing and build up that area so that the section is fully cloned.

In the darker areas around the eye you can use crosshatching; this is a traditional technique where lines are drawn across each other to create a dense but not black area. When the eye and surrounding area is done, reduce the brush opacity to 20% and add some shading in the white of the eye. This should be kept lighter than anything else. Continue with the rest of the picture ensuring that the bands of darker feathers are clearly shown.

A more detailed step by step example is on the DVD.

Tutorial files on the DVD

Greasy Pencil

Grainy Cover Pencil

Grainy Pencil

2B Pencil

Grainy Variable Pencil

Cover Pencil

Oily Variable Pencil

Sketching Pencil

Pens

As you might expect, the Pens brush category contains a fair number of different variants, but they are nearly all designed for small-scale use and do not work well when cloning at a larger size.

The Nervous Pen is very useful when cloning water as the irregular brush stroke is very reminiscent of water ripples. The Barbed Wire Pen has a strong fibrous texture and is very useful for creating backgrounds or overlays in montages; this is one pen that also works well at larger sizes. The Leaky Pen is rather fun as it leaves blobs of ink across the page and is also good for creating textures in montages.

FIG 3.31 Lakeside reeds

Make a Quick Clone. Select the Smooth Ink Pen, size 1.5 and Opacity 100%.

Select black in the Colors palette. Create a new layer and paint over the posts and fence; trace the posts and wires and outline them with the pen. Change to the Nervous Pen, size 5.4 and Opacity 100%. Use Clone Color and paint the reflections. Make a new layer under the layer on which you have been painting. Select the Smooth Ink Pen in Clone Color. Paint the reeds with brush size 1.5 and Opacity 100%. When the painting of the outlines is complete, make a new layer under the other layers. Change to the Airbrush> Graffiti, size 128, Opacity 48%. Click the Clone Color option. Paint the warm colors in the reeds and surrounding area. Adjust the Opacity of the layer to around 75%.

A more detailed step by step example is on the DVD.

Tutorial files on the DVD

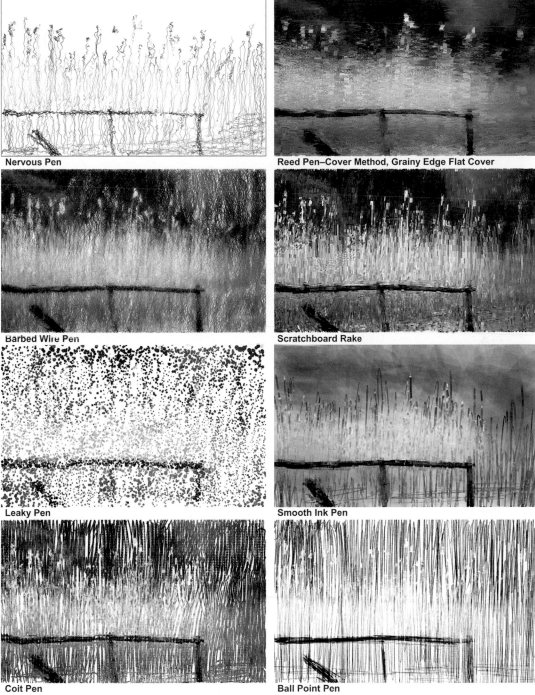

Nervous Pen

Reed Pen–Cover Method, Grainy Edge Flat Cover

Barbed Wire Pen

Scratchboard Rake

Leaky Pen

Smooth Ink Pen

Coit Pen

Ball Point Pen

Photo

The Photo brushes are used for adjusting small areas of photographs.

The Burn and Dodge brushes are very useful for lightening or darkening areas, which adds local contrast. There are four brushes which diffuse to varying degrees. Diffuse Blur is the strongest and has a grainy finish; Fine Diffuser works in a similar way but more gently. Blur diffuses in a smooth manner while Scratch Remover can blend imperfections or be used as a small blender. Colorizer changes the color based on the current color in use, and Saturation Add is self-explanatory, as is Sharpen. Be careful of these last three brushes as overapplication can easily ruin a picture.

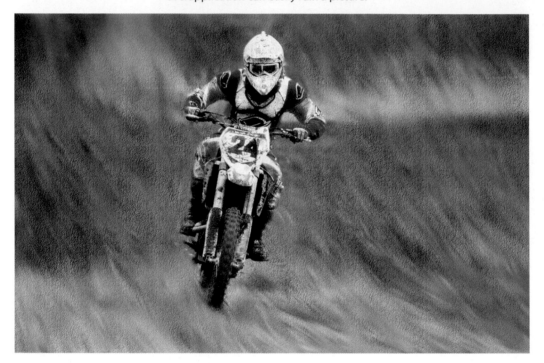

FIG 3.32 Motocross rider

File> Clone, then make a copy of the Canvas. Select the Rough Charcoal Paper in the Papers palette. Select the Diffuse Blur brush, size 85, strength 49% and paint over all the background area. Select the Blur brush, size 42, strength 57% and paint over the blended areas to remove most but not all of the rough texture. Select the Scratch Remover, size 8.5, strength 75%. Use this brush to slightly diffuse the edges of the motorcycle and the rider. Select the Dodge brush, size 45, Opacity 3%. Paint over the white areas of the clothing to brighten them. Select the Sharpen brush, size 21.5, strength 2%. Paint over the helmet and parts of the clothing to add a touch of sharpness. Select the Saturation Add brush, size 19.6, strength 65%. Paint over the eyes and parts of the clothing to add a little extra saturation. Select the Add Grain brush, size 99.6, strength 3%. Paint over the entire picture to add a paper grain texture.

A more detailed step by step example is on the DVD.

Tutorial files on the DVD

Add Grain

Blur

Burn

Colorizer

Diffuse Blur

Dodge

Saturation Add

Fine Diffuser

RealBristle

The RealBristle brushes all display very beautiful brush strokes and are all very suitable for cloning. The brush marks are quite subtle, however, so when the picture is reproduced at a small size they are not always very obvious.

The two fan brushes are my favorites; apart from the attractive textures when cloning they are also very useful for painting on top of pictures.

The Real Flat Opaque brush is different from all the others and works more like the Artists Oils category in that it continues to paint with the colors first picked up rather than reflecting the clone source. The Oil brush variants all have good brushy strokes.

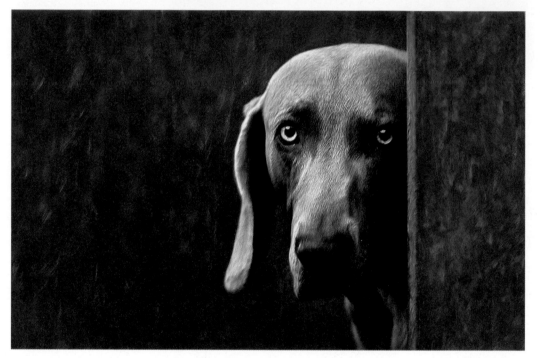

FIG 3.33 Hang dog

File> Quick Clone. Select the Real Fan Soft brush, size 50, Opacity 20%. Click the Clone Color option in the Colors palette.

Paint over all the background and around the dog; make it a fairly solid cover, but leave some lighter areas to show the texture of the bristles. Reduce the brush size to 40 and Opacity 50% and paint the dog. Make sure that you follow the direction of the hair. Reduce the brush size to 7.3 and Opacity 100% and paint the centers of the eyes. The picture is largely complete, so now to add some embossing to make the brush strokes more prominent. Create a new layer. Select> All, Edit> Copy, Edit> Paste in Place; this will copy the Canvas. Effects> Surface Control> Apply Surface Texture. Select Image Luminance in the option in the Using box. Make the Amount 52%. Reduce the layer opacity to 50%. You could also apply a paper texture.

A more detailed step by step example is on the DVD.

Tutorial files on the DVD

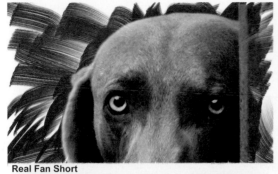

Real Fan Short

Real Fan Soft

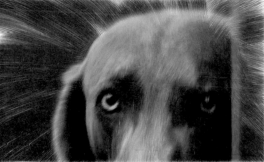

Real Blender Round

Real Oils Soft Wet

Real Flat Opaque

Real Blender Flat

Real Tapered Bristle

Real Oils Smeary

Smart Stroke

These brushes have been designed to work with the Auto-Painting palette and all the examples shown on these two pages have been used in that way. They can of course also be used as normal cloning brushes and they all work very well.

The range of variants covers many of the main categories and includes popular types such as Acrylics Captured Bristle, Chalk and Watercolor.

The Auto-Painting palette can be very useful for creating underpaintings. Let the program do the work of creating the basic textures in the painting style you would like and then you can do the more interesting details by hand.

FIG 3.34 Standoff

Make a Quick Clone and turn the Tracing Paper off. Select the Gouache Thick Round brush, size 20, Opacity 74%. Open the Auto-Painting palette (Window> Show> Auto-Painting). In the Auto-Painting palette, click the Smart Stroke Painting box. Start the Auto-painting by clicking the Play button at the bottom of the palette. Allow the Auto-painting to continue until most of the white areas are covered. You can stop the Auto-painting at any time by clicking in the picture; to start it again press the Play button. Change the brush size to 10 and start the Auto-painting again. When you have finished the Auto-painting there will still be quite a few white gaps – how many depends upon how long you left the Auto-painting running. Use the same brush to paint over the white areas, and also over the heads and horns of the animals if they need to be any more distinct. Add a surface texture to enhance the brush strokes.

Tutorial files on the DVD

A more detailed step by step example is on the DVD.

Acrylics Captured Bristle

Acrylics Dry Brush

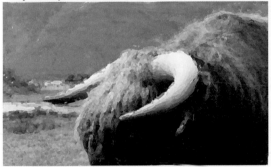

Chalk Soft

Gouache Thick Flat

Sponge Soft

Pastel Tapered

Watercolor Runny

Watercolor Soft Diffused

Sponges

In traditional painting sponges are often used to dab on wet paint and add a textured finish so they are not obvious candidates for use with photographs. However they have a very beautiful painterly appearance and they can be used in several ways. The painting below has a very attractive finish and it was created solely with sponges. Other excellent uses are for preparing backgrounds and adding textures to montages, which will help create layering effects. The Dense Sponge and the Square Sponge have hard edges but will still give reasonably fine detail if used in small brush sizes.

The Sponge variant is a good brush for adding texture.

FIG 3.35 Cherry tree blossom

Make a Quick Clone. Turn off the Tracing paper as you will not need it for this painting. Select the Sponges> Dense Sponge, size 60, Opacity 82%, other settings on default. Click the Clone Color option in the Colors palette.

Open the Auto-painting palette and click the Smart Stroke Painting option.

Start the Auto-painting by clicking on the Play button. Allow the Auto-painting to continue for a few minutes until all the canvas is covered. Make a new layer. Change the brush size to 30 and run the Auto-painting again. Make a new layer. Change the brush size to 15 and run the Auto-painting again. You should now have three layers of painting at different brush sizes. These can now be blended using layer masks and layer opacities.

A more detailed step by step example is on the DVD.

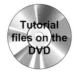

Tutorial files on the DVD

Sponge

Dense Sponge

Smeary Wet Sponge

Wet Sponge

Grainy Wet Sponge

Loaded Wet Sponge

Glazing Sponge

Square Sponge

Sumi-e

Sumi-e is an unusual and distinctive brush which uses the Rake dab in most of its variants. The Digital Sumi-e and the Tapered Digital Sumi-e brushes both use a very thin rake stroke to gradually build up the picture. This can take a long time so it is often better to use the Auto-painting palette to get the bulk of the picture painted and then finish off by hand.

The new Real Sumi-e Dry brush has an excellent texture and is very easy to use. Quite a few of the brushes use the Build-up Method which makes cloning from photographs very difficult as the brush strokes build very rapidly to black.

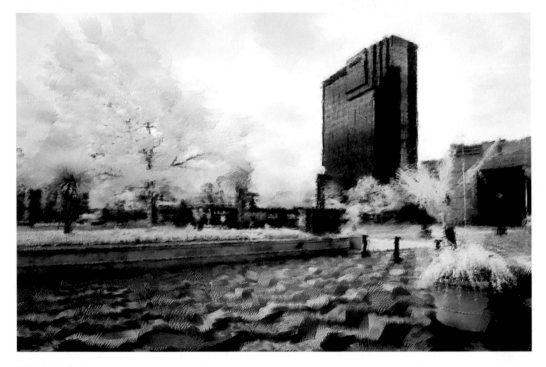

FIG 3.36 Birmingham city

Make a Quick Clone and select the Real Sumi-e Dry brush, size 123, Opacity 77%. Click the Clone Color option. Create a new layer. Open the Auto-Painting palette, leave the Smart Stroke option unticked, and choose Zig Zag in the Stroke drop down menu. Start the clone and allow the Auto-painting to fill the picture. Fill in any white gaps by painting over them; this should give you a roughly painted picture. Create two new layers and make two more Auto-painting versions using brush sizes 61.4 and 30.6. You will now have three versions of the clone, in three different levels of detail. They can now be blended together using layer masks. Create a new layer and clone directly onto this layer by hand to finish the picture.

A more detailed step by step example is on the DVD.

Tutorial
files on the
DVD

120

Digital Sumi-e

Sumi-e Brush

Tapered Sumi-e Large

Real Sumi-e Dry Brush

Coarse Bristle Sumi-e

Real Sumi-e Wet Brush

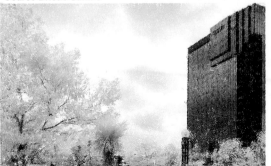

Tapered Digital Sumi-e

Tapered Sumi-e Small

Tinting

The Tinting category is a strange mix of brushes, blenders and erasers. As their name indicates, the brush variants are very suitable for hand tinting, having low opacities in most cases. Even at these low opacities I still find them too strong for delicate work and have developed a procedure of painting on a layer and immediately reducing the layer opacity to around 25%, then adjusting it as necessary.

In addition to the brushes there are several very useful blenders; the two diffusers are particularly good for softening paint into the canvas and can of course be used with many other brushes.

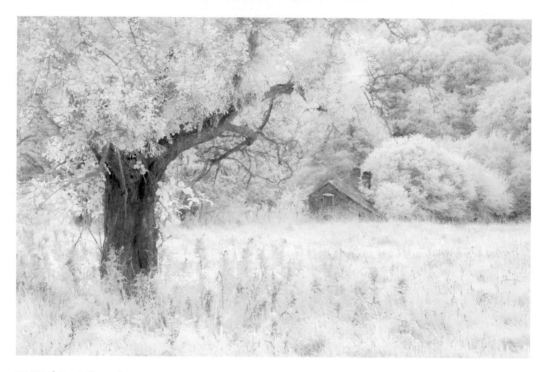

FIG 3.37 Cottage in the wood

In this step by step the procedure is to paint every element of the picture on separate layers so that the layer opacities can be adjusted at any time. The intended effect is a very soft gentle coloring and this is achieved by keeping the brush opacity low, reducing the layer opacity, and selecting delicate colors from the Colors palette. (File> Open> Tinting-Cottage in the Wood).

Select the Tinting> Hard Grainy Round brush, size 24, Opacity 10%.

Select the French Watercolor Paper from the Papers palette.

Make a new layer; change the layer composite method to Colorize and the layer opacity to 25%. Choose a warm brown color for the grass and paint the lower part of the picture. Continue to make new layers with the opacity and composite methods as above, and choose suitable colors for the picture.

A more detailed step by step example is on the DVD.

Basic Round

Bristle Brush

Grainy Glazing Round

Hard Grainy Round

Oily Round

Soft Glazing Round

Diffuser 2–on original photograph

Directional Diffuser–on original photograph

Watercolor

Watercolor is one of the most popular painting styles for artists and this brush category has some beautiful brushes for painting, but unfortunately most of them are not very satisfactory for use with photographs. The main problem when cloning is that the brush strokes build to black very quickly at the default settings. One way to avoid this happening is to reduce the opacities right down to around 5%. All the examples on the opposite page are using between 5% and 10% Opacity. Another way to avoid the build up of color is to paint on multiple layers. This allows the layer opacity to be reduced at any time, see the example below.

FIG 3.38 Clematis

Open 'Clematis' and make a Quick Clone. Select the French Watercolor Paper and the Soft Bristle brush, size 41, Opacity 11%. Click the Clone Color option in the Colors palette. Using the tracing paper as a guide, paint the picture, making sure that your brush strokes follow the lines in the flower petals. Paint very lightly and don't overwork any area or it will darken too much. You will notice that this brush works very slowly, even on a modern computer. Watch the water icon in the Layers palette. Once it has finished moving you can start painting again. When you complete an area, create a new Watercolor layer by clicking on the new Watercolor layer icon in the Layer palette (the blue droplet with a + beside it). Continue to paint over the picture on different layers to build up the density very gradually; this will take a long time.

A more detailed step by step example is on the DVD.

Dry Camel

Soft Bristle

Fine Camel

Diffuse Grainy Camel

Soft Runny Wash

Watery Glazing Round

Dry Bristle

Watery Soft Bristle

FIG 4.01 Geranium

Customizing brushes

C hapter 3 looked at the wide range of ready-made brushes available in Painter 11, but even with all these varieties it is still often necessary to customize them to get exactly the brush strokes required. The Brush Creator contains all the controls for customizing brushes and this chapter explains them in detail.

It is worth remembering that often the only difference between one brush and another are just a few settings in the Brush Creator. The brushes are, after all, just presets made by the creators of Painter for our convenience. In theory you could use just one standard brush and, by changing the relevant options in the Brush Creator, have everything from a pencil to a Watercolor brush. In practice, it is more convenient to use the standard brushes and change a few of the options to fine-tune the brush.

In this chapter some of the more useful Brush Control palettes are explained, with examples to illustrate the effect when changes are made. It is worth remembering that not all palettes are available for all brushes; several, such as Watercolor and Artists Oils can only be used with those categories.

The Brush Creator

The Brush Creator is the powerhouse for customizing brushes as it brings together all the brush palettes into one easily accessible place.

Bring the palette on screen by Window>Show Brush Creator or by the shortcut Ctrl/Cmd+B. When you click back into the image the Brush Creator drops back behind the document you are working on, which is a nice touch and saves time. Figure 4.2 shows the Brush Creator with the Stroke Designer tab active. This is where the many sub palettes are stored.

In the Brush Creator, click the palette names on the left and the controls for that particular palette will appear to the right. Some of the palettes refer to specific types of brush and are grayed out if that brush is not currently active.

At the bottom left is the Preview Grid. This shows a visual representation of the selected brush in both profile view (end on) and as a brush stroke.

The area on the right is the Scratch Pad; this is where you can try out various brushes and options before making a final decision. This scratch pad reflects

FIG 4.2 The Brush Creator with the Stroke Designer tab active

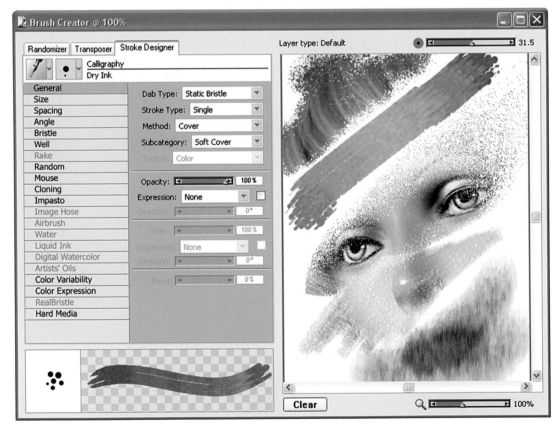

the paper texture in use and if you have a clone document active the brush will work in Cloning Method. Remember that the clone is taken from the top left corner of the original, so nothing will show if this area is blank.

The slider beneath the Scratch Pad will change the magnification; click the Clear button to delete the pad display. The slider above the Scratch pad changes the brush size.

All the Brush Control palettes are available from within the Brush Creator and they can also be brought on screen individually from Window>Brush Controls. They all appear together but if you just need to keep one on screen it can be pulled out from the rest.

General palette – dab types

The dab is the mark that the brush makes when a single mark is made using the brush completely vertical. Figure 4.3 shows the long list of dab types; those grayed out are not available for the chosen brush.

Making alterations in this section will make a fundamental change to the brush so do try out some of these types for yourself. Don't worry if you mess the brush settings up as you can easily revert the brush back to the default setting by clicking the brush Icon on the left of the Properties bar when the brush is active. The chief dab types are illustrated on the following pages.

FIG 4.3 The General palette and list of dab types available from the drop down menu

129

General palette – dab types 1

1. Circular dab types have a very smooth finish, and despite their name the brushes are often long and narrow. Soft clones use circular dab types so this is a good option if you want a smooth clear picture.

2. Static Bristle brushes are made up of individual bristles and therefore the brush lines are usually visible. This is the dab type to use if you want to emphasize the brush strokes.

3. Captured means that the shape has been made from a design or image rather than using individual bristles. When you make your own dab type this is called Captured. The dab illustrated comes from a Chalk variant. How to create your own captured dab is covered later in this chapter.

4. Camel Hair uses what are called Rendered dabs, which means that the brush is made up of individual bristles all computed separately. The brushes are often slow to operate, especially when smooth strokes are chosen. The Feature slider in the Size palette controls the spread of the bristles.

5. Flat dab types also use Rendered dabs like the Camel Hair type.

6. Palette Knife has an elongated shape and can be used to move imagery around directly on a picture. When using this dab for cloning, the image will appear with the very distinctive knife-like shape.

7. Airbrush sprays paint in the direction that the stylus is pointed, just like a real airbrush. This dab has a smooth spray.

8. Pixel Airbrush also sprays in the direction that the stylus is pointed, but the texture of the spray is rougher than the Airbrush.

9. Line Airbrush sprays imagery and also severely distorts it. The Furry Clone uses this dab type.

10. Rendered dab is rather like the Palette Knife in shape and it is difficult to clone with this brush as the image is very distorted.

11. Artists Oils is specifically for the Artists Oils brush category and works like real world oils.

12. Projected takes the source image and from it makes a brush stroke.

Circular

Static Bristle

Captured

Camel Hair

Flat

Palette Knife

Airbrush

Pixel Airbrush

Line Airbrush

Rendered

Artists Oils

Projected

FIG 4.4 Dab types

General palette – dab types 2

1. Watercolor Camel Hair paints in the Wet Method and diffuses the image, blending it into the paper.

2. Watercolor Flat also diffuses the brush strokes but being a flat brush uses a broad or narrow brush stroke depending upon the angle of the pen.

3. Watercolor Palette Knife diffuses less than the other types and has the characteristic bladed knife style.

4. Watercolor Bristle Spray creates spray patterns which then blend into the paper. This is a good dab for creating soft light clones. As with all Watercolor brushes, use at a low opacity.

5. Watercolor Airbrush sprays out paint in an even way and creates a soft finish if used at a low opacity.

6. Blend Camel Hair is the dab which is used in the RealBristle brush category. It gives a most attractive brush texture and when applied to other brush types will transfer the very smooth texture and appearance.

7. Bristle Spray will spray the paint in a distinctive spray. The Nervous Pen from the Pens brush category uses this effect, which is very useful for creating a textured background.

8. Liquid Ink Airbrush. The Liquid Ink dabs resemble free flowing fluid ink and this variety sprays out the ink in an airbrush style.

9. Liquid Ink Bristle Spray sprays out the ink in a pattern. There are several Resist brushes in this category which are paired with this and other variants. Painting with these Resist variants before the main brush will stop the ink from painting in the areas painted with the Resist brush.

10. Liquid Ink Camel Hair creates a very smooth even color across the picture.

11. Liquid Ink Flat is also smooth and clear but due to the flat shape of the brush it paints with a narrow or broad side.

12. Liquid Ink Palette Knife moves the paint around like a traditional Palette Knife.

Watercolor Camel Hair

Watercolor Flat

Watercolor Palette Knife

Watercolor Bristle Spray

Watercolor Airbrush

Blend Camel Hair

Bristle Spray

Liquid Ink Airbrush

Liquid Ink Bristle Spray

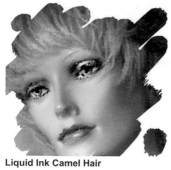

Liquid Ink Camel Hair

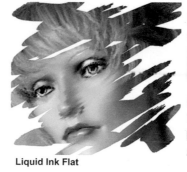

Liquid Ink Flat

Liquid Ink Palette Knife

FIG 4.5 Dab types

133

General palette – method

The Method controls how the paint is laid on the paper.

Cover will cover anything previously painted but will not become darker than the existing color. Build-up will get darker as more brush strokes are added, eventually going to black. Drip distorts the picture, while Wet is a Watercolor method which diffuses the brush strokes.

There are two ways of making brushes into cloners: one is by using the option in the General palette if available, and the other is by clicking the clone icon in the Colors palette. The option in the General palette will generally reproduce the original picture more accurately than the Clone Color option, while the Clone Color creates a more painterly impression.

The brush used for the examples shown was the Dull Grainy Chalk brush. The results would be different according to which brush is chosen, but the general effect will be similar.

FIG 4.6 The Method significantly changes the look of the brush

Cover Method

Build-up Method

Drip Method

Cloning Method

Wet Method

Digital Wet Method

General palette – Subcategory

The Subcategory refines the chosen Method, and each Method has its own set of variables. In the case of the Cloning Method there are four choices: the two that are used regularly are Soft Cover Cloning, which has a smooth even finish with soft edges and Grainy Hard Cover Cloning, which has a rough finish that shows paper grain.

FIG 4.7 The Subcategory refines the Method

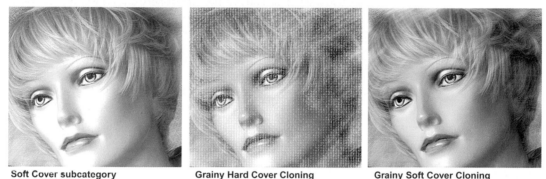

Soft Cover subcategory **Grainy Hard Cover Cloning** **Grainy Soft Cover Cloning**

General palette – Grain

This slider controls the amount of grain that is revealed when brush strokes are applied to the paper. The amount that is needed depends upon the combination of brush and paper being used. Generally the control needs to be set at a very low level, sometimes as low as 1 or 2. It seems strange to be reducing the slider control to increase the amount of grain, but the slider really controls how much paint goes into the grain, so the higher the setting the less grain will be visible. Some brushes such as the 'Real' brushes introduced in Painter 11 use the slider in the opposite way with the higher the setting, the more grain being shown.

FIG 4.8 The Grain slider controls the amount of paper grain that is shown in the picture

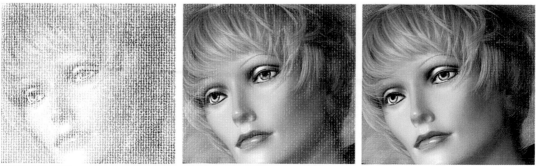

Grain set at 3% **Grain set at 10%** **Grain set at 20%**

Spacing palette

Brush strokes usually appear to be continuous, but are really a series of individual brush dabs spaced very closely so that they overlap. This palette adjusts the spacing between the dabs and Figure 4.9 shows the Acrylic Captured Bristle brush with spacing at 12% (the default setting), 100% and 200%.

The Min Spacing slider lets you control the minimum amount of space between the dabs; the difference is mainly noticeable when the Spacing slider is set low.

FIG 4.9 The Spacing palette adjusts the space between the brush dabs

The default spacing of 12% **Spacing set at 100%** **Spacing set at 200%**

Angle palette

In the Angle palette the shape and angle of many brushes can be changed.

The Squeeze slider flattens the brush shape and will change a round brush to an oval or very narrow shape; moving the Angle slider will alter the angle at which the brush paints.

Not all brushes can be changed in this way. For the example shown I used the Square Conte brush.

FIG 4.10 You can change the shape of the brush in the Angle palette

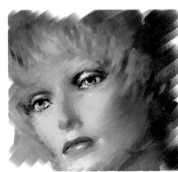
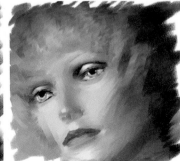

Squeeze 80%, Angle 0 **Squeeze 50%, Angle 50** **Squeeze 4%, Angle 59**

Well palette

The sliders in this section control how much the brush smears the existing artwork and how clear the detail is from the clone. The two sliders that control the level of diffusion are Resaturation and Bleed and they work together. Resaturation controls the amount of paint that is being replenished, and in the case of a clone this means the amount of detail from the clone source. Bleed controls how much the picture is being smeared. The default settings for the Wet Soft Acrylic brush are Resaturation 73% and Bleed 20%. In the examples shown in Figure 4.11 you can see the result of changing the values.

FIG 4.11 Resaturation and Bleed affect the clarity of the picture

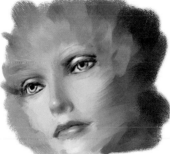
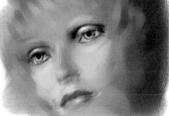

Resaturation 20%, Bleed 73% **Resaturation 73%, Bleed 20%** **Resaturation 50%, Bleed 50%**

Random palette

The Random palette contains the Jitter slider, which is often on the Properties bar for easy access. Increasing the amount of jitter breaks up the image into what looks like cotton wool in some brushes and rough texturing in others. In the examples shown the Jitter slider was increased while using the Thick Acrylic brush and the Square Chalk.

FIG 4.12 The Random palette

Thick Acrylic—Jitter at 0 **Thick Acrylic—Jitter at 2.86** **Square Chalk—Jitter at 2.62**

137

Watercolor or Digital Watercolor?

Painter has two categories of Watercolor brushes: one simply called Watercolor and the other Digital Watercolor. So what is the difference and which should you use?

The main difference is that Watercolor brushes have to be used on a separate layer and those layers can only be used for Watercolor brushes. The digital version can be used on a standard layer and can be used like any normal brush. Digital Watercolor tends to be much quicker to use but the end result can look very similar depending on the choice of brush.

If you are painting from scratch, the Watercolor brushes have more controls to customize the brush so this is probably the one to choose. If you are cloning from a photograph, Digital Watercolor is often more convenient.

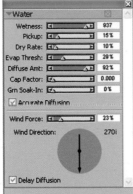

FIG 4.13 Water palette

Watercolor explained

This category has a lot of unique features and the following exercise will take you through some of the settings in the Water palette and explain how the brushes can be adjusted to suit the style of painting you need.

There are over 50 brushes in the Watercolor category and each one has a particular arrangement of settings in the Water palette; with so many brushes available it is worth trying out several to find the one you need before you start to customize the brush.

1. Open the Water palette; Window>Brush Controls>Show Water will show all the Brush Control palettes on the screen. Drag the Water palette out of the stack and close down the remainder. It is useful to have this palette on screen when using the Watercolor brushes; it is also available in the Brush Creator.
2. Open 'Clematis' from Chapter 2 folder on the DVD.
3. File>Quick Clone.
4. Select the Smooth Runny Flat 30 brush from the Watercolor brush category. Figure 4.13 shows the default Water palette for this brush. If your palette has different settings then go to the Brush Selector palette menu and click on Restore Default Variant. You may find it useful to return to the default between each of the examples.
5. Click the Clone Color option in the Colors palette, switch the tracing paper off, and you are ready to try out the examples.
6. Remember that this is a complex brush, so on most computers this will work quite slowly.

All the examples shown here are also included in a pdf file on the DVD so that you can see them more clearly than the size in the book permits.

Watercolor layers

Nearly all the brushes in this category use a dedicated layer on which to paint and this is automatically created when you select and use a Watercolor brush (the exceptions are the three new brushes introduced in Painter 11: Real Filbert, Real Flat and Real Tapered). These layers have some special characteristics; for example, because watercolor will blend when wet, you can return to these layers at a later date and, having wet the layer again, paint over the image and paint 'wet on wet', a traditional watercolor technique. This is only possible if you save the picture in RIFF file format; if you save it in any other format this option is lost.

One other thing to be aware of is that the diffusion process to get the watercolor effect is very complex and brush strokes can take longer than usual. Check the Layers palette when you have used this brush for several strokes and you will see a blue water-droplet symbol (shown in Figure 4.14). When this is moving, the diffusion process is still being computed so you will need to wait until it has finished; this can also be seen by the 'wandering' pixels in the picture.

FIG 4.14 The water-droplet icon which indicates when diffusion is being carried out

Water: Wetness

Make some brush strokes on the default wetness setting, which is 937 for this brush, and see how the paint runs down the page. This blending of color washes is one of the special characteristics of traditional watercolor painting and is caused by the liquid nature of watercolor paint. To get this blending effect the paper is tilted downwards and if you look at the bottom of the Water palette you will see, under Wind Direction, the arrow is pointing downwards. This is telling you that the paint will run down the page.

To understand how the Wetness slider affects the blending, make two more groups of brush strokes: one with the slider set at 500 and the other at 0. Figure 4.15 shows how the blending becomes less as the amount of wetness is reduced.

FIG 4.15 Wetness slider used at various settings: from left to right 1000, 500 and 10

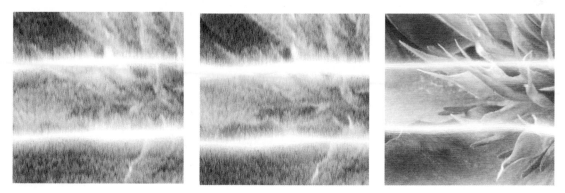

Water: Dry rate

The dry rate controls how quickly the paint dries and has a similar effect to the Wetness slider at the extreme settings, but rather different at 50%. Make brush strokes at 8%, 50% and 100% to see the difference, (Figure 4.16 shows these settings). Brush strokes at low settings will work more slowly.

The other difference that is not apparent in this example is that when paint is applied on top of the previous brush stroke the colors will blend if the paint is still wet. This is more noticeable when painting rather than cloning.

FIG 4.16 Dry Rate slider used at various settings: from left to right 100, 50 and 7

Water: Diffuse amount

The Diffuse Amount slider controls the amount of diffusion. The left-hand example (Figure 4.17) shows the brush at 100%, which produces significant diffusion, while the others at 50% and 7% show very much less. Brushes used with high amounts of diffusion will take a very significant time to complete each brush stroke; be warned and don't try this on a slow computer.

FIG 4.17 Diffuse Amount slider used at various settings: from left to right 100, 50 and 7

Water: Wind force

This was mentioned earlier and is a fascinating feature that replicates the ability in traditional watercolor painting to angle the paper downwards so that a wet wash will run and mix with other washes. In Painter both the angle and direction of the movement can be altered.

Figure 4.18 shows three different examples of using this control. On the right the Wind Force is at 0% so the diffusion has not significantly moved. The centre shows the Wind Force at 50% so the diffusion has moved downwards. The final example is with Wind Force at 100% and the direction of the wind is down in the top example and horizontal beneath, a real gale-force in fact! This is useful as you can control the final result very effectively.

FIG 4.18 Wind Force slider used at various settings: from left to right 100, 50 and 0

Water: other controls

There are several other sliders in the Water palette, not all of which affect this particular brush but they will affect others.

Delay Diffusion, which is turned on in the default setting, allows the brush stroke to finish before the diffusion process starts. Try the two options to see the difference.

Accurate Diffusion results in the clone copy having more clarity. Untick this option to get a rougher impression that can be very useful for backgrounds.

FIG 4.19 Accurate Diffusion has been ticked on the left and left unticked on the right

The Randomizer

The Randomizer is available from within the Brush Creator and allows us to take a brush that is close to what we are looking for and to generate variations of the brush type so that we can consider the options suggested.

Click on the Randomizer tab to bring up the palette and select the brush you want to use as a starting point. Click on the cogwheels and Painter will generate a set of alternatives and show them in the preview area on the left; now try out some of them to see how the original brush has altered. To get a greater variation move the slider at the bottom to the right; to get small variations move the slider to the left.

Figure 4.20 shows a set of variations based on the Smeary Bristle Cloner from the Cloners brush category. In the scratch pad is a selection of brush strokes which illustrate some of the variations that the Randomizer has created.

FIG 4.20 The Randomizer

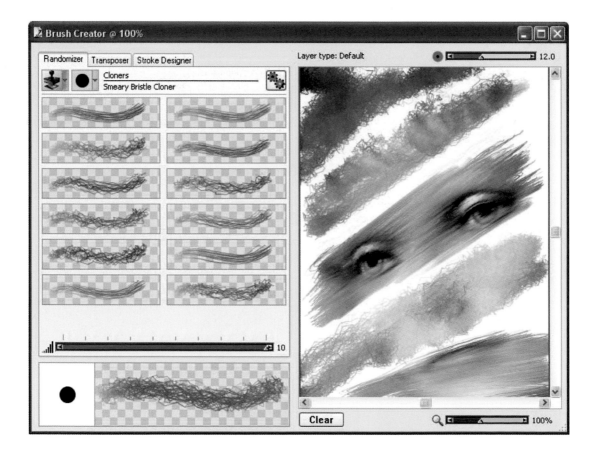

The Transposer

The Transposer is another tool for creating alternative brush variants. In this case Painter starts with the current brush, which is shown at the top of the display and changes it to a different brush, shown at the bottom, in a series of steps.

Figure 4.21 shows how an F-X Furry brush is changed to the Bristle Oils brush, with the Scratch Pad showing how the distinctive furry texture of the Furry brush is gradually changed to the much smoother Bristle Oils brush at the bottom.

Click the cogwheels to generate the transpositions. Try changing the starting and ending brushes to get a completely different result.

This palette is useful for generating ideas when searching for a suitable brush. In the example below the last transformation has a beautifully soft delicate texture.

FIG 4.21 The Transposer

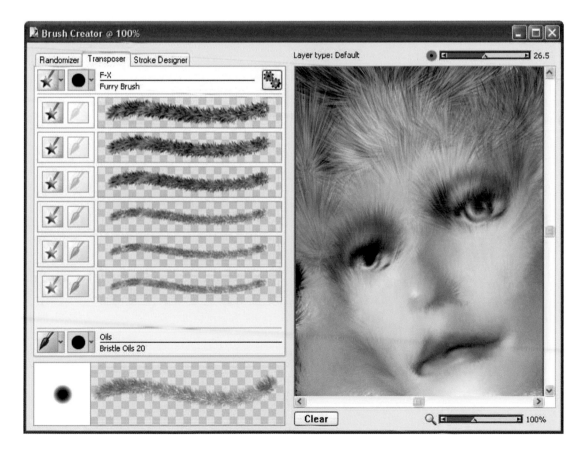

Tutorial files on the DVD

Creating a captured dab

By creating your own captured dab you can further customize favorite brushes. The dab can be made from a specially designed pattern as shown below or could be created from a photograph. Before you start this you need to be careful that you do not replace the captured variant for the default brush you are using. In theory you can click on Replace Default Variant in the Brush Selector menu and it should do what it says; however there are some brushes where this does not work and the captured dab stubbornly refuses to change. A simple way of avoiding this is included in step 6.

1. File>New to make a new empty document. 500 × 500 pixels at 200 dpi.
2. Choose a brush to make the dab; try the Real Drippy Pen variant, size 36.
3. Make some distinctive marks on the paper as in Figure 4.22; this must be on the canvas and not on a layer.

FIG 4.22 Creating a captured dab

Capture Dab	
Capture Brush Category...	
Import Brush Library...	
Load Brush Library...	
Save Variant...	
Set Default Variant	
Delete Variant...	
Copy Variant...	
Show Brush Creator	Ctrl+B
Restore Default Variant	
Restore All Default Variants	
Record Stroke	
Playback Stroke	
Auto Playback	
Save Stroke	
Strokes	▶
Use Stroke Data	

FIG 4.23 The Brush Selector palette menu

4. Select the Marquee tool and, holding down the Shift key to keep it square, make a selection of the marks.
5. Choose an existing brush variant on which you want to base the new brush dab; for this example use Acrylics>Thick Acrylic Bristle. When you choose the brush the characteristics of the original brush will be retained and only the brush dab will be changed.
6. In the Brush Selector menu select Save Variant and give it a temporary name, then select this brush to use for your trial dab captures. This will avoid the issue of losing your default setting.
7. Click the arrow on the Brush Selector to access the palette menu and select Capture Dab (Figure 4.23). Close down the file you have just created.
8. Open 'Mannequin' from the Chapter 2 folder on the DVD.
9. Make a Quick Clone.
10. Click the Clone Color option in the Colors palette.

FIG 4.24 Using a captured dab

11. Paint the picture starting with brush size 132 and gradually use smaller brushes to bring detail into the face; you will need to go right down to size 1.3 to finish the eyes and face. In Figure 4.24 you will see the distinctive marks that this brush has made.

12. To keep the variant for future use you can either keep the name you gave it or save it again with a new name and delete the trial brush.

Brush dabs can also be created from a photograph; Figure 4.25 shows a brush dab made from the mannequin photograph and Figure 4.26 the resulting picture.

1. Select the Sharp Chalk brush, change the Method and Subcategory to Cloning>Grainy Hard Cover Cloning.
2. In the Mannequin photograph make a selection of the eye, and then capture the dab as shown above.
3. Make a Quick Clone and paint the picture.

FIG 4.25 A brush dab has been created from the mannequin photograph

FIG 4.26 Cloned picture made with the captured dab

Saving brush variants

Customizing a brush for a particular use can take some time, so it is sensible to save it for future use. Painter allows you to save brushes and also to make your own brush category.

The process is very easy. When you have customized the brush and are ready to save it, open the Brush Selector palette menu and click on Save Variant. Figure 4.27 shows the dialog box.

FIG 4.27 Save Variant dialog box

Give it a name different to the original and click OK. The new variant will be saved in the same brush category as the original. In order to identify brushes that you have customized and saved, it is a good idea to prefix them with your initials, so 'Dry Brush' could become 'MA Dry Brush Diffused' as an example.

If you want to delete the variant, select the same brush and choose Delete Variant. Painter will ask you to confirm that you really want to delete the brush, if so click OK.

It is a good idea to return the original brush to its default settings when you have finished as it will retain the customizations you have made and may lead to confusion later.

Making a new brush category

It is a good idea to make a new brush category for your own saved brushes as it helps to organize them and keeps them all in one place.

To make a new brush category and add brushes to it follow the next set of instructions.

1. The first step is to create an icon which will be used for the brush category. This can be an image or text, whatever you will recognize. For this example it will be an image with a single letter. Open an image or make a new document and, using the type tool, type a single letter in capitals as in Figure 4.28. Paint some colors around the letter, then Drop all the layers.

FIG 4.28 Brush category icon

2. Make a small square selection of the area with the Rectangular marquee (hold down the Shift key to keep it square).

3. Open the Brush Selector pop-up menu and click on Capture Brush Category. A dialog box will appear and here you can type in a name for the category, click OK, and the new category will appear in the brush category list (Figure 4.29).

M	•	Martin's Brushes
		Martin's Brushes

FIG 4.29 The new brush category in the Brush Selector

4. To add a brush variant to your new category, open an existing brush in any category, make the changes to the brush variant and save the brush under a different name.

5. To move it to your own brush category, go to the Palette menu again and select Copy Variant. In the dialog box that appears, select your brush category from the drop down list and click OK. Finally, go back to the original category and delete the entry there.

Another advantage in saving all your customized brushes in a new category is that you can save a copy in case you have to reinstall the program.

FIG 5.1 Rust Panel painted with the Square Chalk brush using a paper from the Crack paper library

Paper textures

When painting traditionally, the choice of paper is critical to the success of the painting and when using Painter the choice of the right texture is just as important. The huge range of paper textures is one of the reasons that Painter is so attractive to photographers.

In this chapter we will explore the library of paper textures that come as the default set, altering the size of the texture and also the contrast and brightness, all of which will change the appearance of the finished picture.

In addition to the default paper library there are many more papers available to load into the Painter program. You can also make your own paper and this is explained later in the chapter.

Paper textures can be applied after the picture is finished based on both the paper texture and also the image itself, and in many cases this is the best way to get an overall texture such as a canvas effect.

What are paper textures?

When printing on a canvas surface in the traditional manner the surface texture can be clearly seen. Painter replicates this by printing a pattern on the paper which resembles this texture. The result is obviously not the same, but it can be very effective when viewed at the right distance.

The choice of papers is very wide and the first place to check is the Papers palette where the default range of papers is stored.

FIG 5.2 Papers palette with drop down menu listing the default papers in Painter 11. To access this menu, click the paper thumbnail highlighted

Tutorial files on the DVD

Not all brushes show the paper texture clearly.

The best ones to do so are the hard media, that is Chalk, Charcoal, Conte, etc.

The examples in this chapter are designed to work on the photograph provided. When you use your own picture you will need to adjust the brush size, opacity and grain settings as these are all dependent upon the size and density of the photograph being cloned. The key control for using paper textures is the Grain slider. Basically, the lower the setting, the more the grain is visible. The slider is often on the Properties bar, but if it is not there it can be found in the General palette or Brush Creator.

1. Open 'Sand patterns' from Chapter 5 folder on the DVD.
2. Select the Chalk>Square Chalk brush, size 35, Opacity 35%, Grain 9%.
3. In the General palette change the Method to Cloning and the Subcategory to Grainy Hard Cover Cloning. This will make a brush which shows the paper texture clearly.
4. Make a Quick Clone.
5. Try out several of the paper textures on this picture; you will soon appreciate the difference between them.

FIG 5.3 This shows an alternative way to view the papers in the palette. Click the paper icon to show the drop down menu, then click the tiny arrow (highlighted) in that menu and select Thumbnails

Paper scale

The Paper Scale slider (top slider shown in Figure 5.2) slider controls the size of the texture on the paper. This is particularly useful when different file sizes are used. Generally speaking the larger the file size, the larger the paper scale needs to be to show a significant effect. The size to suit the particular picture is of course an artistic decision. Figure 5.4 shows the Paper Scale slider at 25%, 50%, 100%, 200%, 300% and 400%.

FIG 5.4 The Paper Scale slider

Paper contrast

Changing the Paper Contrast slider (middle slider shown in Figure 5.2) increases or decreases the contrast: the higher the setting, the more pronounced the texture appears. Figure 5.5 shows the Paper Contrast slider at 0%, 25%, 50%, 100%, 200% and 400%.

FIG 5.5 The Paper Contrast slider

Paper brightness

The Paper Brightness slider controls the brightness of the paper texture. The brightness is effectively the depth of the paper grain; the shallower the grain the less texture is visible. In common with the other two controls, as the brightness level is raised the texture becomes more pronounced. At very low levels the texture is hardly visible while at 100% the picture is only just discernible and the texture itself dominates the picture. Figure 5.6 shows the Paper Brightness slider at 0%, 15%, 25%, 50%, 75% and 100%.

FIG 5.6 The Paper Brightness slider

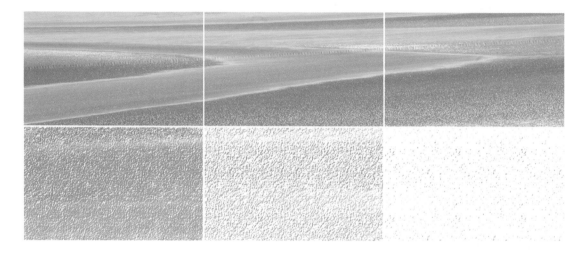

Using extra paper libraries

Painter 11 contains many extra paper texture libraries which are not automatically loaded with the program.

You will need to copy the folder containing these files and place them within the Painter program on your computer; they can be found in the Extras folder on the Painter 11 CD. These papers are not included on the DVD which accompanies this book. Once you have done this, follow the instructions below.

1. On the far right of the Papers palette, click the small right facing triangle to reveal the drop down palette menu.
2. Click on Open Library and a warning message will appear asking whether you want to Append or Load the new library, click on Load. The Choose Papers dialog box will appear as in Figure 5.7; go to the Corel Painter program files and open the Paper Textures folder.

3. Highlight the library you want to load and click Open. The selected library will appear in the Papers palette, replacing the existing default library.

FIG 5.7 Loading additional paper libraries

4. To return to the original paper library, click on Load Library again and in the Choose Papers dialog box go up one level out of the Paper Textures folder and you will see a solitary file named Painter.pap amongst the folders. Select this file and click on Open to reinstate the default paper set.

Painter does not offer an easy way to view all these papers as each paper library has to be loaded into the program before it can be viewed. On the DVD there are examples of all these paper libraries that you can view or print out for reference. The thumbnails should prove very useful to help you decide which paper to choose and therefore which library you will need to load.

Creating your own paper texture

In addition to the many paper textures supplied with Painter, paper textures can also be created from a pattern or a photograph of your own.

FIG 5.8 Photograph used for paper texture and the Capture Paper dialog box

Tutorial files on the DVD

1. Open 'Cracked paint' from Chapter 5 folder on the DVD.
2. Select>All.
3. Select Capture Paper in the Papers palette menu, type in a name for the paper in the dialog box that appears, and click OK. Close the file.
4. Your new paper texture will appear at the bottom of the Papers palette; click the name to make it ready for use.
5. Open 'Sand patterns' from Chapter 5 folder on the DVD.
6. File>Quick Clone.
7. Select the Square Chalk 35 brush from the Brush Selector. In the General palette change the Method to Cloning and the Subcategory to Grainy Hard Cover Cloning.
8. On the Properties bar set brush size 60.0, Opacity 100%, and Grain 7%.
9. Clone the picture and you will see the overlaid pattern.
10. Make a new Quick Clone from the original picture and change the Scale setting in the Papers palette to 25%.
11. Clone in the picture again and you will notice that there is a tiling effect where the pattern is repeated. You need to be aware that when you make your own patterns this will appear when the texture is used at small sizes and it can be very intrusive. These tiling effects can be reduced significantly if the original photograph from which you make the pattern has a very even texture.

FIG 5.9 The new paper texture applied to the Sand patterns photograph

In this example the whole picture was used to create the pattern but you can use just part of a photograph; in that case make a rectangular or square selection before capturing the paper.

Using paper textures for creating pictures

Tutorial files on the DVD

Having made your own texture for use with cloning, it is worth considering other ways in which this technique may be used. In the example which follows the paper texture is created from a clearly recognizable shape and the texture is stamped into a document using colored inks. The first stage is to make a black and white single tone picture which is done by using the Woodcut effect. There is more about the Woodcut effect in Chapter 13.

1. Open 'Gladioli' from Chapter 5 folder on the DVD.
2. Effects>Surface Control>Woodcut.

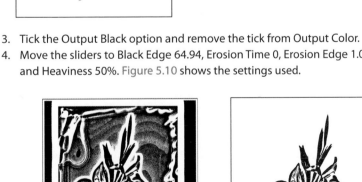

FIG 5.10 The original photograph and the Woodcut dialog box showing the settings used for this example

3. Tick the Output Black option and remove the tick from Output Color.
4. Move the sliders to Black Edge 64.94, Erosion Time 0, Erosion Edge 1.0, and Heaviness 50%. Figure 5.10 shows the settings used.

FIG 5.11 The result of the Woodcut effect being applied and after the unwanted outer area has been erased

5. When the filter has been applied the flower has a lot of black marks around the edges. Nothing is visible in the original, but this is actually the result of some not so good masking on the original! The Woodcut effect

has picked up these small variations from pure white and applied the filter to them.

6. Use the Eraser from the Toolbox at 100% Opacity to remove all the black marks which do not belong to the flower.

7. Select>All.

8. Select Capture Paper in the Papers palette menu, type in a name for the paper in the dialog box that appears, and click OK. Close the woodcut picture.

9. Your new paper texture will appear at the bottom of the Papers palette; click the name to make it ready for use.

10. Make a new document: File>New, width 2783 and height 3374 pixels at resolution 300 pixels per inch.

11. Select the Conte>Square Conte 22 brush, size 149, Opacity 12%, Grain 1%.

12. Make sure that the Gladioli Paper is active and in the Papers palette, then click the Invert Paper button (this is the icon with two arrows). Choose a color in the Colors palette. Keep the colors fairly dark – I started with R127, G9, and B141 – but it is not critical. Paint until the whole flower is visible.

13. Now paint over again with other colors; use dabbing brush strokes so that the colors blend, rather than running in lines.

FIG 5.12 After applying the color

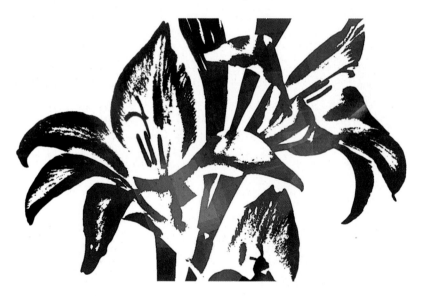

14. Texture can be added to this image to give it more depth.

15. Effects>Apply Surface Texture. Amount 200%, picture 100%, and shine 100%. In the Using box select Image Luminance.

16. Apply the texture a second time.

The picture could be left as it is, or in the case of the version in Figure 5.13 the canvas was filled with black prior to painting and lighter colors were painted onto the canvas. Textures were also applied to this picture.

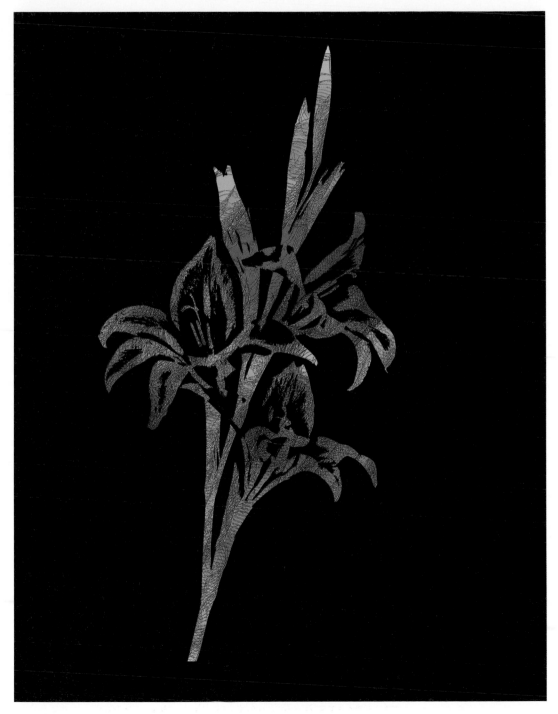

FIG 5.13 Using the paper pattern on a black background

Using paper textures for stamping

Another way to use texture shapes is to apply them like rubber stamps. This is a technique often used by card makers, but making them in Painter means not having to buy lots of individual stamps!

1. Open 'Thistle' from the Chapter 5 folder on the DVD.
2. Make a Woodcut in the same way as earlier in this chapter: Black Edge 16, Erosion Time 20, Erosion Edge 1.0 and Heaviness 50%. Erase all the black areas not required.

FIG 5.14 Thistle picture as a woodcut

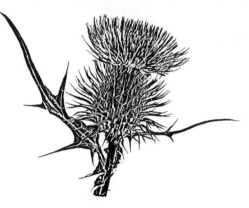

3. Select the whole picture and capture the pattern as a paper texture. Name it Thistle 1.
4. Select just the thistle head and capture the pattern. Name it Thistle 2.
5. Make a new document 3795 × 2740 300 dpi. This is quite a large document but the last stage normally involves cropping so the final picture will be smaller.
6. Select the Blunt Chalk brush, size 127, Opacity 6%, Grain 12%.
7. Make a new layer.
8. Select the Thistle 1 paper texture.

FIG 5.15 Painting with the paper texture using different colors

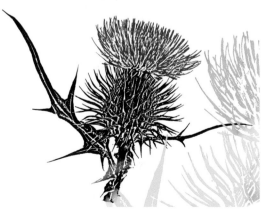

9. Select a color and paint in the design. Use dark colors and have the paper size at 100%. Use the eraser in the Toolbox to remove any unwanted areas.
10. Make a new layer.
11. Increase the paper size to 250% and select a different, lighter color and paint again. This will be larger and fainter than the previous layer; move the layer below the first layer and reduce the layer opacity.
12. Make a new layer.
13. Change to the other paper pattern, increase the size and paint again. Continue painting more layers at different opacities and colors.

The reason for painting on new layers each time is that they can be copied, moved, transformed in size and their opacities changed to get the design just right. If the thistle is not in the right place use the Transform tool from the Toolbox to move it to where it looks better. Using a large size canvas gives you the space to move the layers around.

FIG 5.16 Thistle – created by using the Thistle Captured Paper and painting with different colors

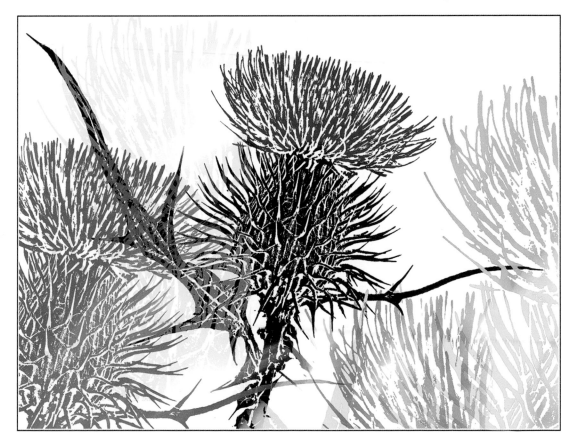

Applying surface textures

Having seen how paper textures can be applied as part of the brush strokes when painting, we now move on to applying the same textures but this time over the top of the painting and usually at the end. The textures that you can apply are not confined to paper patterns and the examples show how to apply textures based on both the clone picture and the original source image.

The choice of whether or not to apply texture to a finished picture can be a difficult one so I would recommend that you save a copy of the file and apply the texture to a duplicate version. An alternative method is to make a copy of the canvas and apply the texture to that layer; this allows you to reduce the opacity thereby lessening the effect. Experience will help you decide on the settings but it is always difficult to tell on screen so a test print is often required.

The controls for applying textures are all contained in the Apply Surface Textures dialog box, see Figure 5.17.

First decide on the source of the texture and select this in the Using box. The default is Paper and this will be explored first.

FIG 5.17 Apply Surface Texture dialog box

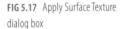

Using: Paper

1. Open 'Railing' from the Chapter 5 folder on the DVD.
2. Select the Italian Watercolor Paper in the Papers palette.
3. Open the Effects>Surface Control>Apply Surface Texture dialog box.
4. Ensure that Paper is selected in the Using box.
5. Use the default settings as shown in Figure 5.17 and click OK; this will apply the texture to this picture.
6. One important point to remember is that texture is file size dependent. This is a small file and the texture is very prominent, indeed it is far too strong for the picture, however had the file been a lot larger then the effect would be quite subtle. Undo the texture before trying the next steps.
7. Open the dialog box and while it is open go to the Papers palette and change the paper. The ability to change papers with the dialog box open is very useful; the preview will update immediately so you can assess the likely result.

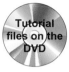
Tutorial files on the DVD

The most important slider by far is the Amount slider; this controls the strength of the applied texture. The default is 100% and I generally find this too strong; try 50% as a starter for most photographs. It is often difficult to assess the amount needed as the preview window is small, so it is usually better to make the amount fairly strong and then to go to Edit>Fade to reduce the strength. This option to fade an action is really useful to remember as it applies not only to this effect but to many actions throughout Painter, including individual brush strokes.

Another way of making textures crisper in a print is by applying sharpening to the picture. In Painter this can be done in the Effects menu. (Effects>Focus>Sharpen).

There are several other sliders in the Apply Surface Texture dialog box, but in most cases they can be left on default. The Inverted option changes the texture from positive to negative; the effect is fairly subtle in most cases.

FIG 5.18 The Amount slider at 25%, 100% and 200% (from left to right)

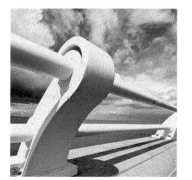

FIG 5.19 This is a clone of the original photograph, using the Soft Cloner from the Cloners brush category

FIG 5.20 Using: Paper. A texture based on the paper has been applied to the clone. In this case the Italian Watercolor Paper has been used. The Paper option applies the texture across the entire picture regardless as to whether it has been painted. This is the big difference between adding the texture at the end as opposed to applying it as you paint.

FIG 5.21 Using: Image Luminance. This option bases the texture on the luminance or brightness of the image itself. In effect, this means that you are putting an embossing effect directly upon the picture. The effect is used to add depth and texture to a picture. This is a very effective way to add more emphasis to brush strokes.

FIG 5.22 Using: Original Luminance. This option uses the original picture as the source of the texture and applies it to the clone copy. You must have the clone source active on the desktop and linked to the clone before the texture can be applied. The original and clone need not be the same picture as the texture can be taken from any open image.

FIG 5.23 Using: 3D Brush Strokes. This is the last of the four options in the Using dialog box and compares the original picture with the clone, and puts the texture on the difference between the two. This is a little difficult to imagine but it does give a very 3D effect to the brush strokes, particularly when a rough brush and textured paper have been used.

FIG 5.24 The four examples shown here clockwise from top left are: Using: Paper, 3D Brush Strokes, Original Luminance and Image Luminance. Note the differences in the hair and face of the statue.

Applying paper textures to a layer

This technique applies the textures created in Apply Surface Textures onto a separate layer rather than putting them directly on the image. The advantage in doing this is that the image remains unchanged and the texture is adjustable at any time as it is not part of the picture.

There are several ways of achieving this: a duplicate copy of the canvas can be made, and the texture applied to this. Reducing the layer opacity will lessen the effect. Any type of texture can be applied and adjusted in this way.

The alternative process shown next will involve making a new layer and applying the texture to that layer.

1. Open 'Pot' from Chapter 5 on the DVD.
2. Click the new layer icon to make a new layer.
3. In the Colors palette select 50% gray (move the RGB sliders until they read 128 for each color).
4. Edit>Fill and choose Current Color.
5. Change the Layer Composite Method to Hard Light and the gray layer will disappear.
6. Change the clone source (File>Clone Source>Pot).
7. Effects>Surface Control>Apply Surface Texture. Select Original Luminance in the Using menu and make the Amount 100%. Click OK.

FIG 5.25 The Layers palette with surface texture on a separate layer

Now that the texture is on a separate layer it can be adjusted. Reduce the layer opacity to lessen the effect. Change the Layer Composite Method to Overlay and Soft Light and see how the texture looks different each time – for more extreme changes try Multiply and Screen. Figure 5.25 shows the Layers palette with the gray layer in Hard Light Composite Method. The examples below show the result before and after applying the texture.

This technique can use the Paper, Original Luminance and 3D Brush Strokes textures but not Image Luminance, as it is being applied to a layer empty of imagery.

FIG 5.26 With and without texture on a separate layer

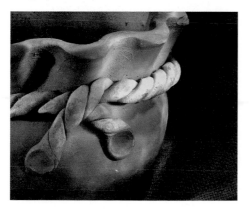

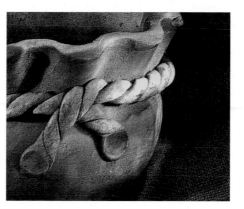

FIG 6.1 Flatworld poster

Layers and montage

Layers are an important part of Painter and they give considerable additional flexibility both in cloning and in bringing together elements from different photographs. If you are already familiar with using layers in Photoshop you will find that the Painter Layers palette looks very similar, however there are some differences which you will need to be aware of.

This chapter is in four distinct sections:

Part I takes the form of a reference section that introduces all the main functions which will enable you to follow and understand the step by step examples in the later sections.

Part 2 is a step by step example of a family history montage which involves collating and assembling images on many different layers and blending them together with various composite methods.

Part 3 explains how to use layers as part of the cloning process. This will enable you to make several different versions and merge them together to make the final picture.

Part 4 covers the subject of making montages using cloning techniques from several different original photographs.

The Layers palette

The Layers palette will be in use throughout this chapter so if the palette is not already visible on screen go to Window>Show Layers.

Open the file that is on the DVD called Multi-layer file which is shown in Figure 6.2. This file has several layers already present which you can use to follow the examples.

FIG 6.2 The Layers palette

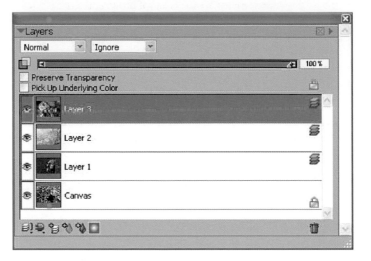

Layers can be thought of as clear sheets of acetate stacked on top of the Canvas. The layer stack is being viewed from the top so that when the top layer is full of imagery none of the layers beneath are visible.

Active layer

Click on any layer and it becomes the active layer, which means that it can be edited, moved or painted on. Normally only one layer can be active at any one time and the active layer is colored dark blue.

Layer visibility

Click the eye icon to the left of the top layer; this will turn the visibility of the layer off and reveal the layer below. Continue to turn off the eye icon of each of the layers until you reach the Canvas layer at the bottom of the stack. When a layer has its visibility turned off it does not contribute to the picture, and if the picture is printed the layer would be ignored.

Canvas

The Canvas is always at the bottom of the stack and is similar, though not identical, to the background in other graphics programs. This layer cannot be moved or have layer masks applied, and is restricted in some other ways.

Making new layers

New layers can be made either by going to Layers>New Layer and selecting the type of layer required, or by clicking the third icon from the left at the bottom of the Layers palette.

There are several types of layers, all of which have their own special characteristics. To make a new standard layer, click the third icon from the left. Standard layers can be painted on with most types of brush and are the ones that are mainly used for cloning.

The second icon will make a Dynamic Plug-in layer, which is a special effects layer that will make adjustments to the layer beneath. They are a bit like adjustment layers in Photoshop as the settings can be changed at a later date; this type of layer is described in Chapter 11.

The fourth icon from the left, which has the blue droplet design, makes a new Watercolor layer; these are described in Chapter 7 and can only be used with Watercolor brushes.

The fifth icon from the left makes a new Liquid Ink layer, which may only be used for Liquid Ink brushes.

Renaming a layer

When you create several layers in a document it is often helpful to rename them to aid in identification.

To rename an existing layer, open the palette menu and click on Layer Attributes and type the name there. You can also double-click on the layer to bring up this dialog box.

Deleting layers

Layers that are active can be deleted by clicking on the Trash can on the far right of the layer icons. This will immediately delete the currently active layer – there is no warning given, so be careful!

Merging and flattening layers

Generally I recommend that you keep the layers intact rather than flattening the picture. However if you do need to, click the icon on the far left and select Drop. This will merge the active layer with the Canvas. If you need to flatten all the layers go to either the palette menu and select Drop All or to Layers>Drop All. When you need to merge the visible layers, hold down the Shift key and click on the layers you want to merge, then, in the Layers palette menu, click on Collapse.

Layer compatibility

When moving image files from Photoshop to Painter and vice versa, most of the elements stay intact including the layers, layer masks and selections. However, there are some special elements that do not work in the same way of which you need to be aware. A table showing Painter/Photoshop compatibility is contained in Chapter 1.

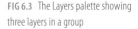

FIG 6.3 The Layers palette showing three layers in a group

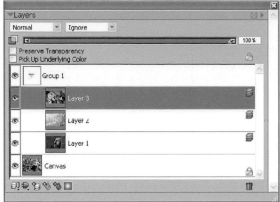

Grouping layers

It is sometimes convenient to store layers in groups; this is rather like keeping them in folders. Hold down the Shift key and click on the layers you want to group together, then click the first icon at the bottom of the Layers palette and select Group. These commands are also available from the Layers menu and the palette menu. Open and close the group by clicking on the Group layer in the Layers palette. To ungroup the layers, highlight the layer group and click on Ungroup in the same place as before.

The Collapse command will merge all the layers that are highlighted within the group. In Figure 6.3, Group 1 contains three layers and they are offset in the layer stack to show that they are contained in a group.

Layer masks

Layer masks work very much like their counterparts in Photoshop. By painting into the mask with black the contents of the layer are hidden. If you have not used masks before you may want to try the short step by step example below.

1. Open 'Multi-layer File' from Chapter 6 on the DVD.
2. Click the top layer to make it the active layer.
3. Make a layer mask by clicking on the layer mask icon at the bottom of the Layers palette. This is the sixth icon from the left.

FIG 6.4 Using a layer mask on layer 1. The result is shown on the right

4. Click on the layer mask itself to make it active – the mask thumbnail will have a black line around it. You must do this or you will be painting on the image itself rather than the mask.
5. Select the Pencils>Grainy Cover Pencil 3 with a size of about 65.0 and Opacity 100%. In the Colors palette make the painting color black.
6. Paint with the brush in the picture area – you will see the face disappearing and the layer below being revealed. The painted layer mask and the resulting picture can be seen in Figure 6.4.
7. Reduce the brush opacity to 25% and paint again. Note that these strokes have only partially hidden the top layer – black hides the picture but shades of gray only partially hide the layers below.
8. Change the painting color to white and paint over the masked area; this will reveal the original picture again.

To delete a layer mask, click on the layer mask to activate it then click on the Trash can which will delete the mask and leave the original layer intact.

Duplicating layers

To duplicate a layer go to Layers>Duplicate Layer or you can right-click the layer and select duplicate from the pop up menu.

The procedure to make a duplicate copy of the Canvas layer is different and is shown below.

1. Make the Canvas active.
2. Select All (Ctrl+A).
3. Edit>Copy (Ctrl+C).
4. Edit>Paste in Place (Ctrl+V).

This will make a copy of the Canvas on a new layer at the top of the layer stack leaving the Canvas layer intact.

If the copy and paste does not work, there are other ways of doing this:

Copying the canvas:

1. Select>All.
2. Make the Layer Adjuster tool active.
3. Hold down the Alt/Opt key and click in the picture.

Copying between two documents:

1. Select>All.
2. Make the Layer Adjuster tool active.
3. Click in the source document and drag into the destination document.

Locking a layer

To lock a layer, click on the layer then depress the Padlock symbol just above the layer stack. Locking is useful to prevent accidental erasure or painting on the wrong layer. Click the padlock icon again to unlock.

Preserve Transparency

This option is used to protect areas of a layer that has no imagery and is often used to paint over objects on that layer without affecting the surrounding empty space.

To see how this works, make a new empty layer (Layers>New Layer) and select the Pencils>Grainy Cover Pencil 3 with a size of about 35% and Opacity 100%. Paint into the picture with any color but leave plenty of blank areas. Tick the Preserve Transparency box and change the paint color. Paint across the whole layer and you will see that the paint has only recorded in the areas that already have some imagery while the areas that were transparent have been preserved untouched, hence the name. Now turn off the Preserve Transparency option and paint again. This time the paint is laid down wherever the brush is used.

Layer opacity

The slider near the top of the Layers palette controls the layer opacity – move the slider to the left to gradually reveal the layer beneath. With multi- layer images it is very useful to be able to fine-tune the opacity of each layer with this slider.

Figure 6.5 shows the slider at 50% opacity.

FIG 6.5 The Layer Opacity slider

Layer Composite Depth

The box to the right of the layer blend mode is the Layer Composite Depth control. The default here is Ignore. This set of options is active when

using brushes that have Impasto strokes which show depth and a three-dimensional appearance. To try the effect now, use the Impasto>Thick Wet Round 20 brush with a brush size of about 40. Select a bright red color and paint into the picture; you will see how shadows have been added to the paint strokes which give them a three-dimensional appearance. The Layer Composite Depth option will have changed automatically to Add when you used this brush; change it to Ignore and see the brush strokes flatten. Figure 6.6 shows the Impasto effect on the brush stroke shown on the left. The example on the right has had the effect removed.

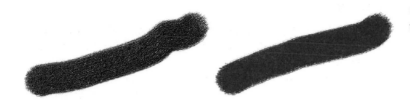

FIG 6.6 This shows the result when the Layer Composite Depth is changed

Layer Composite Method

The Layer Composite Method controls how a layer will interact with the layer beneath and offers a lot of creative opportunities when using multi-layer files. The Layer Composite Method box is at the top of the Layers palette and Is highlighted in Figure 6.7 where it is shown in the Normal mode.

FIG 6.7 The Layer Composite Method drop down menu is shown highlighted in red and the Layer Composite Depth is highlighted in green

The examples illustrate how the Layer Composite Methods will combine layers with different images on each layer. This is extremely useful when making montages as it allows you to mix image layers in ways that are not possible by any other method. Often this can spark off new directions in which to develop your image.

The examples on the following pages will provide an insight into how each composite method works. The effect of the composite method will differ considerably depending upon the content of the two layers that are combined. The opacity setting will also change the appearance.

The two images are on the DVD in the Chapter 6 folder so you can experiment with these, or try your own pictures.

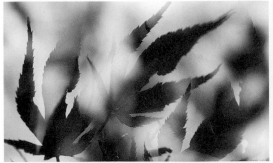

Original (underneath)

Original (on top)

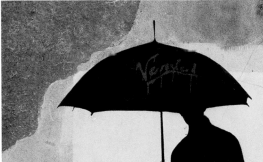

Default

Gell

Cororize

Reverse-Out

Shadow Map

Magic Combine

Pseudocolor

Normal

Dissolve (at 50% opacity)

Multiply

Screen

Overlay

Soft Light

Hard Light

Darken

Lighten

Difference

Hue

Saturation

Color

Luminosity

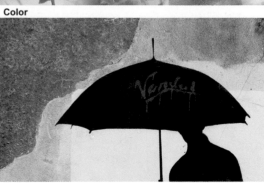

Gell Cover

Family history montage

In recent years there has been an explosion of interest in genealogy and alongside this a desire to collect and display old photographs in imaginative ways; this includes both scrapbooking and creating montages on the computer.

Painter is an ideal tool for this as it allows both the collation of the pictures, together with the ability to add some artistic embellishment yet leaving the originals intact for future generations.

In this step by step example the montage is made using various aspects of layers, including layer masks, layer blending modes and color adjustments.

All the files necessary for this are on the DVD; when you create your own montage the material will vary but the techniques described here should provide you with lots of ideas on how to combine images.

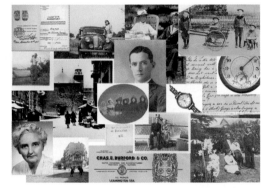

FIG 6.8 Assembling the source material

The first step is to collect together all the material which you may need. This could include photographs, letters, materials and personal effects which may need to be scanned using a flat bed scanner or photographed. In this case of course I have already made the selection for you.

The next step is to work out a rough plan of the design. It can be tempting to throw things together as you go, but it really helps a lot if you have a plan to start with. The plan does not need to be very detailed, and will almost certainly change as you develop your ideas. When you make your own picture, decide on the most important elements which are relevant to the person or family and concentrate on fitting those together – other less important elements can be added in later. There is a tendency to put too much in, so if you have a lot of good pictures it is often better to make a series of pictures, each illustrating a particular aspect. For an example of how this can be achieved, look at my personal website (www.martinanddoreen.co.uk) where my wife has created a series of panels illustrating her own family history. These were made in Photoshop several years ago, but could have been made in Painter.

This tutorial uses copy and paste extensively; however, should the process not work correctly, please read the sidebar note earlier in this chapter (Duplicating layers), which gives alternative ways of copying from one document to another

Open all the pictures in a browser. I used Bridge but any browser will do; alternatively you could use the originals and lay them out on the floor. Having selected the ones which are the most important to the story, sketch out a quick layout on a piece of paper – this will help with the overall design. For this project I opened a blank document in Photoshop and dragged the pictures in and moved them to roughly the correct position – some I resized to fit. After moving things around quite a bit, this gave me a reasonable idea of how the picture might look. The result is on the DVD as 'Rough plan'. I printed a copy of this to act as a guide, but you have the finished version to use – as you will see, I made lots of adjustments as I built the picture, but the contents and overall design are very similar.

FIG 6.9 Rough plan

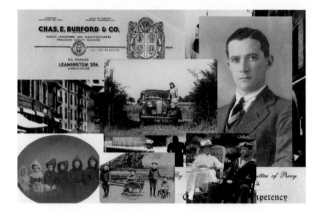

1. Open the folder entitled 'Family History montage' from the DVD and move all the files on to your computer for easy access.
2. Create a new document in Painter – width 27.7 cm, height 21.0 cm and Resolution 150 dpi. Give it a name and save it.
3. Open '01 geneva'.
4. Select>All, Edit>Copy.
5. Click back into the new empty document and Edit>Paste to drop in the picture, then move into position. Close down the 'Geneva' file.
6. You may get a warning (Figure 6.10) regarding whether to commit the layer; if you do, click on Commit to remove this.
7. Reduce the layer opacity to 37%.
8. Open '02 children'.
9. Select>All, Edit>Copy and then paste into your montage document and move into position as previously.
10. The white border needs to be removed so use the Magic Wand in the Toolbox. On the Properties bar change the Tolerance to 47 and click in the white area. This will select the white and Edit>Cut will delete it.
11. This picture is too large so use the Transform tool from the Toolbox to reduce to the size you can see in the finished picture.

FIG 6.10 Commit dialog box

The Transform tool is new in Painter 11 and is hidden behind the Layer Adjuster tool. Hold down the Shift key and click and drag the corner handles to change the size. Holding the Shift key stops the picture from distorting. Click the tick on the Properties bar to accept the transformation. Other options for scaling and distorting are also on the Properties bar.

12. Activate the Layer Adjuster tool and move the picture down to the bottom.

13. Change the Layer Opacity Method to Hard Light. Using this method removes a lot of density from the layer. It has however revealed a black line in the snow on the Geneva layer. Remove this by clicking the eye icon off in the Children layer and clicking in the Geneva layer to activate. (Figure 6.11).

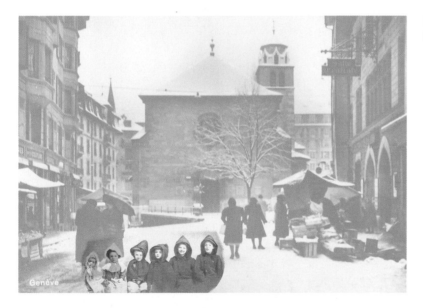

FIG 6.11 Bringing in the Children layer

14. Use the Rubber Stamp tool from the Toolbox, click in the snow just above the mark to set the source point and clone until the mark has disappeared.

15. Returning to the Children layer, make a layer mask by clicking the icon at the bottom of the Layers palette; this is the sixth icon from the left.

16. Click in the layer mask thumbnail to activate it. Be very sure that you do this every time you make a layer mask otherwise you will find yourself painting into the layer by mistake. (It is very easy to do this!)

17. You now need to paint in the layer mask and to do so you need a soft light brush. Sadly there does not seem to be one as a default variant in Painter, but it is easy to make one. Select the Cloners>Soft Cloner brush and set it back to default settings. In the General palette change the

Method to Cover and the Subcategory to Soft Cover. Make the Opacity 20% and the size 78 – this will be ideal. Because it is such a useful brush for masks, and because you will often use the Soft Cloner for other purposes, I suggest that you save this variant with the name 'Layer Mask brush'. See Chapter 4 if you do not know how to save brush variants.

18. Use the new brush you just created and select black in the Colors palette. Paint in the image (with the layer mask active you will actually be hiding parts of the layer) and paint over the top and sides of the layer leaving only the children visible.

19. It is a good idea to label the layers as you go, as this will make it easier later to make the final adjustments. Do that now by double-clicking the layer in the Layers palette and naming the layer. Don't forget to save the document frequently!

20. Open '03 Charles'.

21. Copy and paste as before, move into position, and resize if necessary.

22. Make a layer mask and paint out the edges to make a rough oval. All the masks created will be adjusted later, so there is no need to be too precise at this stage (Figure 6.12).

FIG 6.12 Charles layer after masking

23. Open '10 watch'.

24. Copy and paste as before, move into position, and resize if necessary.

25. Remove the white areas with the Magic Wand as before.

26. Position the layer so that his head is enclosed within the inner part of the watch face.

27. Change the Layer Composite Method to Hard Light and reduce the layer opacity to 47%.

FIG 6.13 The Watch layer

28. Make a layer mask and with the new masking brush, paint out the center of the watch to make the face clear (Figure 6.13).
29. Open '05 Headed notepaper'.
30. Copy and paste as before, move into position, and resize if necessary.
31. Change the Layer Composite Method to Hard Light and reduce the layer opacity to 47%.
32. Create a layer mask and paint along the bottom and right edge to make a soft edge.
33. Open '04 rickshaw'.
34. Copy and paste as before, move into position, and resize if necessary.
35. Change the layer opacity to 85%.

FIG 6.14 Old Car layer after masking

36. Create a layer mask and paint out most of the top and right and also the bottom to reveal the word 'Geneve' if that is hidden.
37. Open '06 old car'.
38. Copy and paste as before, move into position, and resize if necessary.
39. Change the Layer Composite Method to Hard Light and reduce the layer opacity to 79%.
40. Move the layer until it is positioned just over the six children. Create a layer mask and paint out the area around the top and sides of the car. Soften the lower edge to keep it clear of the children (Figure 6.14).
41. Open '08 Charles & mum'.
42. Copy and paste as before, move into position, and resize if necessary.
43. Change the Layer Composite Method to Luminosity and reduce the layer opacity to 67%.
44. Create a layer mask and paint out the space to the top and left of the Figure to soften the edges.
45. Open '11 certificate'.
46. Copy and paste as before, move into position, and resize if necessary.
47. Change the Layer Composite Method to Darken and reduce the layer opacity to 58%.
48. Create a layer mask and paint out the crest on the left.
49. Open '12 Agnes'.
50. Copy and paste as before, move into position, and resize if necessary.
51. Adjust the layer opacity to 66%
52. Open '09 letter'.
53. Copy and paste as before, move into position, and resize if necessary.
54. Change the Layer Composite Method to Darken.

FIG 6.15 Letter and Agnes layers

55. Resize it to the size you see in the finished file.
56. Create a layer mask and paint out the edges, and also where the letter overlaps the face. Paint lightly over most of the layer to lighten the overall appearance of the text. It should be visible, but not obtrusive (Figure 6.15).
57. Reduce the layer opacity to 75%.
58. Open '13 medallion'.
59. Copy and paste as before, move into position, and resize if necessary.
60. Change the Layer Composite Method to Lighten and adjust the layer opacity to 66%
61. Create a layer mask and paint out the center of the layer.
62. Because these pictures have come from different sources and have different colors, it is usually better to harmonize the colors by adding a color layer.
63. Create a new layer.

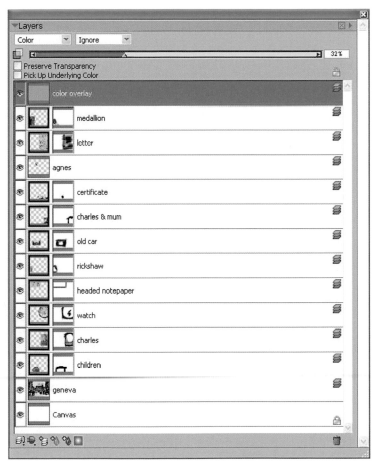

FIG 6.16 Final Layers palette

64. Choose a color in the Colors palette; it should be as close as possible to the sepia color present in the main picture. I used Red 205, Green 161 and Blue 87; this color can be accurately selected by moving the sliders in the Colors palette.

65. Edit>Fill with Current Color.

66. Change the Layer Composite Method to Colorize and adjust the layer opacity to 32%; this will reduce the level of the color to a light overlay.

67. Finally, it is time to step back and review the picture and then to adjust the opacities, size and position of the many layers and make any adjustments you feel are necessary. One example of this fine-tuning is that the layer for Agnes has a building showing from a lower layer in the stack. This spoils the portrait, so to correct this create a new layer beneath the Agnes layer and then paint on this layer with white until the portrait is clear.

That completes this example of a family history montage. You may well like to try one of your own – I am sure that your relatives would be very pleased to have a copy.

FIG 6.17 Final montage

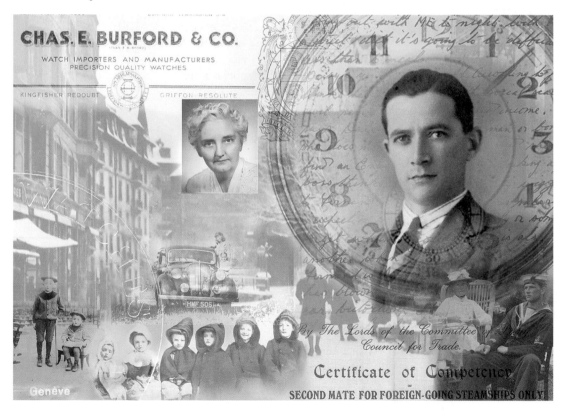

Cloning onto layers

In this step by step example the clone source is a single photograph which is cloned onto several layers using different brushes, and the layers are then blended or adjusted to create the final picture. This technique is often more flexible than using different brushes on the canvas as the layers can more easily be changed at a later stage.

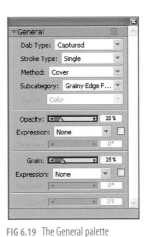

FIG 6.18 Original photograph

1. Open 'Wooden Statue' from Chapter 6 folder on the DVD.
2. Make a Quick Clone.
3. Select the Markers>Flat Rendering Marker, size 43.9, Opacity 20%.
4. In the General palette change the Method to Cover and the Subcategory to Grainy Edge Flat Cover (Figure 6.19). The brush strokes made by the default brush will build to black very quickly but by changing to Cover Method this will not happen. It is worth remembering this option as this build up to black happens with brushes in several brush categories.
5. Click the Clone Color icon in the Colors palette.
6. Clone outwards from the statue making long strokes moving out and up. Paint the entire picture quite quickly. The statue will be very broken up and the outer areas will streak out from the center. (Figure 6.20)
7. Create a new layer.
8. Change to the Cloners>Colored Pencil Cloner, size 56.6, Opacity 39%.

FIG 6.19 The General palette

FIG 6.20 Background

9. Click the Clone Color icon in the Colors palette.
10. Paint over the background area to soften some of the marks made by the previous brush. Don't paint all over, just enough to take off some of the very hard edges (Figure 6.21).

FIG 6.21 Softening the background

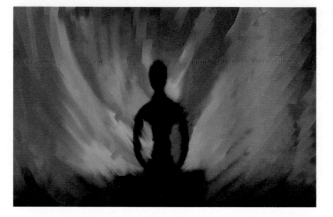

11. Create a new layer.
12. Change to the Palette Knives>Loaded Palette Knife, size 55.9, Opacity 100%.
13. Click the Clone Color icon in the Colors palette.
14. Drag the Palette Knife out from the statue towards the edge; this will create a striking graphic effect which highlights the statue (Figure 6.22).

FIG 6.22 Adding emphasis to the statue

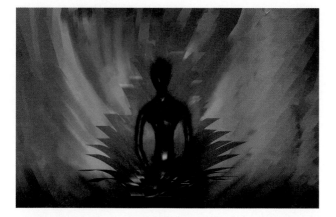

15. Paint over the figure with a smaller brush size to make the shape and the light reflections better defined.
16. This is quite striking but the effect needs strengthening, so two additional copies of this layer are to be created and the contents enlarged.
17. Make sure the Palette Knife layer is active then right-click the layer and select Duplicate layer.

18. Click and drag the layer underneath the Palette Knife layer.
19. Use the new Transform tool introduced in Painter 11, this is top right in the Toolbox and hidden behind the Layer Adjuster tool (Figure 6.23).
20. When you have the tool active go to the Properties bar at the top of the screen and select the Scale symbol (Figure 6.23).

FIG 6.23 The Transform tool and the Transform Properties panel

21. Pull the handles at the top to the size shown on Figure 6.24.
22. Accept the transform by clicking the tick on the Properties bar.
23. Change the Layer Composite Method to Overlay and the layer opacity to 58%. This will make it less obvious but it will add to the design.

FIG 6.24 Making the first transform

24. Duplicate the layer you have just transformed and drag it underneath.
25. Use the Transform tool again and drag out the handle further than previously (see Figure 6.25).
26. Change the Layer Composite Method to Screen and the layer opacity to 36%.

FIG 6.25 Making the second transform

FIG 6.26 The final Layers palette

FIG 6.27 Final picture

27. The background is rather unbalanced, with warmer tones and better shapes on the left side, so the next step is to correct this.
28. Click on the Canvas and using the Rectangular selection tool from the Toolbox select the right half of the picture.
29. Edit>Copy and Edit Paste. This will copy the selection and place it in a new layer at the top of the layer stack.
30. Move the new layer down until it is just over the Canvas.
31. Edit>Flip Horizontal.
32. Use the Layer Adjuster tool to move it across to the right-hand side.
33. As this is under the other layers it blends in fairly well; the only sign of the join is at the top where, if you look carefully, a straight line can be seen.
34. To remove this line, create a layer mask (Layers>Create Layer Mask), click on the mask to activate and then, using the same Palette Knife, paint over the join.
35. Crop the sides and bottom to finish the picture.

Figure 6.26 shows the final Layers palette.

Cloning from three images

Try to visualize what you want to achieve before you start making a clone montage. These three elements were carefully selected to work together; the overall subject is trees, but using three very different scales will add a sense of mystery to the final picture.

The holes in the old leaf are particularly interesting, and the way this hole punches through the more realistic landscapes will also emphasize the sense of unreality.

1. File>Open>Leaf from Chapter 6 folder on the DVD.
2. File>Open>Tree from Chapter 6 folder on the DVD.
3. File>Open>Sky from Chapter 6 folder on the DVD.

FIG 6.28 Leaf original

4. File>Clone with the Leaf as the active document. This will make a clone copy of the Leaf picture without clearing the picture.
5. Change the clone source to the Tree picture (File>Clone Source>Tree).
6. Choose the Graffiti brush from the Airbrush brush category. In the Colors palette click the Clone icon and make the brush size 190.0 and the Opacity 61%.

FIG 6.29 Tree original

189

7. Paint over the Leaf picture; the graffiti brush will spray dots that will give the picture an attractive texture. Emphasize the lines of the tree trunk and branches as seen in Figure 6.31.

8. Change the clone source to the Sky picture (File>Clone Source>Sky).

FIG 6.30 Sky original

9. Change the brush to Airbrush>Fine Tip Soft Air 50, brush size 150.0 and Opacity 4%. In the General palette change the Method to Cloning and the Subcategory to Grainy Soft Cover Cloning. Paint in the sky and tree giving it a dreamlike quality by cloning in some areas but not in others.

10. In the previous step it is difficult to get exactly the right amount of blue; it can also result in the texture being too smooth. If this is the case, change back to the Leaf picture as your clone source and return to the Graffiti brush used earlier. Brush over with this to get the right balance between the three images.

FIG 6.31 Using the Graffiti brush in step 7

11. Continue to swap between the three original pictures by using the Clone Source option until the picture is to your satisfaction.
12. Finally, you will need to crop the picture as the originals are not exactly the same size – you can see this by the line down the right side of the picture.
13. Select the Crop tool in the Toolbox, click in the top left corner and dragging down to the bottom right include the entire picture you want to keep. Adjust the edges by dragging them to the desired position and click in the picture to crop.

The final picture (Figure 6.32) has been cropped at the top and right quite substantially, which has strengthened the balance of the picture.

In this example we used three separate images from which to clone. It is also possible to clone from a multi-layered image so these three pictures could have been in a single document.

The way to change the clone source in this case is to make the original picture the active document and to turn the layers on and off. Whatever is visible on the screen is what you will be cloning. This also works when a layer is only partially visible.

FIG 6.32 Tree and leaf montage

Tutorial files on the DVD

▼Text

Papyrus

27.3

-0.010

100%

Curve Style:

0%

Composite Method: Default

100%

0.0

0°

☐ Directional...

FIG 6.33 The Text palette

This tutorial uses Copy and Paste extensively; however, should the process not work correctly, please read the sidebar note earlier in this chapter (Duplicating layers) which gives alternative ways of copying from one document to another

FIG 6.34 Using the Shape Selector to distort the text

Designing a poster

This step by step example will demonstrate how Painter can be used as a graphic tool to create a poster. The project explains how Painter handles text and some of the many ways in which it can be manipulated to get the required effect.

Before starting work on any design, sketch out some ideas of what you might include and plan the design. This will save a lot of time. I have made a rough plan of the required text and identified some pictures which I think might work.

1. File>New. Enter width: 1240 pixels, length: 1750 pixels and resolution: 150 dpi.
2. Open 'World' from Chapter 6 folder on the DVD. All the pictures are in the folder named Poster.
3. Copy the picture (Select>All, Edit>Copy) then change to the main document and paste the picture in. (Edit>Paste).
4. The picture is too small so click on the Transform tool in the Toolbox, hold down the Shift key and drag a corner handle out until it is approximately the size that you can see in Figure 6.35. Accept the transformation by clicking the tick on the Properties bar.
5. Select a suitable font which you have on your computer and type in capitals 'DISCOVER THE WORLD IN MUSIC' across the top of the document.
6. Window>Text will bring the Text palette on screen (Figure 6.33).
7. Click the second icon of the Curve Style icons. This will bend the text; try the other options to see how they too change the text.
8. Click the Shape Selector in the Toolbox and you will see a blue line protruding from the text. Click on the end and move it to see the text moving and changing shape. Look carefully and you will see a blue line under the text and a dot at each end. Click on the other end to activate that control; these two control points can be moved to reshape the text. The ends can be pulled out to change the shapes further. The control points are circled in red in Figure 6.34. If you have not used shapes previously, it can take a while to understand how they work. The object is to make the text into a semicircle, but if you find this very difficult just skip this step.

DISCOVER THE WORLD

9. Use the Type tool again and type FLATWORLD across the centre of the world picture. Adjust the size using the slider in the Text palette and click

the External Shadow icon at the top of the palette to make it bolder. Click on the previous Type layer and do the same for that. At this point reduce the layer opacity of the world picture to 50%. Figure 6.35 shows the poster at this point.

FIG 6.35 The poster at step 9

10. Open 'The Band' from Chapter 6 folder on the DVD.
11. Copy and paste it into the poster document.
12. Use the Transform tool and reduce the size to that seen in the finished poster, on page 166.

FIG 6.36 The poster at step 13

13. Add another piece of text, at the bottom of the poster. Use type size 23, type 'Roots 'n' groove from Eastern Europe and beyond'
14. Open 'World outline' from Chapter 6 folder on the DVD.

15. Copy and paste the picture into the main document and move the layer beneath the FLATWORLD Text layer.
16. Stretch the layer across the page; use the Transform tool as before. Pull the right and left handles to stretch the image, and the top and bottom handles to squash the image. Reduce the layer opacity to 65%.
17. Now to bring in the individual photos of the band members. Name all the layers as you bring them in. (Double-click the layer to rename).
18. Open 'Georgina', and copy and paste it into the main document.
19. Reduce the Opacity to about 50% and drag to the lower right.
20. Open 'Tim' and place on the left.
21. Open 'Kimberly' and place top left.
22. Open 'Vo' and place top right.
23. Open 'Neil' and place in the center. Reduce the size of the picture to fit.
24. Open 'Eric' and place lower center.
25. When you reduce the Opacity of these layers to 50% you can see that the design is starting to come together. Leaving the layers at reduced opacity helps a lot in deciding where each element should go. Figure 6.37 shows the poster and Layers palette at this stage.

FIG 6.37 The poster with all the photographs roughly in place, with the Layers palette at that stage

26. The next stage uses layer masks to blend the various elements.
27. Select the Chalk>Square Chalk brush, return to default settings and use brush size 83.3 and Opacity 45%. Select black in the Colors palette.
28. Click on the layer named Neil to activate it, increase the layer to 100% opacity, and then click on the layer mask icon at the bottom of the Layers palette.
29. Click the layer mask to activate it and paint out the edges of the picture. The Chalk brush leaves an attractive edge; paint in from the edges so that the edges blend. If you paint out too much, change to white and paint again; this will remove the masked area. The advantage with using layer masks is that they can be adjusted as often as necessary until the poster is complete.
30. Now for the Vo layer. Increase the opacity, create a layer mask and paint out unwanted imagery. To check where you need to paint, turn the layer visibility off and on again.
31. Continue with the other layers and when you have finished, reduce the opacities of the band members to around 80%. Remember to click on the layer mask each time – it is easy to forget this and paint on the picture instead.
32. The round map is currently hidden so move the layer up the layer stack until it is sitting under Neil. Change the layer opacity to 37%.
33. The layers look a little dull, so open the Underpainting palette and increase both the contrast and brightness for each layer.

FIG 6.38 Highlighting the text at the bottom

34. The text at the bottom of the picture needs highlighting, so create a new layer under the layer and use the Chalk brush to paint with white behind the text; leave the edges rough. Reduce the layer opacity to 87%.
35. Right-click the text layer 'Discover the world...' and select Commit – this will prevent the text from being editable but also allow the layer opacity to be changed. Reduce it to 50%.
36. Continue to adjust the layer opacities and position until you have finished the picture.

The final poster is shown at the start of this chapter.

FIG 7.1 This abstract was painted with the Sponge Dense and Acrylics Dry Bristle brushes

Using color

Photographers who use Painter primarily take the color from the original photograph, however there are times when we need to add or adjust the colors and this chapter addresses those occasions.

The chapter starts by describing the various palettes in Painter from which color is available; these include the excellent Mixer and Color Sets as well as the frequently used Colors palette, now updated in Painter 11.

It is also often necessary to adjust the tonality of the picture. This is an important part of the final stages of finishing a picture, but is also frequently used to prepare the photograph prior to cloning. The controls look complicated initially so there is plenty of guidance in this chapter on how best to use them.

There are also occasions when a picture needs to lose the original color and have a tone applied, and there are several ways in which this can be done.

Hand tinting has been popular since the early days of photography before color photography was introduced, and I have included some ideas on how this effect can be achieved.

Choosing colors

The Colors palette

The Colors palette is shown in Figure 7.2. If this palette is not visible on the screen, go to Window>Color Palettes>Colors. Open any photograph in Painter to enable you to work through these examples.

This is the chief color picker for general use in Painter and colors are selected by clicking in the outer ring to select the hue and then in the inner triangle to choose the saturation and value. Within the color triangle the pure colors are on the right-hand side, and as the cursor is moved to the left the colors are mixed with either black (down) or white (up). In Painter 11 the Mixer palette has become resizable, which makes it easier to select precise colors.

FIG 7.2 The Colors palette with the RGB sliders shown on the left and the HSV sliders on the right

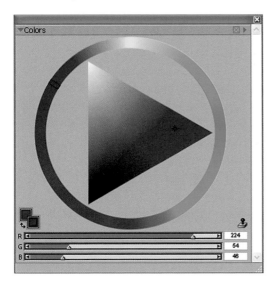 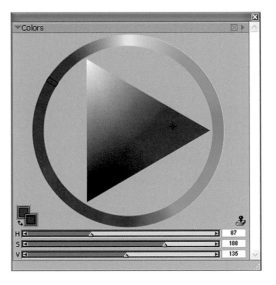

The Colors palette has much improved in Painter 11. The addition of the RGB and HSV sliders is a great help, as is the ability to enlarge the palette to make choosing colors easier.

It is also now possible to make small adjustments by pressing the arrow keys on the keyboard, this will move the color palette cursor by precise amounts.

The three sliders below the color wheel show the RGB values of the color chosen; this information is very useful in cases where you need to use the same color again. Go to the Toolbox and make the Eyedropper tool active, then click in a picture and the exact color breakdown will show in both the color wheel and in the sliders. This is often used when you need to enhance a color in your picture: click to identify the color you need, and then move the color wheel cursor to a stronger color and paint into your picture.

The display shows the RGB values by default but this can be changed. Click on the palette menu (small triangle top right in the palette) and select the HSV option.

The two small color squares on the left show the Main and Additional colors. The Main color is the one that is used for painting and is the one in front.

The square behind is the Additional color and is used for some special brushes that paint with two colors. It is not the same as the Background color in some other graphics programs.

The rubber stamp icon is, of course, the Clone Color option, which we have used many times throughout this book, and which makes the brush pick the color from the clone source instead of the Colors palette. When the Clone Color is selected the colors in the palette are muted; this only operates when you have a clone copy currently active.

Color sets

Color sets, another way of picking colors and, like the other palettes, are displayed via Window>Color Palettes>Color Sets. Figure 7.3 shows the Color Sets palette.

It can be an advantage to choose a color from the Color Sets palette as specific color shades may be more readily identifiable from the individual squares rather than from a continuous color range. To select a color, click on the square and the brush will paint with that color.

FIG 7.3 The Color Sets palette

FIG 7.4 The Color Sets palette menu

The palette menu shown in Figure 7.4 contains options for customizing the display. The first block of options is for creating new color sets from a variety of sources.

New Empty Color Set is for when you want to individually pick a range of colors and store them for future use. This could be useful if you are designing a layout or color scheme and want to keep all the used colors together. Click the New Empty Color Set option in the menu to make an empty set. Use the Eyedropper to add colors, click on a color in the active image, and then click the Color Set icon with the + symbol. Click the Color Set icon with the − symbol to remove a color.

New Color Set from Image creates a color set from the image currently active on the desktop. You could use this to restrict the number of colors in a new

image to those of an existing one. The New Color Sets from Layer or Selection work in the same way but take the colors from the active layer or the active selection.

New Color Set from Mixer Pad takes the colors from the Mixer, which will be covered later in this chapter.

The default color set is only one of many sets available and Open Color Set will replace the current set with a different one. The extra color sets are loaded with the Painter program, and when the Open box appears it will normally take you straight to the relevant folder from where you can choose the new color set. If this does not happen you will need to navigate to the Corel Painter program files and go to the Color Sets folder which is within the Support folder. The default set is called Painter Colors.colors.

There is large selection to choose from, about 50 in all, and Figure 7.5 shows a selection.

Append Color Set will add the new color set without deleting the existing one.

Save Color Set will save sets that you have created.

The other options are all self-explanatory. I will just mention the Swatch Size option, which will show the swatches at various sizes. I find it very useful to enlarge them as the colors can be seen more easily.

FIG 7.5 Some additional color sets

Mixer

When the Mixer was first introduced in Painter it was a huge advance in recreating traditional techniques – it works like an artist's palette where paints can be mixed together to blend colors. Figure 7.6 shows the current Painter Mixer palette which, from Painter 11, is resizable to make it easier to select colors.

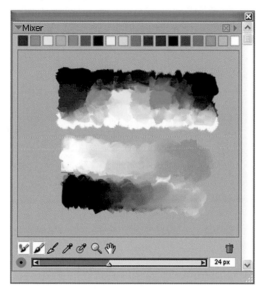

FIG 7.6 The Mixer palette

FIG 7.7 The Mixer palette menu

Click on the second brush icon and select a color from the selection at the top of the palette, or use the Eyedropper in the Toolbox and click in the picture currently open. Paint some brush strokes into the palette then select another color and paint some more. The size of the brush that adds the color can be changed by moving the slider. The paint will mix together as it is layered on top of the previous brush strokes. When you have added several colors click the palette knife icon and mix the colors together.

FIG 7.8 Painting with multiple colors

When you are ready to paint, choose a brush, then click the Eyedropper icon in the Mixer palette; then click in the Mixer to select the color you need and paint into your picture. The Eyedropper icon in a circle is used for brushes like Artists Oils which can pick up more than one color at a time (Figure 7.8 shows the RealBristle Fan Short brush painting with colors mixed in the Mixer palette).

The magnifying glass icon will enlarge the Mixer display to make blended colors more easily visible; double-click the icon to return to full view.

The Hand icon will move the display when the Mixer display is magnified.

The palette menu has controls to save and import Mixer palettes and also the option to create a color set from the Mixer palette.

Click on the Trash can to clear and reset the palette.

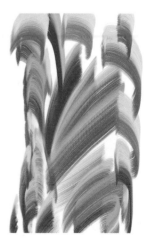

Adjusting tone and color

There are many ways in which tone and color can be adjusted in Painter, and they all have their uses so it is worth getting to know which control is better for which task. Most of the controls are available from the Effects menu with the exception of those in the Underpainting palette. The photograph used in this section (Hydrangea) is on the DVD in the Chapter 9 folder.

FIG 7.9 The original photograph prior to making any adjustments

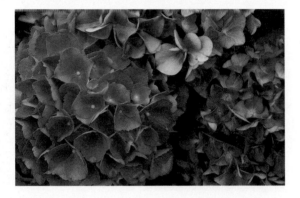

Effects: Tonal Control: Brightness and Contrast

This is a very simple control – just two sliders; its main use is to increase contrast. In most cases the process of cloning reduces the contrast and vibrancy so moving the Contrast slider (the top one) to the right will give the finished picture more impact. I would caution against using the Brightness slider for anything other than very small adjustments as this affects all the tones and it is easy to lose detail in the highlights or shadow areas. If you need to brighten your picture use the Correct Color control.

FIG 7.10 The Brightness and Contrast dialog box with the settings applied to the picture

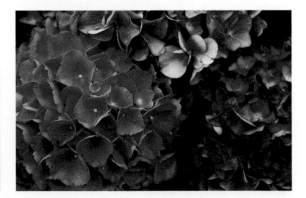

Effects: Tonal Control: Equalize

This is another simple dialog box, which adjusts the black and white points to improve contrast. When the dialog box opens it will automatically set the black and white points to maximum contrast and spread the remaining tones across the dynamic range. You can change the suggested points by moving the black and white point indicators in or out. This is a very useful control to use on a regular basis; it is the equivalent of Levels in Photoshop, but only use it as a suggestion – not all pictures need to have the contrast increases, especially if they have subtle colors. The black shape in the display is the histogram and this shows the distribution of tones in the picture; in the illustration shown in Figure 7.11 the tones are predominantly in the mid-tones with nothing pure white or pure black. The result shows what happens when those mid-tones are stretched; there are now both pure whites and blacks and therefore it looks much more attractive.

FIG 7.11 Equalize dialog box and the result when applied to the picture

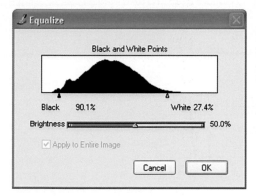
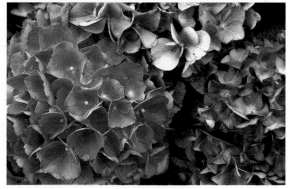

Effects: Tonal Control: Correct Colors

This is a very powerful tool for changing both tone and color. In Photoshop it is known as Curves although in Painter it works slightly differently. If you have never used Curves before it can be very non-intuitive, but it is worth making the effort to understand how it works.

The first confusing thing is that when you open the dialog box there is no curve, just a diagonal line. This line represents all the tones in your picture: the top right corner being the lightest tones and the bottom right the darkest tones, and the middle point being mid-gray. Moving the top slider to the right will produce a gentle S-shaped curve in the display, which increases the contrast. When the curve moves to the left the tones in that area are lighter; to the right and the tones are darker.

Now move the Brightness slider to the right and you will see that the curve has moved mostly in the center; this is the mid-gray point, also known as the Gamma.

FIG 7.12 Color Correction dialog box showing an S curve to increase contrast and the result when applied to the picture

The key point to remember is that an S curve means increased contrast while an inverted S curve means a reduction in contrast. Figures 7.12 and 7.13 shows the difference.

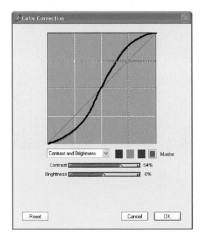

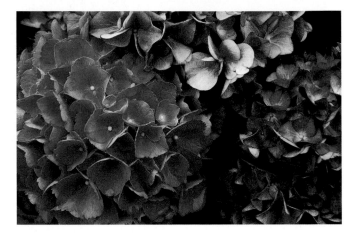

When the center point moves, the overall brightness of the picture is changed but the end points of black and white are unchanged.

Under the display there are four colored boxes which represent the three color channels plus the Master icon. When the Master icon is active all the colors in the picture will change, but when only one color channel is active then only that color will be altered. Try this out by clicking in the red box and moving the Brightness slider all the way to the left. Figure 7.14 shows the result and, as you can see, all the red has been removed.

FIG 7.13 Color Correction dialog box showing an inverted S curve to decrease contrast and the result when applied to the picture

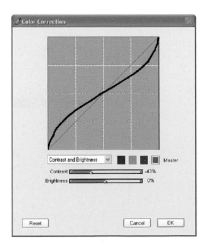

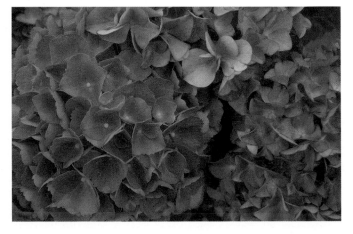

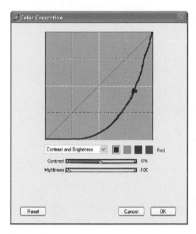

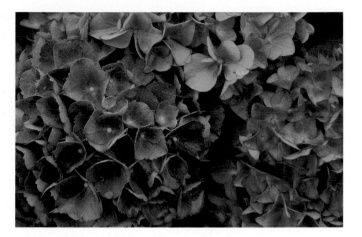

The default option in this dialog box is Contrast and Brightness and you can only use the sliders in this mode; in order to manipulate the curve directly we need to change to the next option in the dialog box which is Curve. Here we can move parts of the curve without creating an S curve. In the example shown in Figure 7.15 the curve has been pulled down to the bottom, which results in only the dark tones being affected and very little change in the lighter areas. This is used when we need to lighten or darken just one part of the tonal range.

This is a very valuable tool as it allows us to target certain tones very accurately without changing the rest of the tones. The option to select specific color channels is also available here, so you could for example select the Red channel and make the same curve as applied in Figure 7.15; the red flower would darken but the blue ones would change less. The whole picture will change to some extent because the purple flower also contains red.

There are two further options in this dialog box. Advanced allows you to enter values into the various boxes to adjust the tones very precisely.

FIG 7.14 Lowering the brightness of the Red channel will remove red from the picture

FIG 7.15 Pulling down the curve manually to darken just the darker areas

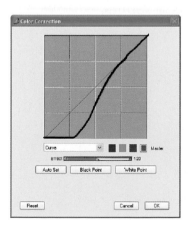

FIG 7.16 The Freehand option produces wild colors

Freehand is where you can go wild with psychedelic colors! The result of drawing vertical lines in the Curves box is shown in Figure 7.16.

Effects: Tonal Control: Adjust Color

Tutorial files on the DVD

This tool is equivalent to Hue and Saturation in Photoshop. The Hue slider will shift all the colors in the picture around the color wheel; this is useful as a quick tool for warming or cooling a picture when a small change is all that is needed. It is also useful for graphic effects, but when accurate color changes are required it is usually better to use either Correct Colors or Adjust Selected Colors.

The Saturation slider is extremely useful and should be used when the colors need boosting, either before cloning or when finishing a picture. It can also be used to reduce color saturation when you need delicate colors, and to remove all the color to make a monochrome picture.

The Value slider affects the overall brightness and should be used with care so that tonal values are not lost.

FIG 7.17 Adjust Color is useful for creating delicate colors as well as for strengthening color

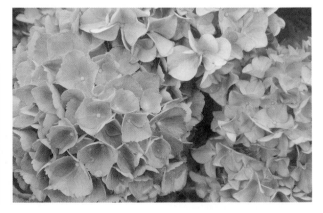

There is a further option in this dialog box and that is the choice of the source on which of the color adjustment is calculated. The four options are Uniform Color, Image Luminance, Original Luminance and Paper. These are the same options for applying paper textures and are described in more detail in Chapter 5. The different results can be seen in Figure 7.18 with clockwise from top right: Uniform Color, Paper and Image Luminance. Original Luminance is only available when cloning.

FIG 7.18 The Adjust Color dialog box with examples showing the four different source options

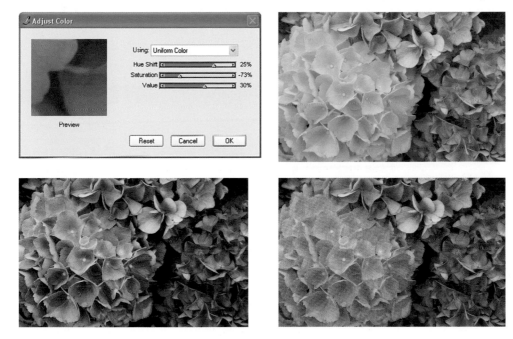

Effects: Tonal Control: Adjust Selected Colors

The Adjust Selected Colors has the same controls (Hue, Saturation and Value) as the Adjust Color tool already discussed, with the addition of extra sliders to restrict the adjustment to specific colors.

The procedure is to open the dialog box and then to click in the main picture to set the color to be changed. Make the adjustment required using the Hue, Saturation and Value sliders and then use the additional sliders to further control the result. Each of the three controls have two sliders each: Extents and Feather. The Extents slider defines how far from the exact color selected the adjustment will be applied; the higher the number, the more colors will be affected. The Feather slider softens the edges of the adjustment; the higher the number the softer the edge is. If you are changing a color with a clearly defined edge the slider should be kept low and vice versa.

207

The Adjust Selected Colors tool is a very precise way to adjust colors but it does suffer from the huge disadvantage that you can only see the planned adjustment in the tiny preview window. This is typical of most of the adjustment previews in Painter; usually you can manage OK, but here it is very difficult to assess what you are doing and that makes it very unsatisfactory to use. You are able to pan around within the window which helps a little. Only the Correct Colors tool shows the preview on the actual picture but it cannot specify the tone changed.

FIG 7.19 The Adjust Selected Colors dialog box with the result of increasing the saturation of the red color

Effects: Tonal Control: Match Palette

The Match Palette lets you take the colors from one image and apply them to another picture. This can be useful if you want to create a set of pictures which all require the same tonal range. In the example shown the colors have been taken from the flower picture and applied to the sand pattern.

The Color slider controls the amount of color transferred. Brightness controls the way the colors are matched; higher settings mean more contrast.

The two Variance sliders, one for Color and the other for Brightness, control the amount of variance from the original image; the higher the value, the wider the range of colors or brightness compared with the source.

When you have found the required settings you can adjust the overall amount of the effect with the Amount slider. The two Match color images are on the DVD.

FIG 7.20 The Match Palette takes the color from one image and applies it to another

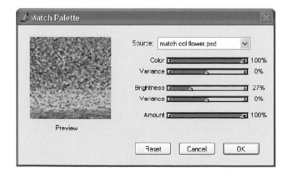

FIG 7.21 Using the Match Palette the colors of the flower picture have been applied to the sand picture. Note that only the colors of the flower picture have been applied and not the shapes

Effects: Tonal Control: Negative

This turns the colors in a picture to negative, which can be useful when creating special effects.

Tutorial files on the DVD

FIG 7.22 The Negative command turns the colors to negative

Effects: Tonal Control: Posterize

The Posterize command splits the colors into a number of levels as determined by the number entered in the dialog box.

FIG 7.23 Posterize splits the tones into a specified number of levels

Effects: Tonal Control: Posterize using Color Set

This also splits the picture into tones but in this case also applies the colors from the current color set, which makes it a valuable tool for creating new color schemes.

To try this effect open the 'Red car handle' from Chapter 9 on the DVD and go to Effects>Tonal Control>Posterize using Color Set. There is no dialog box; the effect is purely based on the color set currently active. The number of posterized tones will depend upon the number of colors in the color set.

If you have not previously loaded any color sets your first result will be based on the default color set. Load some different color sets and see the difference; the instructions for loading color sets are given earlier in this chapter.

FIG 7.24 Posterize using Color Sets – these samples are from a selection of loaded color sets
A Original
B Saturated Greens
C Jacarand
D Flesh Tones
E Using selected colors
F Using another image

A

B

C

D

E

F

Toning techniques

There are several ways to tone photographs in Painter and a very simple but effective method is to use Adjust Color in conjunction with Color Overlay.

1. Open 'Tables' from Chapter 7 folder on the DVD.
2. Effects>Tonal Control>Adjust Color.
3. Move the Saturation slider fully to the left to remove all the color.
4. Make a copy of the Canvas (Select>All, Edit>Copy, Edit>Paste in Place).

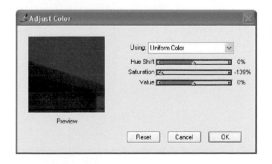

FIG 7.25 Use the Adjust Color tool to remove the color

5. Open the Color Overlay dialog box (Effects>Surface Control>Color Overlay).
6. Use Uniform Color, Opacity 100% and Dye Concentration.

FIG 7.26 The Color Overlay dialog box and the original photograph

7. Choose a suitable color in the outer ring of the Colors palette and move the cursor to the right corner of the color picker to keep the color pure; the preview window will give some idea of the result.

FIG 7.27 The desaturated version

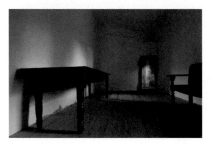

8. Change the Layer Composite Method to Colorize.
9. Reduce the layer opacity to around 10% or what ever looks right.
10. If the color is not what you want apply the Color Overlay again.

FIG 7.28 Final picture after toning with Color Overlay

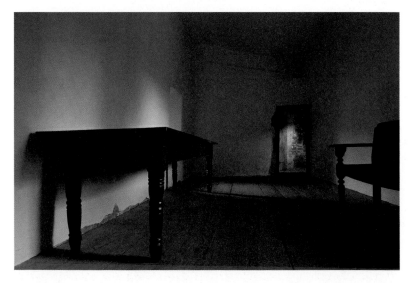

Underpainting palette

The Underpainting palette (Window>Underpainting) offers a wide range of color controls, and for a quick and easy way to make adjustments it is very useful. It may not have the sophistication of the controls described earlier in this chapter, but the big advantage is that they are all in one place and you can see immediately the effect on the picture.

Figure 7.29 shows the Underpainting palette with the drop down menus.

The Color Scheme options are useful for applying to a photograph to enhance or change the color prior to cloning. When first applied the color schemes may not look very good, but the color change looks better after the clone is finished. They are most useful when you want to create an artistic rather than realistic picture.

Photo Enhance offers shortcuts to alterations in color and tone, and there is a list of changes available. This is an alternative to making the changes yourself with the sliders. You can apply more than one of these by selecting one and clicking Apply and then adding more in the same way.

The six sliders are all self-explanatory and can be easily tried; small changes can be made by clicking on the arrows at each end of the sliders.

If you would like to apply the same adjustments to a series of pictures you can do so by making all the adjustments for the first picture, then clicking on the+sign to the right of the Photo Enhance box and giving it a name. This will be saved as a preset for future use.

Edge effects can also be applied from this dialog box and some examples of these effects can be seen in Chapter 14 on printing and presentation.

Figure 7.30 shows the result of making several adjustments together with an Edge effect.

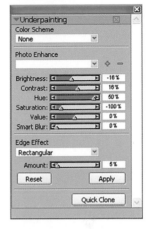

FIG 7.29 The Underpainting palette with drop down menus

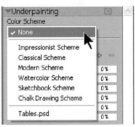

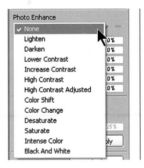

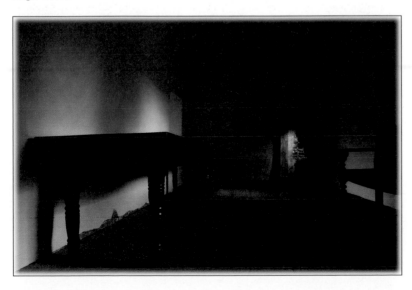

FIG 7.30 Using the Underpainting palette

Hand coloring photographs

Tutorial files on the DVD

Hand tinting photographs is as old as photography itself, and in recent years has experienced a revival as artists and photographers seek to make pictures that have the very special magic that hand tinting creates. This step by step example begins with the all-important job of preparing the photograph before you start to apply color. The starting point is a full color photograph with solid colors; if it was simply desaturated to remove the color it would be too dense and unsuitable for a delicate picture so it needs to be made much lighter.

FIG 7.31 Original photograph

1. Open 'Crocus' from Chapter 7 folder on the DVD.
2. Select>All.
3. Make the Layer Adjuster tool active and click in the picture to lift the canvas to a new layer.
4. Right-click the new layer and select Duplicate.
5. Effects>Tonal Control>Adjust Colors and take the Saturation slider to zero.
6. Change the Layer Composite Method to Colorize.
7. Make the layer beneath active and go to Effects>Tonal Control>Correct Colors.
8. Select the Advanced option.
9. Enter the following values:
10. Green: 15, 15, 25, 15, 25
11. Blue: 50 ,15, 25, 0, 0

FIG 7.32 Color Correction dialog box and lightened Monochrome copy

12. This will lighten the petals; you will see the difference as you enter the figures. The reason that the monochrome layer was created first and sits on top is so that the original tones can be changed on the underlying layer and the result can be easily seen (Figure 7.32).
13. Click on the top layer, right-click it, and select Duplicate.

14. Change the Layer Composite Method to Default.
15. Choose a brush: Blenders>Grainy Blender, size 127, Opacity 38%.
16. Blend the edges of the petals; brush outwards from the petals towards the corners. Do not blend the center (Figure 7.33A).

FIG 7.33
A Blending the edges with the Grainy Blender
B Duplicating the layer

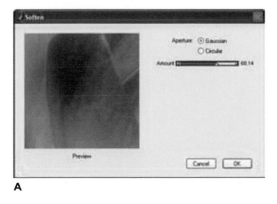

A

B

17. Duplicate the layer again.
18. Change the Layer Composite Method to Screen.
19. The next step is to blur the layer, which will soften and lighten the picture. Effects>Focus>Super Soften and enter 50 in the box. Repeat this step four or five times to build up the blur (Figure 7.33B).
20. Duplicate the top layer again; this should be in Screen Method, which will double the strength of the effect.
21. Duplicate the top layer again; this should be in Screen Method.
22. Effects>Focus>Soften; Aperture: Gaussian; Amount 68. This will lighten the entire picture.

FIG 7.34
A Soften dialog box
B Lightening at step 23

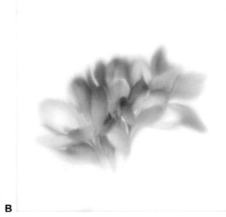

A

B

Should you ever find that you are unable to paint on a layer with any brush, check if the Preserve Transparancy box in the Layers palette has been checked. This option stops you from painting in any area of a layer which does not already have tone. It can occasionally get turned on in error.

23. Duplicate the top layer again; this will double the effect again. You should now have a very delicate monochrome version of the crocus (Figure 7.34).

24. The flower looks very delicate, but in my version I have lost the stem. I would like just an indication of it, so on the top layer create a layer mask and, after activating the mask, paint with black into the mask where the stem should be.

25. There is no really good brush in Painter suitable for use on layer masks so I have made my own. Here is how to do it. Go to Cloners>Soft Clone, open the General palette and change the Method to Cover and the Subcategory to Soft Cover. Make the size 117 and Opacity 50%. In the Brush Selector palette menu select Save Variant. Give it a name – I suggest 'Soft Mask Brush'. For more details on saving and moving variants to a new category see Chapter 4 on customizing brushes.

26. Continue to create masks from the top layer downwards until the stem is just visible.

27. This completes the preparation of the picture prior to coloring, and is a good time to save the layered version, then Drop All the layers and save again to continue work on the new flattened version, which will make painting quicker.

28. Lift the Canvas to a new layer as previously.

29. Duplicate the layer.

30. Select the French Watercolor Paper from the Papers palette and change the sliders to: Size 313%, Contrast 122% and Brightness 76%.

31. Effects>Surface Control>Apply Surface Texture. Choose Paper as the source and make the Amount 20%. Apply the texture and then reduce the layer opacity to 35% (Figure 7.35).

FIG 7.35
A Apply Surface Texture dialog box
B Applying texture

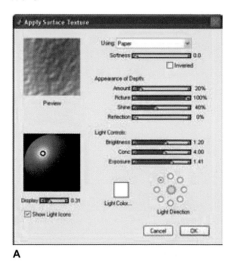

A

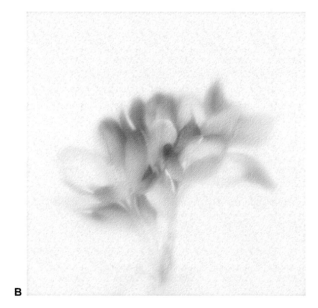

B

32. Create a new layer; change the Layer Composite Method to Color and the layer opacity to 50%.
33. Select a new brush; Airbrushes>Fine Tip Soft Air brush, size 127, Opacity 2%.
34. Open the Mixer palette (Window>Color palettes>Mixer), drag it out on its own and then make it larger by dragging the bottom right corner.

FIG 7.36
A Mixer palette after adding colors
B Mixer palette after blending with Palette Knife

A B

35. Click the Apply Color (brush) icon at the bottom of the palette.
36. In the Colors palette choose a purple color in the outer ring and a light purple in the inner triangle; I used R183, G94 and B246 to start. Paint into the Mixer then select other colors and tones in that color range. Add some greens and browns. Figure 7.36A shows the Mixer palette at this stage.
37. Click the palette knife icon and mix the colors on the palette. When you have finished click the Sample Color icon to start painting.
38. Paint the whole of the flower keeping the tones very light. Brush outwards from the center of the flower so that the brush strokes are lighter at the edges. Change the color constantly, picking various colors in the pink and purple range.
39. Reduce the layer opacity to 24%; the Amount will depend on how heavy you have painted. This is the great advantage of painting on many layers as they can be adjusted afterwards – it is quite difficult to get an even delicate tone.
40. Make a new layer – 50% Opacity in Color Composite Method.
41. Paint the center of the open flower on the left with yellow. You can add yellow to your Mixer or just pick the color from the Color palette. Keep it delicate and reduce the layer opacity to blend well. It is a good idea to name these layers as you make them.

FIG 7.37 Detail of the colors at step 46

42. Looking at the current result I think that the monochrome layer in my painting is too dark, so, if yours is too, here is one way to lighten it further.

43. Create a new layer above the layer with the paper texture. Fill it with white. (Choose white in the Color palette then Edit>Fill>Current color.)
44. Change the Layer Composite Method to Soft Light; this will lighten the darker areas without affecting the color. If it is now too light, reduce the layer opacity; if it is still too dark, duplicate the layer to double the effect.

FIG 7.38 Final Layers palette

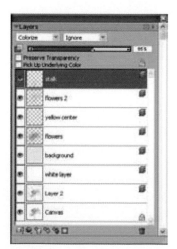

45. Create a new layer on the top of the layer stack, Opacity 50%, and change the Layer Composite Method to Colorize. Colorize is another way of applying color which is similar to Color but the effect is different; try both to see the difference.
46. Paint more color into the petals. Use a smaller brush size, about 61, and then reduce the layer opacity when you have finished (Figure 7.37).
47. Create a new layer on the top of the layer stack, Opacity 50%, and change the Layer Composite Method to Colorize. Paint some color into the stalks – use browns and greens. Reduce the Opacity until it is just visible.
48. Create a new layer; this is an optional step which adds a slight color to the background. Change the Layer Composite Method to Color. Select a very light pink in the Colors palette, red 251, green 198, and blue 255, then Edit>Fill with current color. Adjust the layer opacity until it is just visible, probably about 10%, and move the layer down until it is over the white layer.
49. Finally, adjust the layer opacities of all the layers to achieve an extremely delicate hand tinted result.

The final Layers palette is shown in Figure 7.38 and the finished picture is below.

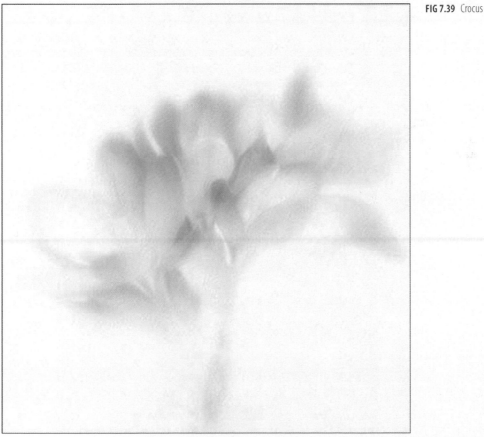

FIG 7.39 Crocus

A

Tutorial files on the DVD

Hand coloring a graphic image

The last example showed how to create a soft delicate picture, but hand coloring can be applied to any style. Here is a vivid example of coloring a very strong graphic image.

1. Open 'Twins' from Chapter 7 folder on the DVD.

FIG 7.40 Original image

2. Create a new layer; change the Layer Composite Method to Colorize.
3. Select the Tinting>Grainy Glazing Round brush, size 30.8, Opacity 50%.
4. Choose an orange color in the Colors palette, R254, G184 B124, and paint the left side of the picture – all except the spectacles with the cyan color.
5. Create a new layer; change the Layer Composite Method to Colorize.
6. In the Colors palette move the cursor to the opposite side of the color ring and paint the right side of the picture – all except the spectacles.
7. Create a new layer; change the Layer Composite Method to Colorize.
8. Change the brush opacity to 100% and paint both pairs of spectacles in the opposite colors to those already used.

FIG 7.41 The image at step 6

9. Create a new layer; change the Layer Composite Method to Color (not Colorize).
10. Use brush opacity 10%; choose a yellow color and paint the white areas of the face on the left. In Color Method the brush will paint over everything, so keep it light. Reduce the layer opacity to around 30%.
11. Create a new layer; change the Layer Composite Method to Color.
12. Choose a light mauve color and paint the white areas of the face on the right. Keep it light; lower the layer opacity to around 30%.
13. Create a new layer; change the Layer Composite Method to Colorize.
14. Paint over the central areas with the four colors to soften the transition between the colors.
15. Save, then Drop All layers and save again; you will find that the two versions are different. When Painter saves in Photoshop format the Colorize layer blend method is not translated correctly unless the layers are dropped (flattened) first in Painter.

FIG 7.42 Twins

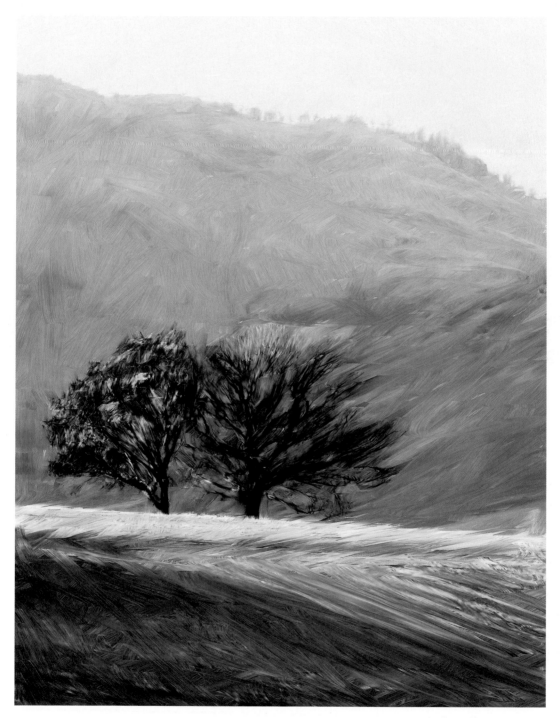

FIG 8.1 Two trees, painted with the Loaded Palette Knife

Landscape

The landscape has been one of the most popular subjects for artists throughout the ages and this chapter on landscape covers a wide variety of subjects from wide open vistas to intimate details.

You can of course use any type of brush to paint the landscape, so the examples chosen in this chapter only scratch the surface of what is possible; the interpretation too can be traditional or modern and everything in between.

The step by step examples in this chapter aim to introduce you to a variety of techniques and styles from which you can create your own paintings of the landscape.

Impressionist landscape

This landscape step by step uses the Impressionist brush from the Artists brush category which creates a very painterly impression and is an excellent brush for this subject. It is also an easy and fast brush for cloning.

1. Open 'Feet in the water' from Chapter 8 folder on the DVD.

FIG 8.2 Original photograph

2. Make a Quick Clone.
3. Select the Artists>Impressionist brush, size 78.2, Opacity 100% and Resat 18%.
4. Click the Clone Color option in the Color palette. This is a necessary step to change this into a cloning brush and must be made for all brushes except for those in the Cloners brush category.

FIG 8.3 Painting the background

5. Paint the background of the picture with the brush strokes in a downwards direction; the water should then be painted with horizontal brush strokes. (Figure 8.3).

6. Change the brush size to 25 and paint the trunk and branches of the tree (Figure 8.4).

FIG 8.4 Painting the tree

7. Paint the leaves with the same brush – paint them in the direction in which they hang (Figure 8.5).

FIG 8.5 Painting the leaves

8. Paint along the shoreline with brush size 27.5; make the brush stroke vertical to bring some variation and texture to that area.
9. Change the brush size to 37.8, Opacity to 100%, Bleed to 100% and Jitter to 1.78. The change to the bleed settings will make it blend more

with the existing image. The jitter setting makes the brush paint with more variation in the strokes. Keep the brush moving in circular directions to create a sense of movement in the leaves.

10. Paint over any other areas that need a stronger color to finish the painting.
11. Make a copy of the canvas (Select>All, Edit>Copy, Edit>Paste in Place).
12. Effects>Tonal Control>Equalize. This will spread the tones and give the picture more contrast. Adjust the Brightness slider to lighten or darken the picture. The Equalize command is explained in more detail in Chapter 7 'Using color'.
13. Because this is on a separate layer the opacity can be reduced if you subsequently decide that it is has too much contrast.

This completes the Impressionist clone.

FIG 8.6 Feet in the water

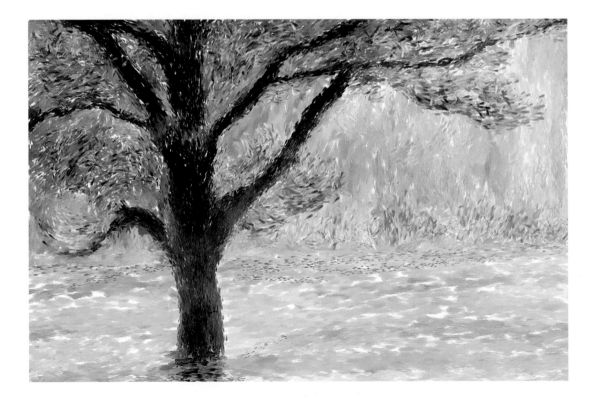

Landscape with oils

This landscape will use a brush from the Oils category to create a fairly realistic landscape.

1. Open 'Black Crag landscape' from Chapter 8 folder on the DVD.

FIG 8.7 Original photograph

2. File>Quick Clone.
3. Select the Oils>Flat Oils 30.
4. Brush size 52.2, Opacity 80%, Resat 10%, Bleed 70% and Feature 3.8%.
5. Click the Clone Color option in the Colors palette.
6. Paint the mountains and sky; the brush strokes should follow the contour lines, so the mountain on the right should be painted diagonally from the top right. Move the brush quickly; this will ensure that the image is smeared, which is the aim, particularly in the background areas. Continue painting down to the trees (Figure 8.8).

FIG 8.8 Painting the background mountains

7. Reduce the brush size to 30 and paint in the trees. Use short brush strokes and once again keep the brush moving quickly to avoid too much detail being shown (Figure 8.9).

FIG 8.9 Tree detail

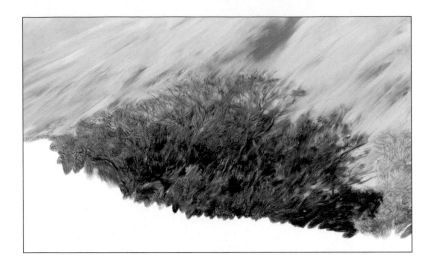

FIG 8.10 Painting with a pressure sensitive pen at different angles with a flat brush will result in different angled brush strokes. You will need a pen that supports this feature

8. Paint the middle ground between the trees. The brush you are using is flat, so use this feature to paint the hillside in levels using the flat side in parts and the narrow side in others to create a variety of textures. This option is available with most flat brushes, provided that you are using a pressure sensitive pen. Figure 8.10 shows the cursor and brush dab when angling the pen towards you and to one side.

9. Paint the trees on the left in the same way and then the grassy slope. This should be done with long horizontal brush strokes interspersed with a few vertical strokes to indicate taller grasses (Figure 8.11).

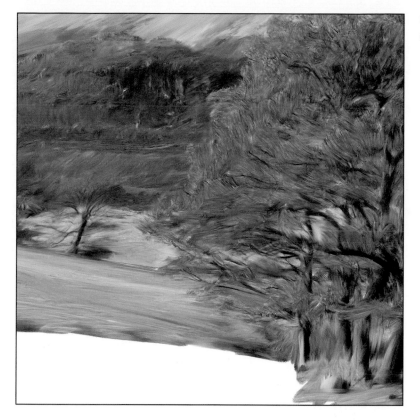

FIG 8.11 Detail showing central area and trees

10. The grass in the lower part of the field is much taller and rough; paint this with vertical brush strokes and with the brush angled to use the narrow edge. Keep the brush moving quickly to create a rough texture.
11. Paint the smooth grass bottom right with long horizontal strokes.
12. Reduce the brush size to 20 and paint the sheep. Don't make them too clear – allow some oily smudges to show (Figure 8.12).

FIG 8.12 Detail of the sheep and trees

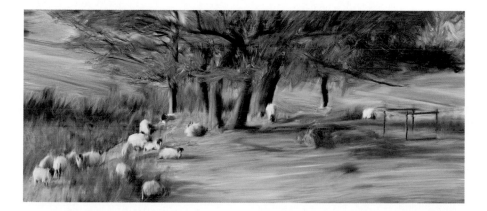

13. Continue using this brush and put extra detail throughout the picture. In particular follow the lines of the tree branches. Paint on the narrow edge of the brush to get the best result.
14. Make a copy of the Canvas (Select>All, Edit>Copy, Edit>Paste in Place).
15. Effects>Surface Control>Apply Surface Texture. Choose Image Luminance and Amount 45%. This will add extra definition to the brush marks. Having this on a separate layer will allow you to reduce the opacity if necessary.
16. It would be appropriate to add a canvas texture prior to printing. Make a copy of the layer you have just created. (Right-click the layer and select Duplicate.)
17. Select Artists Canvas in the Papers palette, then Effects>Surface Control>Apply Surface Texture. Choose Paper and Amount 86%. The canvas texture is not applied to the final picture here as it does not reproduce well when printed this small.

FIG 8.13 Black Crag landscape

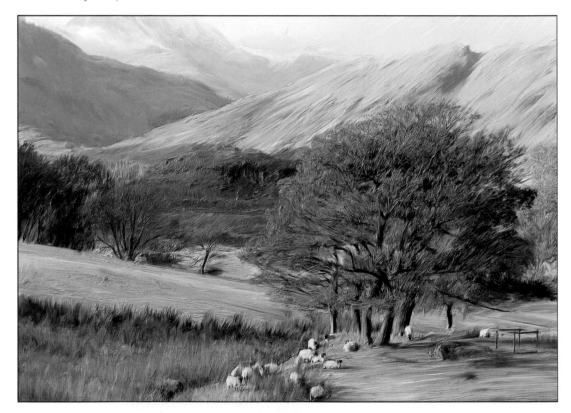

Dry Bristle Watercolor

This step by step example uses the Dry Bristle brush which is one of the easiest traditional watercolor brushes to use when cloning. It does not build up to black as quickly as many other watercolor brushes and, because the diffusion process is only very modest, it is also much faster.

1. Open 'Old Tree' from Chapter 8 folder on the DVD.

FIG 8.14 Original photograph

2. Open the Underpainting palette (Window>Underpainting).
3. In the Color Scheme drop down menu select the Sketchbook Scheme; this will make the colors muted which will suit the picture.
4. File>Quick Clone.
5. Select the Watercolor>Dry Bristle brush, size 28 and Opacity 4%.
6. Click the Clone Color option in the Colors palette.
7. Clone in the old tree; the Sketchbook color scheme has increased the contrast quite considerably so the coverage will be uneven (Figure 8.15).

FIG 8.15 The first stage of painting the tree trunk

8. Increase the brush opacity to 16% and bring some additional texture into the white areas of the tree trunk (Figure 8.16).

FIG 8.16 Building the density

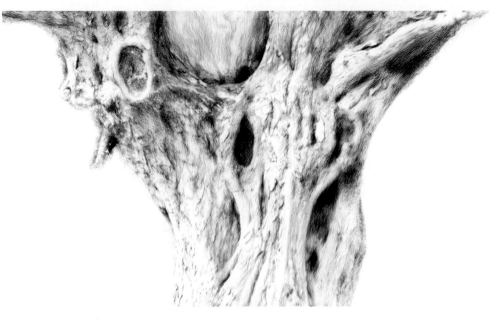

9. Create a new Watercolor layer and move it below the layer on which you have been painting. The new Watercolor layer icon is the blue water droplet at the bottom of the Layers palette.
10. Increase the brush size to 48 and make the Opacity 3%.
11. Paint the background using horizontal brush strokes; keep it a light texture. The reason for painting this on a new layer is that, if necessary, the layer opacity can be reduced to make the background lighter.

FIG 8.17 Adding the background

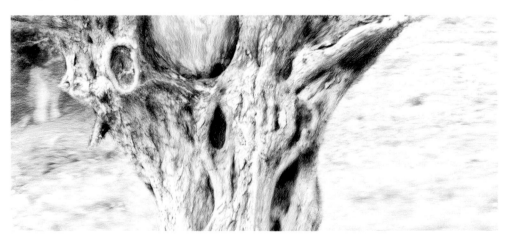

12. Create a new Watercolor layer and place it in between the two existing layers. Paint the daffodils in short vertical brush strokes using the same brush size and opacity. Keep them fairly light and if necessary reduce the layer opacity.
13. Create a new Watercolor layer and move it to the top of the layer stack.
14. Use brush size 11, Opacity 10% and paint parts of the tree trunk to define the edges.

FIG 8.18 The daffodils are painted in the background

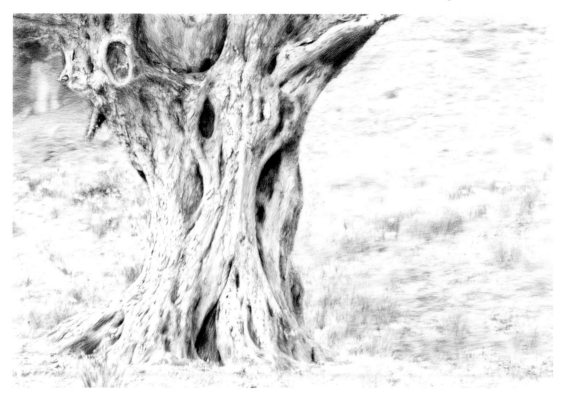

15. Adjust the opacity of the layers to balance the picture.
16. If you intend to open this in Photoshop you will need to drop all the layers first as the Gell Layer Composite Method which Painter uses for Watercolor layers is not recognized by Photoshop and will not translate correctly.
17. At this stage I decided that the lower part of the tree trunk was too light, due to the contrast added by the color scheme chosen at the start. My solution was to go back to the original photograph, darken it considerably, apply the color scheme as described earlier and then clone from that. This gave me the solidity which the composition required.

FIG 8.19 Old Tree detail

FIG 8.20 The Old Tree

Oil Pastels

In this step by step you will discover ways in which to transform a photograph into an artistic impression using brushes from the Oil Pastels brush category to both clone and paint.

1. Open 'Worcester Cathedral' from Chapter 8 folder on the DVD.

FIG 8.21 Original photograph

2. File>Quick Clone.
3. Select the Oil Pastels>Variable Oil Pastel brush, size 52, Opacity 11%, Resat 2% and Bleed 92%.
4. Select the Sandy Pastel Paper in the Papers palette.
5. Hide the tracing paper as this will not be used until later. Do not click the Clone Color option as the early stages will involve painting a background into which to clone.

FIG 8.22 Painting the background 1

6. Paint all the picture using medium size brush strokes. Select colors from the Colors palette to paint with, mainly light yellows and warm tones for the top half and darker browns and blues for the lower part. Keep all the colors light. After putting a reasonable amount of color onto the paper,

keep the brush on the page and blend the new color with the color on the Canvas. The intention is to create a mix of colors which vary across the picture (Figures 8.22 and 8.23).

FIG 8.23 Painting the background 2

7. When all the picture area is covered change the brush to Blenders>Soft Blender Stump, size 48 and Opacity 46%. Blend the entire picture; you should have a diffused picture with plenty of color variation – light at the top and darker at the base (Figure 8.24).

FIG 8.24 Blending the background

8. Make a copy of the Canvas. Select>All, Edit>Copy, Edit>Paste in Place.
9. Return to the Variable Oil Pastel. Click the brush reset icon to return to the default settings, then, the in the General palette, change the Method to Cloning, Subcategory to Soft Cover Cloning, Brush size to 30 and Opacity to 100%.
10. Pull the brush upwards from the bottom; this will create streaks out of the colors. Continue over the entire picture.

11. Select the Chunky Oil Pastel, then, in the General palette, change to Method: Cloning, Subcategory: Soft Cover Cloning, size 52 and opacity 13%.

12. Turn the Tracing Paper on and lightly clone in the cathedral and some of the trees; don't clone in the lower parts of the picture. Turn the Tracing Paper off when you have finished (Figure 8.25).

FIG 8.25 Cloning in the cathedral

13. Make a new layer in Colorize mode and change back to the Variable Oil Pastel; click the brush reset icon to return to the default settings. Brush size 91 and Opacity 11%.

14. Select a light orange in the Colors palette and paint over the entire picture; this will overlay a texture on the picture and also lighten the image (Figure 8.26).

FIG 8.26 Creating a color overlay

15. Reduce the layer opacity to around 50%.

16. I decided that the top was too yellow in color and needed to be lighter; if you need to change this too follow the next three steps.
17. Make a new layer.
18. Return the Variable Oil Pastel brush to the default settings, then change to brush size 105 and Opacity 5%.
19. Select white in the Colors palette and lightly paint over the top part until most of the color has been hidden. Adjust the layer opacity to get the right level; I reduced it to around 50%.
20. Make a new layer.
21. Select a new brush: Cloners>Soft Cloner, size 190 and Opacity 3%.
22. Lightly brush in the cathedral until you can see detail in the top of the tower.
23. Adjust the layer opacity to keep the effect subtle. I reduced it to 54%.
24. Add a Brightness and Contrast layer by clicking the Dynamic Plug-ins icon in the Layers palette. Move the top slider a small amount to the right and the bottom slider a little to the left; this will intensify the colors and contrast. Adjust the layer opacity if required.

FIG 8.27 Worcester Cathedral

FIG 8.28 Worcester Cathedral detail

Pencil landscape

The introduction in Painter 11 of the new range of Real hard media brushes, and in particular the Real pencils, has transformed the way that pencil drawings can be made in Painter. The brushes work a lot more like their real life equivalents, in particular by having the flexibility that a traditional pencil has that allows it to be used at various angles, getting a sharp point when it is held vertically, and shading when held at a shallow angle; for the first time this is possible in Painter. What's more there is a new Hard Media palette in which the pencils can be customized to your choice.

To make full use of these brushes you need a pressure sensitive pen with tilt control – without that you will find it difficult to follow this demonstration.

The photograph used for this demonstration was taken on a camera which has been converted to use just the infra-red spectrum. This produces light and delicate tones in monochrome, which should work well with the pencil clone technique.

1. Open 'Six cold crosses' from Chapter 8 folder on the DVD.

FIG 8.29 Original photograph

2. File>Quick Clone.
3. Select the French Watercolor Paper from the Papers palette.
4. Select the Pencils>Real 6B Soft Pencil, size 108, Opacity 5% and Grain100%.
5. Click the Clone Color option in the Colors palette.
6. Starting in the top right area sketch a light tone across the right side of the picture; hold the pen at a shallow angle to allow the delicate shading to cover the area smoothly. You will need to use various angles and directions to get a good even cover. Paint down and over the large crosses but only lightly outline the crosses at present.
7. Paint the background trees with the same brush. Use the pen at an angle as before but use short strokes in a circular direction. This should bring out an impression of the trees.
8. Continue painting down the picture until the whole area is covered with a light tone (Figure 8.30).

FIG 8.30 The whole picture covered in a light tone

9. Change to the Pencils>Real 4 H Hard Pencil, size 32.2, Opacity 10% and Grain 100%.
10. Click the Clone Color option in the Colors palette.
11. Paint the large crosses. Angle the brush strokes differently on each of the sides of the cross – this will help separate the sides.

FIG 8.31 Adding detail to the crosses

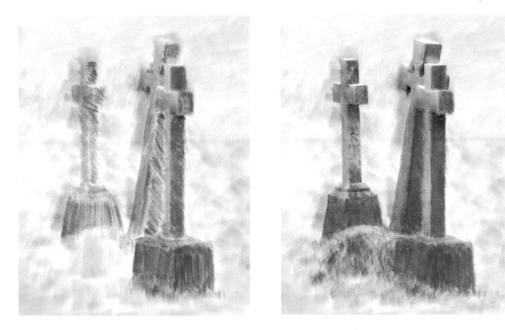

12. Build up the density of the crosses in stages until they are quite clear. Try not to define the edges of the crosses by painting downwards, rather continue to work across the face of the crosses until the edge appears. The crosses are covered in lichen, so they will remain mottled. Remember that detailed pencil drawings are not usually quick to make, so you will need patience to get a good result.

13. Increase the brush opacity to 27% and paint over again, concentrating on the edges, especially the light tops. Hold the pen vertical to get a fine edge.

14. Now paint the small crosses in the same way. Start with 10% Opacity and then increase it to around 30%. The pen can be held at various angles but the best detail is when held vertical and the line is very fine (Figure 8.32).

FIG 8.32 Picture at step 14

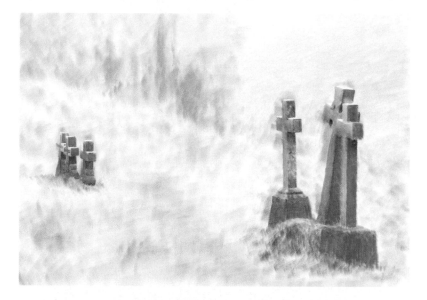

15. The crosses are now clear but the background and grass need to have more detail so that the two areas can be integrated. Keep the size at 32.2 and Opacity 10%.

16. Starting from bottom left paint the grass, working across to the right-hand side. Keep the brush at a slight angle and paint so that the brush stroke are roughly vertical. When you come to the path make the brush strokes less vertical as there is little grass there.

17. Reduce the brush opacity to 5% and paint the remainder of the grass; because there is little density in the original photograph the cloning will look light.

18. Paint the trees in the background. Use the pen vertical to get the outlines of the tree trunks and branches, then paint over again with the pen at an angle – this will soften the lines.

19. Increase the brush opacity to 70% and holding, the pen vertically to get a fine point, paint the edges of the large crosses to add some contrast and bring out the frost on the tops and sides.

FIG 8.33 Detail of small crosses

20. Finally, you may wish to add a little contrast to the picture. If so go to Effects>Tonal Control>Brightness/Contrast and move the top slider a little to the right.

FIG 8.34 Six cold crosses

FIG 9.1 Harvey and Toby, painted with the Artist Pastel Chalk

Children

I n this chapter a variety of brushes are used to create painterly pictures of children and young people. The chapter starts with an explanation of some of the brushes in the Blenders category, as these are particularly useful when making portraits and also for finishing off pictures of all types.

Brush categories which I find particularly valuable for portraits are the Pastel and Chalk, and there is a step by step example using the Pastel brushes which are great for making light delicate portraits.

Another traditional style of painting is Oils, where the rich textures give a much more substantial finish with some lovely brush textures. The example of Griff shows how to use some of the Oil brushes.

Also included in this section is a step by step illustration of how to use inset mounts to make a picture more special.

Tutorial files on the DVD

Using Blender brushes

Some of the most valuable brushes for creating cloned pictures of people are the Blenders. These reside in several different brush categories including Blenders, Tinting and Distortion, and can also be created from many other brushes by altering the settings.

Before we start making the first step by step tutorial it will be useful to check out the brush examples below as they highlight some of the most useful blending brushes.

The principal characteristic of a blending brush is that it smears or distorts the existing image and in doing so creates soft, rough or textured versions of the original picture. The brushes work directly on the image and although in all cases we will use a clone copy to work on, the brushes do not depend purely on taking information from the original.

At the size shown here it may not be possible to see the different textures very clearly so a pdf file with the pictures enlarged is included on the accompanying DVD.

FIG 9.2
A Grainy Blender: Just Add Water.
B Coarse Oily and Soft Blender Stump

A B

Example (A):

Blenders>Grainy Blender was used for the edges and the background; this is a rough blender which is affected by the chosen paper.

Blenders>Coarse Smear was used for the hair; this is similar to the previous brush but is not affected by the choice of paper. Both the above blenders are useful for hair.

Blenders>Just Add Water was used on the face; this is a very soft smooth blender which is a useful brush for removing blemishes on skin. Use it at a low opacity for the best results.

Example (B):

Blenders>Coarse Oily Blender was used for the background and gives a very chunky, rough appearance and smears the images around significantly.

Blenders>Oily Blender was used for the hair; this is smoother than the grainy blenders used in Figure 9.2A.

Blenders>Soft Blender Stump is a good brush for the face; used at a low opacity it polishes the skin beautifully. I used it here at between 5% and 10% Opacity.

Example (C):

Tinting>Diffuser 2 was painted all over this picture at 49% Opacity and brush size 30. This gives a very attractive Watercolor effect to the edges. Blend the edges outwards first then run the brush around the edges several times and the edge will spread very effectively. The central area was then restored with Soft Cloner. Distortion>Grainy Mover was used for the hair and dress.

Diffuser>Grainy Water was used on the face; this leaves a little more texture than in the earlier examples.

FIG 9.3
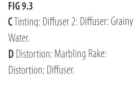
C Tinting: Diffuser 2: Diffuser: Grainy Water.
D Distortion: Marbling Rake: Distortion: Diffuser.

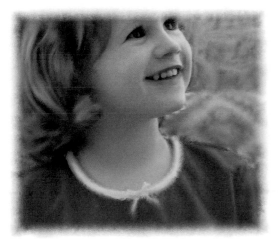

C

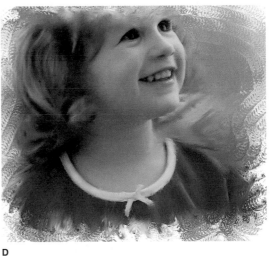

D

Example (D):

Distortion>Marbling Rake, size 23, strength 100% was painted all over this picture. This is a rather drastic result but it achieved the intention which was to thoroughly break up the image. The central areas were then restored with Soft Cloner.

Distortion>Diffuser was blended over the central areas at various sizes and opacities, leaving the edges roughed up. The face was blended at 25% Opacity.

FIG 9.4

E Acrylic Captured Bristle

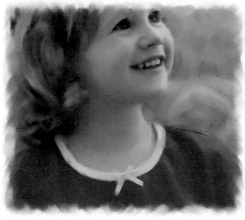

E

Example (E):

The Acrylic Captured Bristle from the Smart Stroke Brushes category.

The background and edges were painted using a size 26 brush with 41% Opacity.

The face was blended with brush size 11 and Opacity 51, then again with size 56 and Opacity 5%.

This is a very bristly brush and gives the edges an attractive finish.

Tutorial files on the DVD

Portrait using Blenders

In this first example you will use some of the blenders described on the previous pages. The general process with portraits is to start with the rougher brushes and to gradually bring back more detail where required. In all cases it is advisable to work on a clone copy so that you always have the option of using the Soft Cloner to return parts to the original source state.

FIG 9.5 Original photograph

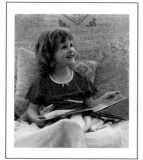

1. Open Annabel 1 from Chapter 9 folder on the DVD.
2. Canvas>Canvas Size and add 150 pixels to each side and 200 pixels to the top and bottom. This will add a white border into which the edges can be blended.
3. File>Clone.
4. Select the Blenders>Grainy Blender 30, brush size 136, Opacity 100%.
5. Change the paper to Sandy Pastel Paper and paint over all the edges leaving the head and body clear. The intention is to remove all traces of the original picture edge, but not to extend right to the edge of the Canvas. If you paint over part of the figure by mistake it can be restored with the Soft Cloner. Figure 9.6A shows the picture at this point.

6. Select a new brush from the Blenders brush category Just Add Water, size 160, Opacity 20%. Paint over all the background with this large brush until all the area is completely smooth. You will need to reduce the brush size down gradually to do the areas around the head and body. Figure 9.6B shows the result.

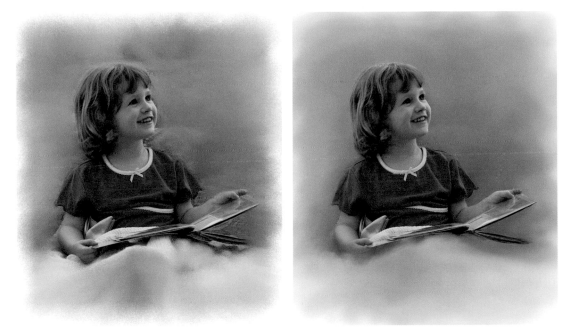

7. If you have encroached on the face and clothes, this is the time to restore it to the original. Select the Cloners>Soft Clone brush and brush over the areas which need replacing. There is no need to be totally accurate with this step as the edges will be softened in the next step; the face is the most important.

8. Change to the Distortion>Grainy Mover 20, brush size 20, strength 25. Paint over the hair making sure that you follow the direction in which the hair flows. Cover all the hair with brush strokes. Reduce the brush size to 10 and smooth out all the texture; the hair should look soft and silky when you have finished (Figure 9.7).

9. Select the Blenders>Grainy Blender 10, size 10, Opacity 38% and paint over the pink top following the lines and shadows of the material. Leave the white lace until you have finished the pink, then use the same brush and paint over the lace with small circular motions; this will remove the photographic appearance but it will remain distinct from the pink.

10. Use the Blenders>Soft Blender Stump 10, size 10, Opacity 20% to smooth out any rough areas. These are usually near the darker sections; Figure 9.7B shows a detail of the dress.

11. Return to the Grainy Blender 10 and blend the book and the remaining non-blended areas, with the exception of the face and arms. Soften the rougher sections with the Soft Blender Stump as before.

12. To paint the face and arms select the Soft Blender Stump 10, size 4.9, Opacity 25%, Grain 23% and Bleed 56%. Enlarge the picture on the screen and carefully blend all over the face; remember that the blenders will drag one color into the next so do not drag darker tones such as eye shadow into light areas. For larger areas of skin use a larger brush, up to size 25; this will give a smoother overall blend.

FIG 9.7
A Blending the hair
B Dress detail

13. When you blend the hair shadow on the left side of the face, move the brush in the direction of the hair, which will lighten the area slightly.

14. Continue with the same brush and blend the arms and hands.

15. Look at the picture to see if it needs any further work. In the one I have made, the white blanket under the book looks rather dark, so select the Airbrush>Soft Airbrush 50, size 206, Opacity 2%. Hold down the Alt/Opt key and click on a light gray area of the blanket. This will activate the Eyedropper tool and select the color with which to paint. Lightly paint over the darker gray areas. If necessary, select lighter tones and paint until it looks bright but not overbright.

16. Finally, check over the picture and blend any areas that still look photographic or are rather rough. The final version is shown in Figure 9.8.

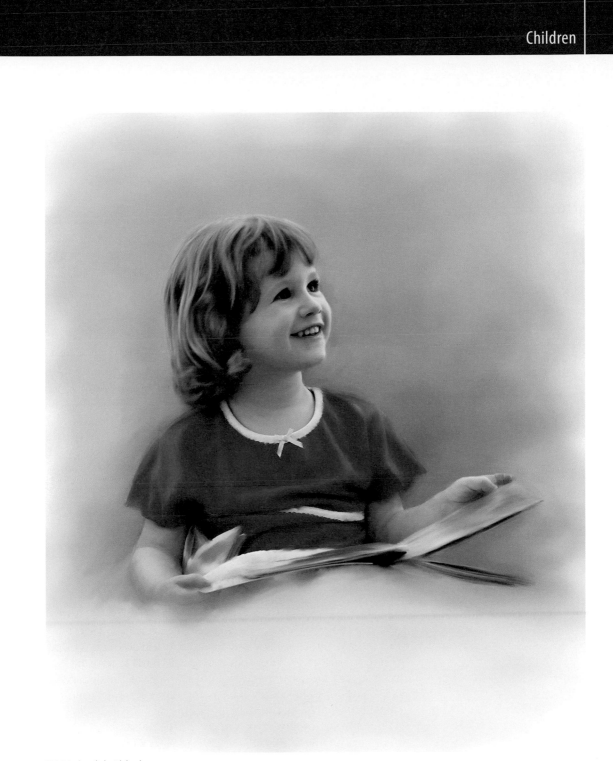

FIG 9.8 Annabel with book

FIG 9.9 Original photograph

Portrait in Pastel

For this next picture we will use brushes from the Pastels section. This particular brush is a favorite of mine as it has such a lovely finish to the brush strokes.

1. Open 'Annabel 2' from Chapter 9 folder on the DVD.
2. Canvas>Canvas Size and add 150 pixels to each side. This will add a white border into which the edges can be blended.
3. File>Clone.
4. File>Select the Pastels>Artist Pastel Chalk, size 127, Opacity 65%.
5. Click the Clone Color option in the Colors palette.
6. Change the paper texture to Sandy Pastel Paper.
7. Paint around the edge, pushing the color to the outside, then run the brush around the very outside to restore the white border. Paint out all the background. Unlike the previous example, this brush is cloning from the source picture and not just blending the picture. Figure 9.10 shows this completed.

FIG 9.10 Edges completed

8. Reduce the brush size to 12.2 and make the Opacity 100%. Paint over the hair, following the flow of the hair; this will give it quite a chunky appearance.
9. In order to restore some delicacy to the hair select the Cloners>Smeary Camel Cloner brush. Make the brush size 23, Opacity 50% and move the Feature slider to 4.9. The Feature slider affects how the individual hairs in the brush work and, by increasing this to 4.9, the individual brush hairs are emphasized; you should experiment with this slider to understand how the control works. Figures 9.11A and 9.11B show the difference in the hair.

FIG 9.11
A Hair detail – step 8
B Hair detail – step 9

10. Return to the Artists Pastel Chalk and with brush size 22 and Opacity 100% paint over the pink dress.
11. The face can be painted with the same brush – reduce the Opacity to 21% and make the size about 40. At this opacity the brush will smooth out any blemishes but still leave a delicate texture on the skin.
12. Paint over the lips and eyes with care; use a small brush and vary the size and opacity until they look right. Eyes are particularly difficult to handle as too much overpainting will look wrong, while not enough will look too photographic.
13. Check over the picture now for final corrections. Tidy the edge if necessary and adjust saturation and contrast prior to printing.

FIG 9.12
A Dress detail
B Painting the face with the Chalk brush

Compare this picture to the previous step by step tutorial; the choice of a Pastel Chalk brush has given it a more obvious pastel finish while the first example in this chapter has a watercolor look.

FIG 9.13 Annabel

Making an inset mount

This charming picture was taken at a wedding. I loved the expressions on the faces of the girls but the background was rather distracting and needed to be simplified. This tutorial explains how to change the tones to a very pastel finish and make the inset mount.

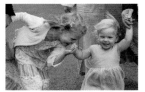

FIG 9.14 Original photograph

1. Open 'Wedding Children' from Chapter 10 folder on the DVD.
2. The first step is to remove all the distracting background, but before we do that the picture can be cropped to reduce the amount of work. Crop the left to the edge of the girl's sleeve and the right side to where her arm goes up to the hand.
3. Use the Rubber Stamp tool, hold down the Alt/Opt key and click in the picture from where the imagery is to be taken, then paint. Use 100% for most of the background and reduce it to around 20% around the hair. It is not necessary to get it perfect as some imperfections will be hidden by later steps.
4. File>Clone.
5. In the Layers palette make a new empty layer.
6. Edit>Fill With Clone Source.
7. Effects>Tonal Control>Adjust Colors and reduce the Saturation to zero, which will turn the layer into monochrome. Figure 9.15 shows this stage completed.

FIG 9.15 Monochrome layer

8. Make a new empty layer and once again Fill with Clone Source.
9. In the Layers palette change the Layer Composite Method to Screen and reduce the Opacity to 75%. This will gently overlay the original color Figure 9.16.
10. Effects>Focus>Super Soften and set 13.0 in the number box. This will add a very attractive gentle glow to the picture Figure 9.17. This is a very useful technique for adding a softening layer to pictures.

FIG 9.16 Reduced color (step 9)

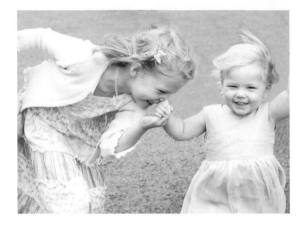

11. Make another new layer; choose white in the color picker and Edit>Fill>Current Color. Change the Layer Composite Method to Soft Light; this will gently lighten the whole picture.

FIG 9.17 Super soften (step 10)

12. Make another new layer and fill again with white. Leave the Layer Composite Method on Normal; this will hide the entire picture.
13. Create a layer mask (click the mask icon in the Layers palette).
14. From the Brush Selector choose the Airbrush>Fine Tip Soft Air brush, size 108, Opacity 10%. Click on the mask to activate it and change the painting color to black. Activate the Tracing Paper briefly to see where you are painting then brush over the faces and clothing and gently remove the white from these areas. Reduce the layer opacity to around 50%. Figure 9.18 shows the picture at this point. As always with a layer mask, if you want to reverse the effect simply choose white in the Color palette and paint in the mask again.
15. Add another new layer and with the same Airbrush as before, size 160, Opacity 10%, slowly paint with white around the edges creating a

FIG 9.18 White layers (step 14)

FIG 9.19 Layers palette at step 15

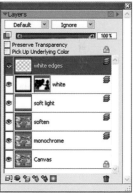

vignette. It is a good idea to paint outside of the picture and allow the brush strokes to gradually encroach into the image. If you don't already have your picture full screen, press Ctrl/Cmd+M to allow you to paint in this way. This creates the soft edges seen in Figure 9.20. You could use an oval selection to make the vignette but I prefer the flexibility available with this method. The layer opacity can be adjusted if necessary. This completes the first stage of the picture.

16. The next step is to create the inset mount. You should have been saving the file at regular intervals but you need to save another copy at this point in its layered version. Then save it again using Save As and give it a new name so that you do not inadvertently overwrite it.

FIG 9.20 White edges (step 15)

17. Highlight all the layers except the Canvas by holding down the Shift/Opt key and clicking on them in turn. All the layers except the Canvas should have turned blue.

18. Click on the Layers palette menu and select Collapse. This will merge all the highlighted layers leaving the Canvas intact. Rename this layer Composite.

19. Select the Rectangular Selection tool from the Toolbox and make a selection which encloses the two children. This can be any size; you can see what I have chosen in the final version on page 259. This technique also works with circular or freehand selections.

20. Select>Save selection and give it a name. This step is useful in case you lose the selection at any point. Make sure the single layer is highlighted before the next step.

21. Edit>Copy then Edit>Paste in Place. This will copy the selection and put it onto a new layer.

FIG 9.21 Drop Shadow dialog box (step 22)

22. With the newly created layer active go to Effects>Objects>Create Drop Shadow. Use the settings in Figure 9.21 or experiment with your own. Tick the Collapse to one layer box. This layer can have the opacity reduced if the effect is too strong; I have reduced it to 68%.

FIG 9.22 Background blending (step 23)

23. Click on the layer above the Canvas and select the Blenders>Grainy Blender 30 and change the size to 41and the Opacity 50%. Paint over all the background that is visible; this will add an attractive texture to the picture.
24. Now to add back some of the original color to the central panel. Go to Select>Load Selection and choose the previously saved selection.
25. Click on the Canvas layer and Edit>Copy and Edit>Paste in Place to create a copy of the layer at the top of the stack. Reduce the layer opacity to about 30%.
26. Return to the Canvas layer, reload the selection and copy and paste the image again to make another layer on top.
27. Change the Layer Composite Method to Screen and reduce the Opacity to 20%.
28. To give this a final blur, go to Effects>Focus>Soften and select Gaussian and level 40.00.
29. The final layer stack is shown in Figure 9.23. Turn the layers on and off to see what each one does – changing the opacity of any layer will alter the final appearance. I have made a final crop to tighten up the composition.

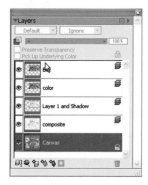

FIG 9.23 Final Layers palette

FIG 9.24 Final picture

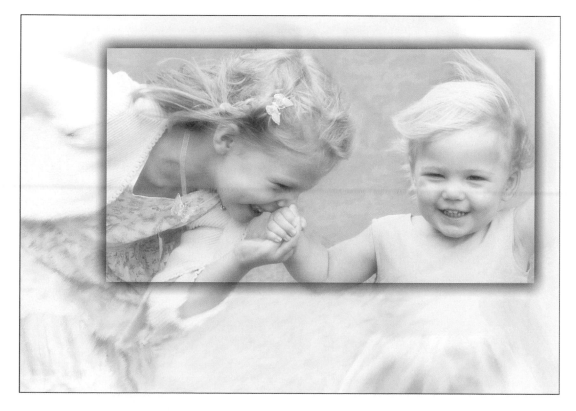

Tutorial files on the DVD

Portrait in Oils

The sun shining through the open door highlights this teenager filling in a waiting moment by playing with his electronic game. The warm tones will work well in Painter but there are background distractions. In this step by step you will see how easy it is to remove undesirable elements by simply painting over them.

FIG 9.25 Original photograph

1. Open 'Griff' from Chapter 10 folder on the DVD.
2. File>Clone.
3. Select the Oils>Round Camel Hair brush, size 41, Opacity 100%, Resat 17, Blend 100 and Feature 7.8. The Feature slider has been increased from the default and will result in a more textured finish.
4. Click the Clone Color option in the Colors palette.
5. Start by painting the curtains. Brush down the folds until the pattern has disappeared and the colors have blended well. The glass doors can be brushed straight down and the horizontal bars reintroduced by running a slightly smaller brush along them.
6. Continue to brush out all the background and the chair – follow the shape of the chair covers (Figure 9.26). This is a fairly large brush and you may well paint over the boy's face or shirt, but this can be corrected quite easily later.
7. Having completed the background and chair, it is time to remove the distractions from the background. In order to really simplify the picture we will remove the two pictures, the stone fireplace on the left, and also the black objects behind his left shoulder. I also feel that the patterned wallpaper will be better painted out.

FIG 9.26 Painting the background (step 6)

8. In the Colors palette untick the Clone Color option so that the brush will paint color rather than clone. Holding the Alt/Opt key, click on an area underneath the picture on the wall; wherever you click, the brush will use that color to paint.

9. Paint over the picture until it cannot be seen, then continue down the wall, hiding the texture of the wallpaper. Change the color frequently so that the wall has some small variations of color. Watch out for the shadow in the corner where the two back walls meet – this should be retained to keep the perspective.

FIG 9.27 Overpainting the background (step 10)

10. Paint out the other wall, picture and stone chimney and the black area by his left shoulder (Figure 9.27).

11. Change to the Soft Cloner brush and clean up the edges of the boy where previous brush strokes have spread too far.

FIG 9.28 Shirt detail (step 12)

12. Use the Camel Hair brush again for his shirt, making sure you are back in Clone Color mode. We will use a smaller brush with less bristles: size 16.9, Opacity 60% and Feature 6.3. Follow the folds of the clothing but also paint the opposite way; this will give a subtle crosshatching effect. The lower opacity with overpainting several times will allow a more subtle finish to build up (Figure 9.28).

13. When you get to the design and writing on the shirt, go out of cloning and paint over the area; remember to sample the color many times and to keep the overall shape of the cloth. Logos and writing on clothes are difficult to handle; if you clone them very accurately it often looks false and if they are smeared then it can look dirty. In this case we will paint out all of the writing then bring back some parts.

14. Turn on the Tracing Paper and reduce the brush size to 2.9. Enlarge the view on the screen and clone the bird design and the posts onto the shirt.

FIG 9.29 Face detail (step 15)

15. We now come to the face where we have another problem because Griff has freckles. We cannot paint every freckle but if we smooth out all the freckles then this will not reflect Griff as he appears. The solution in this case is to clone over the face using a medium opacity and a light touch on the pressure sensitive pen so that the sense of the freckles will still be there but in a diffused form (Figure 9.29). If you are using a mouse for this then reduce the Opacity to around 30%.

16. Reduce the brush size to 4.6, Opacity 60% and the Feature to 2.9. We could use a blender brush here but by altering some aspects of the brush, but retaining the general characteristics, the brush marks stay consistent with the rest of the picture. Paint over the face carefully; don't rush this stage as the face is the most important part of the picture. Under the chin, and for some areas of the face, a larger brush can be used. This will give a slightly more textural finish.

17. Paint the arm and hands in the same way but use a larger brush, around 6.9, and use crosshatching again, pulling the light areas of the arms into the dark. Figure 9.30 shows this stage.

FIG 9.30 Arm detail (step 17)

18. Paint the legs now. Use a larger brush, size 15.6, and a lower Opacity 28% and concentrate on where the light and dark areas come together. The reason for the light strokes pulling into the dark and vice versa is the Resat and Bleed settings. Try changing these and see how the brush characteristic changes.
19. Paint his trousers with the same brush. Remember that we do not need clean edges in this area; slightly smudge the edges to reduce their importance.
20. If you have painted over any part of the electronic game you can restore the clarity with the Soft Cloner, then use the Camel Hair brush, size 5.4, opacity 65% and feature 2.0 to give back some texture.
21. The hair can be done now. Change to the Medium Bristle Oils brush, size 9.6, Opacity 28% and click the Clone Color option in the Colors palette.

FIG 9.31 Hair detail of original picture

263

The default bristles are too thick for this picture so go to the Window menu on the top bar, click on Brush Controls and then on Show Bristle. This will bring all the brush control palettes on screen and in the Bristle palette change the thickness to 29%.

22. Brush over the hair following the flow of the hair and allow the brush to streak out a little around the edge of the head so that the transition between the head and background looks good.

23. The back of the head is very black so untick the Clone Color option and reduce the brush opacity to about 15%. Holding the Alt/Opt key click on a lighter part of the hair to select a suitable color and then lightly brush in some detail into the very dark areas. Don't fill all the dark areas in, just enough to provide some detail and texture. Figures 9.31 and 9.32 show details of the work on the hair.

FIG 9.32 Hair detail of final picture

24. As always, this is the time for a final check around the picture and to finish any areas which are not satisfactory. Crop if necessary.

25. To finish the picture it is often useful to add a texture overlay in order to emphasize the brush strokes. It is more flexible to apply this on a separate layer so that it can be reduced later if it proves to be too intrusive.

26. Select>All, Edit>copy, then Edit>Paste in Place will make a new layer with a copy of the Canvas.

27. Effects>Surface Control>Apply Surface Texture. Select Image Luminance in the Using box, set the Amount at around 30% and click OK.

28. Check the result at 100% size on the screen. I reduced the overall layer opacity to 41% and still felt that the brush strokes on the face were too intrusive, so I made a layer mask and painted with gray in the mask, which reduced the effect on the face but left the remainder intact.

FIG 9.33 Griff

Blenders and Pastels

This step by step example shows how to create a soft gentle picture, the sort that will suit a newly born baby. Auto-Painting takes us through the first stage and then one of the new Real brushes, introduced in Painter 11, is used to bring in the detail. This brush has a very attractive painterly texture which will clone and blend the colors beautifully, yet when reduced in size is capable of really good detail.

1. Open 'Jesse' from Chapter 9 folder on the DVD.

FIG 9.34 Original photograph

2. File>Clone (not Quick Clone as we want to blend the existing photograph).

FIG 9.35 After Auto-Painting

3. Select Basic Paper from the Papers palette.
4. Select the Blenders>Oily Blender, size 66.6 and Opacity 43%.

5. Click the Clone Color option in the Colors palette.
6. Open the Auto-Painting palette, ensure that the Smart Stroke box is not ticked, and select Scribble Large. Turn the Tracing Paper off.

FIG 9.36 Bringing in more detail with the Real Soft Pastel brush

7. Click on the Start button and allow to run until all the picture is blended, about 3–4 minutes probably, depending on the speed of your computer (Figure 9.35 shows this stage).
8. Select the Pastels>Real Soft Pastel, size 104 and Opacity 22%.

FIG 9.37 Painting with the smaller sizes will bring in extra detail

9. Paint the face and surrounding area, and also the rabbit and blue bear; this brush will start to return some definition to the shapes. Turn the Tracing Paper on and off regularly to check where to paint (Figure 9.36).

10. Use your pressure sensitive pen at an angle to smudge and smooth areas; paint with the pen vertical to bring in more detail.
11. Reduce the brush size to 48.2 and paint over the central areas again. When you need to refine an edge, such as the hair, paint both sides of the line – this clarifies the different tones.
12. Use circular polishing movements when painting the face – this will smooth the features.
13. Reduce the brush size to 21.3, increase the Grain to 43%, and paint the face and also the toy which says 'It's a Boy'. At this size the brush will bring in a lot of detail, so only paint the key areas as the less important sections will look better very diffused (Figure 9.37).
14. Increase the brush size to 56.6, reduce the Opacity to 12% and soften any areas that look rough.
15. Make a copy of the Canvas (Select>All, Edit>Copy, Edit>Paste in Place) and in the Underpainting palette increase the Brightness by 12% to give the picture more sparkle.

FIG 9.38 Jesse

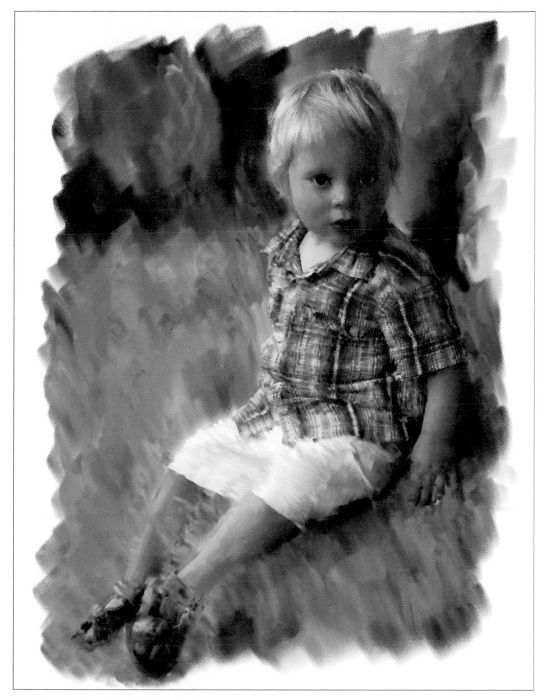

FIG 9.39 Jack, painted with the Real Soft Colored Pencil

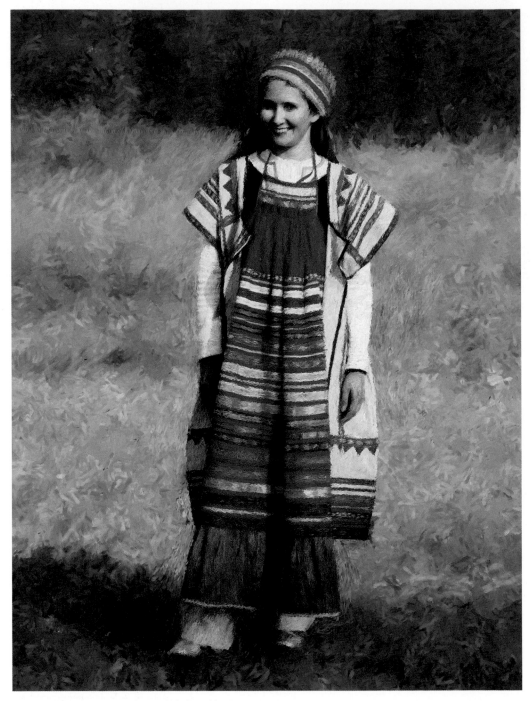

FIG 10.1 Kensia, painted with the Impressionist brush

Portraits

I n this chapter we look at various ways to make portraits of adults using a range of different brushes and techniques. As always when making portraits in Painter it is for you to decide just how painterly they should appear. The step by step examples included here are all fairly close to the original photographs however this is just a matter of choice and you can decide whether to make any one more impressionistic by increasing the amount of painting.

These techniques are intended to give you the basics and can be taken further depending upon the result you think appropriate.

Also in this chapter are included several ideas for handling pictures of weddings and how to take standard photographs and turn them into something that bit special for the bride and groom.

Portrait using Artists Oils

The brushes in the Artists Oils category have many interesting features that closely replicate the performance of a real brush. Two of the special features are that when sampling colors from an original to a clone copy the brushes will pick up multiple colors. Another speciality is that the brushes run out of paint fairly quickly as a real brush does. This portrait step by step takes advantage of both these features and in addition uses the Auto-Painting feature first introduced in Painter X to start off the painting.

1. Open 'Bob' from Chapter 10 folder on the DVD.

FIG 10.2 Original photograph

2. File>Quick Clone to clear the clone copy.
3. Select the Blender Bristle brush from the Artists Oils brush category, brush size 60.0, Opacity 100%. Click Clone Color in the Colors palette.
4. Window>Show Auto-Painting. Tick Smart Stroke Painting and leave Smart Settings unticked as in Figure 10.3.
5. Click the arrow in the Auto-Painting palette to start the auto-clone. This will continue to paint until you either depress the Stop button or click inside the picture. This will provide a roughly painted base for the picture. Let the program run until nearly all the picture has been painted, then stop the Auto-painting and, with the same brush paint, out all the white areas that have been missed. Figure 10.4 shows the process; turn off the Tracing Paper to see the result.
6. Reduce the brush size to 35 and untick the Clone Color option so that the brush is painting rather than cloning. Hold down the Alt/Opt key and click into the picture to sample a color to paint with. Start with a darkish brown color. The way that this brush works is that it will start painting with the selected color, run out of paint fairly quickly, and then turn into a blender. We can use this feature by introducing a color onto the Canvas and then continuing to paint with the brush and blend this new color gently into the

FIG 10.3 The Auto-Painting palette

Auto-Painting

☑ Smart Stroke Painting
☐ Smart Settings

Stroke
Scribble Large

Randomness: ◄ ► 80%
☐ Pressure: ◄ ► 85%
☐ Length: ◄ ► 75%
☐ Rotation: ◄ ► 180°
Brush Size: ◄ ► 75%

Speed: ◄ ► 100%

existing colors. The intention in using this on the background is to darken it right down but still to retain traces of the original colors to add interest and subtlety. Change the sampled color regularly, making the bright areas darker and introducing touches of color into the black areas. Use the Tracing Paper to check where the figure is, and paint over the edges to keep the background consistent. The figure will be cloned in again in a later step. Figure 10.5 shows the picture at this point.

FIG 10.4 The Auto-Painting process

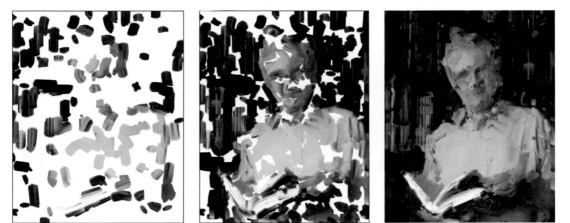

7. Reduce the brush size to 21 and the Opacity to 40%. Click the Clone Color option in the Colors palette and start to paint the shirt. Keep the brush strokes short to retain a chunky feel to the painting; use longer light strokes to smooth down the larger areas.

FIG 10.5 Picture at step 6

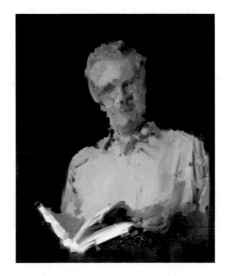

8. We now turn to the face and have a change of brush. Art Pen Brushes>Soft Flat Oils will be much softer and allow more detail to return to the face. Use Clone Color and set the brush size to 40 and the Opacity at 100%. Turn the Tracing Paper on and start painting the face. The speed with which you use this brush is critical: too fast and the face will be completely blurred, too slow and the detail will be too clear. Brush slowly, just enough to see some detail, and make short brush strokes. Paint over all the face and hair.

9. If you have made the face too clear, reduce the Opacity to 30% and make short fast brush strokes over the area – this will diffuse the area. Try making rapid dabs with the brush – this adds a texture which can be softened again by using the same brush.

10. Reduce the brush size to 10 and 24% Opacity, and work over any rough areas that need smoothing out.

FIG 10.6 Detail of shirt

11. Paint over the hair with the same brush – take it out of Cloning mode and paint directly with color to improve texture; Alt/Opt-click in the picture to sample colors. Darker parts of the hair will benefit from this application of lighter color and texture.

12. Check over the picture and make any final adjustments.

13. Make a new layer and Select>All, Edit>Copy, Edit>Paste in Place to make a copy of the Canvas.

14. Effects>Tonal Controls>Apply Surface Texture. Select Image in the Using box and 25% as the Amount.

15. Adjust the layer opacity to suit the picture; I suggest around 35% to add a light texture to the brush strokes but not to be intrusive. I have cropped the picture slightly to tighten up the composition and also to remove some of the hand under the book, which did not look very satisfactory. This completes the portrait of Bob.

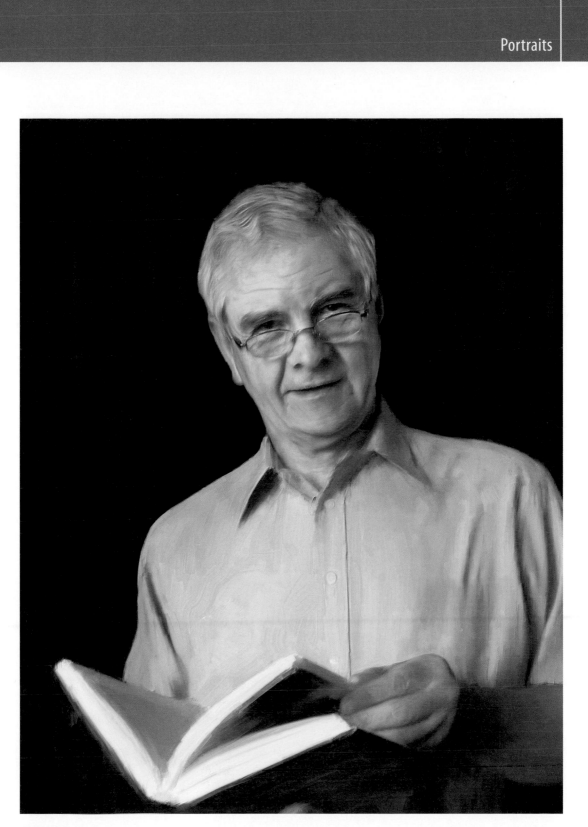

FIG 10.7 Bob

Tutorial
files on the
DVD

Portrait using Pastels

Pastel brushes are excellent for making a picture from this colorful and joyous photograph. These two delightful ladies were enjoying a visit to a jazz festival, a lifelong love, and I captured them in all their colorful clothing beneath a traditional jazz umbrella. In the painterly version we will retain the strong colors and vivacity of the scene.

1. Open 'Jazz Ladies' from Chapter 10 folder on the DVD.

FIG 10.8 Original photograph

2. File>Clone.
3. Select the Pastels>Round Soft Pastel 40, brush size 40, Opacity 100%.
4. Click the Clone Color option in the Colors palette.
5. Select the Sandy Pastel Paper in the Papers palette.

FIG 10.9 Underpainting at step 6

6. Paint over the picture ensuring that the entire photograph is covered. Follow the general direction of the colors so that the picture still retains the

overall shapes. The aim is to produce an underpainting into which more detail can be cloned with a smaller brush. Paint over the faces as well.

7. Before we start adding detail it is good to deal with any problem areas such as the dark corner bottom right. Take the brush out of Cloning mode by unticking the Clone Color option. Sample the painting color by holding the Alt/Opt key and clicking in the picture – in this case one of the gray colors next to the very dark corner. Paint over the dark corner, changing the color at regular intervals so that the result is a blend of colors that matches the color and texture of the rest of the picture.

8. Reduce the brush size to 20 and the Opacity to around 50%, and paint over any other areas that look too dark.

9. Click the Clone Color option again, reduce the brush size to 7.5, Opacity to 100%, and paint down the umbrella handle. Go over this again with brush size 20 to blend it with the background.

10. Reduce the brush size to 13.0 and paint more detail into the hat and the hair of both ladies – this size brush will give a softer finish (Figure 10.10).

FIG 10.10 Detail of hair at step 10

11. Using brush size 10, with 100% Opacity, paint over the colorful red and purple feathers to bring out more detail and highlights. Use the Tracing Paper to check where the areas of contrast are greatest and paint over these.

12. Change the brush size to 10 to paint the faces and gently emphasize the detail. Repeated strokes in one direction will smooth out the textures.

13. Reduce the brush size to about 3.4 to paint the eyes and, using the Tracing Paper, carefully paint following the light and dark areas. This size

FIG 10.11 Faces at step 14

brush may lose the texture. Paint over the same areas using brush size 8.9 which will soften the appearance.

14. To bring back more clarity in the eyes switch to the Soft Cloner brush and restore detail from the original, then lightly brush over with the Pastel brush to blend with the rest of the picture. Do the same with the teeth. Figure 10.11 shows the faces at this stage.

FIG 10.12 Hair detail added using the Square X-Soft Pastel

15. Having completed most of the picture it is time to add the important finishing touches to improve the detail and textures of the picture. The hair needs better definition so change to the Square X-Soft Pastel 30, size 3.4 Opacity 27%. Tick Clone Color and clone in the hair to add more texture.

16. If the result is too harsh, change the Resat to 0 and the Bleed to 100%. This changes the brush to a blender, which will soften the brush strokes where necessary.

17. Change to the Artist Pastel Chalk, tick Clone Color, and polish any rough areas of the face. This also works well as a blender and is excellent on skin. Use a size 10 brush with 11% Opacity.

18. Paint out the top left corner with suitable colors to avoid a change of color in that area.

19. Add a surface texture if required, as in the previous example, and make any final tonal adjustments.

20. This completes this step by step example. As you will have seen, the Pastel brushes are very versatile and particularly effective with pictures of people.

FIG 10.13 Jazz Ladies

Acrylics Real Wet

In this tutorial one of the new brushes from Painter 11 will be used to paint this lady in her beautiful traditional Russian dress.

1. Open 'Ksenia' from Chapter 10 folder on the DVD.

Tutorial files on the DVD

FIG 10.14 Original photograph

2. File>Quick Clone.
3. Select the Acrylics>Real Wet Bristle brush, size 92.2 and Opacity 75%.
4. Click the Clone Color option in the Colors palette.
5. Paint all the background and up to the edge of the figure. It does not matter if the brush goes over the edge as this can be repainted later.
6. Reduce the brush size to 25 and paint over the figure. Roughly follow the lines of the clothing but there is no need for detail at this stage. Figure 10.15 shows the picture at this point.

FIG 10.15 Using the Real Wet Bristle brush

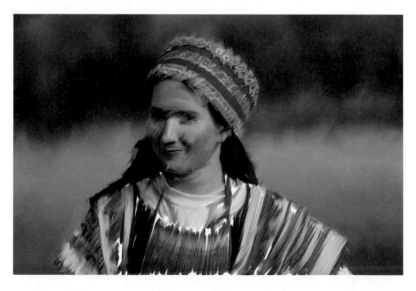

7. Reduce the brush size to 13 and, beginning with the head covering, follow the lines of the material carefully and bring in the detail. Make circular brush strokes around the top edge, then long diagonal strokes on the red, and cross strokes on the next layer. Figure 10.16 shows the detail.

FIG 10.16 Detail in the head covering

8. Continue with the dress using size 13; follow all the lines and colors. Figure 10.17 shows the detail.

FIG 10.17 Detail of the dress

9. Change the brush size to 32.2 and the Opacity to 35%. Paint over the face in a circular motion – this will smooth out the textures.
10. Reduce the brush to size 10 and gently brush over the face once again to bring in the detail, particularly in the eyes, nose and mouth.
11. Check the picture to ensure that you are happy with the finish, then apply surface texture.
12. Copy the Canvas layer (Select>All, Edit>Copy, Edit>Paste in Place).
13. Effects>Surface Control>Apply Surface Texture. Select Image Luminance and set the Amount slider at 25%. This will add a texture based on the picture, emphasizing the brushwork.
14. Copy this surface texture layer.
15. Change the paper to Artists Canvas.
16. In the Papers palette, change the Paper Scale to 165% and the Contrast to 160%.
17. Effects>Surface Control>Apply Surface Texture. Select Paper and set the Amount slider at 25%. This will add a texture based on the paper selected.

FIG 10.18 Ksenia

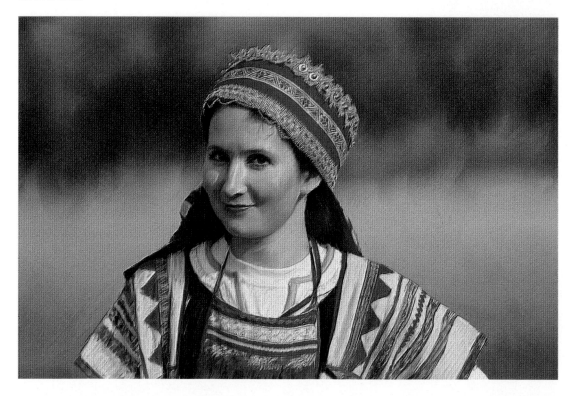

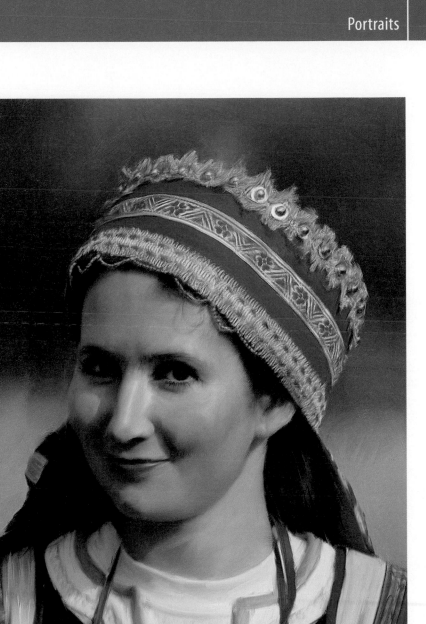

FIG 10.19 Ksenia detail

Design ideas for portraits

Painter can be valuable in creating design concepts as well as making cloned pictures. In this example the original photograph will be overlaid against a painted backdrop.

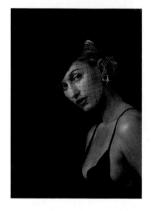

FIG 10.20 Original photograph

1. Open 'Donna' from Chapter 10 folder on the DVD.
2. Open the Layers palette and make a copy of the Canvas layer (Select>All, Edit>Copy, Edit>Paste in Place).
3. Activate the Rectangular Selection tool in the Toolbox and draw a selection to include the head of the model.
4. Select>Save Selection and give it a name.
5. With the new layer active make a copy; (Edit>Copy, Edit>Paste in Place) this will place a copy of the selected area on a new layer above.
6. Hide the top layer by clicking the eye icon and activate the layer below.
7. We need to lighten and desaturate this layer, so go to Effects>Tonal Controls>Adjust Colors and adjust the sliders to Saturation −55 and Value +40.
8. Blenders>Grainy Blender 30, size 85 and Opacity 100%.
9. Change the paper to Sandy Pastel.
10. Blend the whole layer so that the picture is very well diffused. Turn the top layer on to see the effect and make further blending adjustments.
11. Select>Load Selection and choose the name you used for the selection.
12. Select>Modify>Border and enter 4 pixels as the size. Change the color to white in the Colors palette, then Edit>Fill with the current color.
13. To make a drop shadow go to Effects>Objects>Drop Shadow. Change the Opacity to 80% and the Radius to 30 pixels, but leave the offsets at 10, angle at 114.6 and thinness at 45%. Tick the Collapse to one layer option.
14. Activate the middle layer again and use Adjust Colors again to lighten and desaturate some more. I used −24 Saturation and +46 Value.
15. Finally crop the picture.

FIG 10.21 Making the selection and the picture at step 10

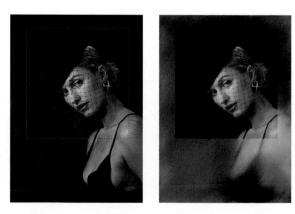

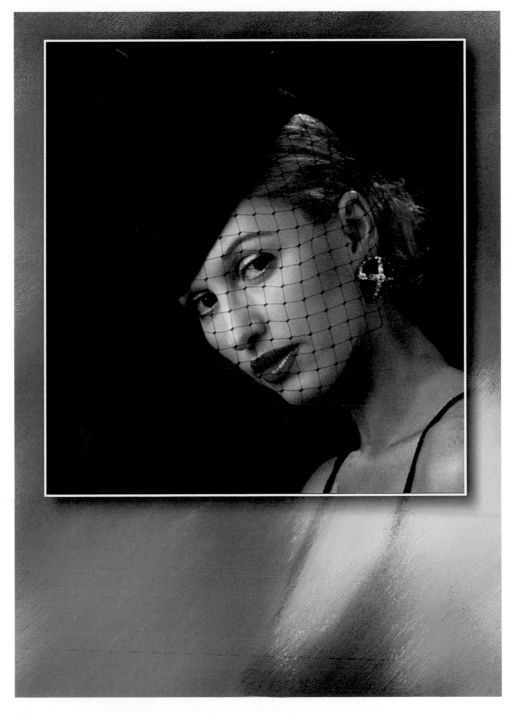

FIG 10.22 Donna

Moody portrait

This example starts with a studio portrait and transforms it to a dark and moody, low light picture. The process is simple and easy to follow.

1. Open 'Donna' from Chapter 10 folder on the DVD.
2. File>Clone. Do not clear the picture.
3. Using the Eyedropper, click on a point behind her head to sample the color which is a dark red. Edit>Fill with the current color.
4. Select Cloners>Soft Cloner brush, size 72.1 and Opacity 2%. Lightly brush in the face – with this opacity the face will just be visible.
5. Reduce the Opacity to 1% and brush in the rest of the body.
6. Increase the Opacity to around 5% and go over the face again to make this brighter. To finish off the picture add a surface texture called Artists Canvas. This process is covered in detail in Chapter 5 'Paper textures'.

FIG 10.23 Original photograph

FIG 10.24 Low light portrait

Weddings

Weddings are a staple for many professional photographers and one way in which to sell a premium product is to offer a painted version of selected wedding portraits. Some techniques which can achieve this using Painter are demonstrated in this chapter. In all cases the emphasis is on being able to achieve the result as quickly as possible and without any knowledge of traditional painting techniques.

This first example takes a head and shoulders color portrait and turns it into a hand colored delicate image. The techniques are all done using Painter, but some of the steps could be achieved in Photoshop, if you are more conversant with that program, and the painterly steps completed in Painter.

1. Open 'The Kiss' from Chapter 10 folder on the DVD.
2. Make a copy of the Canvas, Select>All, Edit>Copy, Edit>Paste in Place.
3. Effects>Tonal Controls>Adjust Colors and move the Saturation slider to the far left. This will change the layer to Monochrome.
4. File>Clone. This will make a clone of the Mono layer only.
5. Change the paper texture to Basic Paper.
6. The background is messy so we need to even it out, and before blending you should add some paint dabs. Select the Chalk>Variable Width Chalk brush at the default settings. Paint light into dark areas and dark into light.
7. Select the Blenders>Grainy Blender 30, size 84, Opacity 100%, and completely blend out the background. The dabs of paint you added in the last step have evened out the tones but left some variation in the background.

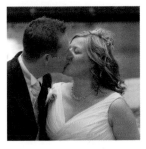

FIG 10.25 Original photograph

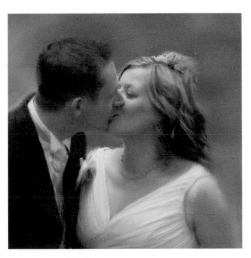

FIG 10.26 The picture at steps 5 and 6

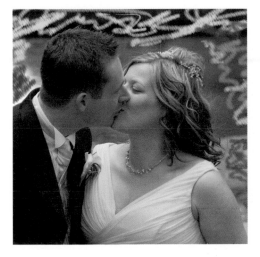

FIG 10.27 Detail at step 7 and the picture at step 8

8. Reduce the brush opacity to 10% and brush lightly over the figures following the general direction of the clothes. This will remove the last of the photographic finish.

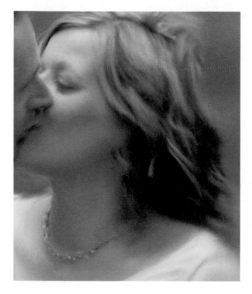
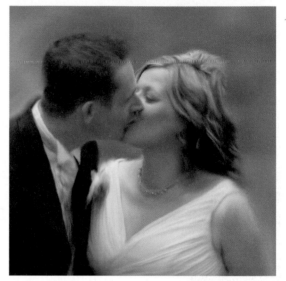

9. Change the brush to Smart Stroke Brushes>Acrylics Captured Bristle, size 11, Opacity 15%, Resat 0, Bleed 38%. Blend the faces and figures, concentrating on the edges where the finish is rough; the roughness helps this blender to work. Remember that as with all blenders the brush will drag one color into another so avoid dragging black areas into white as they will look dirty. Use this same brush at a larger size to clean up any rough areas in the background or to soften areas.
10. Make a new empty layer and Fill>Clone Source; this will put the original color picture on top of the layer stack.
11. Change the Layer Composite Method to Color.
12. Add a layer mask to this layer and click on it to make sure it is active.
13. Use the Tinting>Basic Round brush size 20, Opacity 13%, with black paint and paint out all the background leaving the figures in color. Use a smaller brush to clean up edges around the figures.
14. Reduce the layer opacity to zero then gradually bring it up until the color is visible but subtle. I made the opacity 50%.
15. Finally, make any last minute adjustments and crop the picture.

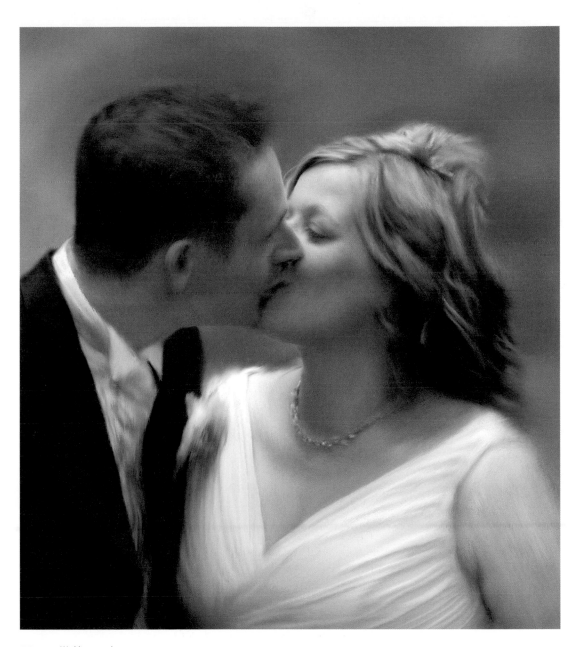

FIG 10.28 Wedding couple

Tutorial files on the DVD

Bride in white

The intention with this example is to show how a simple picture of a bride can be represented in several ways to create pictures which are romantic yet different.

Prior to starting this step by step example I have painted out the background as it was not very suitable. This can be done easily by using a brush with white paint on a separate layer on top of the Canvas.

FIG 10.29 Original photograph

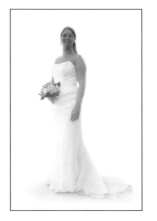

1. Open 'Rebecca' from Chapter 10 folder on the DVD.
2. File>Clone.
3. Select the Blenders>Grainy Blender 30, size 30, Opacity 38%. This is used as a blender not as a cloner.
4. In the Papers palette change the paper to Sandy Pastel.
5. I will mention here once again the convenience of using custom palettes for the brushes you are going to use. This is very useful if you intend to use the same process again on another picture. There is more information on making and saving palettes in Chapter 1. For now, click on the brush variant icon on the Brush Selector bar and drag it out onto the desktop; this will instantly make a custom palette. As you use the different brushes in this step by step, you can add them to this palette by dragging the brush icons to your new custom palette.
6. Enlarge the picture on screen to 100% and begin painting the dress. Paint the top first and paint down the dress; this will smooth out the creases and remove the detail. Figure 10.30 shows the difference.

FIG 10.30 The dress before and after blending

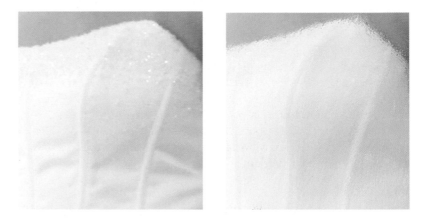

7. Continue down the dress painting downwards, but if you need to remove more detail paint across the line and then blend down again; this breaks up the picture texture. Do this on the outside edges of the dress so that it appears to blend into the background.

8. At the bottom of the dress the blender will drag out the edges beautifully, but do it gently so that the brush strokes show a delicate texture rather than a rough edge. See Figure 10.31 for the details. Paint over the floor at the same time, blending out all the detail.

FIG 10.31 The dress before and after blending

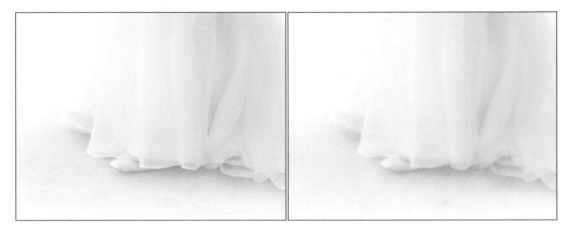

9. Change the brush now to the Blenders>Soft Blender Stump 10, size 13, Opacity 30%. Drag this brush to your custom palette and position the icon to the right of the existing one – the icon is the same as the first.
10. Very gently run over the edges of the bottom of the dress – this will just soften the edges a little.
11. Turning now to the face, use the Soft Blender Stump, size 8, Opacity 25% and blend the face. As always take care not to drag darker colors into light areas; blend out the detail leaving a soft looking skin. Continue down the neck and arms using a larger brush, size 15.0 and 50% Opacity.
12. Blend the hand, including the ring, but then change to the Soft Cloner and bring the ring back so that is clear. Drag the Soft Cloner to your custom palette as you will need to use it later on.
13. To paint the flowers change to the Pastels>Artist Pastel Chalk, size 5, Opacity 100%. Click the Clone Color option. Paint using small circular strokes to create an attractive texture to the petals and leaves. Add this brush to your custom palette.
14. We now need to add the finishing details. Use the Soft Cloner, size 2, and Opacity 24% to add the suggestion of her necklace. Turn on the Tracing Paper to help identify where the chain lies. If it is too clear you can diffuse it with the Soft Blender Stump at a low opacity. Do the same process for the earrings and a few of the crystals at the top of the dress.

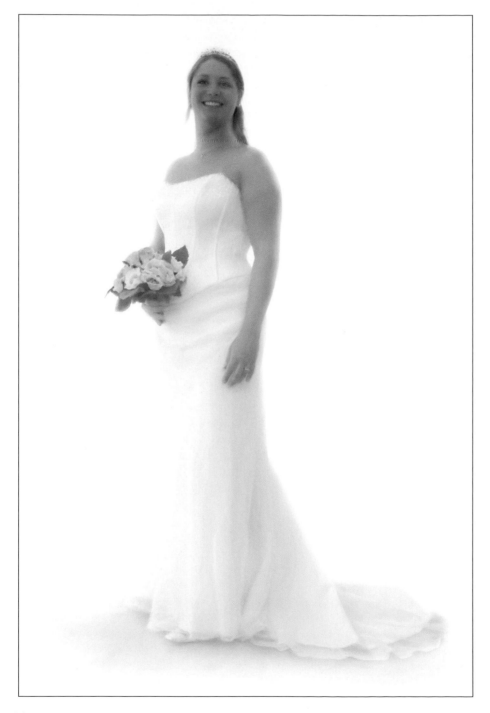

FIG 10.32 Rebecca

FIG 10.33 Another simple picture created from a photograph of the back of the dress

FIG 10.34 The main picture has been cropped and a white layer placed on top of the Canvas in Color Layer Composite Method

FIG 10.35 This version has been softened with the Soft Blender Stump and then cropped to isolate the single shoe peeping from the beautiful dress

FIG 11.1 Woodcut panel

Special effects

At the heart of Painter is the vast range of brushes and art materials which have been explored in earlier chapters, but the program also has a range of special effects and this chapter explores a selection of them.

Special effects in Painter come in many forms; some are in the Surface Control and Focus menus, while others are in the Layers palette in the form of Dynamic Plug-in layers.

One of the most fascinating effects in this section is Kaleidoscope. This creates wonderful patterns as the viewer is moved over the picture – so easy to make and enjoy.

What is common to them all is the ability to make photographs look very different indeed.

Tutorial files on the DVD

Woodcut

The Woodcut effect creates a very creditable woodcut from a photographic original; generally pictures with simple shapes work best. The process creates both monochrome and color images.

FIG 11.2 Original photograph

1. Open 'MG badge' from Chapter 11 folder on the DVD.
2. Effects>Surface Control>Woodcut.
3. Remove the tick from the Output Color box and use the following settings: Black Edge 64.94, Erosion Time 14, Erosion Edge 1.0, Heaviness 50%. The result is shown on the left in Figure 11.3.
4. Colored versions can also be created; open the same picture and add the tick back in the Color Output box; leave the other settings unchanged. This will produce the version on the right in Figure 11.3.

The color can be controlled in various ways; with Auto-Color ticked the woodcut will be colored using the selection of colors shown in the preview window.

The quantity of colors to be used can be altered by using the N Colors slider. Usually it is more effective to use a limited range of colors, but try moving the slider to see the difference.

Instead of using the default set of auto-colors, you can also choose another color set on which to base the colors. Tick the Use Color Set option, open the Color Sets palette and load a color set.

FIG 11.3 The results after using the Monochrome and Color options

Apply Screen

When the Apply Screen effect is used, the original luminance values are split into three tones; three colors can then be chosen in the dialog box which will be applied to the picture.

1. Open 'Portrait' from Chapter 11 folder on the DVD.
2. Effects>Surface Control>Apply Screen. Enter Threshold 1: 94% and Threshold 2: 73% (Figure 11.5).
3. Select Image Luminance in the Using box.
4. Click on the color swatch in the middle and choose a color. You can change all three colors if you wish, but leaving white and black as the endpoints usually creates greater impact.

Threshold 1 slider controls the balance between the two right-hand color swatches, while Threshold 2 controls the left slider.

The source of the surface texture can be changed in the Using box in the same way as the Apply Surface Texture was described in Chapter 5 'Paper textures'.

FIG 11.4 Original photograph

FIG 11.5 The Apply Screen dialog box and two pictures created with different settings

Distress

Distress is in the Effects>Surface Control menu and can make powerful graphic statements from your photographs. Most of the detail will be etched away and replaced with heavy grain. A clear strong picture is needed to get the best out of this effect.

FIG 11.6 The Distress dialog box

The sliders interact with each other to get a balance of detail and overall exposure. Some of the sliders require very small movements to make a dramatic difference.

As in many other Effects dialog boxes, Distress can be based on either the current paper texture or the Luminance of the picture.

The sliders control the size and amount of the edges, the smoothness of the image, and the amount of grain added.

Threshold alters the amount of black and has a very powerful effect on the result. Remember that for fine adjustments of all sliders you can click the small arrows at each end.

Open the 'Poppy' picture from the DVD. Make a clone copy (File>Clone). Apply the Distress effect using the Original Luminance as the source. Other settings are: Edge size: 63.53, Edge amount: 58%, Smoothing: 2.04, Variance: 124% and Threshold: 44%.

FIG 11.7 The Distress effect applied to a photograph. Color from the original has been overlaid on the second version

To create the colored example, apply the Distress effect, make a new layer and then copy the original photograph on the top layer (Edit>Fill: Clone Source). Change the Layer Composite Method to Screen; this will add the color in the black areas created by the Distress effect (Figure 11.7).

Quick Warp

The Quick Warp effect (Effects>Surface Control>Quick Warp) does exactly what the title says – it warps the photograph in various ways, and it does it quickly!

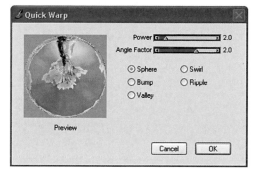

FIG 11.8 The Quick Warp dialog box

There are five options in the Quick Warp dialog box.

Sphere turns the picture into a circle, as below. It also distorts it in many other ways depending upon the Power and Angle settings.

Bump expands the center of the picture.

Valley squeezes the image to the center.

Swirl turns the picture clockwise or anti-clockwise from the center.

Ripple can create the effect of a whirlpool, depending on the position of the two sliders.

FIG 11.9 Quick Warp sphere has been applied to the picture on the left, and Swirl and Sphere to the one on the right

FIG 11.10 The Sketch dialog box

Sketch

The Sketch effect reduces a color photograph to a line drawing. It can be used on its own or, in many cases, the effect can be mixed back into the original photograph to give a delicate colored effect.

1. Open 'Victorian building' from Chapter 11 folder on the DVD (Figure 11.11).
2. File>Clone.
3. Make a copy of the Canvas on which to apply the Sketch effect (Select All, Edit>Copy, Edit>Paste in Place).
4. Effects>Surface Control>Sketch. Enter the following settings: Sensitivity 4.0, Smoothing 1.42, Grain 0.00, Threshold High 34%, and Threshold Low 100%.

FIG 11.11 Original photograph

Figure 11.12 shows the Sketch effect applied on the Building layer. The amount of noise in the background depends largely on the Threshold sliders; how you balance those two and the Smoothness slider will define the amount of detail in the sketch.

The Sketch effect as applied on this picture is not successful on its own, but it provides a starting point to make a more satisfying picture.

5. Change the Layer Composite Method of the Sketch layer to Overlay. This will change the picture considerably, lightening and putting edge lines over the original.
6. Right-click the layer to make a duplicate copy in the Layers palette.

FIG 11.12 Applying the Sketch effect

7. Figure 11.13 shows how this extra layer, which is also in Overlay Method, strengthens the effect. Reduce the Opacity of the layer to about 36% to bring back a little more color. Reduce the Opacity of the layer below if necessary.

FIG 11.13 Adding two copy layers in Overlay Composite Method

FIG 11.14 The Glass Distortion dialog box

Glass Distortion

Glass Distortion creates distortions of the original photograph based on a variety of sources. The effect is available from Effects>Focus>Glass Distortion.

In the Glass Distortion dialog box shown in Figure 11.14, the first option box is Using and the choice of where the texture comes from is identical to the Apply Surface Textures dialog box covered in Chapter 5. The choices are Paper, 3D Brush Strokes, Image Luminance and Original Luminance. As the Paper option is based on the huge range of papers supplied with Painter the choice is very wide.

Map options are Refraction, Vector and Angle Displacement. The last two options work in conjunction with Image Luminance in the Using box, which will result in powerful distortions of the image – you may have to increase the Amount to see the difference.

Softness smoothes the distortions.

Amount increases the overall effect.

Variation distorts the pattern into less recognizable patterns.

Direction works in conjunction with the Angle and Vector Displacement options.

The photograph of Magnolia has used the Image Luminance option with the settings as in Figure 11.15.

The Faceless image has used the Paper option; the paper choice was New Streaks, which has pulled the texture to the right.

FIG 11.15 Two photographs altered with the Glass Distortion effect

Liquid Lens

Liquid Lens is definitely one of the fun effects in Painter. It does what it says – it turns your precious photograph into liquid and then distorts the picture by using the various controls.

Open a picture and bring the Layers palette on screen. At the bottom of the palette click the second icon from the left, which is shaped like a plug, and in the drop down menu which appears select Liquid Lens.

FIG 11.16 The Liquid Lens dialog box

The icons in the dialog box distort in particular ways when painted in the picture.

The first icon top left simulates the effect of a droplet falling into water; select the icon then click and drag in the picture to increase the distortion.

The two icons top right twist the image to the right or left.

The two icons immediately below these will make the picture bulge or contract.

The eraser icon removes any distortion, returning the picture back to its original state.

The brush icon will distort as the brush is dragged over the picture; this is like the Distortion brushes found in the Brush Selector.

The sliders modify the options and will alter the amount of the distortion, the smoothness, the brush size and how the dabs are spaced.

The four buttons along the bottom of the palette will clear the picture of distortion and reset the sliders to their default setting. The less obvious button is called Rain, which simulates droplets of water falling on top of your picture. OK accepts the effect.

FIGURE 11.17 Two photographs distorted by the Liquid Lens

Bevel World

Bevel World is another Dynamic Plug-in and can be used to make bevels of all types, whether simply to add a border to a picture or to make a creative montage.

FIG 11.18 The Bevel World dialog box

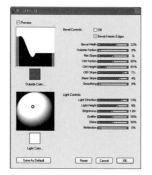

1. Open 'Mannequin' from Chapter 11 folder on the DVD.
2. Copy the Canvas (Select>All, then hold down the Alt/Opt key and click in the image using the Layer Adjuster tool).
3. On the top layer make a square selection with the Rectangular Selection tool from the Toolbox.
4. Select>Invert Selection.
5. Edit>Cut. This will remove the area around the selection.
6. Make a copy of this layer (Select>All, Edit>Copy, Edit>Paste in Place) and turn off the layer visibility.
7. Make the middle layer active and click the Dynamic Plug-ins icon in the Layers palette. Select Bevel World.
8. Move the sliders to see what bevels are possible; the preview is very slow. Click OK when you have found a suitable style.
9. Turn on the visibility of the top layer. Make it active and change the Layer Composite method to Color and reduce the Opacity to 61%. This will strengthen the colors.
10. Click on the Canvas and in the Underpainting palette reduce the amount of Saturation, Value and Brightness to dull the outer area.

FIG 11.19 The Bevel World Dynamic Plug-in has been applied to these photographs

The flower picture was created with the same method except for the selection being circular and a different bevel was chosen.

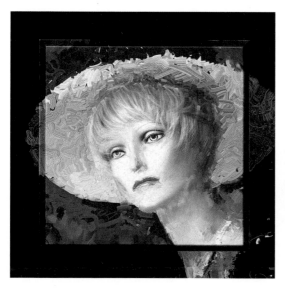

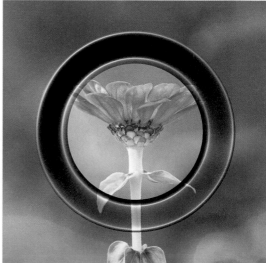

Burn

Burn is a Dynamic Plug-in layer, which means that the layer can be re-activated at a later date and the settings changed. You must however save the picture in Painter's RIFF file format.

1. Open 'Hellebore' or 'Cross' from Chapter 11 folder on the DVD.
2. The Burn effect will be based on a selection, so Select>All to burn the edges of the whole picture. You can make a selection with the lasso or one of the other selection tools if you require only a part of the picture to be burnt.
3. Bring the Layers palette on screen and click the second icon from the left, which is shaped like a plug. In the drop down menu select Burn.
4. When the dialog box appears (Figure 11.20) leave the settings unchanged and click OK.

A new Dynamic Plug-in layer will have been created; hide the Canvas layer to see the burnt edges. The sliders can be changed to adjust the edge effect and, by clicking in the color swatch, the color used may also be changed.

Be aware that it is extremely slow getting the preview updated, so it is difficult to assess the result quickly.

FIG 11.20 The Burn dialog box

FIG 11.21 The Burn effect applied to at different settings

Kaleidoscope

Kaleidoscopic images are great fun and with Painter are incredibly easy to make. Try this out with the photograph on the DVD, or try one of your own, using the steps below.

1. Open any demonstration file from the DVD.
2. Bring the Layers palette on screen and click the second icon from the left, which is shaped like a plug. In the drop down menu select Kaleidoscope.
3. In the dialog box (Figure 11.22); change the size to between 600 and 1000 pixels; the default size is 100 which is too small for most pictures.
4. Turn off the visibility of the Canvas layer.
5. Click and drag the kaleidoscope and move it around the picture – the pattern changes constantly as it is moved.
6. When you find a design you like simply crop to the size of the kaleidoscope, drop the layer, and save the picture.

FIG 11.22 The Kaleidoscope dialog box

Every time the kaleidoscope icon is clicked a new layer is made. This means that you can apply the Kaleidoscope effect on top of an existing kaleidoscope layer, thereby making even more complex designs.

The patterns on these two pages have been created using photographs taken from the DVD which accompanies this book. See if you can work out which pictures they are – it will not be easy!

FIG 11.23 The Kaleidoscope effect applied to pictures in Chapter 3

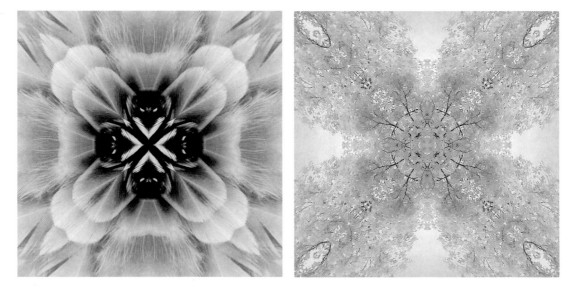

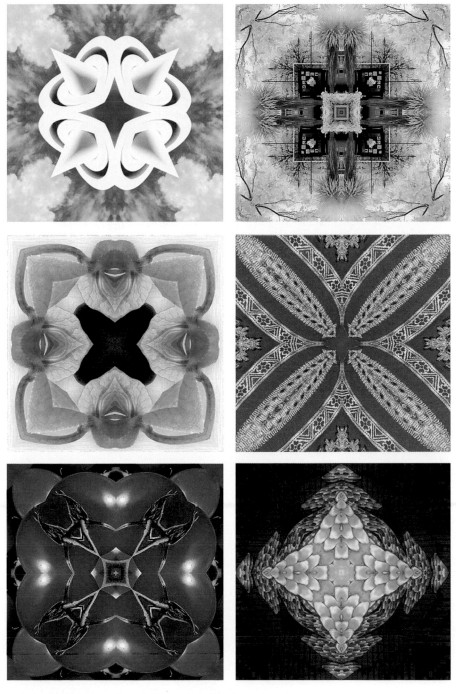

FIG 11.24 The Kaleidoscope effect applied to pictures on the DVD

FIG 12.1 Welder, painted with the Graffiti Airbrush

Printing and presentation

The first part of this chapter looks at the technical aspects of printing, how to choose a suitable file size for the print you intend to make, and what to do if you have to print it at a different size than originally intended. It includes a simple workflow from the camera to the final print setting and basic recommendations on what steps to take and in what order. This is aimed at the beginner using Painter and also covers sharpening and problems with printing textures.

You also need to carefully choose the paper on which to print; a high quality textured paper can make a huge difference to the final print. I use Permajet art papers in the UK which are excellent; there is a catalog of their products with information on color profiles and much else on the DVD.

Understanding Color Management is vital to ensuring that the picture you see on screen will look the same when it is printed. This is a complex subject and I offer some basic suggestions on how to handle it when you use Painter.

Presentation is an important part of showing your work and in the second part of the chapter I show how to make simple vignettes and artistic edges to make the appropriate picture more attractive.

A simple workflow

The workflow for Painter can be summarized in the following steps:

1. Photographic capture
2. Importing into Painter
3. Finishing the picture
4. Preparing to print

Photographic capture

Traditionally, photographic capture has used film which can be scanned using a slide or flatbed scanner and imported into Painter via Twain Acquire in the File menu.

Increasingly the capture is now made by digital methods and files can be imported using the Open command in the File menu provided they are in JPEG, TIFF, PNG or PSD format.

I will mention here the ability to photograph in RAW mode if your camera has this option. This is not the place to explain the many reasons why you should shoot in RAW mode; suffice it to say that in the majority of situations RAW mode will give you better quality and more flexibility over JPEG format.

You cannot however bring a RAW file directly into Painter so this must be done in another program. RAW files can be read in many programs. If you have Photoshop or Aperture or Lightroom these will work well, otherwise there are other RAW converters available including those from the main camera manufacturers Nikon and Canon.

In most cases it is better to turn off the sharpening in the camera and to do it prior to printing.

FIG 12.2 The RAW converter in Adobe Photoshop

File sizes

Early versions of Painter were notoriously slow in handling large files, but Painter 11 has significantly improved in speed so this is no longer an issue with anything but very large files.

The question I am often asked is what file size is the best to use in Painter; there is no simple answer to this as it depends on many different things and in particular the original capture size and the final print size. Generally file sizes between 10 mb and 25 mb are adequate.

The best way to calculate the ideal file size is to decide upon the planned print size and work back from there. So if the plan is to print on A4 (12 \times 8 inches) paper and between 200 and 250 dpi then the ideal size would be between 11 mb and 17 mb. However this is by no means essential and a 17 mb file could easily be printed up to twice that size without significantly losing quality. As you will see later, we can increase the file size if necessary prior to printing.

For those new to digital capture it is worth mentioning that a photograph taken with a camera that has a 6 mb specification will open up as about 17 mb in Painter; this is because the file is compressed in the camera.

Sharpening

Before printing it is usually necessary to sharpen the picture. This can be done in Painter by going to Effects>Focus>Sharpen. Select the Gaussian option as this generally gives the best result, and adjust the sliders.

The Amount controls the overall level of sharpening while the other two sliders restrict the sharpening to either the highlights or the shadows. The tick boxes will also restrict the effect to one of the three color channels.

The amount of sharpening required will vary from picture to picture and often is not required at all. I prefer to keep the sharpening to a minimum as over-sharpening can easily ruin a fine picture.

FIG 12.3 The Sharpen dialog box

The best way to apply sharpening is at the very end when the picture is finished. Make a new copy of the file and give it a new name (add sharpened to the file name). Drop all of the layers if necessary and make a copy of the Canvas (Select>All, Edit>Copy, Edit>Paste in Place) and sharpen that layer. Adjust the layer opacity to reduce the sharpening if required.

The amount of sharpening will also depend on the file size, the print size and the surface being printed on. The larger the file and print size the more sharpening will normally be required. If you are printing on a textured finish such as Canvas, the sharpening can be stronger than on a smooth paper. It is impossible to give specific amounts for these, so experience and test prints are the way to learn how much sharpening needs to be applied.

FIG 12.4 Resize dialog box

Preparing to print

When you are ready to print you need to check the printing dpi and set the dimensions. Go to Canvas>Resize and the current sizes of the image are shown, as in Figure 12.4. In this example the picture will print at 8.33 × 8.33 inches at a resolution of 240 dots per inch (dpi).

To print this at a larger size without changing the file, tick the Constrain File Size box and change the dimensions to the size you want to print. Try changing to 12 inches and see that the resolution has dropped to 166.7 dpi, which is still quite acceptable for most painterly pictures. To print, go to File>Print and the Printer dialog box will appear where you can set the paper size and printing options. This dialog box will vary depending upon the printer you are using.

FIG 12.5 Changing the file size

Increasing the file size

If the resolution drops too low you may need to resize the file. In this case remove the tick from the Constrain File Size box and enter the new print size. You will see that the file size has risen to 32 mb in Figure 12.5.

There are other ways in which to resize the picture. Photoshop has more sophisticated ways of doing this and there are many independent programs such as Size Fixer and Genuine Fractals which can be purchased and which give a much wider range of options.

Many photographers believe that rather than increasing the file size in one jump, a better result can be obtained by increasing the file in small steps; that is by making a 10% increase and repeating the process until the required size is achieved. This can be made easier by creating a script, which can be run many times by pressing one button for each increase.

To make a script go to Window>Show Scripts. Make a new empty file and type in the picture space "10%" in large letters; this will provide the icon in the palette (circled in Figure 12.6). Click the red button at the bottom of the palette to start recording and then go to Canvas>Resize and change the box to read percent and the dimensions to 110%, untick Constrain File Size and click OK. Press the Stop icon (bottom left in the Scripts palette) and this will bring up a dialog box in which you can name the script.

To run the script, first select the script required by clicking on the blue arrow and choosing the one you named, and then simply press the Play button as many times as necessary until you get to the file size you require.

FIG 12.6 Scripts palette

Color management

What is color management?

FIG 12.7 Color Management Settings are in the Canvas menu

Color management is a process that lets you predict and control color reproduction, regardless of the source or destination of the image. For example, a monitor displays a different set of colors than a printer will reproduce, so you may see colors on screen that cannot be printed. If you want to reduce color discrepancies, you can use color management to ensure a more accurate color representation when an image is viewed, modified, or printed.

During the digital imaging process, different tools are used to capture, modify, and print images. In a typical workflow, you capture an image by using a digital camera, upload the image to a computer, modify the image in a photo-editing application, and print the image. Each of these tools has a different way of interpreting color. In addition, each has its own range of available colors, called a color space, which is a set of numbers that define how each color is represented. A color space is a subset of a color model (for example, CMYK or RGB). In other words, each tool speaks a unique language when it comes to color. One number in the color space of a digital camera may represent an entirely different color in the color space of a monitor. As a result, when an image moves through the workflow, the colors get lost in the translation and are not accurately reproduced. A color management system is designed to improve the communication of color in the workflow.

A color management system uses color profiles to translate the color values from the source, which ensures a more accurate color reproduction at the destination. A color profile contains the data that the color management system requires to translate colors. Many standard color profiles are available. In addition, color profiles exist for different brands of monitors, scanners, digital cameras, and printers.

Color profiles can be provided in various ways; the most accurate result will be by employing a specialist to calibrate your system. They will use expensive specialist equipment to analyze each device and will create a custom set of profiles for you to use.

The next best way is to purchase calibration equipment yourself; there are several devices available at various price levels. These will be specific to your own devices and will therefore be accurate, depending on the system used.

The cheapest option is to use generic profiles provided by the equipment manufacturers; these are usually available from the supplier's websites at no cost. They will be based on the manufactured device, but not specific to your particular equipment. They may or may not be accurate, but are worth trying if you cannot get the profiles in any other way.

Why do I need color management?

If your document requires accurate color representation, you should consider using color management. The complexity of your workflow and the ultimate destination of the images are also important considerations. If your documents are destined only for online viewing, color management may not be as important. However, if you plan to open images in another application, such as Adobe Photoshop, or if you are creating images for print or multiple types of output, the use of color management is essential.

Color management lets you do the following:

- Reproduce colors consistently across your digital imaging workflow, especially when opening documents that were created in other applications.
- Reproduce colors consistently when sharing files with others.
- Preview, or 'soft-proof', colors before they are printed.
- Reduce the need to adjust and correct images when sending images to different destinations.

The Color Management Dialog Box

Painter 11 has introduced a new and much improved system of color management which at last allows accurate handling of colors between Painter

FIG 12.8 Color Management Settings dialog box

and Photoshop. There are several aspects to getting the right color and the first place to start is with the main Color Management dialog box.

Go to Canvas>Color Management Settings and the dialog box with the default settings will appear as seen in Figure 12.8.

Presets allows you to save your settings once they have been decided; click on the + symbol and a dialog box will prompt you to enter a name. To delete settings you no longer need, use this box to find the setting name and then click on the – symbol.

Default RGB profile is where you select the color space which you currently use for imaging applications; a list will appear and you should choose one from there. The one you choose will depend upon your requirements but if you are unsure, select Adobe RGB (1998) if you are mainly printing your own pictures or sRGB if your output is mainly for web use.

Default CMYK Conversion Profile is for when you send your pictures to a commercial printer, they will advise you which profile to use.

Color Profile Policies: these two boxes allow you to choose between keeping the color profiles that exist in the document when it is imported, or converting the document to your default profile. In most cases it is better to use the embedded profile as the colors in the image will irrevocably change should you not do this.

The Profile Mismatch boxes allow you the choice of getting a prompt to decide how you want to treat each file when it is opened. If the box is not ticked the decision will be made automatically based on the choices you have set.

The Rendering Intent allows you to decide how out-of-gamut colors are handled. Out of gamut means that the printer is unable to print the color that you see on your monitor so has to substitute another similar color. Each of the four options handles this problem in a different way; here is how the Painter Help describes the differences. For most purposes Perceptual or Relative Colorimetric are the ones to use for printing pictures.

- Perceptual — Choose this rendering intent for photographs and bitmaps that contain many out-of-gamut colors. The overall color appearance is preserved by changing all colors, including in-gamut colors, to fit within the destinations range of colors at the destination. This rendering intent maintains the relationships between colors to produce the best results.
- Saturated — Choose this rendering intent to produce more concentrated solid colors in business graphics, such as charts and graphs. Colors may be less accurate than those produced by other rendering intents.
- Relative Colorimetric — Choose this rendering intent for logos or other graphics to preserve original colors. If a match is not found for the source

colors, then the closest possible match is found. This rendering intent causes the white point to shift. In other words, if you are printing on white paper, the white areas of an image use the white of the paper to reproduce the color. Therefore, this rendering intent is a good option for printing images

- Absolute Colorimetric — Choose this rendering intent for logos, or other graphics, that require very precise colors. If no match is found for the source colors, then the closest possible match is used. The Absolute Colorimetric and Relative Colorimetric rendering intents are similar, but the Absolute Colorimetric rendering intent preserves the white point through the conversion and does not adjust for the whiteness of the paper. This option is used mainly for proofing.

Applying and changing profiles

Under the Canvas menu are two options for handling profiles.

The Assign Profile option allows you to assign a profile to a document which has none; for Painter to handle colors correctly it is better that all documents have profiles. The dialog box gives you the option to use the default profile or to select a different one (Figure 12.9).

FIG 12.9 Assign a profile

The Convert to Profile option allows you to change a document to a different profile or rendering intent. Remember that changing the assigned profile will change the colors permanently (Figure 12.10).

FIG 12.10 Convert to a different profile

Soft-proofing

Soft-proofing lets you generate an on-screen preview of what the image will look like when it's reproduced. This technique simulates the 'hard-proofing' stage in a traditional printing workflow. However, unlike hard-proofing, soft-proofing lets you look at the final result without committing ink to paper. For example, you can preview what the printed image will look like when a specific brand of printer and paper is used.

To see what your picture will look like when printed, go to Canvas>Color Proofing Settings and in the Simulate Device box select the color profile for your own printer and paper combination (Figure 12.11). As mentioned earlier, to use this facility you must have obtained profiles for your printer and installed them in your system. You will need a different profile for every type of paper you plan to use with each printer. If you have ticked the Turn on Color Proofing Mode box, as soon as you click OK your picture will be shown as a close approximation of how it will look when printed. You can turn this preview on and off by clicking Canvas>Color Proofing Mode. If you use this regularly I suggest you assign a keyboard shortcut to toggle this on and off quickly. Alternately you can switch very quickly by clicking on and off the colored icon top right in any document.

FIG 12.11 Soft-proofing dialog box together with box showing Rendering Intent drop down menu

Problems with printing textures

A well-selected texture can considerably enhance the final appearance of a picture, however it can also ruin the picture if applied incorrectly. The main problem is trying to assess how the picture and texture will actually print; often the picture will look really good on screen, but when printed it will look quite different. There are a number of reasons for this and it is worth bearing the following issues in mind when deciding upon a paper texture.

Viewing on screen

One of the biggest barriers to deciding on a texture is the difficulty of assessing the result on the computer screen.

Take the example shown in Figure 12.12. This file has had paper textures applied at four different strengths, however when viewed at 25% enlargement on screen the texture on the left has changed to a pattern and is unrecognizable. Enlarge the view on screen one step to 33% and that texture will look OK, but the second panel will have a pattern imposed over the picture.

The reason for this problem is that the computer screen is made up of a fixed number of pixels so when we try to show the whole picture on screen it can only show as many pixels as the screen resolution. All the other pixels in your file will be hidden. This does not normally cause a problem but when a regular pattern such as a paper texture is applied, the screen pixels interact with the pixels in the picture and can create an interference pattern.

FIG 12.12 Viewing textures on screen

To avoid this problem completely you need to view the picture as Actual Pixels. This can be done in three ways: by activating the Hand in the Toolbox and clicking Actual Pixels on the Properties bar, by going to the Window menu and clicking Actual Size, or by using the keyboard shortcut Ctrl/Cmd+Alt/Opt+0 (zero). This will show how the texture will look more accurately. The problem then is that we can see only a small part of the picture, particularly if you are using a large file.

Although it will not completely solve the problem, one way to avoid some of these problems is to stick to certain enlargement ratios: you will get less interference patterns when you use 75%, 50%, and 25% views.

One final word on the subject of screen viewing – these interference patterns are only a screen-based artefact. They will not actually print unless you can see them at Actual Pixels size, in which case they may.

How file sizes affect paper textures

The actual size of the picture on which you apply the texture will, to a large degree, determine the size of the paper texture which you choose in the Papers palette. In Figure 12.13 the Artists Canvas texture has been applied to a picture which is a 23 mb file. Figure 12.14 shows the same level of paper texture but applied to a file which is just 4 mb. As you can see, the texture is very overpowering on the 4 mb picture but barely visible on the other. Another variation here is that the illustrations have been printed in this book at another resolution so the effect may not show correctly, but the difference should be apparent.

FIG 12.13 Canvas texture applied to a 23 mb file

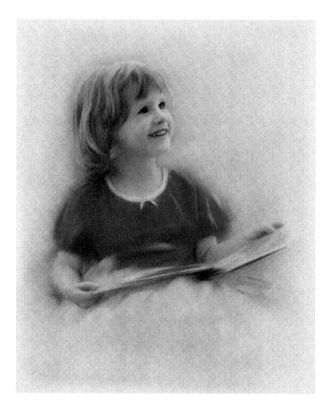

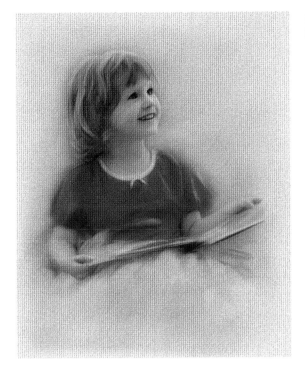

FIG 12.14 Canvas texture applied to a 4 mb file

How print sizes affect paper textures

The final variable to be taken into account is the size at which the final picture will be printed. If you are using a canvas texture then the texture should be somewhere close to the size of a real canvas texture. Looking at the two pictures above it should be obvious that to print the 4 mb file up to an A3 (16 × 12 inches) size would result in the print having a texture which is far too large and distracting, quite apart from the issues of quality of a small file.

Resampling files with paper textures

When you have a small file which you need to print larger than originally anticipated, it is often useful to resample the file upwards to improve the print quality. However a word of warning – should you plan to do this with a picture that has a paper texture applied, don't! In nearly all cases it will result in unsightly lines in the print due to the pattern being repeated, rather like the screen examples shown on the previous page. If possible you should resample the file upwards and then apply the paper texture afterwards, which is why I recommend that you apply textures on a copy layer.

Edge effects

Edge effects are easy to make in Painter and can add a lot to the right picture. This step by step example uses two different brushes and two layers to make a flexible edge effect.

FIG 12.15 Original photograph

1. Open 'Collie' from Chapter 12 folder on the DVD.
2. Make a new layer.
3. Edit>Fill with current color. Select white in the Color palette – this will block out the picture.
4. Add a layer mask by clicking on the mask icon in the Layers palette.
5. Click on the mask to make it the active layer.
6. Select the Artists Oils>Bristle Brush, size 52, Opacity 100%. Tick the Dirty mode option on the Properties bar.
7. Change the color to black and paint into the picture mask – as you paint, the layer beneath will be revealed. Make single brush strokes from the top and ensure that the brush strokes have a good edge which shows the bristles. Continue down the picture leaving white all around the edges and when you get to the bottom take care to get good shaped brush strokes as at the top. Bear in mind that all of the Artists Oils brushes run out of paint so use short brush strokes. The result should look much like Figure 12.16.
8. Now we will do the same process again using a different brush on a new layer. The combination of two brushes will give the edge a better finish.
9. Make a new layer on the top of the layer stack.

FIG 12.16 The Artists Oil brush mask

FIG 12.17 Final Layers palette

10. Edit>Fill with current color. Select white in the Color palette – this will block out the picture.
11. Add a layer mask by clicking on the mask icon in the Layers palette.
12. Click on the mask to make it the active layer.
13. Select the Acrylics Dry Brush, size 78, Opacity 100%, Feature 6.6, and paint into the mask with black. This brush will leave rough streaks on the picture so allow them to stay revealed on the edges but paint out the center so that the dog is clear.
14. The edge of the first mask defines the outer edge while the second mask adds texture to the picture. The final layers stack is shown in Figure 12.17.

FIG 12.18 These Edge effects and color schemes were created in the Underpainting palette where the many options can be combined

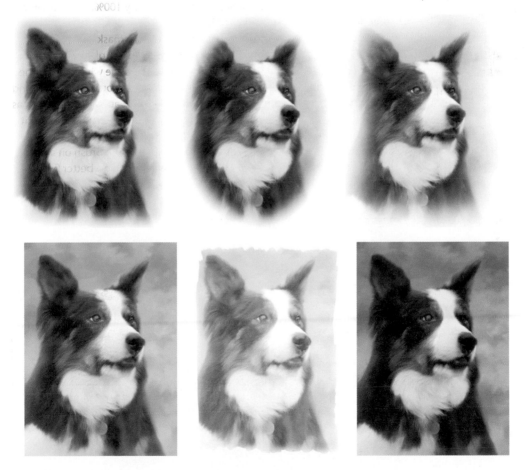

Last word

Congratulations!

You have now reached the end of the book and whether you have worked through the examples or just skimmed it and taken out bits, I hope that you have found it valuable and stimulating. So now it's over to you to use your own photographs and to create some top quality artwork.

This is not the end of course; it is just the beginning of what hopefully will be a fascinating and rewarding journey into using Painter. The Painter program is after all just a tool for your own creativity, great tool that it is.

Practice lots and have fun!

Further resources
There are many resources on the web which you can access and which often link to other sites. Here are a few to start with.

www.painterforphotographers.co.uk

Painterforphotographers is the website which accompanies this book. There are additional step by step techniques, galleries, information and links to other Painter sites, plus amendments to this book.

www.corel.com

The home site of Corel is where you can find information on the latest versions of Painter, updates and training. Look out in particular for the Painter Canvas, a regular newsletter which has tutorials and news about Painter.

www.painterfactory.com

The painterfactory is a community-based website by Corel with a user base of over 1500 Painter users. It is a great resource for learning Painter techniques and sharing artwork and ideas.

www.digitalpaintingforum.com

Marilyn Sholin runs this Digital Painting Forum which allows members to participate and share ideas and pictures with other Painter users.

www.martinanddoreen.co.uk

Not strictly about Painter, but a selection of work by my wife Doreen and myself.

Painter for Photographers DVD

The accompanying DVD for this book contains valuable resources to help you master Painter 11 and produce beautiful pictures. The files and tutorials on the DVD can be accessed from the relevant section of the DVD interface. The DVD can also be opened to access the files directly, all the tutorial files are in the Assets folder.

Video tutorials

The DVD contains over two hours of video tutorials for many of the techniques described in the book. This is an invaluable guide to see Painter in action, with an audio commentary giving hints and tips as each picture progresses from a photograph to the final image. By default, the video tutorials will open from the interface into a web browser, however they can also be viewed in several other programs including Quicktime and Windows Media Player. Open the DVD and go to the Assets > Video folder to play them in a different program. Recent versions of Quicktime and Windows Media Player can be downloaded free of charge from the Apple or Microsoft web sites.

Step by step original photographs

All the original photographs are included for you to work through the step by step exercises in *Painter 11 for Photographers*. Also included are many other photographs that are used throughout the book to illustrate techniques so that you can follow the examples at home. The images are mostly full size files so the brush sizes will be similar when you create pictures from your own photographs. The images can be selected from the DVD interface, or by opening the DVD and going to the Assets > Images folder.

Pdf tutorials

Extended and more detailed versions of the tutorials in Chapter 3 are included as pdf files. These are fully illustrated and explain the process with much more detail than is possible in the limited space in the printed book. They can be viewed on screen or printed. I recommend that these are used in preference to the instructions in the book. There are more than 130 pages.

The following are also included as pdf files on the DVD:

- Samples pictures of every paper library shipped with Painter 11.
- Illustrative pdf files which show details which are not easily apparent in the printed book due to the printed size.
- Permajet catalog: I print all my pictures on Permajet paper and find the range of papers and canvasses excellent. The catalog includes information on the use of color profiles and continuous ink systems.

Index

1 pixel Eraser, 83
2B Pencil, 109

A

Absolute Colorimetric, 317
Accurate Diffusion, 141
Acrylic Captured Bristle, 117, 136, 248
Acrylics Dry Bristle brushes, 196
Acrylics Dry Brush, 117
Acrylics Real Wet, 280–3
Actions, 17
Active layer, 168
Add Grain, 113
Adjust Colors, 206–7, 211
Adjust Selected Colors, 207–8
Adjustment layers, 18
Adobe Photoshop
 vs. Painter, 11, 17–19
 file compatibility, 18
 tools, 19
 RAW converter in, 310
Adobe RGB, 316
Airbrushes, 54, 130, 131
Alpha channels, 18
Amount slider, 161
Angle palette, 136
Apply Screen effect, 297
Apply Surface Textures, 160–6
 3D Brush Strokes, using, 164
 applying paper textures
 to layer, 165–6
 Image Luminance, using, 163
 Original Luminance, using, 163
 paper, using, 161–2
Art Marker, 87
Art Pen Brushes, 56
 Soft Flat Oils, 274
Artist Oils, portrait using, 272–5
Artist Pastel Chalk, 47, 105
 painting, 244
Artists, 58
Artists Canvas, 56, 286

Artists Oil brush mask, 322
Artists Oils, 60, 130, 131
Assign Profile option, 317
Auto-Painting, 23–4
 Tough guy, 28–31
Auto-Painting feature, 272, 273
Auto-Painting palette, 26–7, 45
Auto Van Gogh, 59

B

Baby Blue Eyes, 91
Background, 17
Background Color, 17
Ball Point Pen, 111
Barbed Wire Pen, 111
Basic Round, 123
Bevel World, 304
Bleach, 83
Blend Camel Hair, 132, 133
Blender Bristle brush, 272
Blenders, 62
 brushes, use of, 246–8
 and pastels, 266–8
 portrait using, 248–51, 287,
 290, 291
Blunt Soft Pastel, 105
Blunt Tip, 87
Blur, 113
Bride in white, 290–3
Brightness and contrast, 202
Bristle Brush, 61, 123
Bristle Brush Cloner, 71
Bristle Oils, 101, 143
Bristle Spray, 132, 133
Broad Cover Brush, 89
Broad Grainy Pen, 65
Broad Wheel Airbrush, 55
Brush Creator, 11, 128–43
 Angle palette, 136
 General palette
 Dab types, 129–33
 Grain slider, 135

 Method, 134
 Subcategory, 135
 Random palette, 137
 Randomizer, 142
 Spacing palette, 136
 Transposer, 143
 with Stroke Designer tab
 active, 128
 Water palette, 139–41
 Watercolor
 vs. digital watercolor, 138
 layers, 139
 Well palette, 137
Brush dabs, 145
Brush default settings, 13–14
Brush Selector, 3–4, 33
Brush Tracking, 12
Brush Variants, 146
Brushes, choosing, 49
 Acrylics, 52
 category selection, 50
 shape, 50
 smoothing and mixing,
 blenders for, 51
 texture, 51
Brushes, customizing
 Brush Creator, 128, 143
 Angle palette, 136
 General palette, 129–35
 random palette, 137
 Randomizer, 142
 Spacing palette, 136
 Transposer, 143
 water, 139–41
 watercolor layers, 139
 watercolor vs. digital
 watercolor, 138
 Well palette, 137
 Brush Variants, saving, 146
 Captured Dab, creating, 144–5
 new brush category, 146–8
Brushes, in blenders, 246–8
Buildup method, 134

Bump, 299
Burn, 113
Burn effect, 305

C

Calligraphy, 64, 65
Calligraphy Brush, 65
Camel Hair, 130, 131
Camel Impasto clone, 36–7
Canon, 310
Canvas, 17, 168–9
Canvas effect, 149
Canvas menu, 317
Captured Bristle, 53
Captured dab, 130, 131, 144–15
Card makers, 158
Chalk, 66
Chalk Cloner, 71
Chalk Soft, 117
Charcoal, 68
Chisel Tip Marker, Drip Method, 97
Chunky Oil Pastel, 99, 237
 Cloning Method, 99
Circular dab, 130, 131
Clone Color, 134, 199, 224, 272,
 273, 277
 Auto Van Gogh, 59
 Basic Crayons, 77
 Bristle Brush, 61
 Broad Grainy Pen, 65
 Calligraphy, 65
 Calligraphy Brush, 65
 Captured Bristle, 53
 Charcoal Pencil, 69
 Coarse Dry Brush, 79
 Coarse Mop Brush, 79
 Colored Pencil, 73
 Cover Colored Pencil, 73
 Dry Bristle, 61
 Dry Brush, 53, 61, 79
 Dry Ink, 65
 Dull Conte, 75
 Dull Crayon, 77
 Fine Tip Water, 79
 Finer Mop Brush, 79
 Flat Water Blender, 79
 Grainy Calligraphy, 57

Grainy Colored Pencil, 73
Grainy Dry Brush, 61
Grainy Hard Crayon, 77
Gritty Charcoal, 69, 69
Hard Charcoal Pencil, 69
Hard Colored Pencil, 73
Impressionist, 59
Large Chalk, 67
New Simple Diffuser, 79
Oily Colored Pencil, 73
Opaque Acrylic, 53
Pointed Crayon, 77
Pure Water Blender, 79
Sargent Brush, 59
Seurat, 59
Soft Charcoal, 69
Soft Flat Oils, 57
Soft Vine Charcoal, 69
Square Chalk, 67
Square Conte, 75
Square Grainy Pastel, 57
Tapered Camel, 57
Tapered Conte, 75
Thick Wet Impasto, 61
Thin Smooth Pen, 65
Tubism, 59
Van Gogh, 59
Variable Chalk, 67
Variable Colored Pencil, 73
Variable Width Chalk, 67
Wet Oily Brush, 61
Wet Soft Acrylic, 53
Wide Stroke, 65
Worn Oil Pastel, 57
Cloners, 70
Cloning, 21
 Auto-Painting, 23–4
 Tough Guy, 28–31
 Auto-Painting palette, 26–7
 Camel Impasto clone, 36–7
 Impressionist clone, 38
 Paper Grain, 40
 Texture, creating, 41–3
 onto layers, 185–8
 Pastel Flower, 47
 'Real' watercolor, 44–6
 Restoration palette, 27
 Soft Cloning, 32–5

techniques, 22
 from three images, 189–91
 Tracing Paper, 22–3
 Underpainting palette, 24–6
Cloning method, 134
Clumpy Ink, 95
CMYK Conversion Profile, 316
Coarse Bristle Sumi-e, 121
Coarse Brush Mover, 81
Coarse Distorto, 81
Coarse Dry Brush, 79
Coarse Mop Brush, 79
Coarse Oily Blender, 63
Coarse Spray, 55
Coit Pen, 111
Collapse, 18
Color
 Color Sets palette, 199–200
 Colors palette, 198–9
 hand coloring
 graphic image, 220–2
 photographs, 214–19
 Mixer palette, 201
 tone and color, adjusting, 202
 tonal control, 202–10
 toning techniques, 211–12
 Underpainting palette, 213
Color Correction, 204, 214
Color management, 309
 applying and changing profiles, 317
 dialog box, 315–17
 meaning, 314
 need for, 315
 settings, 314
 soft proofing, 318
Color Overlay, 212
Color Picker, 17
Color profiles, 314
 policies, 316
Color Proofing Mode, 318
Color Scheme options, 24, 28, 212
Color Set, posterize using, 210–11
Color Set option, 296
Color Sets palette, 199–200
Color slider, 208
Color space, 314
Colored Pencils, 72
Colorize, 219

Colorizer, 113
Colors palette, 198–9
 color picking, 4
Confusion, 81, 85
Conte, 74
Convert to Profile option, 317
Correct Colors, 203–6
Cover method, 134
Cover Pencil, 109
Crayons, 76
Curves, 203
Custom palette
 for cloning, 10
 creating, 9
 menu, 10–11

D

Dab, 129
Default view, 2
Delay Diffusion, 141
Dense Sponge, 119
Depth Bristle, 95
Depth Color Eraser, 37
Design concepts, for portraits, 284–5
Design Marker, 87
Detail Opaque, 89
Diffuse Amt slider, 140
Diffuse Blur, 113
Diffuse Grainy Camel, 125
Diffuser, 81
Diffuser, 2, 123
Digital Airbrush, 55
Digital imaging process, 314
Digital Sumi-e, 121
Digital watercolor, 78, 138
Digital Wet method, 134
Directional Diffuser, 123
Dirty Marker, 87
Distortions, 80, 246, 247
Distorto Impasto, 93
Distress effect, 298
Dodge, 113
Drip method, 134
Drop All, 17
Drop Shadow, 284
Drop Shadow dialog box, 258
Dropper, 19

Dry Bristle, 61, 125
Dry Bristle watercolor, 231–4
Dry Brush, 53, 61, 79
Dry Camel, 125
Dry Ink, 65
Dry rate slider, 140
Dull Grainy Chalk brush, 134
Duplicate Canvas, 17
Duplicate Layer, 17
Dynamic Plug-in layer, 18, 169

E

Edge effects, 25–6, 212, 322–3
Effects menu, 17
Enable Brush Ghosting, 14
Enhanced Brush Ghosting, 14
Equalize command, 203
Erase All Hard, 83
Erase All Soft, 83
Eraser, 83
Eraser with Paper Color set to
 light pink, 83
Erasers, 82
Extents slider, 207
Extra paper texture libraries, 152–3
Eyedropper, 19, 286
Eyedropper icon, 201

F

F-X, 84
F/X Furry brush, 143
Fairy Dust, 84, 85
Feather slider, 207
Felt Marker, 87
Felt pens, 86
Fiber, 93
File sizes, 311
 changing, 313
 effect on paper textures, 320
 increasing, 313
Fill, 17
Filters menu, 17
Fine Bristle, 89
Fine Camel, 125
Fine Detail Air, 55
Fine Diffuser, 113

Fine Feathering Oils, 101
Fine spray, 55
Fine Tip, 87
Fine Tip Marker, 97
Fine Tip Soft, 55
Fine Tip Water, 79
Finer Mop Brush, 79
Flat dab, 130, 131
Flat Grainy Stump, 63
Flat Opaque Gouache, 89
Flat Rendering Marker, 97
Flat Water Blender, 79
Flatten Image, 17
Flatworld poster, 166
Foreground Color, 17
Freehand option, 206
Full Screen View, 8
Furry Brush, 84, 85
Furry Cloner, 71

G

Gamma, 203
Gardenias, 91
Gaussian option, 311
Gell layer composite method,
 233
General palette
 Dab types, 129–33
 Grain slider, 135
 method, 134
 Subcategory, 135
Genuine Fractals, 313
Glass Distortion, 302
Glazing Sponge, 119
Gloopy, 93
Glow, 84
Gouache, 88
Gouache Thick Flat, 117
Grabber, 19
Gradient Flat Brush, 85
Graffiti, 54, 55
Graffiti Airbrush, 308
 Welder painted with, 308
Grain slider, 135, 150
Grainy Blender, 63
Grainy Calligraphy, 57
Grainy Cover Pencil, 109

Grainy Dry Brush, 61
Grainy Edge Flat Cover
 Buildup Method
 Thick n Thin Marker, 87
 Cover Method
 Art Marker, 87
 Blunt Tip, 87
 Design Marker, 87
 Dirty Marker, 87
 Flat Rendering Marker, 97
 Med Dull Crayon, 77
 Reed Pen, Cover Method, 111
 Waxy Crayons, 77
Grainy Glazing Round, 123
Grainy Hard Cloning Method, 52
 Captured Bristle, 53
 Thick Acrylic Flat, 53
 Thick Acrylic Round, 53
 Wet Soft Acrylic, 53
Grainy Hard Cover Cloning, 135
 Basic Crayons, 77
 Blunt Chalk, 67
 Cloning Method
 Felt Marker, 87
 Fine Tip, 87
 Cover Colored Pencil, 73
 Dry Ink, 65
 Dull Conte, 75
 Grainy Hard Crayon, 77
 Hard Charcoal Pencil, 69
 Impressionist, 59
 Oil Pastel, Cloning Method, 99
 Seurat, 59
 Soft Charcoal, 69
 Soft Charcoal Pencil, 69
 Square Chalk, 67
 Square Conte, 75
 Tapered Artist Chalk, 67
 Tapered Conte, 75
 Variable Chisel Tip, 97
 Worn Oil Pastel, 57
Grainy Pencil, 109
Grainy Soft Cover Cloning, 135
Grainy Variable Pencil, 109
Grainy Water, 63
Grainy Wet Sponge, 119
Graphic Bristle, 95
 picture painted using, 48

Graphic image
 hand coloring, 220–2
Graphic tablet, using, 11–12
Greasy Pencil, 109
Green Grass Bunch, 91

H
Hair Spray, 84, 85
Hand, 19
Hand coloring
 graphic image, 220–2
 photographs, 214–19
Hand tinting, 197
Hard Cover Cloning
 Soft Oil Pastel, Cloning Method, 99
Hard Grainy Round, 123
HSV option, 198
Hue slider, 206
Hurricane, 81

I
Image adjustments menu, 17
Image Hoze, 90
Image Luminance, 207, 230
Image Luminance option, 302
Impasto, 92
Impressionist brush, 59, 270
 in landscape, 224–6
Impressionist Cloner, 38, 71
 Paper Grain, an introduction to, 40
 Texture, Creating, 41–3
Inset mounts, making, 255–9
Inverted option, 161
Inverted S curve, 204
Iterative Save, 13

J
Jitter slider, 88, 137
JPEG format, 3, 310
Just Add Water, 51, 63, 246, 247, 249

K
Kaleidoscope effect, 306–7
Keyboard shortcuts
 for Painter 11, 8, 19

L
Landscape, 223
 Dry Bristle watercolor, 231–4
 Impressionist landscape, 224–6
 Oil Pastels, 235–9
 with Oils, 227–30
 Pencil landscape, 240–1
Large Chalk, 67
Layer, 18
Layer Adjuster, 19
Layer blend modes, 18
Layer Blending Mode, 17
Layer Composite Depth control,
 172–3
Layer Composite Method, 17, 173–6
Layer effects, 18
Layer groups, 18
Layer Ink Layers, 18
Layer Masks, 18, 170–1
Layer Opacity slider, 172
Layer visibility, 168
Layers and montage, 167
 cloning
 onto layers, 185–8
 from three images, 189–91
 family history montage, 177–84
 Layers palette, 168–76
 poster, designing, 192–6
Layers palette, 168–76
 active layer, 168
 Canvas, 168–9
 compatibility, 170
 deleting, 169
 duplicating, 171
 grouping layers, 170
 Layer Composite Depth control,
 172–3
 layer composite method, 173–6
 Layer Masks, 170–1
 Layer Opacity slider, 172
 layer visibility, 168
 locking, 172
 merging and flattening, 169
 new layers, 169
 Preserve Transparency, 172
 renaming, 169
Leaky Marker, 97

Leaky Pen, 111
Level of diffusion, sliders
 controlling
 Bleed, 137
 Resaturation, 137
Line Airbrush, 130, 131
Liquid Ink, 94
Liquid Ink Airbrush, 132, 133
Liquid Ink Bristle Spray, 132, 133
Liquid Ink brush category, 48
Liquid Ink Camel Hair, 132, 133
Liquid Ink Flat, 132, 133
Liquid Ink layer, 169
Liquid Ink Palette Knife, 132, 133
Liquid Lens, 303
Little Houses, 91
Loaded Palette Knife, 93, 103
 trees painted with, 222
Loaded Wet Sponge, 119

M

Marbling Rake, 81
Markers, 96
Marquee, 19
Match palette, 208–9
Medium Tip Felt Pen, 87
Merge Visible, 18
Min Spacing slider, 136
Mistakes correcting, 5
Mixer palette, 201
Montage, 177–84
Moody portrait, 286
Mosaics, 18
Move, 19
Multi layer file, 168

N

N Colors slider, 296
Negative command, 209
Neon Knife, 103
Nervous Pen, 111
New brush category, 146–8
New Simple Diffuser, 79
Nikon, 310
Normal view, 7–8
Nozzles, 90

O

Oil brushes, use of, 260–5
Oil Pastel, 98, 99, 235–9
 Cloning Method, 99
Oils, 100
 landscape with, 227–30
Oily Blender, 63
Oily Round, 123
Oily Variable Pencil, 109
Opaque Acrylic, 53
Opaque Flat, 93
Original Luminance, 207
Out of gamut, 316
Output Black option, 155

P

Painter 11 workspace
 Brush Creator, 11
 Brush default settings, 13–14
 Brush Selector, 3–4
 Colors palette, color picking, 4
 custom palette
 for cloning, 10
 creating, 9
 menu, 10–11
 default view, 2
 Full Screen View, 8
 graphic tablet, using, 11–12
 keyboard shortcuts, 19
 Keyboard Shortcuts, 8
 mistakes correcting, 5
 Normal view, 7–8
 Palettes, using and organizing, 8–9
 picture, moving around, 6
 picture opening, 3
 preferences
 customize keys, 15–16
 customize workspace, 16–17
 general, 14–15
 operating system, 15
 undo, 15
 properties bar, 5
 Rotate Canvas, 7
 Rotate Page icon, 7
 terminology and usage, 17–18
 Toolbox, 2, 3
 vs. Photoshop, 17–19

'Painter Colors.colors', 200
Palette Knife, 103, 130, 131
Palettes, using and organizing, 8–9
Paper, 207
Paper Brightness slider, 152
Paper Contrast slider, 151
Paper Grain, 40
Paper pattern, on black
 background, 157
Paper Scale slider, 151
Paper textures, 149
 Apply Surface Textures, 160–6
 applying to layer, 165–6
 for creating pictures, 155–7
 extra paper texture libraries,
 152–3
 meaning, 150
 in Painter program, 40
 Paper Brightness slider, 152
 Paper Contrast slider, 151
 Paper Scale slider, 151
 photograph used for, 153–4
 for stamping, 158–9
Paragliders, 91
Passionflower Flowers, 91
Pastel Flower, 47
Pastel, portrait in, 252–4
Pastel Tapered, 117
Pastels, 104
 and blenders, 266–8
 portrait using, 276–9
Pattern Chalk, 107
Pattern Emboss, on original
 photograph, 93
Pattern Marker, 107
Pattern Marker Grad Color, 107
Pattern Pen, 106, 107
Pattern Pen Masked, 107
Pattern Pen Micro, 107
Pattern Pen Soft Edge, 107
Pattern Pen Transparent, 107
Pencil landscape, 240–4
Pencils, 108
Pens, 110
Pepper spray, 54
Perceptual Colorimetric, 316
Photo, 112
Photo Enhance, 25, 28, 212

Photograph, used for paper texture, 153–4
Photographic capture, 310
Photographs
hand coloring, 214–19
Photoshop, 313
Piano Keys, 85
Picture, moving around, 6
Picture creation
using paper textures for, 155–7
Picture opening, 3
Pixel Airbrush, 130, 131
Portraits, 271
Acrylics Real Wet, 280–3
bride in white, 290–3
design, creating, 284–5
moody portrait, 286
in oils, 260–5
in pastel, 252–4
using Artist Oils, 272–5
using blenders, 248–51
using Pastels, 276–9
weddings, 287–9
Poster, designing, 192–6
Posterize command, 210
Preferences
customize keys, 15–16
customize workspace, 16–17
general, 14–15
operating system, 15
undo, 15
Preserve Transparency, 172
Print sizes
effect on paper textures, 321
Printing, 312
Printing and presentation, 309
color management, 314–18
edge effects, 322–3
printing textures, problems with, 318–21
workflow, for Painter, 310–13
Printing textures, problems with, 318
effect of file sizes, on paper textures, 320
effect of print sizes, on paper textures, 321
resampling files, with paper textures, 321

viewing textures, on screen, 318–20
Profile Mismatch boxes, 316
Profiles, applying and changing, 317
Projected dab, 130, 131
Properties bar, 5
Pure Water Blender, 79

Q
Quick Clone, 272
Quick Clone options, 15
Quick Warp effect, 299

R
Random palette, 137
Randomizer, 142
RAW converter, in Adobe Photoshop, 310
RAW files, 310
Real Blender Flat, 115
Real Blender Round, 115
Real Fan Short, 115
Real Flat Opaque, 115
Real Oils Smeary, 115
Real Oils Soft Wet, 115
Real Soft Colored Pencil, 269
Real Sumi-e Dry Brush, 121
Real Sumi-e Wet Brush, 121
Real Tapered Bristle, 115
'Real' watercolor, 44–6
Real Wet Bristle brush, 280
RealBristle Brushes, 114
RealBristle Fan Short brush painting, 201
Red Poppies, 91
Relative Colorimetric, 316–17
Rendered dab, 130, 131
Rendering Intent, 316
Resampling files, with paper textures, 321
Resizing, 312
Restoration palette, 27, 31
Revert option, 15
RGB profile, 316
RIFF format, 3
Ripple, 299
Rotate Canvas, 7

Rotate Page icon, 7
Round Oil Pastel, 99
Round X-Soft Pastel, 105
Rubber stamp icon, 199
Rust panel, painted with Square Chalk, 148

S
S curve, 204
Sargent Brush, 59
Saturated Colorimetric, 316
Saturation Add, 113
Saturation slider, 206
Scratchboard Rake, 111
Scripts, 17
Scripts palette, 313
Selection Adjuster, 19
Selection Tool, 19
Seurat, 59
Sharp Marker, 97
Sharp Pastel Pencil, 105
Sharp Triple Knife, 103
Sharpening, of pictures, 161, 311–12
Shattered, 85
Size Fixer, 313
Sketch effect, 300–1
Sketching Pencil, 109
Smart layers, 18
Smart Settings, 272
Smart Stroke Brushes, 116
Smart Stroke Painting, 26, 28, 272
Smear, 63
Smeary Bristle Cloner, 142
Smeary Bristle Spray, 101
Smeary Camel Cloner, 71
Smeary Flat, 101
Smeary Palette Knife, 103
Smeary Round, 101
Smeary Wet Sponge, 119
Smooth Camel, 95
Smooth Ink Pen, 111
Smooth Thick Flat, 95
Soft Blender Stump, 63, 291, 293
Soft Bristle, 125
Soft Cloning, 32–5

Soft Cover Cloning, 135, 236
 Chunky Oil Pastel, Cloning
 Method, 99
Soft Flat Oils, 57, 274
Soft Glazing Round, 123
Soft Oil Pastel, 99
 Cloning Method, 99
Soft Pastel, 105
Soft proofing, 318
Soft Runny Wash, 125
Soft Wet Acrylic brush, 52
Spacing palette, 136
Sparse Bristle with Sparse
 Bristle Resist, 95
Sparse Flat cloned, 95
Special effects, 295
 Apply Screen effect, 297
 Bevel World, 304
 Burn effect, 305
 Distress effect, 298
 Glass Distortion, 302
 Kaleidoscope effect,
 306–7
 Liquid Lens, 303
 Quick Warp effect, 299
 Sketch effect, 300–1
 Woodcut effect, 296
Sphere, 299
Sponge, 118, 119
Sponge Dense, 196
Sponge Soft, 117
Square Chalk, 137
 rust panel painted with, 148
Square Grainy Pastel, 57
Square Hard Pastel, 105
Square Sponge, 119
Square X-Soft Pastel, 105,
 278, 279
Squeegee, 85
Squeeze slider, 136
Stamping
 paper textures for, 158–9
Standard layers, 169
Static Bristle brushes, 130, 131
Subtle Palette Knife, 103
Sumi-e Brush, 120, 121
Swallows & Palm Trees, 91
Swirl, 299

T
Tapered Camel, 57
Tapered Darkener, 83
Tapered Digital Sumi-e, 121
Tapered Eraser, 83
Tapered Pastel, 105
Tapered Sumi-e Large, 121
Tapered Sumi-e Small, 121
Text layers, 18
Text palette, 192
Texture, creating, 41–3
Texturizer, Variable, 93
Thick Acrylic brush, 137
Thick Bristle Cloner, 71
Thick Flat Cloner, 71
Thick Gouache Flat, 89
Thick n Thin Marker, 87
Thick Oil Flat, 101
Thick Wet Camel, 101
Thick Wet Flat, 93
Thick Wet Impasto, 61
Thick Wet Oils, 101
Thin Smooth Pen, 65
TIFF format, 3
Tinting brush, 122, 246, 247
Tiny Smeary Knife, 103
Tonal control
 Adjust Colors, 206–7
 Adjust Selected Colors, 207–8
 Brightness and Contrast, 202
 Color Set, Posterize using, 210–11
 Correct Colors, 203–6
 Equalize command, 203
 Match palette, 208–9
 Negative command, 209
 Posterize command, 210
Tone and color, adjusting, 202
 tonal control
 Adjust Colors, 206–7
 Adjust Selected Colors, 207–8
 Brightness and Contrast, 202
 Color Set, Posterize using,
 210–11
 Correct Colors, 203–6
 Equalize command, 203
 Match palette, 208–9
 Negative command, 209
 Posterize command, 210
 toning techniques, 211–12
 Underpainting palette, 213
Toning techniques, 211–12
Toolbox, 2, 3
Tracing Paper, 22–3, 34
Transposer, 143
Tubism, 59
Turbulence, 81

U
Underpainting palette, 23, 24–6, 213
Uniform Color, 207

V
Valley, 299
Value slider, 206
Van Gogh, 59
Variable Chisel Tip, 97
Variable Chisel Tip Marker, 97
Variable Oil Pastel, 99, 236
Variable Splatter, 55
Variable Width Chalk brush, 287
Variance sliders, 208
Velocity Sketcher, 95
Viewing textures, on screen, 318–20

W
Water, 139–41
 Accurate Diffusion, 141
 Delay Diffusion, 141
 Diffuse Amt slider, 140
 Dry rate slider, 140
 Wetness slider, 139
 Wind Force slider, 141
Water Bubbles, 81
Water droplet icon, 139
Water palette, 138
Watercolor, 124
 layers, 139
 vs. digital watercolor, 138
Watercolor Airbrush, 132, 133
Watercolor Bristle Spray, 132, 133
Watercolor Camel Hair, 132, 133
Watercolor Flat, 132, 133

Watercolor layers, 18
Watercolor Palette Knife,
 132, 133
Watercolor Run Cloner, 71
Watercolor Runny, 117
Watercolor Soft Diffused, 117
Watery Glazing Round, 125
Watery Soft Bristle, 125
Wedding portraits, 287–9
Well palette, 137

Wet Gouache Round, 89
 Feature 8.8, 89
Wet method, 134
Wet Oily Brush, 61
Wet Soft Acrylic brush,
 53, 137
Wet Sponge, 119
Wetness slider, 139
Wide Stroke, 65
Wind Force slider, 141

Woodcut effect, 155, 296
Woodcut panel, 294
Worcester Cathedral, 238, 239
Workflow, for Painter, 310
 file sizes, 311
 increasing, 313
 photographic capture, 310
 Preparing to Print, 312
 sharpening, 311–12
Worn Oil Pastel, 56, 57

skin color, 55
sleep, 89
sleepy babies, 49–52
Small Business Administration (SBA), 192, 195
smiling, 11, 12, 17, 46, 127
smoothing skin, 149, 159
social media, 187–189
soft and creamy enhancement, 161
soothing techniques, 117–121
space heater, 61, 68, 110, 112
spotter, 69
startle reflex, 117
storyboards, 199
storytelling, 10–18, 123–147
 black-and-white imagery, 144–146
 capturing details, 124–133
 considerations, 10–11, 189
 creating/implementing story, 11–12
 described, 10
 elements of, 13–17
 emotional, 11, 13–15
 expressing baby's personality, 17–18
 goal of, 12
 natural imagery, 146–147
 relational, 15–17
 unwritten words, 18–19
 wrapping techniques, 133–144
storytelling series, 57, 58
studio
 cleanliness, 107
 considerations, 192
 in-person consultations, 47
 policies, 54
 product display, 199
 room temperature, 49
 supplies, 51, 113
style, 5–9, 147. See also inspiration
sucking reflex, 115, 119
supplies, basic, 61–62. See also accessories;
 equipment/supplies
swaddling technique, 118, 139–140

taco pose, 76, 86–88
tax accountant, 195
tax lawyer, 195
T-bar stand, 60, 61
temperature
 baby's body, 49, 68, 110–112, 114
 room, 48, 49, 68, 110, 112

temperature, color, 39, 154
thank you cards, 183
time management, 72–73
tint, 154
tissues, 75
toes/feet, 58, 80, 132
tools. See accessories; equipment; props
towels, 61, 62
tungsten lighting, 39, 153
tushie pose, 79–82
Twitter, 187, 188

vibrance, 157
vintage clothing, 3

waterproof pads, 55, 62
websites, 172, 188–189, 200
welcome package, 52–54, 182
WHCC website, 200
white balance, 39–40
 custom, 39–40
 in-camera setting, 39
 setting in ACR, 153–154
white noise, 61
whites, altering in ACR, 156
wipes, 51
womb wrap technique, 135–138
workflow
 for posing, 88–89
 setup via playback menu, 40–41
workflow sets, 163, 164
"wow factor," 179–180
wrapping techniques, 133–144
 body wrap technique, 135
 fabric choices, 141–143
 swaddling technique, 118, 139–140
 womb wrap technique, 135–138
wraps, 56, 62, 135, 137, 141–143

X-Rite ColorChecker Passport, 39–40, 62

yawning, 6, 126, 146

posing *(continued)*
 overview, 71–72
 planning for, 55–57
 premature babies, 114
 props for, 62–64, 90–94
 safety issues, 69, 71, 87
 with siblings, 48, 95–98
 side pose, 76–79
 taco pose, 76, 86–88
 time management, 72–73
 tips for, 72–75
 transitional techniques, 89–90
 tushie pose, 79–82
postcards, 181
post-processing
 ACR, 151–157
 importance of consistency, 165–167
post-processing, Photoshop
 actions, 164
 efficiency, 163–165
 procedure for, 158–162
 tips/shortcuts, 158–162, 164–165
 workflow sets, 163, 164
PPA (Professional Photographers of America),
 195
PPA Benchmark Survey, 198
preconsultation, 47–54
preconsultation checklist, 48
premature babies, 114
pricing strategies, 47, 197–199
ProDpi website, 200
product resources, 200
product strategies, 178, 197, 198, 199–200
Professional Photographers of America. *See*
 PPA
promotions, 181
props. *See also* accessories; equipment
 baskets, 56, 62, 63, 64, 93, 94
 beanbags. *See* beanbags
 blankets. *See* blankets
 bowls, 56, 62, 64
 buckets, 63, 64, 90
 choosing, 90–94
 color of, 56
 considerations, 90–91
 cushions, 89, 92
 fabrics, 61, 63, 141–143
 ottoman, 60, 61
 pillows, 64, 75, 82, 88
 rugs, 62
 safety issues, 62, 64, 68, 71, 90
 tips/guidelines, 62–64

R

rates, 47, 197–199
raw format, 42, 151–157
redness, removing from skin, 160–161
referrals, 181, 186–187
reflectors, 23, 62
relational storytelling, 15–17
relationships, 15–17
resources, product, 200
retouching images. *See* image editing
RGB histogram, 40–41
RGB mode, 40–41
rooting reflex, 115
rugs, 62

S

safety precautions
 considerations, 69
 importance of, 69, 170
 photo shoot safety, 62, 68, 69, 71
 posing, 69, 71, 87
 props, 62, 64, 68, 71, 90
 tips/issues, 62, 68, 69, 71
sanitizer, hand, 61
saturation, 153, 157
SBA (Small Business Administration), 192, 195
scarves, 56, 63, 143
screeches, 116
seamless paper, 62
search engines, 188
session fee, 48
shadows
 clipping, 35, 37, 38
 modifying in ACR, 156
 nose, 26, 27
sharpening images, 157, 161
SHOOT BABY! accessories, 55, 60, 61, 62
shushing, 118
Shutter Priority mode, 28
shutter speed, 30–34, 37, 38
siblings, 48, 95–98, 182
side pose, 76–79
Simply Canvas website, 200
singing, 121
skin
 exposure and, 37–38
 newborn, 113
 removing redness from, 160–161
 smoothing, 149, 159
 soft and creamy enhancement, 161
 touching up, 149, 158

skin. *See* skin
noise, 31
nose shadow, 26, 27
nursing, 48, 54, 65
Nutrition Guide, 48, 54

O
opacity, 159, 161
organizations, 195
ottoman, 60, 61

P
pacifiers, 48, 119
paper towels, 61
parents. *See also* clients
 father, 95, 101–104
 keeping calm, 55, 74–75, 117
 mother. *See* mothers
 prepping, 46–55
peeing/pooing, 51, 52, 74
photo albums, 76, 176, 178, 184, 199
photo books, 184, 199, 200
photo jewelry, 199, 200
photo shoot safety, 62, 68, 69, 71
photographer's studio. *See* studio
photography
 custom, 46
 learning about, 194
 macro, 131–132
 natural imagery, 72, 146–147
photography career, 169–200
 blog, 188–189
 branding, 7, 9, 165, 167, 176, 183
 building relationships, 182
 business plan, 189–197
 business structure, 195
 clients. *See* clients
 creating value, 177–180
 defining/developing your style, 5–9, 147
 exit plan, 195
 expenses, 197–199
 financing, 195
 fundamental strategies, 194–195
 goal setting, 190, 192–193
 going above and beyond, 182–183
 journey, 172–174
 marketing, 181, 183–189
 mentoring sessions, 71
 networking, 181, 186, 195
 newborn niche, 169–180
 portfolio, 195–197

preconsultation, 47–54
pricing strategies, 47, 197–199
products, 178, 197, 198, 199–200
promotions, 181
services, 178
session fee, 48
setting yourself apart, 174–177
social media, 187–189
studio. *See* studio
time management, 72–73
website, 172, 188–189
"wow factor," 179–180
photos. *See* images
Photoshop, 158–162. *See also* image editing
 adjusting contrast, 159–160
 applying soft and creamy, 161
 brightening images, 159–160
 creating actions, 164
 creating workflow set, 163, 164
 enhancing color, 161
 post-processing efficiency, 163–165
 post-processing procedure, 158–162
 removing redness from skin, 160–161
 retouching images, 158–159
 tips/shortcuts, 164–165
pillows, 64, 75, 82, 88
Pinterest, 187
planning stage, 45–69
 accessories, 55–56
 cheat sheet, 57
 color schemes, 57
 final preparations, 56
 overview, 45–46
 prepping parents, 46–55
 settings/poses, 55–57
 "shooting to sell," 57–58
 simple setup, 59–61
playback menu, 40–41
portfolio, 195–197
posing, 71–107
 age of baby, 65–69
 basic poses, 76–89
 basic workflow, 88–89
 cheat sheet for, 57
 chin pose, 83–86
 with family members, 95–107
 with father, 101–104
 flexibility, 74
 forming the pillow, 75
 fussy/sensitive babies, 73–74, 89
 handheld images, 104–105
 with mother, 95, 98–100

images *(continued)*
 consistency, 165–167
 copyright information, 54
 culling, 151
 editing. *See* image editing
 "must haves," 73
 natural imagery, 72, 146–147
 post-processing. *See* post-processing
 sharpening, 157, 161
 softening, 23, 157
inspiration, 1–19. *See also* style
 considerations, 1–3
 stories. *See* storytelling
 unwritten words, 18–19
inspiration board, 4–5
Instagram, 187
iPad, 186
ISO settings, 30–34

J

jewelry, 199, 200
JPEG format, 42, 153, 154

K

Kotori website, 200

L

LCD screen, 34–35
Leather Craftsman website, 200
lenses, 42–43
Levels adjustments, 158, 159, 164
lighting, 21–43
 Auto mode and, 28–29
 bouncing light, 23
 butterfly pattern, 26–27
 catch lights, 25
 colorcasts, 23–24
 diffusers, 23
 directing light, 23–24
 flat, 26
 fluorescent, 39, 153
 histograms, 34–38
 natural light, 24–27, 41, 180
 quality of light, 22
 reflectors, 23
 "seeing" light, 25–26
 shadows. *See* shadows
 soft, 22, 23
 temperature, 39, 154
 time of day, 22
 tools for, 23–24
 tungsten, 39, 153

 white balance, 39–40
 from window, 22, 25
lighting diagrams, 128–129
Linkedin, 187
lips, 18, 58, 132
Loktah website, 200
lotion, 61
lullabies, 121
luminous histogram, 40–41

M

macro photography, 131–132
macro series, 57, 58
Manual mode, 28–29
marketing plan, 183
marketing strategies, 183–189. *See also* clients
 blogs, 107, 188–189
 networking, 181, 186
 overview, 181, 183
 portfolio, 195–197
 products, 178, 197, 198, 199–200
 promotions, 181
 referrals, 181, 186–187
 social media, 187–189
 target client, 183–185
 websites, 172, 188–189
 "word of mouth," 181, 185
mentoring sessions, 71
metering, 29–30, 34
Millers website, 200
monitor calibration, 150
mothers. *See also* parents
 expectant, 2
 keeping calm, 74–75
 nursing, 48, 54, 65
 posing with, 95, 98–100

N

natural imagery, 72, 146–147
natural light, 24–27, 41, 180
networking, 181, 186, 195
newborns. *See also* babies
 age of, 65–66
 anatomy. *See* anatomy, newborn
 body temperature, 49, 68, 110–112, 114
 circulatory system, 110–113
 circumcision, 48, 69
 considerations, 65–66
 posing. *See* posing
 premature, 114
 room temperature, 48, 49, 68, 110, 112
 safety tips/issues, 62, 68, 69, 71

D

depth of field (DOF), 31, 144
diaper covers, 62
diapers, 61
diffusers, 23
digital files, 178
DOF (depth of field), 31, 144
drapes, 143

E

editing. *See* image editing
email, 46, 52, 188
emotional storytelling, 11, 13–15
emotions, 98, 115–117, 144
equipment/supplies. *See also* accessories;
 props
 basic tools/supplies, 61–62
 contents of camera bag, 42–43
 lighting, 23–24, 62
 "must-haves," 61–64
 pacifiers, 48, 119
 simple setup, 59–61
 space heater, 61, 68, 110, 112
 T-bar stand, 60, 61
 towels/wipes, 51, 61, 62
 waterproof pads, 55, 62
 white noise generator, 61
ETTR (expose to the right), 29, 34
expenses, 197–199
ExpoDisc, 39, 40, 62
expose to the right (ETTR), 29, 34
exposure
 Auto vs. Manual mode, 28–29
 considerations, 28–30
 correcting in ACR, 154–155
 in-camera metering, 29–30
 overexposed images, 28, 34, 37
 underexposed images, 28, 38
exposure triangle, 30, 31–32
eyes, open, 127–130

F

fabrics, 61, 63, 141–143
Facebook, 107, 187–188
family members
 family shots, 106–107
 father, 95, 101–104
 mother. *See* mothers
 posing with, 95–107
 siblings, 48, 95–98, 182
fathers, 95, 101–104. *See also* parents

feet/toes, 58, 68, 78, 80, 87, 132
files, digital, 178
fine art albums, 176, 178, 183, 199
fingers/hands, 78, 82, 131, 135
fluorescent lighting, 39, 153
focus, 31, 32, 151

G

goal setting, 190, 192–193
Google+, 187
grandma brag books, 199, 200
gray card, 62, 153–154

H

hair color, 55
hand sanitizer, 61
handbags, 199
handheld images, 104–105
hands, 68
hats, 62, 63
headbands, 62, 79
heat, 61, 68, 110–112
highlights
 blown, 35, 37
 modifying in ACR, 155, 156
histograms, 34–38
 vs. LCD screen, 34–35
 luminous, 40–41
 overexposure, 34, 37
 overview, 35–36
 RGB, 40–41
 underexposure, 38
home décor, 48, 57
hunger, 115, 116

I

image editing, 149–167. *See also* Photoshop
 Adobe Camera Raw, 151–157
 camera raw clean edit, 152–157
 clean edits, 152
 consistency, 165–167
 monitor calibration, 150
 overview, 149–150
 removing redness, 160–161
 retouching in Photoshop, 158–159
 soft and creamy enhancement, 161
images
 albums, 76, 176, 178, 184, 199
 black-and-white, 144–146
 capturing details, 124–133
 close-ups, 131–132

behavior *(continued)*
 screeches, 116
 soothing techniques, 117–121
 startle reflex, 117
 sucking reflex, 115, 119
birth announcements, 199
black-and-white imagery, 144–146
blacks, altering in ACR, 156–157
blankets
 in buckets/baskets, 63, 64, 91
 considerations, 61, 76
 positioning/using, 55–56, 60, 75
blogs, 107, 188–189
blurring, 31, 32
body wrap technique, 135
bokeh background, 32
books, photo, 184, 199, 200
bowls, 56, 62, 64
brag books, 199, 200
branding, 7, 9, 165, 167, 176, 183
brightness levels
 adjusting in ACR, 154–155
 adjusting in Photoshop, 159–160
 histogram, 34–35
 LCD screen, 34–35
 overexposed images, 37
buckets, 63, 64, 90
business cards, 181
business license, 194
business model, 194
business name, 194
business plan, 189–197
butterfly lighting pattern, 26–27

C

calibrating monitor, 150
calibration, color, 153
camera bag contents, 42–43
camera equipment. *See* equipment
camera raw clean edit, 152–157
camera shake, 31, 32
camera tilt, 76
canvas wall galleries, 178
catch lights, 25
Chamber of Commerce, 181
changing table, 62
cheat sheet, 57
children's stores/boutiques, 181
chin pose, 83–86
circulation, 68
circulatory system, 110–113
circumcision, 48, 69

clamps, 62
clarity, 157
clean edits, 152
cleanliness, 107
client base, 181–183, 185, 195, 197
client database, 182
clients. *See also* parents
 building relationships, 182
 email contact, 46, 52, 188
 going above and beyond, 182–183
 initial contact, 46–47
 keeping calm, 55, 74–75, 117
 marketing strategies, 181, 183–187
 preconsultation, 47–54
 pricing strategies, 47, 197–199
 referrals, 181, 186–187
 repeat, 182
 rescheduling sessions, 68
 session fee, 48
 social media and, 187–189
 target client, 183–185
 welcome package, 52–54
 "word of mouth," 181, 185
clipping, 35, 37, 38
close-ups, 131–132
clothing, 3, 48, 49, 51, 54
COGS (cost of goods sold), 198
cold, 111
color
 considerations, 55
 enhancing, 161
 favorites, 48
 hair, 55
 home décor, 48, 57
 props, 56
 skin, 55
color calibration, 153
color schemes, 57
color temperature, 39, 154
color tint, 154
colorcasts, 23–24
ColorChecker Passport, 39–40, 62
consistency, 165–167
contrast
 adjusting in ACR, 153, 155
 adjusting in Photoshop, 159–160
copyright information, 54
cost of goods sold (COGS), 198
crying babies, 89, 114, 115, 116
culling images, 151
cushions, 89, 92

Index

A

accessories, 55–56. *See also* equipment; props
 basic tools/supplies, 61–62
 beanbags. *See* beanbags
 blankets. *See* blankets
 fabrics, 61, 63, 141–143
 hats, 62, 63
 headbands, 62, 79
 scarves, 56, 63, 143
 waterproof pads, 55
 wraps, 56, 62, 135, 137, 141–143
ACR (Adobe Camera Raw), 151–157
actions, Photoshop, 164
Adobe Camera Raw (ACR), 151–157
Adobe Photoshop. *See* Photoshop
advertising. *See* marketing strategies
age, of babies, 48, 65–69
albums, photo, 76, 176, 178, 184, 199
anatomy, newborn, 109–121
 baby cues, 115–117
 body temperature, 49, 68, 110–112, 114
 circulatory system, 110–113
 premature babies, 114
 skin, 113
 soothing techniques, 117–121
aperture, 29, 30–34, 144
associations, 195
Asukabook website, 200
Auto mode, 28–29
awake shots, 17, 49, 57, 67, 127–130

B

babies. *See also* newborns
 age of, 48, 65–69
 awake shots, 17, 49, 57, 67, 127–130
 body temperature, 49, 68, 110–112, 114
 circumcision, 48, 69
 clothing, 48, 51
 crying, 89, 114, 115, 116
 cues, 11, 115–117
 emotions, 115–117
 expressing personality of, 17–18
 feeding ahead of time, 48

 flailing arms, 117
 fussy/sensitive, 73–74, 89
 happy, 89, 117
 hungry, 115, 116
 keeping calm, 117–121
 keeping warm, 49
 laying on side/stomach, 119–120
 movements, 13–14
 nursing, 54, 65
 open eyes, 127–130
 peeing/pooing, 51, 52, 74
 pooing. *See* pooing
 premature, 114
 room temperature, 48, 49, 68, 110, 112
 rooting reflex, 115
 safety tips/issues, 62, 68, 69, 71
 screeches, 116
 shushing, 118
 skin. *See* skin
 sleepy, 49–52
 smiling, 11, 12, 17, 127
 soothing techniques, 117–121
 startle reflex, 117
 sucking reflex, 115, 119
 swaddling, 118, 139–140
 swinging, 119
 wrapping techniques, 133–144
baby wipes, 61
background stand, 62
backgrounds, 31, 32
baskets, 56, 62, 63, 64, 93, 94
beanbags
 fabrics for, 141, 143
 overview, 60–61
 propping baby on, 75
 setup, 59, 60
behavior
 baby cues, 115–117
 crying, 89, 114, 115, 116
 cues, 11, 115–117
 emotions, 98, 115–117
 flailing arms, 117
 keeping babies calm, 117–121
 rooting reflex, 115

I always add a special gift that my clients aren't expecting. This is part of the customer service I provide to my clients. Some of my gifted products consist of small accordion brag books for grandmas and photo jewelry necklaces. A handwritten Thank You card is included in every order. Everyone deserves to receive something special.

Product resources

Be sure to check out the following websites for additional product resources for your business:

- ProDpi (www.prodpi.com)
- Asukabook (www.asukabook.com)
- Loktah (www.loktah.com)
- WHCC (www.whcc.com)
- Leather Craftsmen (www.leathercraftsmen.net)
- Simply Canvas (www.simplycolorlab.com)
- Millers (www.millerslab.com)
- Kotori (www.mykotori.com)

The PPA's Benchmark Survey estimates that the general expenses for both in-home and retail studios average 30–40% of total sales.

Photographers use many different strategies to determine their pricing and packaging solutions. Sit down, figure out the numbers, and decide what will work best for your business.

Products

Tons of products are on the market, and new and innovative ones are popping up every day. Sometimes it can be overwhelming—not only for beginners, but for seasoned photographers as well. My basic rule is to choose two to three products and either gift or up sell others. My signature product is the fine art album. A display of albums is set up in my studio, and I show them to my clients at the preconsultation session. This is what I sell because they are exquisite and gorgeous, and because they are a high-end value for the product. I don't offer my clients cheap products. Clients get excited about them right from the beginning and value how priceless they are.

Products Unique to Newborn Photography

There are certain products that are unique to newborns. Consider which one(s) are best for your business and plan on offering two or three in your product line:

- Birth announcements
- Fine art albums
- Brag books for grandmas
- Jewelry
- Handbags
- Storyboards
- One year albums for baby plans of 3, 6, and 12 month sessions

Here is a general list of the cost of the products you might sell, usually referred to as the cost of goods sold (COGS):

- Lab costs—prints, albums, canvas
- DVDs and/or USBs
- Packaging
- Shipping

The PPA's Benchmark Survey estimates that the COGS for both in-home and retail studios is 25 percent of total sales.

Then there are the general expenses to run your business, which are all the costs associated with running a business regardless of whether or not you sell anything (this is just a basic list; it is not a complete list):

- Website, blog, hosting
- Advertising
- Rent
- Computer, software, hardware
- Equipment—camera, lenses, CompactFlash cards, and so on
- Props
- Samples
- Utilities, phone
- Insurance
- Printed materials—business cards, client guide, flyers, and the like
- Education, workshops
- Branding
- Memberships, magazines
- Furniture
- Tax and legal services

It took about six months to get my business back on its feet again. That time was a bit scary because I didn't know how long it would be until I'd be busy again. But once it hit, it hit hard, and I began booking three months in advance. I made some mistakes, but in the end I learned how to market myself and how to target the clients who valued my work.

In my opinion, the best way to build a portfolio is to determine your pricing, mark it down by 30–50%, and then inform your clients that you are offering portfolio-building sessions for a limited time. Then when you are ready to raise your rates to the full price indicated, your clients won't be shocked to have to start paying more for your services.

If you give sessions away for free, you will lose the client base you worked so hard to build.

Pricing and Products

Many pricing strategy resources are available for photographers nowadays, but I highly recommend *The Photographer's MBA: Everything You Need to Know for Your Photography Business* (Peachpit Press, 2012) by Sal Cincotta.

Most important is to know your clients and your market before you determine your pricing. High-end photography requires high-end pricing with top quality service and products. Low price/high volume photography will attract clients who are price shopping and asking for more and more discounts.

Sales are about the personal relationship you build with your clients. If they believe in you, your product, and your art, they won't have a problem with your pricing.

Pricing

You must know what your expenses are to run your business whether you sell something or not. Expenses can include websites, blogs, utilities, and so on, as well as the cost of goods you sell to your clients—prints, albums, and packaging.

The goal is to price for profit. Determine what products you want in your collections and keep the costs at the percentage according to the PPA's Benchmark Survey to ensure that you turn a profit.

Build your portfolio by capturing images that represent your true style.

ISO 400, 1/1000 sec., f/1.4, 50mm lens

- **Research your industry.** Become an expert in what newborn photography has to offer in terms of products and services. Join industry associations, such as the Professional Photographers of America (PPA), and begin networking with other photographers. Make sure the groups you join will be useful to your business and worth the investment.
- **Get financing.** You should plan on saving some money ahead of time to start your business, but if you need more, seek out the SBA or your local bank for a loan.
- **Hire a tax accountant and a lawyer.** Decide if your business will be structured as a sole proprietorship, LLC, or an S-Corp. Talk to a tax accountant to discuss the best option for you. You may not need a lawyer now, but planning ahead and having one available should the need arise is a smart idea.
- **Have an exit plan.** Most people don't like to think their business will end, but at some point it will. Will you sell the business, or perhaps hand it over to a family member? Plans can always change, and often do. So make sure you have a strategy in mind regarding what you will do with your business assets should anything happen to you or you decide to end it.

Build Your Portfolio

At the beginning of my career, I learned some valuable lessons. Building my portfolio by offering free sessions was a major setback for me. I didn't think I was good enough yet to start charging for my photography, so I offered free sessions to build my portfolio. Soon word spread that Robin Long offers free sessions! I may as well have set up a billboard on my lawn because I started receiving emails from my clients' friends asking me to provide a free session for them as well.

If you give sessions away for free, you will lose the client base you worked so hard to build. And that's exactly what happened to me. I lost every one of those early clients. You see, I attracted the wrong *type* of clients. They did not value the portraits nor me as a professional. They saw the free sessions as a cheap way to get some pictures of their child because that's how I marketed my services.

Don't get me wrong; I'm not saying you should never offer free sessions. But don't do it while you are building your portfolio. I had to learn the hard way and didn't have a mentor to guide me in the right direction. Save the free sessions until after you are established and have a reason to offer them, such as for a charity, a special event, or a special project.

Strategize Your Plan

In the beginning when you're starting your business and building your client base, it's vital to know your business model so you can define your target market. Will you be a high-volume, low-price photographer? Or will you be a low-volume, high-price photographer? When I first began, I had a high-volume, low-price business model. But I soon realized that model was not for me. I would rather have fewer clients and make the same amount of money instead of working longer hours and making less. Your time is valuable. Think carefully about what is most important to you when you're strategizing your plan. The clients you attract in the beginning should be the ones you want to keep as repeat clients. Will they be looking for a discount, or will they be clients who value your work enough to pay you what you're worth?

When I started, I knew the business side well because I had already owned my own business in medical billing and transcription for 15 years. But I didn't know much about photography except for working with film back in high school. I pretty much had to start from scratch to learn my camera, how it operates, exposure, lighting, and everything else needed to hone my skills at my new craft, as well as my new business.

Based on my experience, here is a list of some fundamental strategies I suggest you use when you're starting your photography business:

- **Do what you love.** There's no enjoyment in starting a business to do something you don't love. Most people have had enough jobs in their lives working for others doing not-so-fun things just to put food on the table.
- **Don't quit your day job yet.** If your household depends on your income, wait to quit your primary job until your business is well on its way to success. In my case, it took two years before I could quit my full-time job.
- **Register your business name with the Secretary of State.** Some states require licensing. Be sure to check your state's rules for opening a business.
- **Run a business from your home.** If you rent or live in an area with association rules, you may want to make sure it's legal to run a business from your home.
- **Develop a business plan.** A business plan is vital to a successful business.

My journal with my business plan and goals.

ISO 400, 1/500 sec., f/2, 50mm lens

The Small Business Administration (SBA) has a great online tool to help you build a business plan. You can log in to check your goals and mark off completed tasks as you progress in your business. You can also get involved with the SBA's community discussions boards and ask business questions. The SBA also offers mentors and counselors who are ready to help you. Go to sba.gov to set up your business plan. You can search this site for the SBA in your area.

A few years ago I wrote down the goal of having my own book published some day, and here I am writing that book. I still have goals I have not met or have changed. But the important thing is to make a plan and evaluate it to make sure you stay on track.

Goal Setting

Tip: Keep your notebook of goals handy and with you all the time! Sometimes you'll think of ideas to implement and want to write them down so you don't forget what a great idea it is!

Get a journal and title the first page, "My Business Plan." Use this solely for the purpose of tracking your goals and visions. Write them down and describe how you will achieve them. Who will you target, and how much will it cost to implement these goals? What new accomplishment do you want to achieve in your business this year? It could be a new product, new packaging, or a new service you want to offer. Maybe you want to work on creating more value, organizing client data, or revamping your branding. What type of equipment can you start with, and what type of studio do you need? How will you handle growth once your business takes off? Think of everything you want to do and record it in your notebook. Then separate the goals into one-year, three-year, and five-year plans. Don't try to do too much at once. Take it slow and be efficient in your workflow.

Some days I have big plans and goals I want to implement immediately, but then I realize I need to prioritize them because I can't do them all at once. Some ideas are still sitting in that book, yet to be accomplished. But that's OK. It's my business bucket list; everything I want to do pertaining to my business is written in a journal. Engraved on the front of that journal are the words "Some people dream of success while others wake up and work hard at it."

This natural portrait of a sleeping newborn is an expression of my goals to keep my style looking as pure and authentic as possible.

ISO 400, 1/1600 sec., f/1.8, 50mm lens

Your business plan should contain the following elements:

- A description of your business
- The purpose of your business
- Your ideal client
- Products and services
- Equipment required
- A description of your competition
- Business insurance
- Financial data

Industry leaders indicate that running a photography business is about 30 percent shooting and 70 percent running the business.

At the end of the year, look at where you started and what you've accomplished. Don't be afraid to change the direction in which you're going. Life happens and things change daily. Be open to change and learn to adapt. My five-year plan, which is where I am now, looks nothing like my five-year plan five years ago. It's changed dramatically. My plan then consisted of a dream of being a big kids commercial photographer with Pottery Barn. Yea, I chuckle now, but back then it was a big dream of mine! Sure, I wouldn't mind doing that now, but my goals have changed. They now consist of working with maternity and newborns, and that's what the future five-year plan is based on.

Short-term goals are just as important as long-term goals. They could be as simple as organizing your desk, answering emails, or making blog posts. Write down your ambitions and desires of what you want to do and how you see yourself as an artist and businessperson. Don't be afraid to modify your goals. I usually look at my long-term goals every month and my short-term goals on a weekly basis.

A business plan requires constant tweaking and revising to build upon. If you are just starting out, it's crucial to write a business plan to help you describe your product and services, and have a detailed marketing strategy in place. Lay out your financial projections, and set a goal of where you will be within the specified times. If you've already begun your business and haven't created a business plan, you can still do it going forward. Planning is a continuous process that never ends, unless you end your business, of course. Otherwise, you should be revising it quarterly, if not more often.

leave comments. Ask them a question at the end of the post so they feel compelled to reply, and always post photos. People are visual creatures. They like to see lots of photos!

Share a special story about a baby's birth or how the parents fell in love. Make this part of the story you blog about after their session.

One of my clients shared her delivery experience with me, and I asked for her permission to share it on my blog when discussing their session. She went into labor at home and decided to wait a little while before heading to the hospital. Her contractions started coming stronger and closer together rapidly, so she and her husband decided to head to the hospital. They didn't think about the time, but of course they hit the freeway during the five o'clock traffic. Suddenly she felt the baby's head and screamed at her husband to pull over! He made a mad dash to the side of the freeway and called 911. The baby was delivered in the car, on the side of the freeway, in the middle of rush hour. This was such an exciting story to tell, that I shared it along with their session on my blog. This compelling story engaged my readers who in turn left comments on the post.

Tip: Blog about everything—your sessions, the products you offer, and the awesome customer service your clients will receive by booking with you!

Creating a Business Plan

There's more to running a photography business than merely taking photographs. Industry leaders indicate that running a photography business is about 30 percent shooting and 70 percent running the business. And the business side is the challenging part. Granted, photographers are artists at heart and the last thing you want to do is deal with expenses, taxes, marketing, and so on. But all of these factors come with running a business, and as entrepreneurs you must learn to manage these tasks.

Before you start your business, it's important to set up a business plan. A business plan involves setting goals detailing where you want to be in a year from now, three years, and five years, and what you need to do to achieve those goals. It's a living blueprint of your business to help you market and manage your company, and guide you in the right direction while keeping your long-term goals in sight. It also entails determining the equipment you need to start your business including a camera, lenses, and a computer.

You can create albums of your best work and post details about your business. Post frequently and engage your followers with photos. Talk about your sessions and the time with the baby and parents. Encourage your clients to share the posts with their friends and family by "tagging" themselves on your post.

Facebook also has an advertising tool you can use that can be seen by prospective clients. You can select specific demographics, a city, and even a zip code. I tried this once and did book a couple sessions from it. The best thing to do with any marketing or advertising option is to try it once and see if it works for you. You won't know until you try it.

Twitter

Twitter is growing in popularity, but I have yet to utilize it much except when I find some downtime. It seems to be a more personal-level medium to me, and I mostly use it to connect with my peers in the industry. It's useful to get the word out about my workshops, book, and other photography related happenings, but I haven't ever booked a client from Twitter. It can be a great tool for you to connect with other photographers and learn about the resources they have to offer.

Blog and Website

Surprisingly, 90 percent of my inquiries come from emails sent through my website. People live busy lives. Rarely do I get phone calls from prospective clients anymore. Most of these referrals are generated through Facebook. Then they view my work on my website and contact me via the website.

Tip: Post a link to your blog on your Facebook wall. Not only does this help with search engine optimization (SEO), but when clients click the link on your wall, it will take them directly to your blog.

Your blog and website are your clients' first impression of you. Clients should be able to come to your site often and see fresh images and content. Write articles or stories about your sessions to share with everyone, and entice your viewers to want to come back time and time again. The worst thing you can have is a stagnant blog. If clients return to your blog a few times and haven't seen any new content, they're likely to move on, because it will give them the perception that you're no longer running a business.

When you're writing blog posts, keep your audience engaged by not only sharing new information, but also sharing a little personal side of yourself. This helps them to get to know you better and trust you. Your posts should encourage readers to

client to me by giving them an incentive to make a referral and show them my appreciation for doing so. You might also offer them a gift card to a local boutique clothing store that could open the door for potential advertising within the store as well. Any type of referral credit you can offer gives them another reason to share their experience with you with someone else.

Social Media

It's vital as a business owner to have a presence on online social media sites—Facebook, Twitter, Instagram, Pinterest, Linkedin, and Google+, among others. I know it's difficult to keep up with all of them, but try starting out with a few of the top sites and build from there. Your goal should be to stay connected with your clients, and more and more people are accessing their social media outlets than ever before.

The future is a digital world, and in order to stay on top, you have to be where your clients are—online.

Facebook

Facebook seems to be the number one social media site today that clients access daily. You can use it as a marketing tool and an advertising tool. There's no waiting for clients to find you; you can post photos on your page so they appear on your client's feed.

From my personal page, I've created a separate business page. I know most people say not to friend your clients, but I friend almost anyone. I don't mind my clients getting to know me on a more personal level because the type of photography I do demands a more personal level with my clients. If I want to post private messages or images to only close friends and/or family, I just create a secret group and invite them there.

It's always best to keep your business page business related. I don't post personal information on my business page, nor do I post anything politically related. My faith is an open book, and I don't mind sharing that even with clients. However, I don't post anything that would warrant a debate. But letting people know I am a Christian is an important part of me that is worth sharing.

Face to Face

Face-to-face networking is still going strong and is one of the best ways to network your business. Join a local networking group and get involved. Networking with other businesses, not only those that have a similar interests as you, but even those businesses you wouldn't think of as being a good reference for you, are sometimes the best referrals. Leave your business cards with as many businesses and people as you can, and ask them to pass them around to someone who may be planning on having a child. Even grandparents are potential clients!

Tip: *For some awesome marketing strategies, read the book* Worth Every Penny *(Greenleaf Book Group Press, 2012) by Sarah Petty and Erin Verbeck.*

Every person I meet in person is either a potential client or may possibly know someone who is. I always keep an open ear in conversations that might warrant a potential diversion to talking about newborns. While out having lunch with a friend one day, one of her friends came into the restaurant. They made eye contact and she invited her to sit at our table for a moment. They started chatting and in their conversation the topic of newborns came up. My friend told her friend I specialized in newborn photography. Her friend was instantly intrigued about what that even meant! I showed her my work on my iPad, which I just happened to have in my purse, and she was thrilled to see such beautiful photos! She didn't know there was a specialty in this area of photography. As our conversation progressed, she told me about her sister-in-law who was expecting her first child. She had three children herself and said how she wished she had known about custom photography when her children were newborns. The conversation ended with me giving her my business card as she went on her way. A week later her sister-in-law called me to say she wanted to book a maternity and newborn session with me. Fast forward six months after her session and a new client has emerged when she passed along my information to her moms group. I'm still booking sessions from this one friend of a friend of a friend.

Referral System

A referral system is crucial to your business marketing plan. It goes hand in hand with face-to-face and word of mouth advertising. Having a referral card that your clients can give to others puts something tangible in their hands that they can see, feel, and know is real. When my clients come in for their preconsultation, they receive a referral card outlining my referral system along with five cards to give out to potential clients. If a booking comes out of their referral, both parties receive a $100 print credit. I want to make it worth their time to refer a potential

I've been running my photography business for five years now. My approach has moved to the next level of *fine art newborn portraiture*—such as high-end portraiture that caters to an affluent clientele. However, high end does not necessarily mean targeting those who are rich. I found this out early on when I landed clients whom I thought would be my largest sale ever. They were well-off, had a nice home, and drove fancy cars. As it turned out, they spent the least amount of money than any client I have ever worked with. I was puzzled. I couldn't understand how people with so much money had such little value for custom portraits. But then I realized that it was a choice, not always a matter of money. Some of my biggest spending clients are those who have saved, planned, and invested in their portraits. They valued the art I provided and were willing to save up for it. That's not to say that wealthy people don't value custom photography, but you need to know the clients who do value it.

Word of Mouth

Everyone is a potential client or referral, even the lady down the street who doesn't have any babies. Most likely she knows someone who has a baby or knows a friend of a friend who has a baby. Word of mouth is the best form of advertising. And this is what most of my entire client base is built around. The advantage is that there isn't any out-of-pocket expense for me to advertise.

You may have noticed the dry cleaners down the street, but when your best friend tells you about the great customer service she received, you're more likely to go there the next time you need your clothes dry cleaned. Or how about your hair stylist? I'm very picky about who does my hair and will go to great lengths to find the right stylist. My stylist is not only great at what she does, but she provides awesome customer service and goes out of her way to get me in when she's already booked. She also goes to the beauty supply to pick up the hairspray and hair treatment I want, and calls me when it's ready to be picked up! I always refer her to others because she has provided me with exceptional customer service and continues to do so. I market her by word of mouth.

Word of mouth is the best form of advertising.

Provide high-quality customer service so your clients say great things about you, and they'll be your best advertisement! You'll never have to advertise again.

My niche is differentiated by the pure, soft, airy feel, and tone of my images.
ISO 400, 1/640 sec., f/1.4, 50mm lens

If I were targeting a market whose main objective was a low-cost, high-volume product, I would offer a press printed photo book. See the difference? Who do you want to market to, and what products and services will appeal to your market? If your business model is to provide low cost and high volume, offering a press printed book instead of an album would be the perfect product!

Gift your clients with a welcome bag full of goodies when they arrive at their pre-consultation. Send a thank you card a week later telling them how excited you are to meet their new baby!

Find ways to go above and beyond, and give your clients an excellent customer service experience, and they'll be talking about you forever.

Marketing Your Business

Marketing is an ongoing task that involves promoting, selling, and distributing your products and services, and communicating that value to your clients. It includes certain aspects of your business, such as your brand, advertising, customer service, sales, and pricing strategies. Marketing never ends and demands evaluation at least every six months. You'll need to look at what's working and what isn't, and try different approaches. The purpose of marketing is to make people aware of you, your brand, and what you have to offer. Therefore, it's vital that your entire brand works cohesively. You have to keep up with the needs of your clients and be willing to adapt and change if needed.

Without a marketing plan, your business will move blindly. You won't know what to do next, hoping someone will come along and find you. It's like building a website to sell children's clothing and sitting around waiting and hoping someone will discover your site and buy your products.

To market and target your prospective clients, you have to know who they are, where they shop, and what they like to do.

Without a marketing plan, your business will move blindly.

Your Target Client

Because newborn photography is such a specialized market, it's important to pinpoint who your audience is to maximize the effectiveness of the service and products you offer. My market consists of those who value newborn art and are looking for high-quality, natural-looking images. Therefore, I need to make a special appeal to them and provide a product and a service that are extraordinary, and they can't get anywhere else. I provide images that tell a unique story about their child and present them in fine art heirloom albums.

Building Relationships

In today's world, it's all about building relationships with people. When your clients talk, listen to them. Show them you care by showing interest and engaging in conversations about them. Know who they are, what their hobbies are, and where they work. Build a database of your clients with everything you want to know about them. Recently, I've begun developing a more personalized new client form to include all these areas so I can input them into my client's account. My clients fill it out before they come for their preconsultation so I have a chance to get to know them before I meet them. By getting to know them on a personal level, I can build a better relationship with them.

To inspire loyalty in your brand, reach out to help people where you live and work, and get involved in your community. Help with local charities and organizations. These are great ways to build relationships with everyone you meet and a perfect way to get people talking about you!

Go Above and Beyond

It's the way you make your customers feel that makes their experience better than anyone else's.

Many times I've had repeat clients come back with a second and third child. The older children are typically about two years old, and everyone knows how children that age can be! They run the show, and if they don't want to do something, they won't do it. It's tough to get a sibling photo when the two year old doesn't want to cooperate.

In my studio, if I'm unsuccessful at getting the sibling shot that mom so badly wants, I'll tell my client to call me when the older sibling is feeling closer to the baby and they can come back in for a half hour session to try for the sibling shot again. I know how important it is for moms to have that photo, and I'll go out of my way to make it happen. Usually, a couple weeks is all it takes for the older child to settle in to having a new baby in the home and be willing to have a photo taken with the baby.

It's the way you make your customers feel that makes their experience better than anyone else's.

Your Client Base

The most difficult business aspect for new photographers is to build a client base. You're new and no one has heard of you before. Once you know who your target market is, you need to build trust and a rapport with that audience. Venture out into the community, talk to people, pass around your business cards, join the local Chamber of Commerce, and get involved. The ability to network is crucial to growing your client base.

When I first started out, most of my referrals came from word of mouth, which is one of the best and cheapest ways to market yourself. I actually started at the beginning of a baby boom with my oldest daughter's friends. They were all the same age, and everyone was having babies, so word of my new business spread quickly. It really was a quick start for me, and my business grew rapidly. I also approached local boutique children's stores and midwife clinics in town, and was very successful marketing to them as well. I offered large complimentary wall portraits for their offices and left a stack of business cards with them for display. I offered a $100 print credit to all clients who were referred from these businesses. These promotions exposed me to many new clients who have been coming back to me with each new child for quite a few years now.

To stay in contact with the businesses I network with, I stop by every couple of months with boxes of chocolates or cake pops for the girls in the office. They are thrilled, and it gives me a chance to replenish my cards, offer new promotions, and talk to them about how their business is growing.

I also continue to market my business to other venues, such as my hair dresser, nail salon, and an artist who makes hand-made silver thumbprint baby necklaces for new moms. We exchange business cards and constantly network with each other. I created 4x6 postcards with approximately six images on them to display my work. It has been a huge advantage for me, because they've left these displays at their stations where all their clients can see them. I also provided them with an easel with a 5x5 mounted print of their newborn to set on display with the cards.

I carry my business cards with me everywhere I go, because I never know when I might meet someone who could be a client or who would love to network with me.

I consider one of my wow factors to be my use of natural light and soft, beautiful, natural imagery using white lacey fabrics.
ISO 400, 1/1000 sec., f/1.4, 50mm lens

What I learned was that a company that offers a high-end experience always builds a relationship with its customers that goes above and beyond expectations. I would have never thought to ask if alterations were included in the price, because I would have expected the company to charge more. But in the end, because the experience exceeded my expectations, I was more than just a satisfied customer.

What Is Your Wow Factor?

What is it that makes you different than all the other newborn photographers? If you haven't thought about it, now is the time to do so. Lots of people can purchase a DSLR camera these days, instantly say they are photographers, start booking clients for $50 a session, and charge $200 for a CD of 60 images. The professionals need to stand out, and it's that unique factor that you need. When potential clients look at your portraits, you want them to say, "Wow! Her work is amazing!" Your brand, look, feel, products, style, and even your packaging have to leave your clients gasping for air for them to disregard the price and say, "I have to book her!" That specific advantage will put you ahead of your competitors, and you will dominate in the industry.

Tip: Create your wow factor, and your clients will be as passionate about your art as you are.

Work on developing a distinctive technique, whether it is your exceptional customer service, your style, or the products you offer, or better yet, everything you do. It's your secret ingredient to success that no one else is doing. Find the "wow" and convey this to your target market. Talk about it on your website, blog, and social media. Become obsessed and excited about it! If you show your passion for your work, your clients will be passionate as well.

What's *your* secret ingredient?

Nordstrom is a high-end company. When I shop there, I expect to pay more than I would at a discount clothing store. The company markets itself as a boutique style business that offers designer clothing and high-end service. While shopping for jeans for my teenage daughter one day, the sales lady overheard me telling my daughter that the pair she was trying on and wanted were way too long. I thought I would have to take them to a tailor to have them hemmed, which would increase the already high cost of the jeans. The sales lady very nicely told me that Nordstrom offers complimentary alterations on its clothing. Needless to say, I was sold and walked out feeling excited that my money was well spent!

Change Your Service and Products to Add Value

Every month I sit down and consider what I could be doing better to provide the best customer service to my clients. I look at new products on the market, what my clients are demanding, and how I'm meeting those needs, and then I make any changes for the benefit of my business.

When I first started specializing in newborn photography, my clients demanded canvas wall galleries, so that is what I focused on selling. I created canvas wall galleries and sold them in collections. People loved the product because it was unique and something they couldn't get anywhere else. A few years later, clients wanted albums. To meet their demands, I searched out albums until I found what I loved and then adjusted my product menu to reflect that product. Once again, clients couldn't wait to get their hands on these much sought after fine art albums.

Jump ahead to the present and everyone wants digital files. That's what they all ask for, so that's what I give them. Of course, I do not sell them at a cheap price. They have value, and I've created collections to include fine art products along with digital files for archival purposes. I know my clients want the digital files just for safe keeping and that's what their intended use is for. In this ever-changing industry you need to keep up with the demands of your clients and meet their needs. I don't mean you need to sell yourself short and sell for less; you still need to make a profit. But listen to your clients; ask them what they want. This is one of the first questions I ask my clients during the initial phone call.

As an analogy, consider a pediatrician versus a general family doctor. The pediatrician can treat patients of all ages, just as the general doctor can; however, what makes him different is that he has become a "specialist," an expert who is devoted to learning his occupation. The same is true when you compare a general photographer and a newborn photographer. The newborn photographer can photograph anything, just like a general photographer. But his or her expertise is in newborns. Photographers who specialize in a given area of work can charge more because the market demands allow them to, which tells their clients that they are the best and the reason they should hire them instead of the generalist.

Creating Value

To stand out in your area of photography, you'll need to provide a unique value to your clients. Look at ways your business can promote something different than your competitors—something irresistible that they can't get anywhere else. What can you offer your clients that's truly unique?

Let's say another local photographer is selling a DVD that contains 30 digital files for $200, and you're also selling a DVD with the same number of files for $1,000. If you don't create value for your product and/or service that makes you different, the client has nothing to compare you with other than price. Price now becomes the determining factor; naturally, the client will choose the cheapest option. The more customized your offer, the harder it will be for competitors to compete against you, and price will no longer be an issue.

Photographers who discount their services and products can't compete with a high-end photographer. The service and products you offer your clients should excite them and give them a personalized experience. This is how you create value and what distinguishes you from the average photographer.

How to Be Different

The birth of a baby is as much of an important event in the parents' lives as their wedding day. It only happens once in a child's life and is one worth capturing and remembering. An emotional connection to their child is what compels parents to seek out a photographer who is not only an expert at photographing newborns, but is well educated in handling, soothing, and baby safety as well. Parents naturally want the best of everything for their children. They want to work with someone who is passionate, caring, patient, and trustworthy, and they will pay for a specialist who has these qualities and experience. You can create a specialized niche that not only sets you apart from the average photographer, but makes you a highly sought after newborn photographer. Granted, not everyone will be able to afford custom photography, and that's OK.

Ten Ways to Set Yourself Apart

With so many newborn photography businesses in the industry you can use the following suggestions to set yourself apart from other photographers, so clients will see the value of doing business with you:

1. Be cohesive and consistent with your style and your brand on your website, as well as in the materials that you present to potential clients.

2. Give your clients more than they expect.

3. Research your competition and offer a product or service they don't provide.

4. Always say yes to special requests that are reasonable.

5. Surprise your client with a gift at booking and complete the ordering session with a hand-written note.

6. Offer hand-made fine art albums.

7. Hand deliver your client's order.

8. Create a style that no one else has.

9. Be recognizable in your work.

10. Charge more for your work.

To set yourself apart and aspire to elite status, you need to offer outstanding service and products that leave your clients thirsting for more.

By specializing in a specific product, you'll become a master, and by master I mean that you'll become an expert in your field. The reason is that you'll dedicate all your time, energy, education, and passion to learning that particular area of expertise. The more you do something, the better you'll become at perfecting it.

Inevitably, you'll be doing something you're good at, love, and have strong feelings for. As a result, you'll mostly likely excel at that craft. It's difficult to be an expert at something you don't feel you're good at or don't like doing.

Tip: *Differentiate your brand from other local photography studios and watch your business skyrocket.*

I love documenting unplanned moments like this four-image series of baby Gia as she settles down and goes to sleep.

ISO 400, 1/800 sec., f/1.4, 50mm lens

That's when I began to specialize in newborn photography. To create my own niche and set myself apart from other photographers in my area, I began to differentiate my photography with my style, the products I offered, and the customer service I provided to my clients. While everyone was trying to compete with one another, I focused on being different by increasing my prices, searching out better products, and doing anything I could to reflect my newfound niche. I've always been this way, doing something different and pushing myself to succeed. At this time is when my business really began to soar.

Setting Yourself Apart

New photographers are popping up everywhere, and you're probably asking, "How can I compete with the low-priced photographers?" Well, you don't have to compete with them. In fact, you shouldn't ever try to compete with them based on price. Instead, you need to be extraordinary, exceptional, and a step above everyone else.

For years I've traveled a lot, flying all over the country, Canada, and Australia teaching newborn workshops and always have flown coach. Every time I boarded a plane, I'd envy the people in first class and think how special I would feel if I were sitting there. Last year when I flew to Oahu to teach a class, my husband and I were fortunate to get an upgrade to first class by using miles we had saved up. I was thrilled to give up those miles just to have the experience of sitting in first class. We boarded the plane before anyone else and sat in large, leather comfortable seats. The flight attendants brought us water while we waited for the plane to take off, and I remember feeling giddy about the experience. Once the plane was in the air, we were served a delicious nonalcoholic POG (pineapple, orange, guava) drink. I must have had five of them during the flight. Before our meal, we were first served an appetizer and then bread and butter. Our meals were served on porcelain plates with real forks, not those plastic ones you get in coach. Dessert consisted of a yummy chocolate mousse pudding, which was followed by hot washcloths at the end of the meal. It was the finishing touch of one of the most enjoyable flights I've ever flown.

First class is a specialized niche the airlines offer to their passengers at a higher price. With the higher price comes a higher level of expectation in customer service and product. If I had paid the high price and not received the same attention in coach, I would not have been a happy customer.

fortunately it was a friend's wedding and was pretty casual, I would photograph this sweet little baby every chance I got. At that moment, it hit me: This was an awakening to what my inner soul had been trying to tell me all along. I recognized where my passion was and knew that I had found my calling. Photographing a baby with smashed cake on her face was way more exciting than shooting two adults with cake all over their faces! That's not to say that I didn't enjoy photographing the wedding, but I never shot another one after that day. From that point on, all my focus, education, and passion went toward learning about newborns and how to establish myself in this ever-so-populated industry.

Tip: *Define what your niche is, and then create and implement that style into your brand.*

A simple, yet elegant pose of the baby lying on her side.

ISO 400, 1/800 sec., f/1.4, 50mm lens

Define, Create, and Implement

The first step in creating your niche or brand is to define it. What is it about your work that sets it apart from others? It must be something exceptionally better than any of your competitors and makes you simply irresistible. It could be your perspective in your shooting style or an extraordinary way in which you post process your images. Providing outstanding customer service where you meet the needs of your clients and hand deliver their products also sets you apart. Or possibly, you can offer your clients a unique product that they can't get from another photographer or the local lab. You can differentiate yourself in a number of ways; you just have to find what it is that your clients want, create it, and do it better than anyone else.

You may be a photographer who "does it all"—the one who is everyone's photographer, shooting a client's wedding, pregnancy, newborn, family, pets, and even sports. There's nothing wrong with that if that is what you love, but it will be difficult to specialize in one area, and "doing it all" could hold you back from focusing on your specific niche. Choose an area that you love and are passionate about, and focus on being unique.

My website contains mostly photos of newborns with some maternity and baby images mixed in. You won't find any images of families or weddings because I choose not to photograph those subjects, and quite frankly, I'm not very good at those types of photos. My passion is in photographing newborns, so that's what I show. Does it mean you can't photograph weddings and family if you choose newborns as your niche? Of course not! But you may want to consider having separate websites to show your specialties differently in a cohesive manner. This will set you apart and say, "I am the specialist, and this is why I am able to charge more than the general photographer."

My Journey

After doing small kids commercial work, I went on to photograph a wedding, some families, and children, and even tried my hand at sports photography. All along I was trying to *find my niche* in the industry. While I was shooting one wedding, I realized that my attention was being diverted every time I saw a baby out of the corner of my eye. Although I was there to photograph the wedding, and

The true essence of my style is photographing newborns using beautiful natural light and white as my base color.

ISO 400, 1/800 sec., f/1.4, 50mm lens

My early work started with independent clothing designers, photographing girls in their clothing lines. It was fun, and I dreamed about being a big kids commercial photographer some day. Later, I would realize that even though I loved commercial work, it was not an option for me at the time to be available to travel across the country where the work was. Instead, I started working toward another passion—photographing newborns—which eventually became my specialized niche.

With the numerous types of photography genres in the industry today, there's a niche for everyone. The newborn niche is an elite and specialized area that requires passion and patience, as well as demands that set you apart from the saturated market. It's essential for anyone who wants to go into this field to learn baby safety and seek out the proper education required to handle babies. The newborn photography industry is growing more and more every day, making it of utmost importance to stand out and be different.

In this chapter I'll show you how to define your work, what it means to establish a particular area of work you are good at, and how to differentiate yourself from the average photographer. You'll also learn a bit about how to build your client base and the elements needed to create a business plan.

The Newborn Niche

When I began my photography career in 2005, I started with a three-light studio setup, shot in raw and manual mode, and was photographing babies and children age 18 months to ten years old. I've always loved children and had a desire to build my career around that passion.

I mostly photographed girls, because all my children are girls, and there seemed to be an abundant supply of little girls around me. High key photography was typical with children's commercial work, and this preference ultimately led me to work with white as my base color.

ISO 400, 1/1000 sec., f/1.4, 50mm lens

It's not coincidental that my brand colors of white, robin's egg blue, and gray are consistent with who I am and even match what I wear. My wardrobe is full of these colors. People recognize me and relate to me when they see these colors, especially the robin's egg blue. I've branded myself and created this consistency in my work to the point where not only my clients and friends recognize it, but my peers as well.

It's important to be clear in how you represent your work. If your portfolio jumps from bright colors that pop to light, fresh, and airy colors, it won't show consistency in what your clients can expect to receive. If you are a family and newborn photographer and one session calls for bright colors and another session calls for light and airy colors, you can still make it work as long as you're consistent with the overall *feel and look* of both sessions.

Your clients hire you for what they see on your website. If you show one style and then use a different style with your clients, they will be confused. They want to see the style they fell in love with when they hired you, and they should expect to receive it.

Stay true to who you are, and don't try to be someone you're not. Of course, always allow yourself to experiment and try new things. But remember to conform your work so it all flows together nicely.

Consistency begins with style, your brand, and all components of your work.

· · ·

Processing images with the same techniques throughout a session creates a uniform look.

ISO 400, 1/250 sec., f/1.8, 50mm lens

These are the most common shortcut keys I use in my workflow. (Windows users need to substitute Ctrl for Command.)

SHORTCUT KEYS	ACTION
Shift+Command+E	Merges layers
Left bracket key [Makes your brush smaller
Right bracket key]	Makes your brush larger
Command+	Zooms in
Command-	Zooms out
Spacebar	Changes the pointer tool to the Hand tool
I	Selects the Eyedropper tool
Command+J	Makes a duplicate copy
Shift+Command+N	Adds a new layer (Mac)
Command+Z	Activates undo
Command+S	Saves the file
C	Selects the Crop tool
X	Changes background and foreground colors

Tip: *Don't forget to save every time you make a change to the actions or set.*

Consistency

As artists, it's your photographs that represent who you are, your style, and your caliber of work. It's vital that all your photographs are uniform in quality and look. It's OK to experiment with shooting and editing styles, but if you're going to change something, change it throughout all the images within the session. However, keep in mind that the overall feel of your portfolio should be cohesive in tone and style for each image throughout a session, as well as for your entire portfolio.

Consistency begins with style, your brand, and all components of your work. It isn't something that just happens over night. It takes time to create the entire brand and pull all the elements together. Consistency begins before you start your business and should be uniform across all platforms ranging from your portfolio, website, blog, and social media outlets to your packaging and presentation.

Making an Action

You may already have an arsenal of many different types of actions, as I have. Don't get me wrong, I love actions and I too will use them in my workflow for an artistic look after doing the initial clean edit. But you can also make your own actions to help speed up your processing time by combining the most used steps in your workflow.

Using my workflow as an example, let's take a look at how you can turn your clean edit workflow into one action and run it on all your images.

1. Open one image.
2. Choose Window > Actions to open your Action panel.
3. Click the down-pointing arrow in the Actions panel, and choose New Action.
4. Name the action, apply it to a function key if you'd like and/or set a preferred color if you desire. Then select the "set" you just created called Robin's Newborn Workflow and click Record.

 Now everything you do to the image will be recorded. Don't mask or edit anything at this point. You just want to record the steps of the workflow.
5. Duplicate your background layer twice. Add a Levels layer, a Hue/Saturation layer, and a Color Balance layer. Move one of the background layers to the top of the stack. Rename the bottom layer "Retouch" and the top layer "Soft and Creamy." Then click the Stop button. Your action will then appear in the Actions panel under the name of your set.
6. Drag and drop your favorite actions directly into your own workflow set for better efficiency!
7. Be sure to save all your actions and workflow after you have created them. Otherwise, if Photoshop closes automatically, they will be gone when you open it again. Click the down out arrow at the top of the actions panel and select "Save Actions." Make sure you have the action or workflow set you want to save highlighted.

Time-saving Tips and Shortcuts

Efficiency is key in the digital darkroom. You shouldn't be spending a lot of time sitting at your computer editing photos. Set up your editing workflow with useful actions using the following tips and shortcuts to save you time.

Post-processing Efficiency

It's important to keep your editing workflow as efficient as possible. Photoshop can be daunting at times, and you can get caught up trying many different techniques. Time is money when you're running a business, so save that time for personal editing practice, not while you're editing client images. It's great to experiment and try new processing techniques, but it's more important to stay on task to get the job done in a timely manner by not using this time learning new techniques.

Once you've developed your editing style, create custom actions to speed up your workflow and reduce your post-processing time. For instance, I've combined the first three steps in my Photoshop processing into one action. Now I can run this action on my images, and it will apply all those steps faster and more efficiently,

Create Your Workflow Set

Now that you've created the edits you want to apply to all your photos, you need to create your personal workflow set where you can store all your actions in one place.

Tip: Create your set first, and then create the action(s). Give your set and actions a name.

1. Click the down arrow in the Actions panel and choose New Set. I've named my workflow **Robin's Newborn Workflow,** so let's use that name for this exercise.

2. To change the workflow name at a later time, just double-click the name in the Actions panel and rename it. Be sure to SAVE your workflow.

Before and after photos. As you can see, very little processing is needed to enhance a beautiful portrait.

a soft white brush and brush on the red skin areas. Make sure the foreground color in the Tools panel is set to white on top and black on the bottom.

Keep in mind that the white brush reveals and the black brush conceals. Vary the opacity of the brush and/or layer as needed.

Another way to apply the adjustments is to select the face first, either by using the Quick Mask or Lasso tool, and then add the adjustment layer. This will apply the adjustments to only the selected area.

Enhance color

At this point, I zoom out of my image to see what enhancements to color are needed.

To enhance the color of the image, add a Hue/Saturation layer and increase the saturation of the master file. Mask off areas you don't want affected by using a soft black brush on the white mask.

Apply soft and creamy

The last step in my Photoshop enhancements process is to add a soft and creamy touch to the overall image.

Tip: You can vary your brush and/or layer opacity to taste.

1. Make a duplicate copy of your background layer by highlighting the layer, Ctrl + J. Then move this layer to the top above all the other layers.

2. Choose Filter > Blur > Gaussian Blur and select a Radius of about 7–10 pixels.

3. Add a mask by clicking the Add Vector Mask button at the bottom of the Layers panel (the second tool from the left that looks like a shaded box with a white circle in the middle).

4. With a soft black brush at 100% Opacity, mask off eyes, nose, mouth, fingers, and anything else you want sharp.

5. Reduce the brush opacity to 50% and mask off the rest of the baby and areas in front where you don't want to apply as much blur. Then adjust the layer opacity to approximately 40%.

6. Crop, sharpen, and save the file. I crop at a ratio of 15x11, sharpen selectively using the Unsharp Mask, and then save the file.

A close-up view of the skin after a Gaussian blur is added.

A brightened photo shown with its histogram.

As you can see in this image, the tonal range is distributed across the histogram, so there is no need to pull in the outside sliders. I've moved the middle slider slightly to the left to brighten the image, which in turn has reduced the red in the baby's skin.

Remove redness

Tip: Avoid removing all red from the skin. This can result in gray and dull-looking skin. The goal is to reduce excessive redness, not to completely remove it.

To remove redness from the skin, add a Hue/Saturation layer and adjust the "Reds" to your liking. My settings are Hue +8, Saturation -3, and Lightness +6.

When you add the layer and make the adjustments, the adjustments will apply to the entire image. The easiest way to apply the adjustments to only the areas you want affected (the skin) is to invert the white mask in the Layers panel to black. Click the white mask and then press Command+I to change the mask to black. You can then use

Hue/Saturation layer adjustments.

An image after applying a skin smoothening action.

Also at this point, I smooth the skin. Many actions and plug-ins are available to use for skin smoothening. Use the one that you like best. My action of choice is Creamy and Smooth Skin, which is included in the Picture Perfect Portrait Mega Set from paintthemoon.net. Be subtle when you're smoothening skin. You want to retain detail without making the skin look plastic. I generally set the Opacity of the layer between 30–50%.

Brighten and adjust contrast

Adding an adjustment of brightness and contrast gives an added "punch" to your image.

1. Make a Levels adjustment layer.
2. Pull the right and left sliders out or in to even out the tonal range across the graph so each side is gently touching the ends of the histogram.
3. Move the middle slider to the left to brighten or to the right to darken the image.

Be careful not to push the highlights too far, which might result in overexposure.

Photoshop Enhancement

After all raw adjustments have been done in ACR, it's time to bring the images into Photoshop for final enhancements. I select my best three or four images from each fabric and/or setup and open all of them together in Photoshop.

Even though I've done the basic adjustments in ACR, I double-check my histogram in Photoshop using Levels and make any minor adjustments needed to bring in the right and left sides of the histogram for contrast.

My five-step Photoshop post-processing procedure looks like this:

1. Retouching
2. Brighten and adjust contrast
3. Remove redness
4. Enhance color
5. Apply soft and creamy

Let's walk through each step of the Photoshop enhancements.

Retouching

Duplicate the background layer and then use the Patch and Healing Brush tool to touch up the skin. I touch up only temporary blemishes and rely on the parents to inform me of other skin touch-ups, such as birthmarks, they want me to retouch. As a general rule, don't remove any blemishes, marks, and the like unless the parents have requested you to do so.

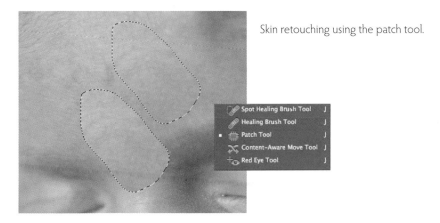

Skin retouching using the patch tool.

Both the Exposure and Blacks sliders should be brought to the edges of the histogram on both sides to ensure that the overall contrast of the image is correct.

Add Clarity

The Clarity slider sharpens or softens your photo. Proceed with caution when you're using this slider because you can easily oversharpen or soften with unpleasant results. I tend to move this slider to the right for a little midtone punch, but you can play with it and see what you like best. Dragging this slider to the left will soften the image, whereas dragging it to the right will sharpen the image.

Enhance the Vibrance/Saturation

I prefer to use the Vibrance slider instead of the Saturation slider when I need to add a bit more color to the image. Its effects are not quite as harsh as those of the Saturation slider, and it is more suitable for adding a softer color to newborn photos.

Synchronize all images

Once I've made all adjustments to one image, I then apply those settings to every image in the set (for each blanket/fabric setup).

1. Click the Select All button in the top-left corner to select all the images at once.
2. Click the Synchronize button to bring up the Synchronize dialog box.
3. Choose Everything in the drop-down menu.

All the adjustments you made to the one photo will then be applied to every image you've selected. How neat is that? This process saves you time and makes your workflow more efficient.

Make all adjustments throughout your entire session using each gray card you took at the beginning of each fabric or background change to guarantee complete consistency throughout all your images.

Set the Shadows

The Shadows slider controls the "darker" portions of the image. Move the slider to the left to darken the shadows, and move it to the right to brighten the shadows. I tend to like lighter shadows, so I'll typically move this slider to the right to lighten them. Darkening the highlights and brightening the shadows will give you less contrast in your image. However, you can go back to the Contrast slider and bump it up to add more contrast if you need to.

Alter the Whites

Tip: *The Highlights and Shadows sliders focus on the bright and dark areas of the image, whereas the Whites and Blacks sliders focus more on each end of the histogram in a much tighter fashion.*

The Whites slider is a bit different than the Highlights slider in that it really targets the "extreme" highlights, the brightest areas of the image. You'll notice that when you move this slider, it focuses more on the histogram highlights.

Adjust the Blacks

The Blacks slider targets the darkest areas of the image. Moving the slider to the left darkens the image; moving it to the right lightens the image.

If you have lost detail in the shadows, the clipping warning will display as "blue" splotches, indicating the areas where you have lost detail. This won't happen often unless there are very dark tones or blacks in the image.

To bring back the detail back in the lost shadows, move the slider to the right until the "blue" spots disappear. If the histogram is short of reaching the left side, move the slider to the left until it reaches the end of the histogram.

Here you see the shadow clipping warning in blue.

If you are blowing out highlights, the clipping warning displays as "red" splotches, indicating the areas that are blown out. To bring back the detail in the lost highlights, move the Exposure slider toward the left until the red spots disappear.

This image shows blown highlights as referenced by the red splotches.

Add Contrast

Although the Contrast slider is under the Exposure slider in ACR 7, I generally use this slider after I've fine-tuned the highlights, shadows, whites, and blacks. So, after you have made the other adjustments, return to this slider and adjust it up or down depending on how much contrast you want in your image.

Modify Highlights

The Highlights slider controls the "brighter" portions of the image. Moving this slider to the left will darken the highlights; moving it to the right will brighten the highlights. If your image has some very bright highlights, don't be afraid to pull the slider all the way back to -100 if you need to. I love this tool because it allows me to bring back detail in the brightest highlight areas.

Using your White Balance tool (upper-left corner, second from left), click on the picture you took of the gray card. Notice how the Temperature and Tint sliders change after clicking on the card. This will set your white balance to the proper temperature (custom).

Adjust the Temperature/Tint

After adjusting the white balance—either with one of the settings listed in the drop-down menu or by using a custom white balance—you can then tweak your image if you need to by moving the Temperature and/or Tint sliders to make the image cooler or warmer to your taste.

Don't base your white balance on skin color. Look at the overall image to determine what the proper temperature should be. Whites should always look white. If they aren't white, adjust the Temperature and/or Tint sliders until they look white.

Correct the Exposure

Shooting in raw allows for more flexibility with the Exposure slider in ACR than shooting in JPEG does. It's a good idea to always check your exposure in post processing and make minor adjustments if needed.

In ACR there are two little black triangles on each side at the top of the histogram: one on the right for the highlights and one on the left for the shadows. Clicking on each triangle will place a white box around each triangle. These are your clipping warnings, as discussed in Chapter 2. Make sure you have a white box around each, or you will not see the warnings appear on your images.

The Exposure slider affects the basic midtone brightness of your image. Move the Exposure slider right or left to extend the histogram toward the right side, just until you see the clipping warnings begin to appear.

This histogram shows clipping with warning triangles and white boxes around them.

Adjust the Camera Calibration tab in ACR

The Camera Calibration tab in ACR allows you to set a calibration setting for raw processing.

When you are shooting in raw, your camera does not set any type of color calibration to the file. Color calibration measures or adjusts the color response of a device to what your eyes see. Shooting in JPEG allows you to set color calibration in-camera by choosing Neutral, Standard, Vivid, and so on. Shooting raw does not have this option "in-camera"; therefore, you can set it in ACR.

When you open your image in ACR, you'll notice that the Calibration tab drop-down menu defaults to Adobe Standard. In some instances this might be a good option. However, I prefer the Neutral calibration option when processing newborn photos. This eliminates the extra saturation and contrast that the Standard option applies to the image. I prefer this setting because it allows *me* to set adjustments, such as Saturation or Contrast, depending on what the image warrants. Some images, like flowers or landscapes, will look better with Standard or Vivid color calibration, so experiment by selecting each option and applying it to your photos. Then decide what works best for you and your style.

Tip: *Do not confuse this step with the actual calibration of your camera.*

Tip: *In post processing, white balance should always be adjusted before the exposure because it can affect the overall brightness of the image.*

Set the white balance

White balance can be somewhat subjective. Some people like their images cool, whereas others prefer a warmer image. However, to ensure that your image has a proper white balance, look at the whites in your image and make sure they look white.

The White Balance box has a drop-down menu in ACR to select other options, such as Auto, Daylight, Cloudy, Shade, Tungsten, Fluorescent, Flash, and my favorite, Custom. Experiment with each one to see which one looks best. You can also make minor adjustments with the Temperature and Tint sliders (discussed in the next section).

Recall that image you took of your gray card during capture (as explained in Chapter 4)? This is where it will come in handy to adjust the white balance. Now, I always set a custom white balance in camera; however, I make it a point to capture a photo of the white balance card so that I have an image of gray in my scene to reference if I need to fine-tune my white balance.

Selected images within the same set opened in ACR, including the White Balance tool image I took during capture.

Camera Raw Clean Edit

After culling your images, you then need to apply the clean edit steps to all your selected images.

Tip: A clean edit is where the whites are white, the blacks are black, and the grays are gray.

Here are the ACR processing steps to a clean edit using the features available in version 7:

1. Adjust the Camera Calibration tab in ACR.
2. Set the White Balance.
3. Adjust the Temperature/Tint.
4. Correct Exposure.
5. Add Contrast.
6. Modify Highlights.
7. Set the Shadows.
8. Alter the Whites.
9. Adjust the Blacks.
10. Add Clarity.
11. Enhance the Vibrance/Saturation.
12. Synchronize all images.

To better understand the process, let's look at each step of the clean edit processing.

Using Adobe Camera Raw and Adobe Photoshop

I shoot raw for maximum control of my final images. Therefore, I need software to open my raw images. Adobe Camera Raw (ACR) is included with Photoshop, is quite easy to use, and produces consistent results. Other raw software programs are available for you to use as well, such as Adobe Lightroom and Apple Aperture. Use what works best for you and what you are most comfortable using.

Let's look at the various sliders in ACR. You'll learn how to adjust each one to render the proper enhancements. My raw processing consists of ten steps. You can use other tabs and adjustments as well, but these are the main adjustments I use for my processing.

Culling and Check Focus

The first step in my postproduction process is to cull and check focus by opening all the images into sets in which I used the same fabric in the photo session. The purpose of culling is to select your best images and delete the rest.

Let's say I have ten images in which I used a white fabric. I open all ten images in ACR, select the number of images I want to keep, check focus by zooming in at 100% to make sure they are sharp, and then delete the rest and any out-of-focus images. Once I have my chosen images, I then make all adjustments to only one of the images. There is no need to adjust each image. I'll discuss how to synchronize the adjustments to every image later in this section.

The purpose of culling is to select your best images and delete the rest.

In this chapter you'll work in the digital darkroom and learn how to take your photos through raw processing and Photoshop to create beautiful portraits. You'll also learn some quick tips and shortcuts for processing your images in a timely and efficient manner. To help speed up my workflow, I've actually created my own actions. You can do the same once you determine how you want to process your images. Let's start by walking through the post-processing steps I apply to all my newborn images.

Calibrating Your Monitor

Calibrating your monitor is the first thing you should do before moving on to processing your images. If your monitor is not calibrated to the correct color for printing, any editing you do will be useless.

The proof of calibration is in the printing. Before calibration, send a few test prints to the professional lab of your choice to see if the color matches the color on your screen. Make sure your photos are in the sRGB color space and the lab does not add any "color corrections" to your images.

When the photo lab returns your images, open the processed images in Photoshop and compare them to your prints. They should closely match in color. If there is a difference, you need to calibrate your monitor with calibration software. My choice is the X-Rite i1Display Pro from xritephoto.com.

Before running the calibration software, dim the lights in the room so you have a low-lit room. If too much light enters the screen when you're calibrating, it can cause unpredictable results during the test. After calibrating, turn the lights back on when you're editing or comparing future prints. Don't expect your prints to match the monitor screen exactly, but the colors should be pleasing and acceptable to you.

Once your monitor is calibrated, send another batch of test prints to the lab and again compare them to your screen when they are returned. As a general rule, you should calibrate your monitor once a month.

The Digital Darkroom

Keeping it real and natural looking is my photographic preference. And every image should begin with a nice, clean edit in post processing. That means exposure, white balance, contrast, clarity, saturation, and color adjustments all need to be correct before adding any type of artistic style. A clean edit is an image that doesn't look like it's been "edited." Because I prefer my images to have a clean, fresh, and genuine look to them, I don't add any type of special effects at the end of my processing. If I were to add an artistic enhancement, I would initially ensure my image has a clean edit first.

In addition, skin smoothening is kept to a minimum to preserve detail in the baby's skin, because I'm not a fan of overly smoothed skin where the baby looks plastic. Of course, I will touch up blemishes and reduce too much redness in the skin when needed. In retrospect, post processing should be used to enhance your images, not to fix something that should have been applied in-camera during capture.

ISO 500, 1/160 sec., f/2, 50mm lens

There's something sweet about beginnings; a new life and a whole existence begin with this tiny baby.
ISO 400, 1/200sec., f/2, 50mm lens

What do parents want to remember years from now when they're looking back on their newborn's first photos? What do you want them to see? Sure, the hat is cute and the basket their child is lying in is beautiful, but the most important thing on their minds is remembering their baby—how tiny he was, the little pucker lip, and itty bitty toes. They might want to recall the way she yawned so big or his big bright eyes staring up so curiously. They'll cherish the series of her story you captured for them while she was exploring her own little world, as well as the moment they held their newborn baby in their arms and kissed her sweet lips. Those are the moments they will remember—the timeless portraits captured during their newborn's first few days of life.

A good exercise is to look at the overall contrast in your frame and imagine it in black and white. Everything becomes shades of gray; some are light, some are neutral, and some are dark. Determine if there are enough shades to create a compelling black and white image. You can also set your camera to monochrome, which allows you to take the photo in color and black and white, providing you the flexibility to examine the image more closely in postproduction.

A true black and white image has good contrast between the lightest and darkest shades. However, some photographers prefer less contrast with softer and smoother tones. It's a matter of choice and what you feel works best with your style. Some black and white images can convey a sense of poetic mood to storytelling.

I prefer to convert my images to black and white in postproduction as opposed to shooting them in black and white in-camera because my preference is to have more control over the outcome of the final image.

The Power of Natural Imagery

I seek naturalness in my life—a simple elegance to everything I do, including my photography. Natural imagery is about the baby. It's not about the big fluffy hat or the perfect pose. As artists we tend to gravitate toward the next new prop on the market or the perfectly placed fingers, but we sometimes get lost in the props and forget to focus on allowing the baby to be natural, raw, and untouched from the world, embracing the power of natural imagery and letting it take control.

A simple knit throw was laid over the baby as I shot from above, capturing a yawn. As she stretched her arms above her head, I took advantage of that shot as well, and then placed her hands behind her head for the third and final image in the series.

ISO 400, 1/400 sec., f/1.8, 50mm lens

A simple black and white photo without the use of distracting props creates an authentic portrait.

ISO 400, 1/250 sec., f/1.8, 50mm lens

Black and white imagery forces you to see shape and light in ways you don't with color.

When you're using a wide aperture to create a shallow depth of field, the light is very soft and flattering. I set my camera to f/1.4 and placed my focus on the baby's eye, creating a soft focus in the rest of the image.
ISO 400, 1/500sec., f/1.4, 50mm lens

The Beauty of Black and White

Many photographers view black and white imagery as the purest form of photography, because it offers a unique way to tell a story. It's been a popular art form since the beginning of film and is still prevalent today. Black and white imagery forces you to see shape and light in ways you don't with color. It conveys a natural and raw form of photography that's powerful and emotional. Not every photograph warrants a black and white image. Some photos need to rely on color for impact; others express emotion and beauty as black and white images. Soft, even light is ideal for black and white newborn portraits. Composition, lighting, and perspective are of utmost importance for creating stunning images.

A simple jersey knit, stretch fabric works great for keeping the baby snuggled tightly inside. This fabric comes in a variety of colors, is very simple to use, and is easily found at any local fabric store. The best size wraps are 18 x 30 inches. Typically, I purchase half a yard of fabric for wrapping around the baby. But most of the time this is more than I need, so I cut it down to the size that works best.

Tip: If you purchase 2.5 yards of fabric for your beanbag, you can cut off a ½ yard of the edge to use as a wrap.

Drapes and natural wraps

I'm always on the hunt for natural-looking fabrics I can incorporate into my simple and natural style. I look for light, airy scarves with crochet knits, chiffon-tailored bows, and textured scarves with soft, beautiful lace accents. Simple cotton fabrics with raw threads streaming down on the edges are some of my favorites as well.

These types of fabrics are best used to drape over the baby or to wrap up the baby lightly.

Lacy and knitted scarves placed delicately around the babies result in a subtle and elegant look.

ISO 400, 1/500 sec., f/1.8, 50mm lens

A simple jersey knit, stretch fabric works great for keeping the baby snuggled tightly inside.

A purebaby nest wrap made out of soft yarn is wrapped completely around the baby using the body wrap technique and tucking the baby's legs inside.

ISO 200, 1/320 sec., f/1.8, 50mm lens

Fabric Choices

Many different styles and types of fabrics are on the market these days to use on beanbags and for wrapping the baby that can add visual interest to your story. Types of fabrics include stretch, nylon, sweater knit, jersey knit, cable, and an unlimited supply of textures to choose from. Some types of fabrics work best on the beanbag, whereas others work well for wrapping. I've outlined each one in the following sections.

Beanbags

When you're choosing fabrics for the beanbag, it's important to make sure they have some stretch and are soft. Avoid fabrics that are 100 percent wool, because they can cause allergic reactions with some babies. Several great blanket throws are also available, and although some of them don't have any stretch to them, they do lay out nicely without wrinkles.

Tip: Be sure to buy at least two yards of fabric when you're using it on the beanbag to be able to clamp down all sides, the top, and around the outside area.

I have used cotton fabrics for the beanbag before, and although I do love the simple, natural look they provide, it is difficult to stretch them out enough to avoid wrinkles. Then again, sometimes I don't mind the wrinkles. So, what I use during a session all depends on what my artistic vision is for the image being captured.

Wraps

I use a variety of fabrics for wrapping the baby. Typically, material that has some stretch is best, especially with awake babies, because you need to pull the wrap tightly to hold the baby's arms snug inside.

My favorites are hand knits or sweater knits. You can find them at your local fabric store or by searching on Google. I also sell a selection of my own brand of hand knit, nest wraps called purebaby in the Photographer's area on my website.

Tip: Cutting off a 12 x 18-inch piece of an old sweater also works great for wrapping babies.

You can find another popular type of stretch knit fabric at www.lostriverimports.com, and it comes in a variety of colors. Because the fabric is made into very long scarves, you may find that folding the scarf in half before wrapping eliminates the need to wrap the scarf around the baby numerous times.

A good wrap is key. Although there are many styles of blankets and fabrics used for wrapping, swaddling blankets need to be a bit larger, about 18-inches square, and can be made out of a stretch knit fabric or fine, simple cotton.

The basic swaddle steps.

ISO 400, 1/400 sec., f/2, 50mm lens

Step 1 Lay the blanket in a diamond shape and fold down the top to form a triangle. Place the baby in the center with the child's neck right below the top of the fold.

Step 2 Place the baby's left arm slightly bent at the elbow flat against the body. Take the right side of the blanket and bring it across the baby's chest to the other side. Make sure the shoulder is inside the wrap and the arm is securely tucked under the fabric. Tuck the edge of the blanket under the body to ensure a tight swaddle.

Step 3 Tuck the baby's feet up in a criss-cross position while bringing the bottom of the blanket up and over the feet, tucking it up and under the baby's right side.

Step 4 Place the baby's left arm slightly bent at the elbow flat against the body. Take the left side of the blanket and bring it across the baby's chest. Tuck the excess blanket underneath the baby to secure the swaddle.

I used a simple cotton nonstretch type fabric to wrap around the sleeping baby.
ISO 400, 1/640 sec., f/2, 50mm lens

The Swaddling Technique

Swaddling can at times save your session when you have a fussy baby or one that won't go to sleep. Swaddling helps babies calm down and/or fall asleep because they are comforted fairly quickly. If babies are swaddled properly, it can help them feel warm, safe, and secure, and keep them from flailing their arms. However, some babies do not like to be swaddled. If the baby you're photographing does not like swaddling, try swaddling him a bit looser. In my entire career only one baby did not like to be swaddled, so I swaddled him loosely and allowed him to have his arms free while I focused on awake photos until he eventually gave up and went to sleep.

There's a difference between the types of fabrics you use for swaddling awake babies who are moving all around and flailing their arms as opposed to the fabrics you use to swaddle a calm sleepy baby. If the babies are awake, you must swaddle them tightly to keep them from breaking free. Therefore, stretch wraps work best in this situation because they stay tight. If they are asleep, your options are unlimited; you can use any type of stretch or nonstretch fabric, because the baby isn't moving and wiggling out of the wrap.

If babies are swaddled properly, it can help them feel warm, safe, and secure, and keep them from flailing their arms.

This wrapping technique is best achieved by laying the baby on a padded setup on the floor because you can move around the baby more easily, although the beanbag works well too. Place the wrap horizontally on the floor and curl up the baby in your arms. Lay the baby on top of the wrap with a little of the edge showing. Take the long end and start wrapping the baby from head to bottom. I like to start the end of the wrap where the bottom will lie. Tuck the wrap underneath the baby as you go along, leaving the outside edge showing. Continue wrapping, making sure to cover the baby's private parts and keep the little toes tucked inside.

You can use any type of fabric for this type of wrapping, such as lace or scarves, or even stretch fabrics.
ISO 400, 1/640 sec., f/1.8, 50mm lens

This series of photos shows a couple of different wraps used with these two babies. The first wrap was a piece cut off from a beanbag fabric. The second two images show the Purity wrap.

ISO 400, 1/800 sec., f/1.8, 50mm lens

Baby Brooklyn slept during her entire session and loved being wrapped up. I didn't worry about tucking her foot back in when she poked it out, because I thought it gave her portrait a sense of character.

ISO 200, 1/320 sec., f/1.8, 50mm lens

The Body Wrap Technique

Sometimes I find it easier to wrap the baby on my lap versus on the beanbag, because it prevents me from straining my back. Place the wrap across your lap, floor, or beanbag, and lay the baby on top with approximately ¼ of the wrap on one side. Depending on whether the baby is awake or asleep, you'll need to decide if you'll tuck the arms inside or have the fingers peek out over the wrap. If the baby is awake and moving a lot, you may find it easier to tuck the arms inside the wrap.

Either way, take the short end of the wrap, drape it over the shoulder to the other side, and tuck it snugly under the baby. Pull tight. Curl up the legs and tuck the bottom portion under the baby. Then proceed wrapping with the other side around the baby several times, pulling tightly as you go. Continue to hold the legs curled up until you have used the entire wrap around the baby. Tuck the edge under the baby. The key to keeping the baby from wiggling out is the tightness of the wrap. Keep it tight, and the baby should not be able to escape. Adjust the hands if you need to and tuck any loose edges under the baby. Make sure the wrap is not too tight around the baby's neck.

The key to keeping the baby from wiggling out is the tightness of the wrap.

The Womb Wrap Technique

Womb wrapping is curling up the baby in the womb-like position and wrapping from head to bottom. This is one of the most challenging, yet creative ways to wrap the baby. I don't attempt this style of wrapping unless the baby is sound asleep, because any movement the baby makes will loosen the wrap. You may find it easier to create a little divot in the beanbag or the padding you've created on the floor to allow the baby to sink inside. This helps the baby to stay in the curled womb position.

The womb wrapping requires a smaller piece of fabric that is approximately 6-inches wide and at least 18-inches long, depending on how many times you want to wrap it around the baby. Purity wraps are available on my website at www.robinlong.com in the Photographers area. These are nonstretch wraps that are soft and natural looking with raw edges made out of a cotton and gauze material.

Tip: You may also want to have a second set of hands to hold the baby in position while you wrap. Don't be afraid to ask the mom or dad to assist you.

I used a stretchy jersey knit to wrap up this little guy snuggly. His little fingers and toes peeking out emphasize his tiny features.

ISO 400, 1/400 sec., f/1.8, 50mm lens

A simple, classic look of a baby wrapped up as if still in the womb.
ISO 400, 1/400 sec., f/1.6, 50mm lens

Wrapping the Baby

There's something primal about a baby all wrapped up with his arms tucked snugly inside. It represents a feeling of safety and warmth, and the wraps add an artistic touch. Most newborns love being wrapped, and it can potentially calm a fussy baby. Every session I do, I use at least two or three wrap selections in various ways. Typically, I'll use all these wrapping techniques in one session, utilizing my favorite lace and cotton fabrics.

Tip: There's no limit when it comes to the different types of wrapping poses you can create. Try using a doll to practice, using fabrics in a variety of ways.

Shooting

I shoot with the Nikkor 60mm f/2.8 macro lens. Macros require a lot of light, so don't be afraid to move the beanbag closer to the light if you need to. The closer you are to the light, the softer and more luminous your portraits will be. Get in close to shoot and think about interesting angles. You can accomplish precision adjustments by using manual focus.

Tip: When shooting macro shots brace your arms against your sides to steady the camera.

Throughout the session, there will be many opportunities to shoot macro shots. There's no specific time I choose to do them. I use my Nikon D700 as a back up with my macro lens attached so that at any given time when I see the perfect moment arise, I can grab my camera with the macro lens and get these shots. Sometimes I'll need to turn the beanbag more toward the light to illuminate my little subjects.

A variety of different macro images that show close-ups of the baby's features.
ISO 400, 1/200 sec., f/2.8, 60mm lens

An assortment of different ways to photograph toes.
ISO 400, 1/200 sec., f/2.8, 60mm lens

Macro Photography

Macro photography produces a specialized type of image that allows for shorter focusing distance and greater magnification. The closer you place your lens to the subject, the larger the subject will appear in the image. This style is used to capture shots of baby lips, tiny toes and hands, wispy hair, eyelashes, and noses. It's essential to use a macro lens to get up close and capture these special details.

Detail images also allow you to capture more clearly just how the baby's tiny hand is clasping mom's finger or held in both parents' hands.

You can still shoot with another type of lens, such as the 50mm, besides the macro if you want to or don't have a macro lens. It's not necessary to use a macro lens, but it does allow you to get in close to see a more life-like view due to the high magnification of the lens. It's important to make sure you pay attention to the tiny fingers, little toes, and puckering mouth. These are the characteristics that shape each newborn's personality.

For every session, I make sure I capture these details for storytelling purposes and to create a series of four images that I will present to the parents in a 5x5-mounted print as a special gift. It's a nice surprise they are not expecting.

I asked mom to grab hold of her newborn son's hand and place it on her finger.

ISO 400, 1/200 sec., f/2.8, 60mm lens

Here is a telling image of dad, mom, and their newborn son's hands together.

ISO 400, 1/200 sec., f/2.8, 60mm lens

This little beauty was calm, awake, and very happy to partake in her session. It was amazing how engaged she was and the number of times she made eye contact with me! I placed her on the floor on soft padding right next to the window, camera right.

ISO 400, 1/160 sec., f/1.8, 50mm lens

45-degree angle
Subject at 7 o'clock to me

window
3–4 feet

In the 45-degree angle lighting diagram, the window is camera left and the subject's nose faces the light.

90-degree angle
Subject facing me

window
3–4 feet

In the 90-degree angle lighting diagram, the window is camera left and the subject's nose faces me.

The splendor of the soft window light appears to wrap around the baby's tiny, delicate body, captivating her with a warm glow.

ISO 400, 1/200 sec., f/1.8, 60mm lens

I lay down a large piece of foam, about 3 feet by 3 feet in size, right next to the window and place a padding of blankets on top of the foam. Using my fabric of choice, I stretch it out to eliminate wrinkles before placing the baby down.

Shooting

You'll want to shoot a multitude of photos when babies are awake, because they tend to move their arms and feet all over the place. You can easily use scarves and cotton gauze to loosely wrap them or just lay over them, or you may find that swaddling is your best option during these times. For me, deciding which technique to use always depends on how much the baby is moving. If the baby is awake and calm, I'll leave her arms out to move freely. If she is very active and moving around quite a bit, I'll swaddle her with her arms tucked in. If I try to shoot when her arms are flailing all over, the result will be lots of out-of-focus hands in the shots.

Shooting from above, to the side, and down close are my preferred angles when I'm photographing awake babies. Don't be afraid to walk around the baby and capture a different perspective, such as standing directly over the baby and shooting down, focusing on the child's eyes.

Place the baby at either a 45-degree or 90-degree angle to the window until you see the catch lights in the upper portion of the eyes, preferably at the 10 o'clock or 2 o'clock position.

For the following two images, the lighting diagrams show precisely how to place your subject relative to the light. Typically, my subjects are approximately 3–4 feet from the window. However, if you need more light, move your subject closer to the light source.

This baby had her eyes open for only about ten minutes. I draped a cotton scarf over her and captured her expression as she turned toward the light and back to create this memorable and inquisitive moment.

ISO 400, 1/400 sec., f/1.8, 50mm lens

Open Eyes

Some photographers think that they need the babies to be asleep for the entire session. So, instead of taking advantage of the time when the babies are awake, they spend a half hour or so painstakingly trying to get them to sleep. But there will be times when the baby will remain awake no matter what you do. Why not keep shooting? Parents love to see their baby wide awake, especially in a large canvas print on their wall. Every time I've captured a baby with open eyes, the parents have always chosen those images.

The most compelling awake shots are when you can capture a variety of facial expressions. These are some of my favorite images because the reflection of her personality defines her story.

Anytime the baby is awake, whether it's when the family arrives, in the middle of a session, or even at the end of the session, take this opportunity to tell her story. This is not a time for posed shots. It's a time to make a connection with the baby and capture smiles, milk bubbles, yawns, and stretches. These are the characteristics that will some day mold her personality.

My approach to natural imagery is the same whether I'm photographing an awake or sleeping baby. However, when the babies are awake, I prefer to set up a padded area on the floor right next to the window. This setup not only allows me the freedom to move around to shoot, but also allows the baby to move freely without being propped up on the beanbag.

Each yawn begins with a little stretch until it reaches the end of its capacity, leaving you entranced as you watch this seemingly simple action unfold.

ISO 400, 1/400 sec., f/1.8, 50mm lens

Each moment captured completes the story and leaves the viewer curious to see what her next move will be.

ISO 400, 1/400 sec., f/1.8, 50mm lens

In this chapter, you'll explore how the concepts of natural imagery are created to complete a series of storytelling portraits. You'll learn how posing a newborn in a natural form conveys emotion to the viewer as the story unfolds.

Capturing the Details

In Chapter 1, I discussed storytelling and the emotions stories evoke. Here, I'll explain in more depth how to capture those split-second moments that will soon be forgotten. These are the fleeting instances that happen in the first few weeks of life as the baby grows and changes with each passing day.

Each detail in a series of images communicates her curiosity of not only herself, but also the sounds and feelings of the world around her. The specifics of the story can involve a range of information. They might reveal her discovering her tongue, the natural response of a yawn, how she kicks her foot, or even a bewildered look on her face as she hears the shutter clicking. At that very moment, you've captured the series of *her* story and *her* expressions of what is happening. It's a chain of events that creatively tells the personal story of each baby.

The actions and movements of this tiny baby are the elements that design her story. How does she move? What is she doing with her hands, her mouth, and her feet? Each movement in the series holds your attention while your heart desires to continue looking to see what she will do next.

Tip: I tend to shoot a copious amount of images when I'm shooting natural imagery so that I don't miss any of the important moments.

There's no specific right or wrong way to shoot natural imagery. It comes from your own creativity and the perspective of how you see your subjects. You must be aware and ready to shoot at any given moment. When the baby moves, stretches, or makes any kind of expression, you need to shoot quickly. Move around and shoot to the side, or stand over the baby from above and shoot down. Think about composition and how you can artistically frame your subject. Move in close so you are able to focus on the small details.

It's a simple story and is one that needs no narration. These are the pure and natural moments in time captured at the beginning of her life, and are the details that create compelling pictures.

Natural Imagery Through Storytelling

During the first couple of weeks after a new birth, there's a short window of time when you have the opportunity to capture a newborn in an untouched and unposed form. This window of time demands no rules to posing as the baby waits for you to tell her story. There's no reason to intentionally place perfectly aligned fingers or feet. It is a time when a baby is allowed to communicate who she is in the most uncomplicated way—a story conceived with a classic and timeless beauty.

It is during these first few weeks after birth that you are able to capture a memorable glimpse in time into the baby's secret little world of new life. With every portrait I create, there is a reason to express that special personality gracefully unfolding right in front of me. The images are powerful because they represent a series of emotional and compelling moments where the child's story and art come together.

ISO 400, 1/800sec., f/1.8, 50mm lens

More Soothing Techniques

Of course, you can use other soothing techniques to comfort the baby.

Babies love soft, quiet, and gentle lullabies. The peaceful sounds help them to feel safe and stay calm. Numerous nursery lullabies are available that you can purchase and download to your phone. As mentioned earlier, using a white noise app will also help the baby sleep. These types of mellow, steady, noise-induced sleep techniques can be very useful to pacify the baby.

Lightly stroking the baby in between the eyes with your ring finger can be incredibly soothing, as well as gentle massages on the shoulders. When I've worked with fidgety babies who seem to be taking some time to settle down and go to sleep, I've asked the mom if she would sing softly to her baby. The tender sound of the mother's voice is the essence of all soothing techniques!

* * *

Babies love being on their sides. It's reassuring and comforting, and they will generally sleep very well in this position for the entire session.

ISO 400, 1/800 sec., f/1.8, 50mm lens

Swinging

Babies love any type of swinging motion. They've been accustomed to being carried around in their mother's womb for nine months. If the baby needs comforting, I will hold the newborn close to my chest and gently sway back and forth until the baby is asleep. Rarely do I have the mother hold the baby during the session unless the baby needs to be fed. Otherwise, I take care of soothing the baby.

Sucking

The sucking reflex comes from deep within the nervous system and triggers a calming response from the baby. Pacifiers are a great tool to use for soothing and can satisfy the need to suck that all babies possess.

Although some parents may not want their baby to have a pacifier, even during a photo session, I try to encourage all my clients to bring one for their session. I explain to them how soothing and comforting it is to the baby, and the short amount of time we are using it should not have any adverse affects. Of course, I always abide by the parents wishes and will not push the issue if they refuse. But I do keep a supply of Soothie pacifiers (size 0–3 months) on hand at all times. These have become my best friends. They are the most effective pacifiers I've found because they closely mimic the mom's breast nipple and are small and easy enough for newborn babies to suck on.

> The sucking reflex comes from deep within the nervous system and triggers a calming response from the baby.

Side/Stomach

To soothe newborns, sometimes all it takes is laying them on their side or stomach. For this reason I usually start with a side pose at the beginning of my sessions and then move on to the tummy position. See Chapter 4 for more about *side posing*. This approach gives babies some time to feel soothed and relaxed for their session.

Swaddled babies are calm babies.
ISO 400, 1/320 sec., f/2, 50mm lens

Swaddling

From the moment babies are born they are wrapped tightly in swaddled blankets to help them feel warm, loved, and comforted. Babies are used to being in a small, tight space in the womb, so swaddling them to prohibit them from moving makes them calm and happy. Refer to Chapter 6 on how to swaddle newborns.

Shushing

Newborns are used to the "whooshing" sound made from the blood flowing through the arteries in the womb. Any kind of white noise or "shushing" will comfort the baby. In fact, I have a white noise app downloaded onto my phone that I lay close to the baby on the beanbag or underneath the blankets. If I need to add more noise, I just "shhhhh" the baby with my voice as I gently rock the child to sleep.

Startle Reflex

Sometimes an inner source can trigger a baby's startle reflex, and you don't always know why. Loud noises, bright lights, sudden movements, a sense of falling, and even their own cry can also cause a reaction that could result in the baby lunging. Too much stimulation results in brain overload and can cause the baby to cry and be upset. The reflex could make babies jump with extended arms, or if they are lying on a beanbag, they could lunge forward or sideways in a matter of seconds. Maintain a calm and quiet environment during the session as much as possible. Babies should always feel safe and secure because they depend on you for comfort.

Flailing Arms

If babies suddenly flail their arms, the reason is that they have either been startled by something or they don't feel secure and feel like they are falling. It is frightening to babies when they don't feel safe. When you're moving babies or picking them up, hold down their arms with gentle pressure to help them relax. Don't allow their arms to be free. Show the parents how you do this and point out how calm the baby becomes.

Soothing Techniques

Soothing techniques are vital to a smooth and successful session. Newborns cannot soothe themselves. They depend on others to soothe them. But first *you* need to remain calm and then educate the parents on how to remain calm as well. Babies will sense if you are upset or tense and will become frustrated.

According to the book *The Happiest Baby on the Block* (Random House Publishing Group, 2003) by Dr. Harvey Karp M.D., the five S's are the simple steps that trigger the calming reflex: swaddling, shushing, swinging, sucking, and side/stomach position. In his book, Dr. Karp teaches parents exactly how to do these five steps.

A Sudden Screech

A sudden screech indicates there is something the baby does not like. Perhaps you have moved the baby into a position the child is not happy with, or the baby's hand is bent, the umbilical cord is caught on the fabric, and so on. There could be a number of things that could be wrong. Depending on what was going on before the screech, take a look at everything to help make the baby more comfortable. Go slow in your movements, and readjust the baby if you need to.

Crying

Determine why the baby is crying. See the sidebar "Why Babies Cry." You should always keep the baby from getting to the crying point by tending to the baby's needs right away. Check for the obvious reasons of hunger, poo, or peeing. Babies can also be overstimulated or understimulated. If there is too much noise in the room, this can affect the emotions of the baby as well.

Why Babies Cry

Babies cry for a reason. Crying is the only way they know how to communicate what their needs are. As a newborn photographer, you need to understand why they cry to know what action to take when they do cry. Responding to the early warning signs as quickly as possible will help avoid a frenzy of an excessively crying baby.

Eight of the most common reasons babies cry include:

- Hungry
- Sleepy
- Poo or pee
- Gas
- Need to burp
- Body temperature
- Not enough stimulation
- Too much stimulation

Reading baby cues and knowing how to soothe them will help you to calm and put the babies to sleep.
ISO 400, 1/500 sec., f/1.6, 50mm lens

Baby Cues

Babies can express several emotions, even as newborns. Not only do they cry when they need something, but there are specific cues they give you when they are hungry, scared, or hurt. By learning their cues, it will help you to determine what their needs are so you can tend to them right away.

Rooting and Sucking

The rooting reflex is a baby's survival cue and helps the baby to find food. Babies will turn their head whenever something touches the side of their cheek. They may even start sucking on their hand. When this happens, it's best not to wait until the baby starts crying. You should allow the mom to go ahead and feed the baby. If babies start crying because they are hungry, they've already gone beyond the stage where they've been trying to give you their hunger cues.

Premature Babies

A baby is considered premature if the child is born before 37 weeks of pregnancy. Generally, babies born before this time can have a higher risk of complications. One important aspect of preterm babies is lower body fat, which means they may get cold more quickly and require careful monitoring to maintain their body heat. They may cry softly rather than loudly, like a full-term baby. Preemies require added special care, and concerns should be addressed with the parents before the session. Ask the parents if there were any complications at birth or specific conditions the doctor may have mentioned that you should be aware of.

Preemies are most comfortable if they are laid on their tummies.

ISO 400, 1/200 sec., f/2, 50mm lens

One important aspect of preterm babies is lower body fat.

Often, preemies can have a difficult time maintaining their airway due to low muscle tone and decreased musculature. It is important not to compromise their airways with certain poses, such as the "chin up" pose or any positions where their neck is not in line with their bodies, such as slumped over or hyperextended. Avoid using these types of poses with premature babies.

Tip: Stick to simple poses with premature babies to avoid breathing stress.

Premature babies are often in the hospital following birth for 4–8 weeks or longer. There's no "best time" to photograph a preemie. Each is an individual case, and you should discuss this with the parents and their doctor. If you are concerned, call the baby's doctor and let the doctor know you are planning a photo session with the baby. Ask if there is anything you should be aware of or concerned with. Inform the doctor of how long the session could last and what type of poses you will be putting the baby into. It's best to keep poses simple when you're working with premature babies.

Sometimes babies will have peeling skin. It's OK to leave it alone.

ISO 500, 1/200 sec., f/2, 50mm lens

Newborn Skin

A newborn's skin is delicate and can be susceptible to sensitivity and irritation. The products you use in the studio, such as lotions, wipes, and hand sanitizers should be mild, hypoallergenic, and devoid of dyes or fragrances. If you notice the baby's skin peeling, it's best to leave it alone. Allow the parents to decide if they want to apply any lotions or creams to their baby's skin. It's perfectly normal for a baby's skin to peel and is usually a sign of a baby who was born past the due date.

This little sweetie loved being curled up while she slept.

If the baby's skin is turning red or the baby begins to sweat, this is a sign of overheating.

If the baby's skin is turning red or the baby begins to sweat, this is a sign of overheating. Turn the heater off, take off all wraps or blankets you may have the baby in, and allow the baby to cool down. For this reason, it's important to regulate the room continuously throughout the session. I'll often turn the heater on and off during a newborn session to maintain the temperature of the baby. It's vital to keep the baby warm, not hot or cold.

Regulating the Heat

The heat control center of a newborn's brain is still developing. Therefore, losing heat can put the baby at increased risk for a variety of problems. If a baby gets too cold, the baby will start mobilizing his fat stores. This in turn can cause the blood sugar to drop too low. If this happens, damage to the brain or other internal organs can occur because the body will shunt the heat and glucose away from the baby's extremities to try to feed the brain and heart.

A newborn's circulatory system is very fragile and requires constant monitoring.

Too Cold

When newborns begin to lose their body temperature, their skin can become blotchy and even blue or purple. If this occurs, immediately wrap the babies tightly and hold them until they have regained their heat.

Heat loss will also increase their need for oxygen, which is another high risk. And if the baby is too hot, this can lead to increased oxygen demands as well. Therefore, it's important to maintain a properly thermo regulated room. The website docstoc.com explains this as a thermo neutral environment—an environment or conditions under which the core body temperature is normal with minimal caloric expenditure and oxygen consumption. In other words, the room must remain at a consistent temperature so the newborn maintains a normal body temperature without needing additional oxygen or burning more calories.

Too Hot

If newborns are too hot, they can also burn more calories from sweating (just like us when we work out; our core temperature increases, so we burn more calories), and still have the same issues with low blood sugar. Also, when babies are too hot, they increase their oxygen consumption because they breathe faster—again, the same as we do when we work out; we breathe faster.

If the room temperature is regulated, babies will be warm even without clothing on.
ISO 400, 1/800 sec., f/1.4, 50mm lens

Circulatory System

Tip: *Watch for cold feet, paleness, purple or splotchy skin, or sweating, which are indications of temperature change.*

A newborn's circulatory system is very fragile and requires constant monitoring. The baby's body temperature can drop quickly and should be regulated very carefully. Babies are born with a limited supply of energy stored. Without stored fats and calories to keep their bodies warm, their temperature can drop quite rapidly. Having the room heated to 80–85 degrees is vital to ensure that their body temperature is maintained. Heaters should be kept nearby to keep the baby warm but not too close as to cause the baby to overheat or get burned by the heat blast. The baby should also be kept away from doorways where drafts can cause heat loss.

The Anatomy of a Newborn

Newborn photographers should be well versed in the behavior and mechanics of newborns, and what their needs are. We aren't pediatricians, of course, but we should understand and learn as much as we can about them. Why they cry, how to read their baby cues, and ways to soothe a newborn baby are some of the important areas we should study.

This chapter discusses not only baby cues and crying, but also explains a newborn's circulatory system and why it's important to maintain a thermo neutral environment at all times.

ISO 400, 1/200 sec., f/2, 50mm lens

I make sure I capture at least one family photo with everyone looking into the camera, because these are the shots grandparents like best.

ISO 400, 1/200 sec., f/2.2, 50mm lens

Completing the Session

Once we've completed the session, I take a few moments to sit with the parents and discuss what will happen next.

The baby is usually ready for a feeding at this time, so the parents are welcome to stay and feed if they'd like.

I want to ensure cleanliness in my studio, so I finish up by washing all blankets and props, whether the baby has soiled them or not.

A few days after the session, I post a sneak peek of one or two images from their day on my blog or Facebook page. They are pretty excited as they await these photos! I remind them that I will have their gallery ready for them within three weeks and at that time their balance is due. Then I give them a call when their gallery is ready for viewing.

A beautiful moment for me as I photograph my daughter and her husband holding my precious granddaughter in their arms.

ISO 400, 1/200 sec., f/2, 50mm lens

I placed the mom facing in to the light to allow it to illuminate her beautiful face. The dad is placed behind her as he snuggles in close with his wife and new baby.

ISO 500, 1/200 sec., f/2, 50mm lens

Family

All my newborn sessions include family time with mom, dad, baby, and siblings. We always spend 30–60 minutes at the beginning of the session to capture beautiful family photos. Generally, I will do two poses each of mommy, daddy, and family, and then move on to photographing the baby alone. I like to shoot family photos at the beginning of the session for a couple of reasons: As mentioned earlier, the parents look and feel the best at the beginning before they get too hot from being in the studio and the siblings can leave once their session is over. To keep a quiet and calm environment when I'm photographing the newborn, I don't allow the siblings in the studio during this time.

It's important to capture family shots at every session, so I highly suggest it to my parents during the preconsultation time.

The daddy cups his hands as I place the baby gently into them. A beanbag is placed underneath the baby for safety.

ISO 400, 1/250 sec., f/1.8, 50mm lens

This is precious Nora lying on her daddy's strong out-stretched arm. A beanbag is placed directly underneath her for safety.

ISO 400, 1/125 sec., f/2, 50mm lens

Handheld Images

Handheld images are great shots to do if you have a fussy baby. You can have mom or dad hold the baby and take advantage of the time to capture them snuggling and talking with their baby.

It's also a great way to showcase how tiny the baby is lying on dad's arm or in his hands. There's just something about large hands and a tiny baby that evokes emotion.

This little sweetie was having a hard time lying up on daddy's chest, but the moment he brought her down to kiss her, she settled right down. I had the dad stand with his back to the window, camera left, so the light could illuminate the baby's sweet little face.

ISO 500, 1/125 sec., f/2, 50mm lens

A fully awake baby girl rests on her daddy's big, strong arm, sharing her excitement as she looks straight in to the camera.

ISO 400, 1/200 sec., f/2, 50mm lens

This was a funny moment when baby Eliza decided to stretch her foot right into daddy's nose!

ISO 400, 1/200 sec., f/2.2, 50mm lens

Daddy snuggles with Nora while standing at a 90-degree angle to the window, camera left.

ISO 400, 1/200 sec., f/2.2, 50mm lens

Daddy and Baby

Daddies sometimes have a hard time figuring out how to hold their new baby and can feel a bit awkward. To help them to feel more confident holding their newborn child, I have them hold my doll in the studio first before I place the baby in their arms. Be sure to stress how important it is to move slowly with the baby to keep the newborn calm and asleep.

It's great if you can get the dad to pose without a shirt. There's something about skin on skin newborn photos that simply expresses emotion. However, not all dads are keen to this. Talk with the mom at the preconsultation and let her discuss it with him. I like to show how big and strong the dad's arms are while holding his newborn child.

You can just feel the emotion between the mommy and her baby as she hugs her closely.

ISO 640, 1/200 sec., f/2.8, 50mm lens

Because the baby was awake, I laid her on her back against her mommy's shoulder so I could capture eye contact with both of them.

ISO 400, 1/200 sec., f/2.2, 50mm lens

These are precious moments of this little baby girl while she was awake and then cuddled as she fell asleep.

ISO 400, 1/250 sec., f/2, 50mm lens

In this photo I had mom lie on the floor cradling her new baby as she holds her hand.

ISO 400, 1/320 sec., f/2.8, 50mm lens

Some beautiful moments are captured as mommy cuddles her baby girl.
ISO 200, 1/100 sec., f/1.8, 50mm lens

Mommy and Baby

Capturing emotion in an image occurs when a mother embraces her newborn child. The moment she cuddles her baby close to her is magical and one that I encompass with my inner feelings. Waiting for the right moment and knowing when to capture it is the key to connection images.

For a change of pace, try wrapping the mom with a yard of fabric and clipping it in the back for those wonderful skin on skin images. I use small clips from the home improvement store to clip the fabric closed.

This little girl was only 18 months old, which is usually an even harder age to work with. I was surprised at how well she did without crying or getting upset at all. She did have some amusing facial expressions throughout the series. These images make me laugh because her reactions are priceless. At first she was not happy with me standing over her with this huge camera in her face; then she didn't want her baby sister touching her; then for a moment all was OK; and then the kiss came in the end. Because I took the time to focus on this story, it's the perfect series of images that would look great in sequence printed and mounted as wall art!

A sibling series that started with uncertainty to a loving kiss for her baby sister.

ISO 500, 1/200 sec., f/2, 50mm lens

Big sister Arielle decided she would lie down next to her baby brother, Seamus, just for a moment.
ISO 400, 1/400 sec., f/2, 50mm lens

It took us about 15 minutes to get the little sweetie above to cooperate and lie down. She wasn't fussy about it at all; she just didn't want to do it. And if you know two year olds, if they don't want to do something, they won't do it! Everything is on "their" terms, and you just have to wait it out or let it go. We were almost ready to let it go when she decided she would do it. I tried placing her arm under her baby brother's head, but she didn't want anything to do with that, so I gladly let her have her arms free. I seriously had five seconds to capture this one photo, and she was up and out of there! But that's OK! I only needed one photo for mom and we were good.

I get quite a chuckle out of watching older siblings react to their baby brother or sister. I always make sure I capture these in a storytelling series, because moms will cherish these uncertain moments.

Captivating Connections with Families

Portraits of mommy and baby, daddy and baby, and even family shots create some of the most powerful images that can take your breath away. To capture the relationship between a mother and her child or a father and his daughter or son, truly shows the little miracles they are. Parent's emotions surface when they see their photos for the very first time, and they generally will order all of them.

Sometimes parents, especially moms, don't want to have their photos taken. They've just given birth and the last thing on their mind is being in the photos. Although I can certainly understand this, I always tell them about past clients who have felt the same way. I used to let the parents decide if they wanted their photos taken, and of course, if they were firmly against it, I certainly didn't push it. But after having one too many clients come back to me later and say they wished they had taken some photos, it broke my heart. I decided I would try my best not to let that happen again. So now I ask all my parents to at least allow me to take one of them with their baby, and if they choose not to purchase the photo, that's fine. More often than not, they end up buying the image. I explain that they shouldn't worry about the photo, because I only photograph them from the waist up. My focus is close-ups and capturing the relationship with their baby—nothing else.

I shoot the connection portraits at the beginning of the session when everyone is at his or her best, ready to go, and not sweating from sitting in a warm room for an hour. Then we move on to photographing the baby alone. Typically, I'll allow 30–45 minutes for family and sibling shots, and then devote the remaining hour to the newborn. If the baby wakes up during the family session, I ask the mom to feed the baby a little before moving on to the newborn images.

Siblings

Sibling shots can sometimes be challenging, especially if siblings are less than three years old. Moms are usually anxious to get some of these shots, but I can never promise we will be able to do them. The reason is that most children haven't settled in to having a new baby in the house yet. They've had only about a week since this new little person came into their lives and took over, so they aren't quite sure what to think about the whole situation. The last thing they want to do is lie next to this little baby and have their picture taken.

Tip: *To prepare older siblings for the photo session, ask the parents to practice taking snapshots at home with them and the new baby prior to their session.*

This little set of twins is nestled in a large basket approximately 20 inches round.

ISO 400, 1/200 sec., f/2, 50mm lens

A sleeping baby lying in a twig nest. I used a small blanket and a couple of towels underneath her to make sure nothing was poking into her.

ISO 400, 1/250 sec., f/2, 50mm lens

Large, hand-woven baskets are great for props, because they allow the baby to snuggle in and relax comfortably.

ISO 400, 1/200 sec., f/1.8, 50mm lens

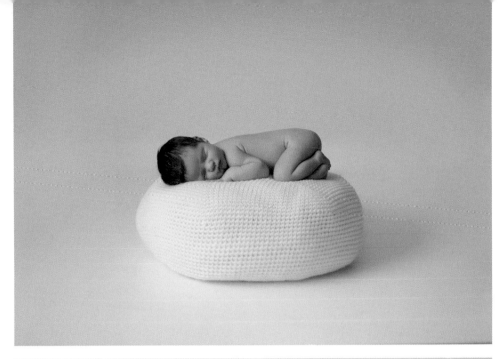

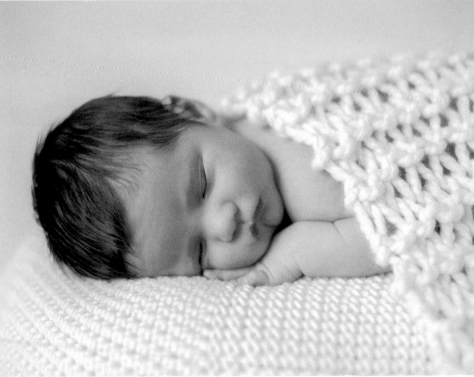

This custom-made, hand-crocheted, creamy pouffe cushion has become one of my all-time favorite props.
ISO 400, 1/400 sec., f/1.8, 50mm lens

Props should be at least 18 inches round to allow the baby to fit comfortably. However, babies come in all sizes, so ensure that they are not too small or too large for the prop being used.

When I do prop shots, I always take the time to shoot at different angles, up high on a step stool (be sure to wear an over-the-head camera strap for safety!), and up close. It's a great time to capture some macro shots with your macro lens as well.

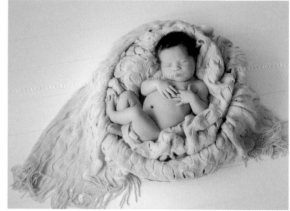

I used a short basket, stuffed it with enough blankets inside for comfort, and laid my top blanket over it. I then used a small towel underneath the baby's head to prop him up a bit.

ISO 400, 1/500 sec., f/1.8, 50mm lens

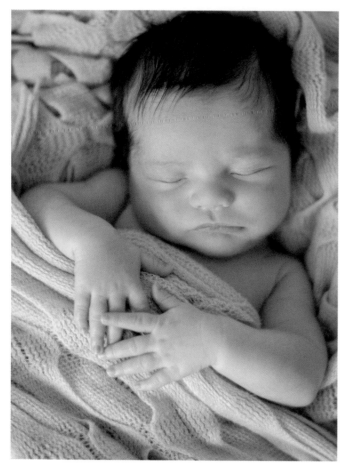

gently, *shhhhh* him, be patient, and wait until he is settled before you proceed. If the parents allow it, I use a pacifier when I see signs of the baby waking up. This helps to soothe the baby back to sleep with little worry about what I'm doing.

The transitions outlined earlier will guide you through a session with ease because you'll know what to do next. You should be able to complete the full set of beanbag poses without having to pick up the baby. However, if the baby needs to be comforted or needs to feed, that's the time to take a break.

It's your job as an educated and experienced newborn photographer to keep the baby relaxed and comfortable throughout the entire process. If you get through only a couple of poses, don't worry. Start simple and slow, and work your way up to more poses. Don't push yourself to do too much too soon.

Choosing Your Props

Props are plentiful in the newborn photography industry and trends continue to change almost daily. A new, cute little hat or a fun new basket comes on the market and is so tempting to buy! Sometimes photographers go crazy wanting to buy everything they see, but you have to remember that you are running a business and need to have a prop budget. Because I love to keep the focus on the baby, I don't use too many props. But I do love to use simple hats and a lot of wraps in my work, and sometimes I may use a basket or other basic props; however, I keep it simple. You must always consider safety when you're choosing your props, especially buckets, baskets, and the like. Refer to the section "Baby Safety" in Chapter 3 for a list of specific suggestions.

There are some props you may want to use to pose the baby in the chin pose and have the baby resting on the edge. You've probably seen this done quite a few times by many photographers. I used to do this type of pose, but I've discontinued it because my preference is a more natural-looking style. If you do love that type of style, a good transition would be to move the baby from the chin pose on the beanbag to the chin pose in a bucket. But make sure you have at least ten pounds of weight in the bottom of the bucket to prevent any tipping.

3. Coordinate each prop with each pose and lay out the props in your shooting area.

4. Start with one large, twin-size fleece blanket as your base on the beanbag.

5. Layer the three blankets or fabrics on the beanbag with a waterproof pad in between each layer.

6. Place all the supplies, such as wipes, cloth diapers, hand sanitizer, white noise, heater, small garbage can, step stool, and so on close by the beanbag for easy accessibility. See Chapter 3 for a full list of supplies.

7. Place a small padded cushion for kneeling on by the beanbag.

8. Prepare all backdrop setups you will be using off to the side so they are ready to go.

9. Set your exposure and white balance before the client arrives and then again with each new setup.

Smooth Transitional Techniques

I continually hear from the photographers I mentor that the baby wakes up and starts crying, and they have a hard time settling the baby back down and getting more poses. Of course, there are general guidelines for keeping babies happy, such as keeping them warm, making sure they have a full belly, and using white noise in the background. However, sometimes these methods are not enough. Babies like to sleep. Who doesn't? When you disrupt their sleep, they can get a little cranky. So how do you move them from pose to pose without disrupting them? Follow my simple techniques, and you should be able to flow through the poses with ease the majority of the time.

Certainly, there will be times when you've done all you can and the baby still isn't content. But I can tell you that rarely do I have a baby who is not happy. If you educate the parents, helping the mom choose good foods if she's breast feeding, be patient, and keep a warm and calm environment, you should be able to keep the baby satisfied.

Following the poses in order and paying close attention to the soothing techniques will allow you to move the baby with little disruption. If the baby gets a little upset because you've disturbed the newborn in a deep sleep to move him to another pose, then stop, listen to the baby, place your hands on him, sway him

Positioning

Once the ankles are crossed, very gently roll the baby to his tummy and move the bottom toward the back of the beanbag. Rest the baby's head on top of the wrist with the back arm tucked next to the chest comfortably. Make sure the baby isn't lying on top of the back arm because he could lose circulation in that arm. If you lose the feet and can no longer see them, scoop the legs from behind and bring them forward.

Add a couple of scrunched up or rolled towels as a pillow underneath the head for support. Make sure the baby is lying on the edge of the pillow so his face doesn't sink into the blanket.

It can be tricky to hide all the little private parts of newborn boys, so make sure the legs are tucked under the tummy. You can add a small washcloth under the knee if you need to.

Shooting

When I'm shooting the taco pose, I like to tilt my camera a lot. Be careful not to tilt it too far so the baby looks like he is falling out of the frame (meaning the baby appears to be in an upright sitting position). This makes the baby look unnatural.

Step in front of the baby's face and come in close. Then move back to get a full shot of the baby at a wide angle.

Come to the side, directly over the baby, and shoot from above for a nice profile view. If you haven't taken any macro shots yet, this is a good time to include those sweet shots of the eyelashes, toes, and lips.

Basic Posing Workflow

To ensure an easy flow to your sessions, I've outlined a basic posing workflow to follow for each session and items to set up prior to your session. This procedure will help you eliminate having to take the time to set up during the session. It's always best to plan for more setups than you'll use, but keep in mind that you may not always get through every setup you've selected.

1. Write out your shooting schedule with all the poses you will do.
2. Prepare at least five posing setups that include three blankets, two props, three hats/headbands, and three wraps.

While the baby is lying in the chin pose, gently remove the pillow of blankets underneath, bring the arms down, and tuck them in by each side with the arms bent and hands by his shoulders.

Place one of your hands by the head and the other hand around the bottom, and gently roll the baby to his side. Allow the baby to settle. Remember that slow movements will guide the baby into a smooth transition. As the baby lies on his side, scoop up the legs and cross the *ankles* with the outside leg on the bottom and the inside leg on top. Let the legs bend naturally and remember to scoop the legs forward. At no time should you pull on the legs or feet. This could injure the baby's hips.

At no time should you pull on the legs or feet. This could injure the baby's hips.

You can achieve plenty of variety with the taco pose. Begin by using no props, and then add a couple of props, changing out the baby's hands and your direction with each shot.

ISO 400, 1/500 sec., f/1.8, 50mm lens

Positioning

Begin by placing the rolled up receiving blankets underneath all the layers of blankets, directly under the baby's arms. Typically, I'll use three stacked on top of one another as shown in the blanket views images in the section "Forming the Pillow" at the beginning of this chapter.

While holding the baby's head, slide the blankets underneath to support the chest and elbows. The key is to support the baby's head and balance him as he lies on his hands. Sometimes you'll need to push down with your fingers on one side or the other on the stack to obtain balance on both sides. Start with the baby laying his head sideways on his arms and take a couple shots in this position; then move to the full chin pose. This allows the baby time to settle into the pose.

You can then move on to the full chin up pose where the baby's head is up and the chin is resting on the hands. Cup both your hands around the baby's face and gently move it facing forward. If the baby's head is wobbly, you'll need to have the parent support the baby's head. Have the parent hold the side of the baby's head with one finger and take the shot. Then you can clone out the parent's hand in post processing.

Shooting

Tip: When you need something small, use washcloths to add extra support under the baby's arms.

My favorite position to stand in while shooting this pose is directly in front of the baby. The baby in the preceding photo had the cutest little cupid hair, so I knew this pose was perfect for him!

Most of the time I shoot in landscape orientation, but shooting this pose in portrait orientation works just as well. If you step to the side a little and shoot from that direction, you'll also be able to see a portion of his body.

The Taco Pose

The taco pose is an advanced pose and should be done only when you are confident and competent using the preceding three poses and have been properly taught by an experienced newborn photographer.

The baby is now moved into the full chin up pose.

ISO 400, 1/1600 sec., f/1.8, 50mm lens

This is another variation of the chin pose coming around to the side of the baby and shooting down so you can see his whole body in the frame.

ISO 400, 1/1600 sec., f/1.8, 50mm lens

If you have layered the blankets on the beanbag as suggested in Chapter 3, this is a good time to switch to the next blanket. Place one hand underneath the crossed arms and head with the other hand under the bottom. Have the parent pick up the top blanket and waterproof pad and throw them over the background. Pick up the baby about six inches off the beanbag, turn and place him with his head toward the front of the beanbag and his bottom toward the back. Hold the baby until he is settled. When the baby is comfortable, have the parent place their hands on the baby while you adjust the blankets.

The Chin Pose

The chin pose can be challenging at times. It generally takes the baby a little extra time to settle than it does with the side or tushie pose. Therefore, you'll want to take your time and continue soothing the baby as you make the transition. Refer to Chapter 5 for soothing techniques.

I always have one of the parents help with this pose because I need extra hands and eyes to ensure that the baby's head is stable. The parent is given strict instructions to remain right next to the beanbag and watch the baby the entire time.

While the baby is still in the tushie pose, bring up both arms with elbows out and cross the hands, one on top of the other, right underneath the chin. There's no need to pick up the baby at this point, unless she becomes upset and you need to comfort her further. Hold the baby's arms in this position until she is settled.

Here are two sets of a side view chin pose. I typically always start with this position before moving on to the full chin up position.

ISO 400, 1/800 sec., f/1.8, 50mm lens

Positioning

Once the baby is laying on her tummy with hands tucked in and legs crossed, bring the bottom toward you in a slight "U" shape. Pay attention to the baby's cues, because some babies will not like their bottom curved in. If this is the case, leave the bottom as is and don't force the pose.

Stretch out the fingers and tuck her hand slightly under the chin so the elbow can touch the knee. She should be resting her chin on her hand, not the arm. Add a tissue or two underneath the blankets under the cheek to create an arch of the hand. The head pillow is already there from the side pose, but go ahead and scrunch it up more or add more fabric if needed. Make sure you can see all of the baby's face and it isn't squishing into the fabric.

To get the bottom up a little higher, bring the knees in slightly under the tummy. Place a small towel or piece of fabric underneath the back knee to support the baby from rolling to her back. Build up rolled towels underneath the bottom as you go so they push up against the feet, raising up the bottom. If you'd like the bottom raised a bit higher, you can place a small washcloth under the knees, but most of the pillow should be placed up against the legs. I don't like the baby's bottom up real high, so I just keep it natural looking and create a small pillow.

Shooting

Tip: *To create some variety with the tushie pose, take a full shot straight on, and then add a wrap or hat and come in close at an angle.*

Once again, stand back and position yourself in front of the baby's face. Take a wide shot by moving back a couple of feet to create a lot of blanket around the baby in your frame. This will make the baby appear tiny in the final image.

Come in close and shoot at an angle to the baby's face. Make sure you have an over-the-head strap on your camera anytime you are shooting from above the baby.

The tushie pose is also a great pose to shoot from above for a full-body profile shot.

Most tushie poses are generally done the same. However, you can switch up the legs by either facing the toes or the heels out and adding a wrap or hat.

Kneeling down allows you to get a close-up view of the baby in the tushie pose. Because I wanted the baby to rise up toward the right, I tilted my camera to the left to produce the second view.

ISO 400, 1/800 sec., f/1.8, 50mm lens

Once the baby has settled into the new position, cross the legs under the bottom. It doesn't matter if the foot is facing you or not. I usually face the toes out, but if the baby isn't comfortable or the foot isn't staying in place, I'll face it in the other direction with the heel out. Both ways look cute, so don't get too caught up on which is better.

The tushie pose using a bonnet and knickers set. I was positioned a little above the baby so I could shoot in a downward view.

ISO 400, 1/800 sec., f/1.8, 50mm lens

Shooting

Step back so that you are directly in front of the baby's face, lining up your eyes to hers, tilt your camera, and take the shot. Remember to tilt in the opposite direction you want the baby to rise up. Move around, get on your knees, and shoot low; stand up and shoot high; come in close; and get creative with different compositions. Look at the baby from different angles to experiment. The only way you learn which angle or direction you like best is to practice moving around the baby utilizing all your angles.

Plan on shooting two to three angles and/or close-ups with each set and then move on to the next. Keep the baby in the side position, but change one or two things about the shot. You might change the hands or bring the feet in a bit closer. You could add or remove a wrap, hat, or headband. Create variety and maximize the pose as much as possible. The objective is to get four to six images from each pose by using different variations.

If the baby is unsettled, take the time to lay a blanket over him for security and hold your hands on him. Be firm, but gentle. He will soon realize that you are in control and will give up and relax. If he doesn't, you'll need to decide if he needs to be picked up and cuddled.

If at anytime the baby awakes, you'll need to assess if he needs to feed or keep shooting if he is happy and content. You will also most likely need to move on to the awake or wrap poses, as discussed in Chapter 6, because he probably won't stay in the basic poses.

Keep your hands gently cupped around the baby's face to help her feel secure and safe.

The Tushie Pose

When you're moving the baby to the tushie pose, while keeping the head pillow where it is, gently place one hand on the baby's shoulders and the other hand on her bottom, and slowly roll to the tummy. Most babies don't mind this transition, because they love to be on their side and tummy. Even with fussy babies, the tushie pose is always my *go to* pose when all else fails.

As you roll the baby to her tummy, keep the outside arm tucked under the chin while placing the inside arm snug against her. Make sure the baby is not lying on the inside arm or else she could lose circulation.

Give babies
time to get their
wiggles out and
get comfortable.

With your beanbag placed at a 45 degree angle to the light, as discussed in Chapter 3, place the baby on the beanbag with the top of her head toward the window and cover the baby with a blanket while soothing and rocking her gently. Be careful not to move too fast; slow is key. Give babies time to get their wiggles out and get comfortable. If a pacifier is acceptable to the parents, don't be afraid to use it anytime the baby seems unsettled.

Once the baby is content and happy, I move forward with setting up the pose. The main goal with the side pose is to have the focus on the baby's face. This requires the feet to be back behind the face. If the feet are out closer to you than the face, the photo will make the feet appear larger than they are because the distance to the camera is closer to the feet than it is to the face. This applies to any type of posing, so keep this in mind when you're deciding how to position the baby.

Positioning

Bend the knees a little and angle the baby's body slightly with the face forward and bottom back. Keep your hands gently cupped around the baby's face to help her feel secure and safe. Place the baby's hands together, gently stretch out her fingers, and slide them underneath the cheek. If the baby is still partially awake, she may pull against you to keep a fist. Some babies never do release their fingers. If this happens and I'm unable to release them, I just leave them as they are. You always need to remember that your time is money, so while you may want to perfect a pose, you must decide how important it is to you and how much time you're willing to allow. Two hours is enough time to capture the number of photos you need and a long enough time for the parents to be in the studio, especially because they are already tired and sleep deprived.

Keeping the variations to a minimum, yet utilizing the angles and composition from which you shoot, will result in more photos that look like you changed the complete setup.

Tip: Check for milk stains and fuzzy hairs on face and lips before taking the shot.

The next step is to place the towels and/or receiving blankets under the baby to mold her into place. Use a hand towel, or as mentioned earlier, small pieces of fabric, and scrunch them up under the baby's head, ensuring that you keep the edge of the face on the edge of the pillow you created underneath. Don't be afraid to use more blankets if you need to. Keep manipulating them underneath until the baby's head is supported and you have a clear view of the face. Avoid tilting the baby's head back where you can see up the nostrils. The chin should be in a slight downward position.

The side pose using three angles of the first variation.

ISO 400, 1/640 sec., f/1.6, 50mm lens

The side pose using two angles of a second variation. Notice how the baby's bottom was moved back slightly while moving the head forward and placing her hands on her face.

ISO 400, 1/640 sec., f/1.6, 50mm lens

The Four Basic Poses

The four basic poses using the beanbag are the side, tushie, chin, and taco. I'll walk you through each pose and show you how to work with angles and compositions to maximize each pose.

The goal is to produce at least 30 useable images consisting of a variety of poses with the beanbag, props, siblings, and parents to provide enough variety to create a beautiful heirloom-quality album the parents will be able to treasure for a lifetime. This is the product I want my clients to buy, so this is what I shoot for. Every photo I take has a reason and a place in the album, and these are my objectives during my sessions. I typically shoot a total of 100–120 frames per session.

Camera Tilt

As you work through the poses, try tilting your camera the opposite way in which you want the baby's head to rise up. For instance, if you want the baby to appear as though he is on a slant tilted up toward the right, tilt your camera to the left. You don't need to build up the pillow underneath the blankets very high, because the tilt of your camera will render the same effect.

Tip: Be mindful of the wrinkles that might occur with the top blankets the baby is laying on. Taking the time to smooth and stretch the blanket or fabric will save you costly time in postproduction.

The taco pose works best with babies less than five pounds because they tend to curl up easily and don't mind being positioned into a ball. Larger babies, those eight pounds and over, do quite well with the tushie pose where you can see all their sweet baby chub. However, don't always rely on weight as the determining factor, because all babies are different and may or may not tolerate certain poses.

If you are a beginner at newborn posing, master the side and tushie poses first before moving on to the more advanced poses, such as the chin and taco. You can also concentrate more on the natural poses, as discussed in Chapter 6.

The Side Pose

Laying the baby on her side is the simplest pose to begin your session with. Some babies need time to settle in when they first arrive, and this pose seems to help them to relax and fall asleep quickly.

If I'm working with a fussy or sensitive baby who is having a hard time settling, I'll stop and let the mom snuggle with her baby for a little while. My job is to not only be attentive to the baby's needs, but the mother's as well. Sometimes that's all it takes to bring the situation back to a peaceful and stress-free environment.

Forming the Pillow

One of the most difficult tasks for photographers when posing babies on the beanbag is getting them propped up enough to hold the position and still see their cute little faces. I use towels, receiving blankets, and fabrics to form a little pillow underneath the baby's head and/or feet. Sometimes, especially for the chin pose, I'll fold the blankets and stack them to create enough height to support the baby's head, but other times I just stuff them underneath without folding them. Small washcloths or cut up pieces of fabric can be easily stuffed into a ball and tucked underneath. I prefer doing it this way rather than always folding because it creates smoothness without seeing the edge poking up through the blankets on top. Tissues also work wonders for extra stuffing underneath the fabrics. While I'm shooting, I have a basket full of receiving blankets, fabric pieces, washcloths, towels, and tissues right next to the beanbag.

Blanket views: For poses like the chin pose, stack three receiving blankets folded on top of one another and place them underneath all the blankets. Use scrunched up fabric pieces for the side, tushie, and taco poses.

ISO 400, 1/640 sec., f/2, 50mm lens

How much time should you spend on each pose? That depends on a number of factors. In the end, you'll have to decide whether it's worth taking the time to perfect a pose or move on to the next. Sometimes I'll take 15 minutes if I'm working with a fidgety baby who is moving out of the pose every second I position him, whereas other times I can position the baby within a few minutes. While you're organizing your shooting schedule and planning the number of poses you want to achieve, jot down an expected amount of time you'll spend on each pose, prioritize the *must haves,* plan for extra poses, and try to stay on schedule. Remember that every baby won't like every pose. Some may require their own posing position depending on what is comfortable to each one.

Be Flexible

Babies are little people; they're not all alike. Some sessions will go smoothly, and other sessions will be more challenging and require some flexibility in your shooting schedule. Babies can sense frustration and will respond likewise. If you can remain calm, they will also feel calm and relax much easier.

Don't be afraid to stop and tend to the baby's needs if she pees or poops, or wants to eat. There's no need to prolong her discomfort further if she's not happy. If the baby soils the blanket and I'm able to continue shooting without it bothering her or showing it in my shot, I'll continue shooting. But if she has soiled a lot or is unhappy, I'll take the time to pick her up and clean up the mess before we continue. It's a decision you'll make with each situation, but always keep the baby's best interest as your main priority.

Keeping Mom Calm

Sometimes moms may get a little upset if they see their baby upset. First time moms tend to be more anxious than most and may require special attention. If you notice mom feeling tense, take the time to sit and talk with her, and assure her that her baby is safe and you will take good care of him. Let her know that it's important for everyone to stay calm and relaxed to help the baby as well. A little reassuring will help her relax and enjoy the session. I'm always aware of how my first-time moms are feeling at the preconsultation session, because they can be extra sensitive and worry about their baby. Added attention is given to assure them that everything is OK and their baby is safe.

Now, before each session I write out a shooting schedule to stay on track. Because I've had the preconsultation beforehand and have asked the parents what their *must-have* shots are, I'm aware of what setups and poses I'll include. While I'm choosing blankets and props for the session, I jot down which poses I'll use and which angles I want to achieve. With each session, I incorporate something that I've never done before, such as a new angle, new prop, or a different perspective. It's important to me to create a session that doesn't look like all my other sessions. Of course, there are specifics that are similar, such as my use of color choices or the same blanket, but the final images are unique to each family. If my clients have brought a favorite blanket or other special items, I'll be sure to incorporate those as well.

Fussy and Sensitive Babies

Some babies are simply fussier and more sensitive than others. You don't always know why, but you can go back and review everything you're doing to ensure the comfort of the baby and try to pinpoint any areas that might need special attention. Is the baby being over stimulated? Is he fed, warm, and comfortable? These are just a couple of questions you should ask. However, sometimes it's unclear to what his needs are. So what do you do if you have a fussy, sensitive baby?

Reading a baby's cues and listening to them is key to understanding what the child needs. Refer to Chapter 5 for an in-depth look into why babies cry and ways you can soothe them.

During one of my sessions, the baby was fussy every time dad tried holding her close to his chest. We were trying to do a shot where he was cuddling her close, but she cried every time. Most babies love to snuggle on their tummies touching skin to skin, but she seemed sensitive at the time about doing this. So I asked the dad to hold her out, cup her head into his hand, and bring her face close to his. Once he did that, she calmed down immediately and fell asleep. We don't know why she didn't like being held that way; possibly it hurt her umbilical cord or she had some tummy issues going on. But listening to her needs and knowing to do something different was crucial to her comfort and getting the shot. We didn't get what we wanted, but in the end the photo resulted in a beautiful daddy and daughter moment. See the third image in the section "Daddy and Baby" later in this chapter.

In this chapter, I'll walk you through how to create a complete newborn session utilizing four basic poses and teach you how to transition the baby from pose-to-pose while keeping the baby comfortable and relaxed at all times. You'll also learn how to work with a fussy baby and the newborn's concerned parents.

Posing Insights

My philosophy is to keep the baby looking natural.

All photographers have their special tips and little secrets that help the session workflow run smoothly. Over the years I've learned some tricks and efficient ways to reduce my time to two-hour sessions. My advice to which poses to do first, second, third, and so on are laid out here in order and consist of the main four basic poses: chin, side, tushie, and taco. I suggest planning your schedule with this strategy as a starting point and tweaking it as you see fit the more sessions you do. You'll find that what works best for you may not be what everyone else does.

My philosophy is to keep the baby looking natural. Props should be minimal with the focus on the baby. When clients of mine look back on their baby's portraits years from now, I want them to remember how tiny and delicate their baby was, not which hat the baby was wearing. Natural-looking types of portraits are timeless and memorable.

Time Management

Yes, I do keep an eye on the clock. Although I love photographing babies and could potentially shoot all day, I have to remember that I'm running a business and time is money, so keeping the session on time is a financial benefit to me. Of course, there are exceptions to every rule, but having a policy in place allows you to be more efficient with your time.

Tip: Schedule a two-hour block of time for each session and stick to it.

When I first started shooting newborn photography, it took me four hours to get through a session because I thought I needed to shoot hundreds of frames. I had heard other photographers say that they shot 300–500 frames per session, so I thought that's what I needed to do. Soon, I realized that the parents were not very happy being in the studio this long, so I needed to find more efficient ways to minimize this time for the parents as well as me.

Newborn Posing

Newborn posing styles have changed dramatically. An image that used to show a baby against a simple black background has evolved to baby bum poses, babies swaddled up tightly and snugly, or a baby curled up as if still in the womb. You'll find an abundant supply of props just about anywhere, and some of them are bound to break the bank!

With posing, comes baby safety. New photographers who see images of babies hanging from tree branches in stork-like slings or sitting like a froggie with their legs stretched out beside them resting their head on little hands may think these images are exactly as they seem. However, I can assure you they are not. These are composite images—that is, two images taken and then merged together in Photoshop to create the final image. This is the way these types of images should be created. Baby safety should always be your top priority (see Chapter 3, "Safety Tips for Photographing Newborns"). I won't be teaching you how to create these advanced types of images, but you should know that they require experience and complete knowledge of how to do composite shots while keeping the baby safe, and should never be attempted if you're unsure of what you're doing. For additional education in newborn photography and posing, schedule a mentoring session with me or an advanced newborn photographer who has had at least five years of experience working with newborns.

ISO 400, 1/160 sec., f/1.8, 50mm lens

When you're scheduling sessions for boys, be sure to ask the parents if and when they plan on circumcising the baby. Advise them (if they can) to schedule the procedure right after birth or after their photo session because the baby will be more comfortable. It takes five to seven days for a circumcision to heal. Don't schedule a session for a newborn boy for at least five days after he has had a circumcision because it can be too uncomfortable for the baby when you're moving him on different blankets and fabrics. You want to ensure the best comfort for the baby, so keep this in mind and discuss it with your clients ahead of time.

Baby Safety

Being a newborn photographer is one of the greatest jobs in the world. And being able to hold and cuddle sweet little miracles every day is heaven. Baby safety should always be your number one priority. Everything you do, including beanbag poses, handheld poses, and even prop shots should all be done with safety in mind, no matter what!

Keep a close distance between you and the baby at all times. I am never farther than a foot away from the beanbag, and I have my eyes on the baby at all times. At anytime I need to walk away, I ask one of the parents to come and sit by the baby. If I'm talking with the parents while shooting, I place my hands on the baby while I look away and speak with them. Baby's reflexes are quick, and in an instant they can roll or lunge. Don't take chances; *be safe!*

At times you will have parents request poses and/or props of which you either have no experience doing or don't feel it's safe for the baby. Listen to your gut. Just because the parents want it doesn't mean you have to do it. Always think about safety. If you have any doubts at all for any reason, don't risk doing it and don't be afraid to say "no."

Make sure you always use a spotter when you're doing any type of prop shots. I always have a parent sit on the floor next to the baby at all times. The parent is instructed to keep an eye on the baby, not on me, and not to be afraid to jump in my shot if the parent feels the baby's safety is at risk. Babies can startle and move very easily, so make sure you are prepared and ready for any rapid movements. For more details on the characteristics of a newborn, see Chapter 5, "The Anatomy of a Newborn."

Baby's reflexes are quick, and in an instant they can roll or lunge. Don't take chances; be safe!

Don't be afraid to reschedule a session if the first one didn't go well. Although this should not be a regular occurrence, if it does happen, take some time to evaluate what you can improve on before the next session. Review the instructions with the mom one more time, and make sure she is following them without making her feel badly, of course. Gently remind her of what you need from her. The reason for the failed session could have been that the baby had a bad day because of an unsettled tummy. It could also have been a number of other things. Usually, the next day the baby will be completely different; so don't be afraid to reschedule if you need to.

Safety Tips for Photographing Newborns

Baby safety should always be your top priority! Make sure you are taking every precaution to keep the baby safe at all times. Here are some suggested baby safety guidelines for anyone handling a baby:

- Remove all jewelry, including rings, earrings, bracelets, and necklaces.

- Make sure your nails are filed smoothly to avoid scratching the baby.

- Use an assistant when needed for safety.

- Sanitize your hands constantly throughout the session—not just once but continuously.

- When you're using buckets and baskets, put a ten-pound sandbag weight in the bottom of the bucket.

- NEVER leave the baby unattended!

- ALWAYS wear a neck strap around your camera when you're shooting from above.

- NEVER take your eyes off the baby. If you need to look away to talk to the parents, put your hands on the baby. If you need to step away from the baby, have an assistant or parent sit next to the baby.

- Keep the baby comfortable. When you're posing babies, if they don't like the pose, move on to another one. Never force a pose!

- Get experience with and master basic poses before attempting advanced poses.

- Regulate the heat, and keep babies warm. But babies should not be sweating. If they are sweating, it's too hot. Be careful the baby does not overheat!

- DO NOT put the heater too close to babies; the heat could potentially burn them.

- Watch for poor circulation. If you see the baby's feet or hands turn deep red, blue, or purple, you need to readjust the baby or possibly move the baby to a different position.

- If the baby feels cool or looks splotchy, warm up the baby immediately by wrapping or placing a blanket over the baby.

- Be aware of the baby's reflexes. Babies are easily startled, especially when they are in a prop, like a basket or a bowl.

shots. Not all parents are concerned about getting the early, curly poses. They just want photos of their baby. It is best to let them know not to expect those types of poses, but that you are happy to create beautiful portraits for them!

I never cancel a newborn or baby session merely because the baby has missed the "window of time" for the curly shots. Instead, I'll refocus the session on the fact that the baby may be awake most, if not all, of the session. Be prepared and plan your setups accordingly. Wrapped shots, above shots, and handheld shots are the best for babies who are awake. Assure the parents that they will walk away with gorgeous photos of their baby no matter what the age.

This little sweetie is Nora, my youngest granddaughter. She was seven weeks old at this photo shoot and wanted nothing to do with sleep. Sometimes awake shots can make the most compelling photographs.
ISO 200, 1/200 sec., f/2, 50mm lens

A seven-day-old, newborn girl sleeps soundly as she allows me to pose her so sweetly.
ISO 400, 1/800 sec., f/1.8, 50mm lens

Photographing newborns under two weeks of age rather than babies older than two weeks has its advantages and disadvantages. The younger they are, the more apt they are to stay asleep and curl easier, whereas the older they are, the more awake and personable they are.

Babies Older than Two Weeks

On occasion, you'll have clients who want to book a session with their baby who is older than two weeks of age. That's OK! Don't turn them away. Just inform the parents that babies older than two weeks might not curl up as easily or like their clothes off. When you have a session with an older baby, you'll need to focus more on images of the baby dressed, awake, nicely tucked in a basket, or handheld

Age Matters

The age of the babies can sometimes make a difference in what type of poses you are able to position them in and whether they will like it or not. All babies are different, and it's not to say that one baby will be easier to pose over another one merely based upon age, but generally speaking, the age of the baby can dictate how the session will run.

Younger babies tend to go into certain curly poses much easier than older babies and don't mind much about having their clothes off if they are kept warm.

Babies Younger than Two Weeks

Typically, I schedule all newborn sessions between five and ten days after birth. Although I will schedule newborns at any age, I strongly encourage parents to schedule sessions when babies are at least under two weeks of age. At this age, they are more likely to curl up in "womb-like" poses, stay asleep longer, don't mind being unclothed, and usually have their feeding schedules set to at least every two hours.

The best time to schedule sessions for newborns is a week after the mother's due date. I do leave room in my schedule to make adjustments to session dates once the baby arrives. Of course, babies will arrive on their own terms, but at least we have a guideline to go by of what the session day will be. From there we can adjust the date once the baby is born. Tell the parents you have a set date, but that they should call you the day of or the day after the birth so you can make schedule adjustments if needed. Scheduling newborns can sometimes be a juggling act, but if you stick to this general rule, the shoot date should be around the five to ten day mark the majority of the time.

Tip: Schedule newborn sessions when the baby is between five and ten days old to help ensure a sleepy, curly baby.

Scheduling babies less than five days old may create some issues around their feeding. It usually only affects nursing babies due to the fact that it typically can take up to five days for the mother's milk to increase in volume. If the mother's milk hasn't increased, babies eat more often because they are not getting fully satisfied. They can also be more fidgety at this age, which makes it difficult to keep them in certain poses.

A ten-pound weight is placed in the bucket to keep it from tipping over, and a spotter sits close by for safety.

ISO 400, 1/1250 sec., f/1.8, 50mm lens

Buckets, Baskets, and Bowls

Buckets are great to use as props, and you can find a variety at your local home décor or antique stores. When you're using buckets, baskets, and bowls as props, make sure they are sturdy and large enough for the baby to fit in. Stuff blankets inside the bucket for comfort. You don't need to stuff the bucket full, just enough so the baby can sit inside comfortably. I like to use a neck pillow placed in the front of the bucket for the baby's arms to rest on. Use enough blankets underneath it so that it can rest at least five inches above the bucket. Use small throws, scarves, or the edges of the blanket to drape over the top of the bucket or basket. Knitted 24x24-inch squares work great!

In this photo, the father was sitting next to the baby with his finger holding her head to keep her safe. The father was edited out of the final photograph.

ISO 400, 1/400 sec., f/2, 50mm lens

When planning your sessions, remember to coordinate your props with your fabrics and blankets. I like to keep things simple and not use too many props. A simple hat, lacy scarf, and a coordinating basket are my favorites. Keep the focus on the baby, and make sure you select props that are appropriate for the size of the baby. When you use a basket, place a ten-pound weight in the bottom for stability. In addition, stuff blankets inside the basket for the baby to lie on comfortably.

- 18% gray card—X-Rite ColorChecker Passport or ExpoDisc
- Reflector or white foam core board
- Background stand (or you can use chairs to clamp the fabric to)
- Five clamps (SHOOT BABY! has easy-to-open clamps, or use cheap ones from any home improvement store.)
- Thick towels (for inserting into buckets and baskets)

You might consider these extras further in your career or try renting them before purchasing:

- Background stand
- More blankets and fabrics
- SHOOT BABY! waterproof pads
- Seamless paper, floor drops, and backdrops
- Changing table (for parents, stocked with newborn diapers and wipes)

Additional props might include:

- Variety of wraps approximately 18-inches wide
- Hats and headbands
- Baskets, bowls
- Flooring, rugs
- Diaper covers

Props

With newborns, you can use many different types of props. Anything from buckets, baskets, beds, bowls, and so on will do. When you're choosing a prop, always look for safety first.

Props should be:

- Free from harmful objects and chemicals
- Sturdy
- Not too small
- Not glass

This front view of the beanbag on its own shows you how full to fill it.
ISO 400, 1/250 sec., f/2.8, 50mm lens

Here is a front view of the T-bar background stand.
ISO 400, 1/250 sec., f/2.8, 50mm lens

Baby Tools Every Newborn Photographer Should Have

You will need some basic tools when you're setting up your business. These basics are *must-haves*; however, then there are the extras, which are nice to have but are not necessary when you're first starting out. Start with the basics and add the extras when you are able to.

Here are the basics:

- Sensitive baby wipes
- Hand sanitizer
- Sensitive lotion
- Paper towels
- Cloth diapers (I use these mostly for cleaning up messes. They're soft and warm for the baby's bottom.)
- Puck-style beanbag (The SHOOT BABY! ottoman is the best.)
- Receiving blankets, cut up fabric pieces, or cheap white towels (for use under the blankets to prop up the baby on the beanbag)
- White noise—an iPhone app
- Space heater
- Fabrics and/or blankets—approximately 55x70 inches or two yards

The Beanbag

For all my shoots, I exclusively use the SHOOT BABY! ottoman with the SHOOT BABY! adjustable background T-bar stand. I set the adjustable stand at approximately 45-inches tall and 55-inches wide, placing it up against the back of the beanbag. The reason I choose to use this beanbag over others is because of the remarkable way it is constructed.

The beanbag is about 40-inches in diameter and has a large zipper that extends three quarters of the way around the bottom. Inside are two inner bags to put your beans into, and each bag has its own zipper to contain the beans. One bag is larger than the other and is intended to go on the bottom; the smaller bag goes on the top. You can regulate how many beans you want in the bags by filling them a desired amount. My large bag is always full, but the smaller bag is only three quarters full. Be sure to fill the bag to the point (which is usually completely full) that when you push down in the middle of the ottoman, you can create a small dent. *Firm is key!*

Layer blankets on the beanbag with waterproof pads in between each layer.

ISO 400, 1/250 sec., f/2.8, 50mm lens

A front view of the beanbag showing the blankets and the use of the T-bar background stand.

ISO 400, 1/250 sec., f/2.8, 50mm lens

Simple Setup

My basic beanbag setup is typically at a 45-degree angle to my north-facing window. I can shoot from this window all day long without any direct light coming in. Sometimes direct light will come in from the east-facing window and pour into my shooting area. If this happens, I block it off by either hanging a dark blanket or setting up a large floor board that I have in my studio to block the light. It's best if your setup has only a single light source to avoid different light temperatures interfering with the white balance and exposure.

Remember to layer your blankets or fabrics and pull them tight to reduce wrinkles and less time in postproduction.

My basic beanbag setup is typically at a 45-degree angle to my north-facing window.

Position the beanbag at a 45-degree angle to the window.
ISO 400, 1/320 sec., f/2, 50mm lens

A three-image series makes for a compelling framed wall gallery.

ISO 400, 1/200 sec., f/1.8, 50mm lens

Tip: *Capture the same specific shots at every session.*

Use the four-image macro series—lips, eyelashes, hand, and toes—to print up 5x5 mounted portraits or include them in fine art albums.

ISO 400, 1/200 sec., f/1.8, 50mm lens

My Cheat Sheet

At the beginning of my career, I would get nervous and have a mental block, forgetting what poses I had planned for the day. So I decided to start writing out a *cheat sheet* and leave it on the floor under the beanbag. Just knowing it was there helped me stay focused. And when I forgot what I wanted to do next, it was easily within reach to grab a sneak peek at it and carry on.

Tip: Slip a little cheat sheet of poses and setups you plan to do right by the beanbag where you can easily reference it.

Selecting Color Schemes

As mentioned earlier, during the preconsultation I like to discuss the color and décor in the family's home. Is their home decorated with dark brown and orange colors, or bright white walls? The reason is that white, pink, or soft blue colors might not go well with a darkly decorated home, yet white walls will render just about any colors as long as they go with their decor. It helps to know what the interior colors of the home are when you're preparing your shooting color schemes and the props you'll be using the day of the session. By taking detailed notes at the preconsultation, you'll be able to refer back to them and be prepared ahead of time when the session day arrives.

Another idea is to have the clients take some photos of the areas in their home they would like to display their portraits. This can easily be done with a cell phone so they can bring them to the preconsultation session.

Tip: Cater to your clients and please them. I'm happy to use props that parents may bring, as long as I feel they are safe for the baby, even if they may not render to my style. Keeping my clients happy keeps me happy!

Shoot to Sell

At every newborn session, I capture specific shots. They include the four-image macro shots of lips, eyelashes, hand, and toes; the three-image storytelling series; and if possible, close-up awake shots. This helps me to plan ahead for shooting to sell. These types of detail images are truly favored by parents, and they will generally always purchase them. The three-image series can be a collection of two 16x24 portraits paired with a 20x24 portrait in between—a framed wall gallery of portraits that beautifully complement one another. The macro shots are perfect for albums, and the awake shots are the ones parents choose for the big canvas prints. Think about what you want to sell, and then shoot for those products.

helps when I'm transitioning the baby from one fabric to the next so I can move quickly and efficiently without disrupting the baby much.

Because my style is to use neutral colors, such as white, cream, gray, and tan, these are the colors of props I use the majority of the time. But if a client requests another color, I'm happy to use it if I have it.

If I plan on using prop setups, such as baskets or bowls, I get them ready to go ahead of time by tucking the blankets, weight, and neck pillow inside.

Final Preparations

Set up your beanbag, props, and all your baby tools so you're ready to go and can easily move from one setup to the next. Keep in mind that most likely you won't get through all the setups you have planned. You'll have more ideas in your head than you'll end up doing, but that's OK. At least you have a plan and are organized and prepared. Assume that the baby will be asleep when the family arrives, but be prepared with a wrap setup just in case. I'm happy to begin with awake shots, because they are very compelling and parents always buy them. Once the baby is wrapped up tightly and you have time to shoot a few awake shots, the baby will calm down and go to sleep, and you'll be able move on to the curly poses.

I love selecting different wraps and scarves in my work. The babies are kept nice and warm, and you can achieve a variety of looks.

ISO 400, 1/800 sec., f/1.8, 50mm lens

Keeping Your Clients Calm

It's important to educate your parents in remaining calm during the session, even if the baby cries or gets upset. The baby will sense that mommy is frustrated and will in turn become frustrated. As the photographer, this holds true for you as well. Be patient and remain calm. A quiet and peaceful environment is essential for a successful session.

Ask the mom to feed the baby fully before arriving at the studio. If the baby has a full tummy, the child will sleep longer. If your clients are traveling more than 15 minutes to the studio, ask them to arrive 15 minutes before their session to allow for extra feeding.

Planning the Session

A few days before the session, I start planning the setups and poses I'm going to use. Keep in mind what the parents look like so you'll have a general idea of how the baby will look. If the parents are dark skinned and have dark hair, plan colors that best complement their coloring. You might want to use dark or bright colors, whereas lighter colors work well with light hair and fair skin. There's really no right or wrong color, but there are certain colors that can complement hair and skin color more than others. Refer back to the notes you took during their pre-consultation about their preferences to begin planning the session.

Tip: Take a quick photo of the parents together at the preconsultation to keep in their file.

If the parents are adopting a child, ask the ethnicity of the child so you can get a good idea of colors and props that would work well for the child's skin and hair color.

Choose Your Accessories

Once you've pulled your ideas together, you can start picking out your fabrics, hats, headbands, wraps, and props that you plan to use. Typically, I'll set up three blankets with two on reserve, and have two props ready to go. I like to layer the blankets and fabrics on the beanbag with a SHOOT BABY! waterproof pad in between each fabric (I use three pads in between each fabric). If the baby pees or poos on the top blanket, the fabrics below will be protected. Layering the blankets

The Client Welcome Guide

The Client Welcome Guide is a 20-page 5.5x8.5-inch bound printed booklet that includes all the preconsultation checklist details. The guide is loaded with my portfolio of newborn images throughout that portrays my style. I also include a section about me and my studio as a personal touch to help clients feel welcomed. I take the time to go over all the information in person so they understand and can ask any questions at this time. It's critical that they follow my guidelines and understand how important they are to a successful session. By working together with your clients, everyone understands their role in the process.

The Client Welcome Guide includes:

- **What to expect.** Explains to the parents how the session will go and how long it will last along with any other pertinent information they need to be aware of.

- **What to bring.** Tells the parents what essential items they should bring the day of the session, such as a pacifier, extra bottles, and clothing for themselves.

- **Studio policies.** My basic policies are as follows: Session fee is due at booking and is nonrefundable; no outside cameras are allowed in the studio; payment is due in full at the time of ordering; all orders printed through my studio are guaranteed against fading or discoloration.

- **Nutrition Guide for nursing mothers.** A complete guide that narrows down specific foods moms should avoid at least two days prior to the session. Some foods can upset a newborn tummy, and it's important to help ensure the comfort of the baby at all times. The most common foods to avoid include:

 Acidic foods, such as lemons, oranges, berries, pizza, spaghetti, chili, and tomato products

 Gassy vegetables, such as asparagus, onions, broccoli, cabbage, and cauliflower

 Foods that should be restricted, such as soda, coffee, and beer

- **Copyright.** All clients receive copyright information at the outset. The form states that I retain the copyright to all images captured through my studio or on location. It is illegal to scan, copy, or reproduce the images in any way or manner. This includes copying images from my blog, Facebook, website, or any other form of social media. Fines start at $150,000 as part of the copyright law.

- For a full review of the Federal Copyright Laws of the United States, go to www.copyright.gov.

Cover of the Client Welcome Guide.

Some parents want to help you and be right by their baby during the session. Although I completely understand this, I let the parents know they are welcome to sit back, relax, and even take a nap if they'd like. A lot of the parents I work with love this opportunity to catch up on some sleep. I ask them to remain in the sitting area, which is close to where I'm shooting and where they can still see their baby. The reason for seating the parents, especially the mother, a bit farther away from where the baby is located is because a baby can smell mommy, which might trigger the need to eat more often, even though the baby does not necessarily need to. This can lead to the baby stirring and possibly waking up. For this reason, I try to keep the baby from being too close to the mom unless the baby needs to feed or I need her to assist me.

Welcome package

If you are a boutique photography studio, it's important to give your client a personalized experience, which should reflect in all aspects of your business—everything from the first contact to the final packaging. When my clients arrive at their preconsultation, they receive a nice little package from me thanking them for booking a session with my studio.

The welcome package includes:

- Thank you card for booking their session
- Appointment card for the newborn session
- Referral cards; five cards to pass out to friends and family
- Goodies, such as cookies or candy
- Personalized pen and notepad with my business name, website, email, and phone number
- Client Welcome Guide (see details in the accompanying sidebar), including Product Menu with pricing

A sweet moment captured when the parents were waiting for me. I asked them to come in close and snuggle for a moment while I got my camera ready. These are the unexpected, natural shots I love to capture.

ISO 640, 1/250 sec., f/2.8, 50mm lens

Let the parents know that when you photograph the baby unclothed, they should be prepared for the baby to pee and/or poo at least once during the session, most likely more! It's not a matter of *if* the baby will pee, but *when* the baby will pee! Tell them not to worry or panic. I always have plenty of wipes, towels, and hand sanitizer in the studio. Everything is washed before each session anyway, whether its been peed on or not, for sanitary purposes. If you will be photographing the parents, make sure they bring a couple of clothing changes. Their clothes should be simple and solid colors, avoiding clothing with logos.

Tip: *Make sure the parents dress the baby in clothing that is easy to remove to prevent waking the baby.*

This is an image I took while in Australia teaching a workshop. I used a step stool to get up high and shot from above the baby with a slight tilt of my camera.

ISO 400, 1/200 sec., f/1.8, 50mm lens

Guiding the client

To ensure a smooth session, guide your clients through the entire session from the beginning to the final stage of selling. Assure them that you are well versed in handling newborns: They can then rest easily knowing that their baby's safety and comfort are your top priorities, and you will in no way ever put their baby in harm's way. This is the time to develop a rapport and trust with your client. After all, they are putting their most loved and precious gift into your arms a few weeks after the child is born. You wouldn't give your baby to someone you didn't trust, would you? Show confidence in yourself and your work, and in turn your clients will do the same.

Prepare the parents ahead of time by going over your preconsultation checklist of important procedures to follow prior to their session.

Keeping the baby warm

Inform your clients that your studio will be kept between 80 and 85 degrees for the comfort of the baby. Educate them that newborns lose their body temperature fairly quickly once you unclothe them, so it's essential to keep them warm at all times. Tell them to dress in layers so they are comfortable as well. I ask them to dress the baby in a zip-up or snap-up onesie—nothing that goes over the head because it tends to wake the baby if we need to pull clothes off over the head.

Sleepy, happy baby

It's helpful if the parents can interact with the baby before arriving for their session. This will help the baby sleep later while in the studio. Although capturing the baby during awake times is ideal as well, I prefer to have them asleep during the first part of the session.

To get curly poses, you need to have a sleepy baby, not an awake baby. But the parents don't realize this. They think their baby needs to be awake for their session and fully clothed with cute little clothes that can seem to swallow up the baby (newborn clothing tends to be larger than the baby), which makes it difficult to see the baby under all the clothes. Although I always strive to capture some of the darling awake shots, it's difficult to pose the baby in certain poses while the newborn is awake. My goal is to keep the baby warm, comfortable, asleep, and happy.

Tip: *Securing the session fee prior to booking the newborn session assures you that the client is committed.*

I show them all the products I offer. I don't wait until the sales presentation after the shoot to show the products. Instead, I set up a beautiful display to show them so they can begin dreaming about how badly they want that gorgeous album and where they're going to display their beautiful wall art.

With my notebook in hand, I'm ready to write down everything my client desires, including colors of the home and nursery, and even colors to avoid. I want to ensure that the color palettes we choose for their portraits will complement the colors in their home. Although it's true that my style of neutral colors complements most home décor, I'm still attentive to what will work best in my clients' home by allowing them to be a part of the planning process. If they desire a specific color, I'm happy to oblige.

All clients are charged a session fee upon booking their session. This session fee includes my time and talent only, is nonrefundable, and assures that my clients are committed. I secure the payment at the in-person preconsultation.

Preconsultation Checklist

Here is my checklist of the important points to discuss with clients during the preconsultation:

- **Age of the baby.** 5–10 days is preferred
- **Temperature of the room.** 80–85 degrees
- **Boys and circumcision.** Schedule at least five days after procedure
- **How long the session will last.** Approximately two hours
- **What to dress the baby in.** Nothing over the head; zip-up or snap-up onesie/sleeper
- **Bring a pacifier.** ESSENTIAL! The "soothie" pacifiers are best for newborns
- **Feeding ahead of time.** Within a half hour of the session
- **Home décor and colors.** Favorite colors and colors to avoid
- **Nutrition Guide.** For breast-feeding mothers
- **Clothing for parents and siblings.** Simple, solid colors; avoid logos

I ask the parents a series of questions, such as when they are due, if they have any other children, and what they are specifically looking for in their session. Most parents don't really know what they are looking for; they just love your portfolio and want portraits of their baby. Basically, I go through a 10–15 minute mini preconsultation over the phone with them to determine if we are a good fit for one another. I'm happy to state my pricing over the phone before booking a client, but I don't like to start the conversation discussing it. By informing them of my pricing ahead of time, it helps to eliminate booking clients who might later say they can't afford my rates.

During my earlier years, a client came to my studio and hadn't asked about pricing before the in-person preconsultation because she thought we would cover that later and didn't worry over it. I wasn't experienced enough to know to offer it to her ahead of time, so I didn't think much about it. After spending an hour with her in my studio talking about all the preparations, we began to discuss the pricing and contract, which is when I lost the client. My pricing was out of her budget, and I remember being heartbroken at the time. After the initial shock, I realized she wasn't the type of client I was looking for anyway. I wanted clients who valued my work and were excited about booking me with the rates that I charge. From that time forward, I decided I would make sure my clients knew how much they were spending before we ever made the initial appointment. If they felt they couldn't afford me, no time would be wasted on either side. As you grow in your business and gain experience, you'll learn to adjust your policies and procedures as situations arise, but having some guidelines and policies in place will help alleviate some of the problems later.

Be sure to provide the best "custom" experience you can to your clients from the very beginning. They are paying you for that experience, and they deserve your best customer service.

Preconsultation

The preconsultation day is your opportunity to gather the details and ask the parents all the essential questions. It is the most important step in the process. I bring my clients into my studio for an in-person consult to go over the contracts, products, preparing, pricing, and policies. This is also the time when I start thinking about upselling products, such as wall portraits, canvas prints, and albums.

Your first contact with a potential client is your first step in establishing a lasting relationship.

Tip: *Smile when you talk on the phone! It makes a difference in your tone.*

In this chapter you'll learn how to prepare and plan your newborn sessions, which baby tools every newborn photographer needs, and what I've learned over the years while working with parents. This information will help you stay organized, gain trust, and complete a successful sales session by learning to shoot for the products you want to sell.

Prepping the Parents

Tip: *Set up a mock pre-consultation session with a friend so you can practice working through the prep stages.*

Prepping the parents is a very important fundamental aspect to a smooth session. Parents don't realize how important their part is in the process of their newborn session unless you educate them. They're used to retail studios where the photographer takes a few shots and quickly sends them out the door. Custom photography is a luxury most parents have never experienced before. You'll need to hold their hand and guide them through the entire process, and help them understand how they can help ensure a smooth session.

Initial Contact

Tip: *When I first started, I would get nervous to the point of nausea right before the session! To help me relax and calm my nerves, I would pop a peppermint candy in my mouth. I still do this today!*

Your first contact with a potential client is your first step in establishing a lasting relationship. Photographing newborns is an intimate and personal experience for parents. They need to know they can trust you. To have confidence in you, you must portray self-confidence. When you're first starting out, it's typical to be uneasy and anxious. You're passionate about your work, and you want to do the best you can.

In today's society, most people use email in lieu of a phone call. In fact, I receive about 90 percent of my inquiries via email. People have busy lives and email communication is the quickest and easiest way to contact someone. Nevertheless, I like to create a more intimate and personal relationship with my clients by calling them after their first initial contact. This is my opportunity to capture their interest in booking me. Before placing the call, I make it a point to smile. It's amazing what smiling can do to the sound of your voice. It's like a soothing euphoria over the phone!

The Planning Stage

Planning everything from educating the parents to the sales presentation is crucial to a successful newborn session. Each session takes careful preparation to ensure that everything goes smoothly. A newborn shoot is more personal than your typical portrait session in that you need to develop a rapport with the parents. They need to feel you are a safe person to handle their baby and be able to trust you.

When I first began my business, I was still learning how to plan and organize a complete session. I had the business principles and policies in place, but I lacked knowledge in planning and prepping the parents. However, with experience and through trial and error, my learning improved. I didn't have a book to read or someone to guide me through this process, informing me what to tell the parents or how to make them feel more at ease. I had to figure it out on my own. Even now I continue to think of new and better ways to implement the process and will make appropriate changes when needed. It's perfectly normal to feel nervous when you're meeting with the parents at first, but once you gain some experience, you'll be able to relax and feel more self-confident.

ISO 400, 1/200 sec., f/2, 50mm lens

The equipment in my bag is very simple. Keeping it simple and easy allows for a quick and efficient workflow to my sessions.

ISO 640, 1/125 sec., f/2.8, 24–70mm lens

Raw vs. JPEG

There are many differences between shooting raw versus shooting in JPEG. Basically, a raw file is not an image. It's a high-dynamic range of data that needs processing to become an image. Shooting in raw retains all the data your camera has captured, allowing you full control in post processing for adjusting the exposure, saturation, and sharpness. Although it is always best to achieve proper exposure in-camera, shooting raw allows you more leeway when you're correcting exposure than JPEG does. If the white balance is not accurate, it is much easier to adjust a raw file using your raw software than a JPEG image. I shoot in raw 95 percent of the time. The only time I might shoot in JPEG is for family gatherings.

Even if you shoot raw, your camera will display a JPEG image while you're viewing the photo in-camera.

What's in My Camera Bag

The contents of my camera bag for shooting newborns is very simple. My 50mm lens is on my Nikon D3S the entire time I'm photographing newborns. I also pack my backup Nikon D700 camera with the 60mm macro lens ready to go to capture those sweet little detail shots. Here's the equipment in my bag:

- Nikon D3S
- Nikon D700 as a backup
- Nikkor 50mm f/1.4G
- Nikkor 60mm f/2.8G macro
- 85mm f/1.4G for outdoor sessions
- X-Rite ColorChecker Passport and ExpoDisc

The reason it's best to view each channel rather than just the luminous histogram is that although the luminous channel can look correct, you still may have clipping in one or more of the other channels, especially the red channel, which is mostly affected by skin tones. Therefore, setting your highlight warning to the red channel can be most advantageous.

After you've taken a photo, bring up the RGB channels of the histogram. In the bottom-left corner of the screen, you'll see "RGB" and R G B. Most likely, the "RGB" will be blinking if you've blown out any highlights. To change to the red channel only, hold down the thumbnail button and press the Multi selector button to the right until the "R" is highlighted. Now your camera is set to alert you when you've blown out the highlights in the red channel.

My Settings

My usual camera settings are f/1.8 or f/2, shutter 1/250, and ISO 400. Most of the photos in this book have been captured using these settings, with the exception of the shutter, which fluctuates due to properly exposing the image based on the available light.

Here are the settings I use when I photograph newborns indoors using natural light:

- **Camera.** Nikon D3S and Nikon D700; Manual mode, raw
- **Aperture.** f/1.8–f/2
- **ISO.** 400
- **Shutter.** Typically, 1/250, or set to render a proper exposure

Tip: *Be sure to review the three steps to a proper exposure:*

1. *Determine your light*
2. *Adjust your settings for proper exposure/ metering*
3. *Set your white balance*

balance will be set in-camera. All the images you take from this point on will have the same Kelvin temperature (white balance).

The ExpoDisc is also a handy little tool that is very easy to use as well. ExpoDiscs come in different sizes for different lenses. However, if you order the largest size in 77mm, you can hold it up to any size lens.

Place the ExpoDisc over your lens. Following the preceding instructions for setting a custom white balance, take a picture from where your subject is facing your camera toward the light source. A Nikon camera will not take a picture, but look for the flashing "GOOD" sign, which tells you your white balance is set.

If your light changes suddenly, you may need to set your white balance again. Normally, while I'm shooting indoors, I don't necessarily reset it based on a minor light change. I can always adjust it a bit in post processing if I need to. But if the light changes significantly, I'll take another white balance setting. Each time you change out your background or blanket, you need to set another custom white balance. Be sure to do this to ensure proper white balance for all your images.

Customize the Playback Menu

Setting up the playback menu on your camera is very helpful to create an easy shooting workflow. With my camera of choice, the Nikon D3S, the most important settings for my workflow are the histogram, focus point, data, and highlights. Once set, the camera will show each of these functions after each image you shoot. I find this to be a very effective shooting workflow.

Check your camera manual to understand the setup of these functions. For my camera, the path to its setup is Playback Menu > Display Mode > RGB histogram, focus, highlights, and data.

Cameras are set to default to the luminous histogram (the white one). However, if you change your settings to show the RGB histogram, you'll be able to make better decisions on your exposure. In RGB mode, you'll still be able to see the luminous histogram, as well as the red, green, and blue channels.

White Balance

White balance is simply an adjustment of the colors in your photo to make them appear as accurately as you see them. Different sources of light have different temperatures. Fluorescent lighting adds a blue cast, whereas tungsten light sources add yellow to a photo. It's important when you're shooting natural light indoors that you turn off all other lights in the room. The amount of white balance in a photo can be subjective. Some people prefer warmer images; others prefer cooler images.

Of course, the babies shouldn't look too blue or too yellow either. But just know that people have different preferences in how warm they prefer their images. It's all a matter of what looks good to you. There's no right or wrong white balance. You can use any "in-camera" white balance setting you want, such as auto, cloudy, daylight, Kelvin, or so on, or you can set a custom white balance. I prefer using Kelvin or the custom white balance options.

Custom White Balance

Many different types of white balance tools are on the market today to help you set a custom white balance. My two favorites are the X-Rite ColorChecker Passport and the ExpoDisc. Both tools cost about the same and are worth the investment. The ColorChecker has three different targets that work with colors, highlights, shadows, DNG profiles, and white balance. It's quite the handy tool if you want more for your buck and are able to use the other targets. When you're setting the white balance, use the 18 percent gray target.

With my Nikon D3S, I set the white balance button to "PRE," holding the button down until I see the word "PRE" flashing. Once it's flashing, with your ColorChecker Passport placed where your subject will be, fill the frame with the entire gray area of the target. If your camera won't focus and take the picture, change it to manual focus. It's not important that the image be in focus.

Tip: K.I.S.S. Keep It Simple Silly. Don't over think the process of a proper exposure. Take it a step at a time and practice until you get it! I promise.

Then look in the viewfinder: It should be flashing "GOOD." If it displays "NO GOOD," start all over again. Once it displays GOOD, your custom white balance is all set to go. *My Nikon camera does not take a picture of the gray card while setting a custom white balance.* Don't look for a picture of the card because it won't be there! But your white

Underexposed Images

When a photo is underexposed, it means that it is too dark. Often, you'll lose details in the shadow or darkest areas, which causes them to look solid black. If the area is already black, it won't matter because black is black. It is just as important not to underexpose an image as it is not to overexpose an image. Underexposing can also cause noise in your image, resulting in a loss of quality.

Notice in the underexposed histogram that the right edge is far from touching the right side of the histogram.

Tip: *Avoid clipping detail in the shadows. Clipping shadows results in an underexposed image.*

What happens if you've determined that you aren't blowing out any highlights, but your image looks underexposed? You'll need to adjust your exposure. While you're looking through your viewfinder at the metering ticks, keep changing the shutter speed until you are two or three ticks toward the highlights. By doing so, you'll be adjusting your shutter to allow more light into the camera and pushing those highlights more toward the "+" side because the image will be a bit underexposed.

You can see from looking at the image that it is too dark, or underexposed.

ISO 400, 1/ 400 sec., f/2, 50mm lens

Overexposed Images

When a photo is overexposed, it simply means it is *too bright* and you've lost details. Colors may look washed out, and highlights will be blown out, or completely white.

In the overexposed image, you can see the clipping warnings in red on the baby's skin, as well as the spike up the right side of the histogram. As discussed earlier, the red channel best represents the skin. Therefore, if you are blowing out the red highlights, there is a good chance you are blowing out the skin. I'll generally meter to the brightest area of light hitting the skin to avoid overexposing the image. If I want to open up the shadows with more light, I'll meter the shadows. You'll have to decide if something else in the frame, such as a blanket or background, is worth blowing out or not.

If you've tried setting the tick mark on the (0) (as mentioned earlier in the "Metering" section), and the histogram shows that the photo is underexposed or overexposed, keep changing your shutter speed until the histogram has rendered a proper exposure (meaning no spikes on either side).

Tip: *Avoid overexposing the skin (red channel). Blowing out highlights means the image is overexposed.*

Note that the red marks shown in the "overexposed" image are the highlights that are clipping when the image is opened in ACR (Adobe Camera Raw).

This image shows the overexposed areas.
ISO 400, 1/125 sec., f/2, 50mm lens

A. This image shows dark tones.

ISO 400, 1/320 sec., f/1.6, 50mm lens

B. This image shows neutral tones.

ISO 400, 1/400 sec., f/1.6, 50mm lens

C. This image shows light tones.

ISO 400, 1/200 sec., f/1.6, 50mm lens

image according to the histogram, you can then adjust the brightness level on your LCD screen so that when you look at the screen, it appears to be a better representation of the histogram.

Why is the histogram more important than the LCD screen? All camera LCD screens are generally set to default at "zero" straight from the manufacturer. If you put more importance on the LCD screen to indicate that you've exposed properly, it may fool you if the brightness level isn't adjusted accordingly. I've changed my LCD brightness level to -2 because I've determined this to be the best setting to represent my histogram rendering a proper exposure. Although I still rely on my histogram for accurate exposure, my LCD screen is now more comparable to the histogram.

Understanding the Histogram

In the histogram, the key to proper exposure is an even distribution of tones throughout the dynamic range. However, keep in mind that a proper exposure will not always have a balanced histogram. The tones in your frame will determine the spikes across the graph. For instance, if most of the tones in your image are dark, the values will be shifted to the left side. If there are more light tones in your image, the values will be shifted to the right side.

The first detail you want to watch for is clipping (a tall peak) on either side of the histogram. If you are clipping shadows, you'll see a spike in the shadows increasing up the left side of the histogram. If the highlights are blown, you'll see a spike increasing up the right side of the histogram. It's important to note that clipping on either side results in loss of detail.

A proper exposure will not always have a balanced histogram.

On the following page are three images with their corresponding histograms using different tones: dark, neutral, and light. As you can see, each image shows a perfect distribution of tones across the dynamic range, rendering a proper exposure. Notice where the values are in each image. Image A shows the dark tones toward the left (shadows). Image B shows the neutral tones in the middle (gray). And image C shows the light tones (whites) toward the right. Don't get too caught up on the difference in peaks throughout the graph. It's important to keep a watchful eye on the left and right sides.

Metering

Once you have your aperture set to where you want it and your ISO is set, it's time to meter so you can set your shutter speed to get a proper exposure.

When you look in the viewfinder, you'll see a little zero, plus, and minus signs. It looks like this -..............0.............+. Your camera might show the "+" on the left and the "−" on the right. That's OK.

I've changed my meter from the default setting because it makes more sense to me to have it this way based on the histogram having the highlights on the right side as well. It doesn't matter which way you have your meter. Do what works for you. Just remember that the "+" is toward the highlights and the "−" is toward the blacks. If you want more light, adjust your shutter speed toward the "+"; if you want less light, adjust it toward the "-."

Expose to the Right (ETTR)

Tip: *Remember that your camera is metering 18 percent gray. That's your starting point. Then you need to adjust from there.*

Using your focus point while looking through the viewfinder, determine where the brightest light is hitting the baby's face and adjust your shutter speed until it is on the zero. Take a picture. Open your histogram on your camera and look at the tonal range across the graph. All histograms will render differently depending on the tones in the image. Most of the time you'll need to push your exposure more to the right from the 0. If the histogram is not slightly touching the "+" side, keep adjusting your shutter speed until it does. Make sure you don't push it so far as to have a spike going up the right side. This will render an "overexposed" image.

Histograms

The histogram is a simple graph that registers all the brightness levels in an image from the darkest to the brightest. It is one of the most useful tools in digital photography, although many photographers fail to learn and understand it.

After you've taken a photo, look at the histogram in the camera to make sure you have a proper exposure. Don't rely merely on the LCD screen unless you have adjusted the brightness to display properly. When you have a properly exposed

The baby is positioned at a 45-degree angle to the large west-facing window, camera right. It was in the morning hours, so the light was nice and soft.

ISO 400, 1/640 sec., f/1.6, 50mm lens

When I'm shooting a prop setup, such as the baby on a bed or in a basket, I'll sometimes shoot with an aperture of f/2 or f/4, depending on what I want in focus. If you have a background that has texture, you don't want to be out of focus, so a setting of f/4 or larger would be a good choice.

Tip: Remember to set your aperture first, then your ISO, and then your shutter speed.

generally be the best choice. Most of the time, you can set your preferred aperture and ISO and make minor adjustments with your shutter speed when the light changes on your subject. However, in this situation, because your shutter speed is already as low as it should go without putting it on a tripod, you have plenty of room to increase your ISO.

This is how the exposure triangle works. Any one of the settings on the triangle will affect the others. Therefore, it's important that they all work together in uniform.

This is a good representation of how the exposure triangle works. ISO, shutter speed, and aperture all work together to render the proper exposure.

Setting Your Aperture First

The first step I take for the best exposure is to determine the aperture setting depending on how much background blur I want. Because I love bokeh (a soft, out-of-focus background or DOF), I typically set my aperture at f/1.8 with my 50mm f/1.4G lens. If you are just starting out, I recommend a setting of f/2.8 until you are comfortable nailing your focus. Shooting wide open requires a steady hand. Once you can perfect your focus without any camera shake, you can then try opening up to f/1.8.

Shooting with a small aperture allows you to focus on the baby's face while the rest of his body remains out of focus. This creates a creamy, dreamy look to your portraits.

After you've set your aperture, you'll need to set your ISO to the lowest setting or one stop up. For instance, my Nikon's lowest setting is ISO 200, but I like to keep it set to ISO 400. This allows me to think only of my shutter speed if the light suddenly changes. I can easily change my shutter speed to get a proper exposure and don't need to adjust my ISO, unless of course I start losing light and my shutter speed drops too low for me to hand hold the camera. If this happens, you need to bring more light into your camera by increasing your ISO. However, I can set my shutter speed as low as 1/60 with my 50mm lens if I really need to. If I go slower than that, I risk the chance of blurred images from camera shake. But because newborns are generally still subjects, I don't have to worry much about movement, as long as I have a steady hand.

The Three Elements of the Exposure Triangle

These three elements intersect in the middle to render the exposure:

Aperture is the size of the opening in the lens and controls Depth of Field (DOF)—the portion of the image that is in sharp focus.

- A large aperture lets in more light (f/1.8), which results in a small depth of field.
- A small aperture lets in less light (f/8), which results in a large depth of field.

ISO is how sensitive the sensor is to the light.

- A low ISO (ISO 200) produces less noise.
- A high ISO (ISO 1600) produces more noise.

Shutter speed is the amount of time the shutter is open and controls blur: Camera shake or motion blur. Keep your shutter speed at a minimum of one times (1x) the focal length of your lens (50mm lens x 1 = 1/60).

- A slow shutter speed—a small number, such as 1/15—lets in more light.
- A fast shutter speed—a higher number, such as 1/500—lets in less light and freezes motion.

The Exposure Triangle

Understanding the exposure triangle takes time and practice. All three elements—aperture, ISO, and shutter speed—must work together to produce a proper exposure. You always need to be aware of what your settings are, what you're shooting, and what each setting is doing.

Let's say you're using a 50mm lens f/1.4, your aperture is set to f/1.8, the shutter speed is 1/60, and your ISO is 200, but you don't have enough light to render a proper exposure. Should you slow down your shutter speed, open up your aperture more, or increase your ISO?

Because you're already at 1x the focal length of the lens with the shutter at 1/60, and opening up to f/1.4 narrows your focus area even less (depth of field), you may want to avoid changing either of those settings. By slowing down your shutter to below 1/60, you risk the chance of blur by either camera shake or movement from your subject. Therefore, increasing your ISO to 400 or 500 would

A representation of a properly exposed image. As you can see, hardly any post processing will be needed. ISO 400, 1/200 sec., f/2, 50mm lens

Understanding Aperture, ISO, and Shutter Speed

The three main elements to a proper exposure are aperture, ISO, and shutter speed. Each of these settings relates to light and how it interacts with your camera. And each one has a direct relationship with the other two in order to render the proper exposure of your photo. Changing one will affect the brightness in the photo. Therefore, it's important to learn how the three work together in the *exposure triangle* so you can then make the best creative decision.

Manual mode can be intimidating when you are first starting out. When you shoot manual, you are telling your camera to shut off all other exposure settings and let you make the decisions. You'll need to decide which aperture, shutter speed, and ISO settings to use. When you're shooting in Auto mode, the camera makes all those decisions for you. Sometimes the camera will get it right. But other times it will get it wrong. Do you really want the camera to control your photos?

Shooting in Manual mode isn't as difficult as it may seem. With newborn photography, once you determine your aperture setting, that's where it will stay, and you should no longer have to think about it. With your ISO set, you then only need to think of the shutter, adjusting it to make the proper exposure.

Exposure and Metering

Most DSLR cameras these days have a pretty good in-camera metering system. However, the in-camera metering is just a guide. It can't think. So, you will have to do the thinking and decide on the exposure settings to use. The in-camera meter does what it's suppose to do, which is expose everything to 18 percent gray, the point that all exposure metering measures. It's your job to meter and expose properly for the scene.

Meters don't recognize colors. They "see" only brights and darks. When you take a photo of someone wearing white, the meter changes that white to middle gray. In turn, the camera's meter will determine the exposure based on that middle gray. You need to adjust the exposure to compensate so the meter will maintain the white, not change it to gray. I keep my metering mode on spot metering for indoor natural light and expose to the right (see "Expose to the Right (ETTR)" later in this chapter). You should ETTR as far as you can without clipping the highlights and allow the histogram to gently kiss the right edge. A properly exposed image will show the tonal range across the histogram slightly touching both sides.

The Importance of Proper Exposure

When it comes to proper exposure, it's important to know the many elements that are used to create the final photograph. Consider your surroundings, what's in the background, the light, camera settings, and your shooting position in relation to the baby. Many factors need to be carefully thought out before you start clicking the shutter.

Exposure is the amount of light that contacts the imaging sensor in your camera. A proper exposure captures the overall tonal range and displays details in the highlights and shadows. Additionally, the image should have good color with proper white balance and sharp focus.

Rendering a proper exposure in-camera is the most important first step to creating beautiful portraits. With a properly exposed photograph, there is little work to do in post processing. The goal should always be to *get it right in-camera* rather than trying to "fix it" in post processing later. Digital cameras today make it easy to reshoot if you have exposure problems while your subject is still in front of you. A simple check of your histogram (see the "Histogram" section later in this chapter) on the camera to evaluate the exposure will help you determine if you are overexposing or underexposing your images.

From a creative standpoint, there are times when you may feel an overexposure or underexposure renders the photograph to your vision. It's perfectly acceptable to break the rules sometimes, as long as you know what they are and are doing so purposely. See the sections "Overexposed Images" and "Underexposed Images" later in this chapter.

Get Out of Automatic!

When you first get your DSLR camera, it's easy to just shoot in Auto mode. It's simple, and you don't have to think about any other settings. I understand that there are times when shooting in Aperture or Shutter Priority mode will work to your advantage, but you'll only have control of one part of the exposure. However, shooting in Manual mode allows you complete control over your exposure as opposed to letting the camera make decisions for you.

A proper exposure captures the overall tonal range and displays details in the highlights and shadows.

Watch for the Nose Shadow

If you remember to always be looking for the nose shadow (butterfly pattern), you'll learn to readjust your beanbag to the light when it changes. Once you have the baby in position, watch where the light falls across the baby and how it hits the other features, like the tiny toes and cute little bum. If you don't see the nose shadow, begin moving the beanbag and angling it to the light until you can see the shadow. You'll find when you're working with natural light that you'll need to adjust the beanbag during your session, especially if the light is continually changing.

If you position the baby facing directly into the light, you'll create "flat" lighting. That's OK if that's the look you're going for, and sometimes it works. I do this sometimes as well. But to create more shadow and dimension, you should avoid flat lighting.

Think about the positioning of your subject like a clock in relation to the light. In this photo, the baby's nose is at 7 o'clock and I am at 6 o'clock. The baby is about three feet from the north-facing window at a 45-degree angle to the light source, which is camera left.

ISO 400, 1/800 sec., f/1.6, 50mm lens

With the baby's nose at 6 o'clock and the baby positioned at a 90-degree angle to the window, camera left, you can achieve a little more shadow on the other side of the baby.

ISO 400, 1/800 sec., f/1.6, 50mm lens

Notice the butterfly pattern under the baby's nose in this photo. This is what I look for when I'm photographing newborns and is achieved by placing the baby at a 45-degree angle to the light.
ISO 400, 1/200 sec., f/1.6, 50mm lens

Butterfly Lighting Pattern

There are four common portrait lighting patterns: split, loop, Rembrandt, and butterfly. The main pattern used in newborn photography is butterfly lighting, although the other patterns are used creatively as well. It's called this because of the small, butterfly shadow shape that appears under the baby's nose. In portrait photography, the main light is placed high and behind the camera to achieve the butterfly pattern. However, with newborns, because they are generally lying down, you need to place the light slightly behind them and above their head at a 30–45 degree angle to create this pattern.

When I'm photographing newborns or babies, I place them approximately three feet from the window at a 45- or 90-degree angle to the window. My angle is determined by what look or mood I am shooting for. When you're working with natural light, you'll need to adjust your subject to the light if it changes, whereas with studio light, you'll have the ability to move the light to your subject. (To see lighting diagrams, refer to Chapter 6.)

How to See Light

You can learn how to see light by taking some time and watching the light around you in your everyday life. Notice how it falls on objects and people's faces. Look for catch lights in people's eyes. Pay close attention to where the sun is in the sky and the angle at which your subject is to the light.

When I first started learning about light, I made it a point every day while I was out and about to look at how the light was hitting people around me and to notice where it was coming from. I would take notes of what time of day it was and what the weather was like. I would sit and look at my surroundings, and determine how it affected the light on my captured subject. When I would talk to people or stand close to them, I would look straight in their eyes to see the catch lights and note where they appeared in their eyes. People would look at me funny and wonder what I was doing, but I had a thirst for light and I wanted to absorb it all. I still do this today and continue learning and soaking up as much knowledge as I can about light. It's fascinating how no matter what situations you are in, you can always find some sort of light to dissect.

A catch light is the white dot in the eyes of your subject that is the shape of your light source. Catch lights provide light on the subject and make the eyes sparkle.

ISO 500, 1/250 sec., f/2, 50mm lens

Tip: Learn to "see" the light. Place the baby next to the window and notice how the light falls across the baby's face, and how it gently kisses the other side.

This was a moment when the baby was just settling in, stretching and making all sorts of lovely expressions. She is positioned at a 90-degree angle to the window and about three feet away.

ISO 400, 1/250 sec., f/2, 50mm lens

Working with Natural Light

Natural light is God's big soft box in the sky. What you see is what you get. Because light is the most important element of photography, you need to know how to see and work with it. All photography begins with light, which creates shape, color, mood, and depth in a photograph. Learning how to see the light and how it illuminates your subject takes time and practice. Direct light that comes mainly from one direction produces high contrast between bright highlights and dark shadows. In newborn photography, soft shadows with soft light wrapping around the baby is the optimum lighting condition.

Tools to Direct Light

Diffusers come in all sorts of types, shapes, and sizes, and are used to "soften" harsh lighting. Instead of moving your subject away from the light source, you have the option of using a diffuser to soften the light. Sheer curtains or nylon diffuser panels are typically used in newborn photography. The diffuser panels can be set up against the window to soften the harsh light.

Reflectors redirect or "bounce" light from a light source to your subject. They are usually made from various materials, such as nylon or foam board. You can use natural reflectors, like buildings, sidewalks, the ocean, and sand, when you're shooting outdoors. Also, you can treat reflectors as another light source. Place the reflector on the shadow side of your subject and move around until you can see the light bouncing back onto your subject.

Colorcasts

Avoid shooting on or around objects that can create colorcasts. Colorcasts are caused by other colors in the room or outside the window reflecting onto your subject. As well, colorcasts can be caused by improper white balance. However, avoiding unwanted colors near your subject can help alleviate the problem.

The wall color, your clothing, and shrubbery close to the window are all color-cast culprits. Surrounding the baby with neutral colors will help to eliminate this problem. Wearing a white shirt will act as a reflector because the light will bounce off your shirt and onto your subject. If green shrubs outside the window are creating green casts on the baby, try throwing a white sheet over the bushes while you're shooting. Learn to make the light work for you in your situation by being aware of what is around you. Experiment with your options to make the most of the available light you have. If you're using bright-colored fabrics and backgrounds, be aware that most likely you will have colorcasts on your subject that will require some post-processing work.

Quality of Light and Time of Day

The quality of your light can be soft or hard depending on how large the light source is compared to your subject and how close it is in relation to your subject. When you place the baby close to a large window, the light creates very soft shadows as the light essentially wraps around the subject. The farther away the baby is from the light, the more well-defined shadows and moody effect you will have. On a day when the light is strong, move the baby farther away from the window to avoid the harsh lighting.

Tip: *Study the light throughout the day at a location where you will be shooting and determine when is the best time to shoot based on how much light is coming in. Pay special attention to the direction the light is coming from. Make notes at different times of the day and the weather conditions throughout your study.*

The time of day can determine the quality of light you have to work with. I typically shoot all sessions in the morning in front of a north-facing window. These two factors help create a soft, beautiful light that feathers across the baby. Weather conditions will determine how close I need to be to the window or if I need to use a reflector. If it's a sunny day, I'll need to move the baby farther from the light or diffuse it. If it's a cloudy day and I don't have enough light, I'll need to move the baby closer to the window and possibly use a reflector to fill in the shadows on the other side.

Of course, there are always other factors involved in determining the quality of light, such as where you are in the world or if there are any obstructions outside your window. If you are shooting in the northern hemisphere, a north-facing window is best. If you are shooting in the southern hemisphere, a south-facing window will work best. Morning and evening light will be softer than midday light. If a north-facing or south-facing window is not an option for you, you can use other windows and still make them work by using reflectors and/or diffusers.

This beautiful girl is laying on the beanbag two feet from the window, camera left. You can see how the light creates soft shadows wrapping around her body.

ISO 500, 1/200 sec., f/2, 50mm lens

Beautiful Light

Beautiful light is all around you, shaping and adding color to everything your eyes can see. There are soft shadows and harsh shadows, and colors of reds and blues. Oh, abundant light is everywhere!

In this chapter I'll walk you through learning how to find beautiful, natural window light and how to use it to your benefit. I'll also explain the basics of understanding exposure and the wonders of the histogram. You'll discover what it means to expose to the right (ETTR) and how to use white balance tools to your advantage.

ISO 400, 1/320 sec., f/2, 50mm lens

your head and yearn to be captured in a mere second. They speak to you in soft whispers and gentle breezes, digging deep inside your soul. They don't need to be written, because their strength is in your thoughts. I close my eyes for a moment and contemplate these words, letting them take over and giving me the vision of their true existence. It is the unwritten stories of her life yet to unfold.

Although the words are unwritten in your thoughts and stories yet to come, you can clearly visualize them, helping you to connect with your littlest subjects.

Before each session, I take time to put myself in the moment by sitting quietly and thinking of just me and the baby, together, creating the memories of her life. The memories of these first few moments can only be captured at this time and place.

Here is a visual compilation of the unwritten words captured in beautiful natural light.

ISO 400, 1/320 sec., f/1.8, 50mm lens

At a 45-degree angle to the window, camera left, I'm able to use my macro lens. You can see the catch light—a light source that causes a specular highlight—on the baby's bottom lip.

ISO 500, 1/160 sec., f/2.8, 60mm macro lens

Using a macro lens, I placed this baby at a 45-degree angle to the window, camera left, to allow all the light to hit those wonderful, squishy little back wrinkles.

ISO 500, 1/160 sec., f/2.8, 60mm macro lens

A good photo needs to have a focal point to grab viewers' attention and not confuse them about what they are supposed to be looking at. Keep your images simple and free from unwanted clutter. Don't just shoot and edit; tell the story.

Don't just shoot and edit; tell the story.

Photograph different character traits and baby bits to portray the child's story. Dad might look at the baby's mouth and say, "He has my mouth." Or Mom may say, "His nose looks like mine." These types of character shots are very important in capturing and telling the baby's complete story.

The Unwritten Word

Sometimes when I remember my child as a baby, I sit back and think about her before she was born. I recall dreaming of all the wonderful little features that would make up this tiny little miracle and what stories would be made from her existence. There were words that explained my thoughts, emotions, and soul— the unwritten words, such as pure, soft, natural, beauty, love, forever, priceless, precious, forever, and on and on. It is these unwritten words that swirl around in

The light from the window is gorgeous and illuminates her tiny features.
ISO 400, 1/800 sec., f/1.4, 50mm lens

Expressing Their Personality

Engaging with an awake baby is a special moment you should always embrace. Babies make all sorts of facial and tongue expressions that make up their unique personality. It's a simple story, but one worth capturing.

My job as a storyteller is to be ready for moments when babies are expressing their personalities. They can go from pouting to smiling in five seconds. Within that time frame, you can pull together one to three images to tell a personality story.

When the baby in the above photo arrived at the studio, she wasn't quite asleep yet, so I left her in the onesie she was wearing and continued to first capture some of the storytelling photographs. I placed the baby on a beanbag facing the window while I shot from above. The tilt of my camera adds to the overall composition of the image.

Many times it's the unplanned shots that are the most compelling.

Tip: *Think of your story as a short story using one to four images.*

photo, she looked straight at me with an open-eyed amazement. Fortunately, I was ready for it and was able to capture a moment the parents will always remember and treasure.

When you're creating your storytelling images, keep the emotional and relational elements in mind, and express them through your images. Take time to plan out your story, but be ready for the unexpected. Many times it's the unplanned shots that are the most compelling.

Can you guess what was happening in the next photograph? I bet you can! This one image captures your attention and makes you wonder what is happening. It also makes you imagine what future images will look like. No other elements are needed in the photograph to convey the story. You can tell what the story is by the look on mom's face and the wonderment in the baby's eyes. I positioned the parents facing the light. Dad was at a 45-degree angle, and mom faced me directly to allow more light on her face.

Tip: *Sometimes waiting is all you need to do to capture a special moment.*

This unplanned moment led to a tickled "mom moment" and won an Honorable Mention in the National Association of Professional Child Photographer's 2010 Competition.

ISO 500, 1/200 sec., f/3.5, 50mm lens

Usually the baby is asleep during this type of pose, but this little darling was not going to miss a thing.
ISO 800, 1/200 sec., f/2, 50mm lens

Relational story

Relational storytelling consists of an image or a series of images that documents the relationship between two or more people; for example, a series of photographs of mom and dad using their voices to engage the baby or the connection between the tiny baby lying on her daddy's big, strong arms.

This is an example of a "one image" story where the baby wanted to be awake rather than asleep. I wanted to show the dad's big, strong arms against his tiny baby girl. What better way to portray that then to have her lying on his bent arm while he gently snuggled her. At the moment I was getting ready to take the

The four image series portrays the story of the baby's movements within a few moments. By placing the baby curled up on a beanbag where she was kept warm, I allowed her to move freely, stretching and kicking spontaneously. My goal was to capture the baby moving as babies do in the womb. I placed the photographs in the order in which they were taken. Take the time to communicate this type of sequence in your stories.

The mom can look at these photos and remember the feelings of when she carried her. This is a strong storytelling series that the family can use in albums or as wall portraits.

A series of four images capture an untold story of the baby's movements. I shot from above and allowed the baby to move freely on her own.

ISO 400, 1/640 sec., f/1.8, 50mm lens

Years from now, when the parents look back on their photographs, they will recognize little personality traits that have molded into the person their baby has become. It might be difficult for them to remember these things without photographs, so be sure to capture these tiny details.

Elements of Storytelling

How can storytelling relate to newborn photography? The most common storytelling photographs come from "Lifestyle" newborn photography where the session is held in the parent's home. The session focuses on images in the nursery or parent's bedroom while the family interacts with each other. However, there are other ways to create and capture the story of a newborn with studio work.

Although there are many elements to a story, two of the most compelling elements in newborn photography are emotional and relational; however, they both can work together as well.

Emotional story

Emotional storytelling in an image produces a type of emotion, such as happy, excited, sad, or angry. It can be a relational story as well, but mainly focuses on the emotion conveyed.

Emotional photographs have meaning and can be staged or unplanned. Their story is powerful in capturing the emotion of the viewer, especially when there is a personal connection with the subject. Your heart is engaged as you interpret the story. Of course, relational stories can evoke an emotional story as well, because they do go hand in hand.

Put thought and your creative juices into your images to tell a story. Storytelling images create powerful images that "talk" to your viewers, evoking emotion.

Newborns all have their own special uniqueness in how they moved inside the womb. Some babies may love to kick up one foot, rub their face, or even suck their thumbs. These are all characteristics that make up their own story.

Storytelling can consist of something you capture while it is happening, or you may need to create the story. My goal is to have viewers feel like they are sitting right there beside me, seeing the story unfold as it happens. It gives my photographs a sense of meaning and purpose. It takes practice to get into this mind-set, because most likely you're used to just placing your subjects where you want them to be and then snapping the picture. Storytelling goes above and beyond that and is what really sets the image apart from an average photo. It's an element of photography that truly grabs the attention of your viewers, drawing them in with emotion and curiosity. Like a good book, you've captured their attention, making them thirst for more as they wait and anticipate what the next image will bring. If you've ever found yourself in this situation while viewing another photographer's work, you know what I'm talking about. This is how you want people to view your work.

There's a magical moment in capturing the beauty of a mother and the connection with her newborn child. I want to capture the story of the newborn babies: the tiny features, smiles, and movements that make up their personality. You can tell a story with one image or several. It's up to you and what you are trying to convey.

In this photo I wanted to tell the story of love between the mom and her new baby girl. Instead of merely asking her to close her eyes while I snapped a photo, I asked her to snuggle in, close her eyes, embrace the love she feels for her child, and think of those first few moments of her birth and how it made her feel. I want to *feel* the love by the expression and warmth of her face. Her soft smile enlivened me as I snapped the shutter.

Sometimes it may take a few shots before the mom relaxes and engages. Be patient and wait for the right moment.

ISO 200, 1/100 sec., f/1.8, 50mm lens

Babies give little cues right before they are about to smile. I just sit and wait for the right moment.
ISO 400, 1/200 sec., f/1.8, 50mm lens

Create and Implement Your Story

In photography, no matter what you are photographing, evoking emotion generally comes from the story portrayed in the photograph. Using props can help tell your story, but be aware of everything in the frame. If you're going to use props, make sure they are relevant to the story.

The Storyteller

Storytelling is about telling a story through your photographs. You are the storyteller. It's your job to capture the moments to create the story. What is it you are trying to convey to your viewers? What do you want them to see, to feel, and to experience?

The story can have a beginning and an end, or it can lead you around in circles never resolving. It can be the story of simple movements you allow the baby to freely express or capturing a moment between the mommy, daddy, and the baby. Storytelling with newborns is really about expressing who they are and their uniqueness. It could be a series of images where you portray their hair, nose, toes, and feet. Or it could be that moment when the mom sings to her baby and the baby looks straight at her with wonderment in her eyes. A breast-feeding moment will bring a strong emotional attachment to the story as well.

My sessions all begin with some quiet time to reflect on information I've gathered from the parents during the preconsultation. Because the consultations generally take place months in advance of the session, I refer back to my notes to refresh my memory. A few days before the session I begin to put the session together and start planning and preparing, all along thinking of the "story." Special consideration is given to stories the parents have told me about themselves, the pregnancy, their family, and their desires and dreams of their new little baby coming into their lives. Everything they've told me I've written down and meditated on so that I can put the story together.

However, flexibility is just as important. Even though you may have a well-thought-out plan, sometimes—well, most of the time—the shoot doesn't always go as planned. Learn to adapt and be prepared for anything. Concentrate on capturing the baby in a way that you can tell their story through your photographs. Newborn storytelling is about capturing the new baby in a particular moment and conveying that emotion. To capture this significant occasion, I'll create a specific setup with the mood I want to convey. For me, happy emotional stories are the substance to expressing the story. My favorite storytelling setups are those where I create a series of images in which the baby is smiling, kicking, sticking out her tongue, or stretching.

But maybe a shadowy, darker image might speak to you. You feel it in your soul and your emotions. It's a part of you. Take time to see it.

An image full of light, soft, simple white is consistent with my style. It's a spinoff of my inspiration to help me define, develop, and deliver my style.

You may need validation from others to help define your style. Ask friends, family, and colleagues to help you. Their nonobjective views can help validate what you already thought from the beginning, or they may open your eyes to another inspiring vision you didn't see.

Remember that it's important to know who you are and what defines *you*. It's OK to love someone else's work and admire that style, or even be inspired by others. But you have to develop your own style, a look that is unique to *you*. What kind of a world would it be if we were all alike? Each person is what makes the world a beautiful place to be, and we each contribute our own little piece of the puzzle.

Tip: Your style should reflect in everything you do—the way you shoot, the way you process, your logo, your brand—everything. Define it. Own it. Don't be afraid to be different.

This little sweetheart really loved stretching her leg. She did it quite often during the session, enough for me to recognize this trait of hers and take time to capture the moment.

ISO 400, 1/1600 sec., f/1.4, 50mm lens

This photo is a perfect representation of my inspiration board—the true me.

ISO 400, 1/1600 sec., f/1.4, 50mm lens

Develop and Deliver

Once you define your style, you can then develop and deliver it. Embrace and welcome new experiences that spark your creativity and allow yourself to connect with your surroundings. After a few years, you may find that you need to redefine your style and make changes to your approach. All artists continuously grow and look for new challenges. Your current style may not be your style in five years, but it will always be a reflection of who you are and what inspires you.

Style can manifest itself in so many ways. It's not just about how you edit a photo. Take your personality, light, colors, moods and emotions, the subject, the surroundings, and the shadows, and put them into a mental box. Now dissect each one of them as an element to your final photograph. Consider all these aspects when developing your unique style. Sometimes styles just find us when we aren't looking. After all, your style is a reflection of your personality expressed in your work as an artist. So it's OK if you can't define it right away. Experiment and shoot everything. Learn as much as you can. Don't be afraid to step out of the box sometimes or to change your style after years of shooting. Sometimes you need a new direction to stay fresh and challenged. Explore. Practice. Experiment. It's *your* journey.

Stay true to your style.

The next step is to deliver and execute your style in your work. Apply the inspirations, colors, light, feel, and emotions to your sessions. Be consistent and stay true to your style. When you see another's work and think about how much you love it and want to try that, ask yourself, "Is this true to me and my style?" If it isn't, it doesn't mean you still can't try it. But it might be best to leave it out of your portfolio so you don't confuse your viewers as to who you are as an artist. Focus on your inspiration board and allow yourself to be creative and inspired by *you*.

For me it all started with color, light, and emotion. Although I love lots of colors when I'm photographing children, I prefer more neutral and soft colors when I'm photographing newborns; however, as a whole, they both complement one another and still stay true to my style. Once I determined colors and what inspired me, I realized that I like a lot of light in my photography. You can see that from my inspiration board—not just light on my subject, but light everywhere and all around—bright, beautiful light. It just speaks to me. As you can see in the photo, the luminous light radiated the baby's squishy little toes when I placed the baby a few feet from a north-facing window.

Natural imagery is my favorite to photograph. It is simple, timeless, and untouched.
ISO 200, 1/320 sec., f/1.8, 50mm lens

If you line up a group of photographs, would others recognize which is yours? Would someone be able to say, "That looks like your work"? We all strive to be one of the artists whose style is instantly recognizable. But to make that happen, we must focus solely on our own creativity.

The next photo definitely shows my style. The baby was just dozing off. I draped her in a cotton gauze fabric and allowed her to move freely. When she began to rub her eyes, indicating how tired she was, I was ready to record her every movement.

Your style is always growing, changing, and maturing; yet it stays true to your personality. It's not about trying to be a top photographer or setting a trend. It's about your vision and expressing that through your work. Let it emerge and allow it to grow. These are the building blocks to identifying your brand.

Simple black-and-white images are a part of my style. This moment captured with a big yawn went on to win a First Place Award in the National Association of Professional Child Photographers 2012 Competition.

ISO 200, 1/200 sec., f/1.8, 50mm lens

Have you ever heard someone say to you, "That's so you!" They say that because they *know* your style. They *know* your personality, and they *know* who you are. Sometimes others see us better than we see ourselves. Don't be afraid to validate your own visions by asking friends for their opinion.

One of the hardest aspects of becoming a professional photographer is defining your style and who you are as an artist. You're often clouded in seeing your own style because you spend so much time looking at the works of others and trying to be like them. Find the time to concentrate on your own inspirations and style before you spend time looking at the works of others.

Next, select three words that help describe what you see, such as soft, airy, dark, moody, funny, edgy, and so on. Ask a few friends or colleagues to also give you three words that describe your images. You'll soon begin to view your own work and see the direction in which you're going with your photographs. I find this very helpful to see things in a different way and focus on my own inspirations. Take time to ponder your selections and words. It's important to stop looking at other photographer's work during this time, so you can clear your mind and focus on you. Print out your digital board of images, or take the handmade board, and carry it with you wherever you go. Look at it often. Think and ponder the possibilities that lie ahead of you. This is how you begin to define your style.

Define, Develop, and Deliver

Once you've created your inspiration pieces, you can define, develop, deliver, and complete your identity. Walk through each step of this process carefully, taking as much time as you need to complete it. This is your trademark that will identify your work to others. Recognize the direction in which you are headed and being inspired. Sometimes it takes time, so don't rush it. Have confidence in knowing yourself and your uniqueness. Your style will continue to evolve over time. The more you practice and refine it, the more it will improve. You will encounter bumps along the way. That's OK. It's a growing process everyone must go through. You will embrace the process at a later time when you look back and see how far you've come.

Defining Your Style

A "style" is a combination of distinctive features of artistic expression, execution, or performance characterizing a particular person. Style represents a brand and creates a market unique to you. It's a natural expression of *you* that establishes your identity and sets you apart from others. It's a mere replica of your personality.

Create an Inspiration Board

You must capture what inspires you. A great way to do this is to create an inspiration board. Start by photographing everything that "speaks" to you—things you are drawn to that evoke emotion and capture your soul, even colors you prefer. They can be people, places, or objects; anything you'd like. There are no rules. Concentrate on your vision. Take a variety of photographs that you can choose from.

Then put all your photographs onto an inspiration board, either a handmade or digital board. It can be as big as you'd like. Choose four colors from the images you've selected. Group them all together in a collage, as shown in my example.

Get inspired by creating an inspiration board with items, colors, objects, and anything that excites you in some way.

ISO 400, 1/400 sec., f/1.8, 50mm lens

Without identifying your inspiration, it's difficult to distinguish your style. You must feel and live your inspirations; only then can you begin to recognize your emerging style.

One day I was shopping at antique stores, and I came across this little, white, vintage dress. It captivated my artistic vision and sparked my creativity so much that I knew I had to have it. The pureness and originality of the tiny dress truly expresses my style.

This was the perfect moment to use the little, white, vintage dress. Notice how beautiful it complements the mother's blouse as she gazes down on her precious baby. This was a very special moment for this new mommy because this little princess arrived unexpectedly many years after mom thought her family was complete.

I placed the mom's back at a slight 45-degree angle to the light behind her, camera left, and turned her just a bit so the light could embrace her and the baby's face.

ISO 400, 1/250 sec., f/2, 50mm lens

My Inspirations

My inspirations come from how I live my everyday life and the things around me that just simply move me and awaken my emotions. My inspirations express the use of an abundance of natural light, fresh flowers, simple fabrics, summer breezes, the sound of birds gently chirping, robin eggs, warm hugs, baby smiles, snuggles, flowing curtains, and a clear blue sky. These are the elements that define my style and express who I am as a person. In my studio I have an abundant supply of lace fabrics that I use to wrap babies and drape them over expectant mothers. Their beauty influences my inner creativity.

You don't find inspiration; you live it.

An elegant lace fabric bathed in beautiful light is inspiring to me.

ISO 400, 1/160 sec., f/1.8, 50mm lens

This perfect little antique dress adds to my newborn clothing collection.

ISO 400, 1/200 sec., f/1.8, 50mm lens

Inspiration

As much as an emotion of a photograph captures your heart, so must you be inspired and fully connected to your imagery. However, trying to draw from the inspiration that defines you as an artist is sometimes difficult to accomplish.

Inspiration comes from within you—your emotions, feelings, and what comes from your heart. Many things in your life leave you inspired with a sense of peace and well-being. Your inspiration and your style help to define you as a photographer and as a person. You don't find inspiration; you live it.

You'll come across many inspiring things in your everyday life, but the inspiration that I'm referring to speaks to your true passion for life. It's an inspiration that allows you to be free and creative in a unique and energetic way. It's a vision of where you're headed on your own creative path. The way in which you approach your subject will define how you express it. There's no right or wrong way. It's all in your perception and how you envision it. In this chapter, I'll take you on a journey, showing you how to recognize inspiration, define your style, become a story-teller, and learn to apply your inspiration to your own work.

ISO 400, 1/200 sec., f/1.8, 50mm lens

where you want to be. Most businesses start out at the kitchen table with a few basic tools. It's about building and growing as you go, not putting yourself in debt before you even begin.

Although a hobbyist photographer may love this book, it's really geared toward those seeking a newborn photography career and yearning to learn the craft to sustain a profitable business. Photography is about capturing and telling a story. It's not about merely taking a picture. You can easily do that with your cell phones. If you are serious about newborns as your niche and are willing to start from the beginning and learn safe, natural posing using natural light, you'll find this book to be a great resource.

As a professional photographer specializing in newborns, it's pertinent you not only have mastered certain camera techniques, but you also realize that handling newborns in a safe and delicate manner is of utmost importance. You should know what you are doing before jumping into newborn photography.

I'll show you ways you can set yourself apart from other photographers and create value, how to market your business, and steps to creating a business plan. You won't find a comprehensive breakdown of how you should price your products or set up collections. Although I realize this is a big part of the business plan, there are many great pricing guides on the market that will help direct you in a detailed and thorough manner. Instead, I'll give you basic pricing principles and list the most common expenses associated with a photography business. You'll see that pricing is more than just picking numbers from thin air.

In this book, I'll take you through the post-processing workflow I apply to all my images and share tips and techniques on how to be efficient and consistent in your workflow. You'll learn how to prepare your images with a clean edit before enhancing them with artistic styles. Creating an efficient workflow is essential to maximize your time and run a profitable business.

To benefit from this book, you should apply the guidelines set forth and practice, practice, practice. Starting and running a profitable photography business is not easy. There are many fundamentals you need to learn first, and you should expect to take some business courses at your local college as a prerequisite to starting your own business. Don't try to jump in and do everything too quickly. Focus on your business plan, and take one step at a time. It's all about you and how your specialized niche can set you apart from everyone else. It's *your* journey.

—Robin Long

Introduction

When I first started in photography, I remember looking at how peaceful the babies seemed in those squishy little poses and thinking it was quite simple to accomplish. With a little milk and a warm room, there didn't seem to be much else to posing a newborn. After all, I had three babies, so I knew how to comfort them and get them to sleep. But could I move them from one pose to another without disturbing them? I soon realized there was a lot I needed to learn about newborn photography before I could master this specialized niche.

The main focus of this book is about posing newborns in a pure and natural way while keeping them safe and maintaining a thermo neutral environment. I'll also provide you with the key principles of what you need to start a newborn photography business. This book is not about the props or the next best pose, or trying to compete with all the other photographers in the industry. This book won't show you how to accomplish composite shots with the trendy poses, such as froggie or the hanging sling shots. Instead, you'll find instruction on basic posing, storytelling, and the joy of timeless natural imagery to build a lasting foundation for your own work.

We'll start with basic posing and learn how to move babies from pose to pose, keeping them calm and asleep while doing so. This can be a difficult task to perform, so I'll explain the best ways to accomplish posing. I'll describe the specific poses for newborns less than two weeks of age and those that are best for babies up to six weeks of age. I will not discuss photographing older babies or children in this book, because it is strictly centered on newborn imagery.

In addition, we'll examine the tools necessary for every newborn photographer. I'll show you how to start with basic equipment and which products you can purchase at a later time after your business progresses. It's OK to start off simple using just a few blankets and wraps. You shouldn't feel obligated to keep up with everyone else and spend thousands of dollars just to start your business. In addition, I'll share suggestions on how to prep the parents for a smooth session and specifics they should be aware of beforehand. You'll also learn how to set up a complete session by starting with a shooting plan to maximize your time more efficiently.

I started my business in my garage on a hot summer day with a beanbag and a fleece blanket I purchased from Wal-Mart. Spending hours researching on the Internet to learn about lighting and camera techniques was a typical day for me. It wasn't until four years later that we were able to build a studio onto our home. Building a business does not happen overnight; it sometimes takes years to get to

Captivating Connections with Families . 95
Completing the Session . 107

CHAPTER 5 The Anatomy of a Newborn 109

Circulatory System . 110
Newborn Skin . 113
Premature Babies . 114
Baby Cues. 115
Soothing Techniques. 117
More Soothing Techniques . 121

CHAPTER 6 Natural Imagery Through Storytelling 123

Capturing the Details . 124
Wrapping the Baby . 133
The Beauty of Black and White. 144
The Power of Natural Imagery . 146

CHAPTER 7 The Digital Darkroom 151

Calibrating Your Monitor . 152
Using Adobe Camera Raw and Adobe Photoshop . 153
Post-processing Efficiency. 163
Consistency . 165

CHAPTER 8 The Newborn Niche 171

Define, Create, and Implement. 172
Setting Yourself Apart . 174
Creating Value. 177
Your Client Base . 181
Marketing Your Business. 183
Social Media . 187
Creating a Business Plan . 189
Pricing and Products . 197

Index 201

Contents

CHAPTER 1 Inspiration 1

My Inspirations ...2
Create an Inspiration Board...................................4
Define, Develop, and Deliver5
The Storyteller.. 10
The Unwritten Word ... 18

CHAPTER 2 Beautiful Light 21

Quality of Light and Time of Day............................. 22
Tools to Direct Light 23
Working with Natural Light 24
The Importance of Proper Exposure............................ 28
Understanding Aperture, ISO, and Shutter Speed 30
Histograms ... 34
White Balance .. 39
Customize the Playback Menu 40
My Settings... 41
Raw vs. JPEG ... 42
What's in My Camera Bag..................................... 42

CHAPTER 3 The Planning Stage 45

Prepping the Parents 46
Planning the Session.. 55
Shoot to Sell... 57
Simple Setup ... 59
Baby Tools Every Newborn Photographer Should Have........... 61
Age Matters .. 65

CHAPTER 4 Newborn Posing 71

Posing Insights ... 72
The Four Basic Poses .. 76
Smooth Transitional Techniques.............................. 89
Choosing Your Props... 90

Dedication

For my husband and our three beautiful daughters. You're the loves of my life.

Acknowledgments

I would first like to thank God for giving me the gift of my art and being able to share it with the world. The passion and perseverance He has blessed me with has enabled me to continue on a journey I never expected to fulfill.

A special thank you to the love of my life, my husband, Dennis, for his love and continued support. My career and this book would not have been possible without him by my side through this entire journey.

My deepest appreciation goes to my three daughters, Heather, Nichole, and Rebecca, along with my five granddaughters, Emelie, Ashlie, Abbie, Katie, and Nora, as well as our dog Toto too. Their willingness to put up with me dragging them into the light as my captured subjects and sitting patiently while I practiced, even though sometimes I had to resort to bribery, has brought me to where I am today. Without them, I never would have been able to follow my dreams.

A special thank you to my mom, my forever friend, for showing me her love and encouraging me in everything throughout my life. No matter what I've accomplished or didn't, she has guided and cheered me along the way.

I'd like to thank all my clients who graciously allowed me the honor of photographing their beautiful babies portrayed in this book.

Many thanks to the fine team at Peachpit Press, especially to Susan Rimerman my Project Editor and Anne Marie Walker my Development and Copy Editor, who pushed me to go above and beyond, and have been extremely patient throughout this project. Thank you to Lisa Brazieal my Production Editor for her expertise and always being there for me every time I needed her; to Mimi Heft my Designer for her expertise in designing a beautiful layout; and to Sara Todd my Marketing Manager for her extreme dedication. I couldn't have asked for a better team. They have all made this a wonderful and exciting experience.

Natural Newborn Baby Photography
A Guide to Posing, Shooting, and Business

Robin Long

Peachpit Press
www.peachpit.com

To report errors, please send a note to errata@peachpit.com
Peachpit is a division of Pearson Education.

Acquisitions Editor: Ted Waitt
Project Editor: Susan Rimerman
Production Editor: Lisa Brazieal
Development/Copy Editor: Anne Marie Walker
Proofreader: Bethany Stough
Indexer: Karin Arrigoni
Composition: WolfsonDesign
Cover and Interior Design: Mimi Heft
Cover Photograph: Robin Long

ISBN-13: 978-0-321-90361-7
ISBN-10: 0-321-90361-7

9 8 7 6 5 4 3 2

Printed and bound in the United States of America

natural newborn baby photography

A Guide to Posing, Shooting, and Business

robin long

 Peachpit Press